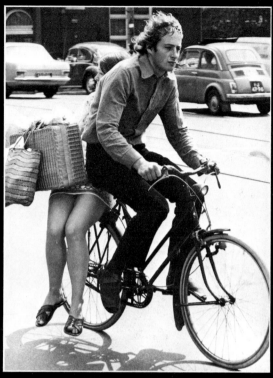

The handbook of
PHOTOGRAPHING
PEOPLE

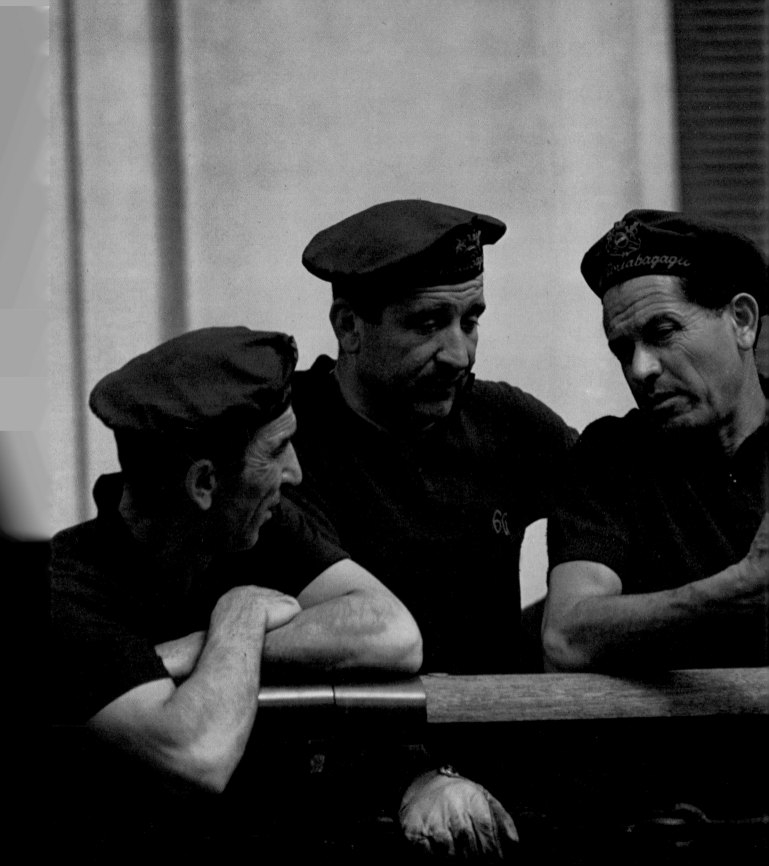

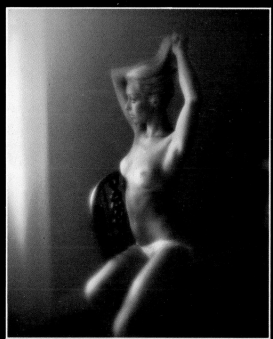

The handbook of
PHOTOGRAPHING
PEOPLE

Michael Busselle

MITCHELL
ARTISTS
HOUSE
BEAZLEY

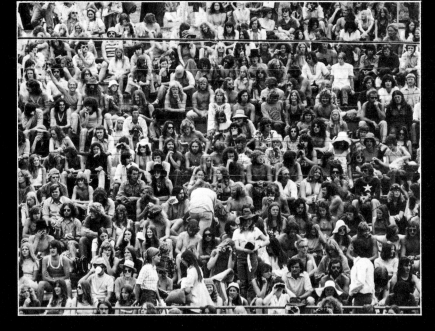

An Adkinson Parrish Book

Published in 1980 by
Mitchell Beazley Artists House
Mitchell Beazley London Limited
Artists House 14–15 Manette Street
London W1V 5LB

ISBN 0 86134 023 X

© 1980 by Adkinson Parrish Limited

Designed and produced
by Adkinson Parrish Limited, London for Artists House.

Managing Editor	Clare Howell
Design Manager	Christopher White
Editor	Alan Reid
Art Editor	Pat Gilliland
Assistant Designers	Suzanne Stevenson
	Mike Strickland
Picture Researchers	Mark Dartford
	Alan Reid
	Lynette Trotter

Phototypeset in the United Kingdom by
Servis Filmsetting Limited, Manchester
Colour illustrations originated in Italy by
Starf Photolito SRL, Rome
Printed and bound in Italy by L.E.G.O., Vicenza

CONTENTS

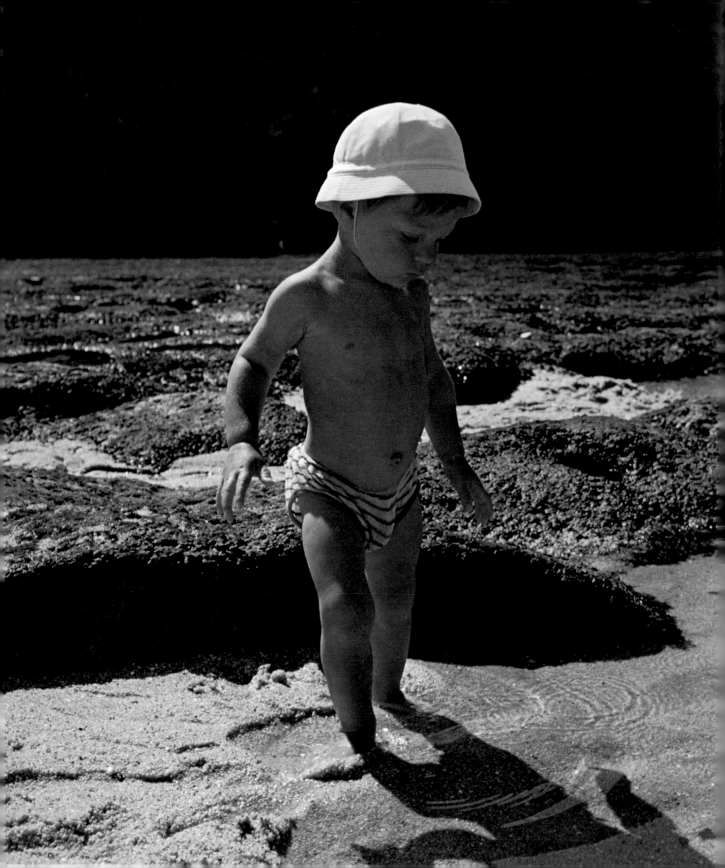

INTRODUCTION

THERE ARE MANY comparatively recent developments that we now take for granted as part of everyday life, and yet life in our society would seem impossible and unthinkable without them. The combustion engine, for example, and now even the micro chip have moved from being amusing novelties to vital necessities in no time at all. These and many other innovations, however, have perhaps done more for our material wellbeing than they have for our souls.

Photography is an innovation, scarcely more than a century old, that is taken for granted even more than most. But it has had a dramatic effect on our lives, and not only materially but also in the way it has enabled people to become far more aware of their own world and of other societies. Photography, too, has made man's inhumanity to man so widely known, in such a visually incontrovertible way, that there is real hope of such excesses becoming unrepeatable.

Today's children are probably unaware of the extent to which the camera brings a new understanding and excitement to their school lives, but education increasingly takes place through the benefits of visual stimulation. And the effect that photography has had on leisure and entertainment is overwhelming.

Photography has in many ways become a new and universal language, one that can be used to inform, educate, persuade, entertain and offer a means of personal expression – and its benefits are available to all who can see. You do not have to be a photographer to enjoy photography, of course, but an understanding of the visual processes involved in making an image will not only increase the pleasure of looking at photographs but will also increase your powers of observation, and produce a heightened awareness of the world.

The greatest pleasures, however, do come to those who make their own pictures, and the satisfaction that can be gained from producing a really fine photograph is hard to describe to anyone who has not experienced it. There is a mistaken belief that some major, rather mysterious skill is necessary to become a good photographer, whereas the only real requirement for taking a good photograph is the ability to see clearly and objectively – something that everyone does in some aspect of their lives. Plus, of course, the urge to take photographs.

The aim of this book is to foster and encourage this urge, and at the same time to help the aspiring photographer to see more clearly, and to understand how he can use the relatively simple mechanics of the process to record what he sees onto the film.

Much of the advice and many examples of techniques given in this book can be applied equally effectively to other areas of photography, such as still life and landscape, but the reason for a book specifically about photographing people is that this field is particularly relevant to everyone who owns a camera – whether they want to record moments in the life of their family, the experiences of a holiday, or to create their own personally expressive images.

It is a book that is concerned primarily with seeing and taking good photographs, rather than with being a technical manual – although there are many practical hints, and I have included, as a guide, the technical details for a cross section of my own photographs, which comprise about half of those used to illustrate the book. I hope that the book will not only suggest to existing enthusiasts new ways of photographing people, but will also help the novice or the casual family snapshooter to experience the pleasure and excitement of producing really good pictures whenever they want to – and that it will demonstrate that you do not have to be 'serious' or 'artistic' or a technical genius to do so.

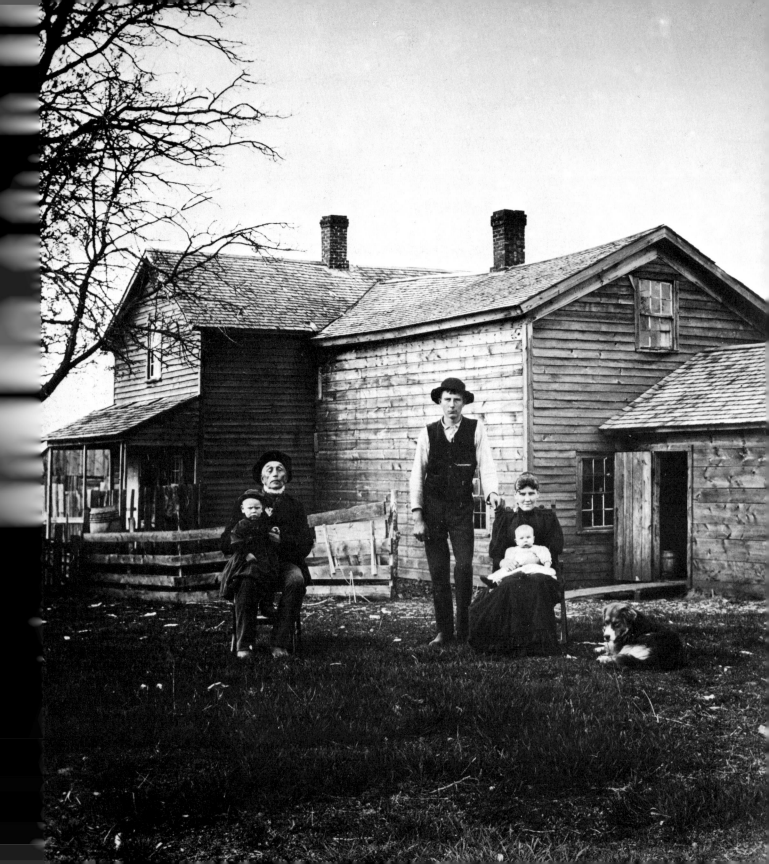

PEOPLE IN THEIR ENVIRONMENT

THE RELATIONSHIP between people and their environment has fascinated photographers ever since a camera was taken outside the studio, and some of the most notable pictures in the history of photography are on this theme. Small, lightweight cameras have simplified documentary photography, but the wealth of fine pictures taken in the days of long exposures and cumbersome equipment proves that it is the attitude and energy of the photographer, and not his equipment, that produces the best results.

It is unfortunate, but understandable, that many people explore the pictorial possibilities of people only when the environment is unfamiliar – while travelling abroad, for instance, or even on holiday in their own country, when even the most jaded eyes are liable to sparkle with enthusiasm.

However many of the best pictures of this type have been taken by photographers living in the area, and who are familiar with the people they have photographed. It is possible to take worthwhile pictures on a brief visit to an unfamiliar location, but ideally you should become attuned to the people and their environment, resisting the temptation to take pictures that have only a superficial and perhaps untruthful appeal. The right attitude of mind is all-important.

A genuine interest in, and a liking for, the subject of your photographs (rather than an intrusive, voyeuristic attitude) will make taking them much more pleasurable and the results far more satisfying.

When visiting an unfamiliar locality, a little research is invaluable. Some knowledge of the people and their culture, of how and where they live, will help you to rapidly develop rapport with them when you arrive. It is also a great help in foreign parts to know enough of the language to at least be able to say 'please' and 'thank you' – and even better 'do you mind' and 'excuse me'.

But it is most important not to undervalue the potential of your own environment. The possibilities that your own familiar town offers may not be immediately obvious, but it is worth remembering that while you may find a mountain village in Mongolia visually stunning, it is likely that its people would find your environment exciting.

There is also the advantage that knowledge and familiarity can be used to produce pictures with far more insight than a casual visitor could achieve; and a series of pictures taken of your own environment over a period of years may well have a more lasting value than those taken during a two-week holiday visit to another country.

A further advantage is that in sweeping aside the mists of familiarity you could considerably increase your visual awareness and develop your creative abilities.

'Family Group', near Black River Falls, Wisconsin, by Charles Van Schaick, c.1900.

People & landscape

The figure in the foreground accentuates the height of the viewpoint (above), and helps to create a greater impression of distance and scale without using any special lens.

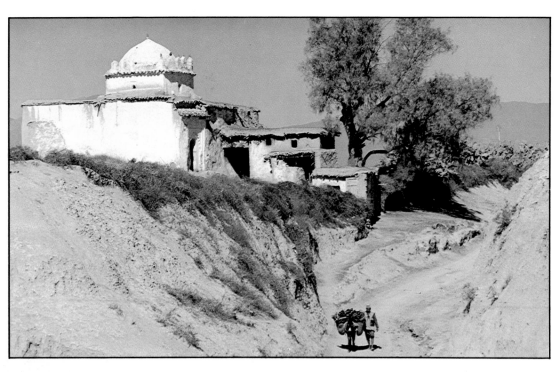

EVEN IN THE MOST **dramatic and panoramic landscape, the presence of one tiny human figure will instantly command attention. Consequently, the way that people are used in a landscape picture needs to be considered very carefully in relation to both its composition and its purpose.**

The presence of a single figure in an otherwise empty landscape often results in the viewer identifying with that person. Travel photographers taking pictures for tour operators invariably use people in their photographs for this very reason. A deserted beach often looks more inviting – and paradoxically more deserted – because the presence of a person more easily enables the viewer to imagine himself in that situation.

Because the human presence is such a dominant element in a picture, its size and position will be a key factor in the picture's balance. When the centre of interest is meant to be a part of the landscape, it is vital that the position and relative scale of the figure does not compete for attention. If it does, the balance will be disturbed.

If, on the other hand, the figure is the key point of the image, then its position should be at the compositional centre of the picture, or at the point at which the image seems to balance best.

It is important to be aware of the purpose of figures in landscapes, and of the relationship between them. In many situations a figure is used simply to create a sense of scale. The wide sweep of a mountain valley, for example, can be more impressively displayed when contrasted against a small figure in the middle distance. Indeed it is often difficult to convey a true impression of scale

in a picture without using this type of technique.

Alternatively the landscape may simply be acting as a background to the person. By playing a secondary role in the picture, its objective is only to help establish the identity or purpose of the main subject.

In the first instance the figure may be so small that only a featureless outline may be visible. Even a tiny silhouette on a horizon will command attention and effectively establish the scale of the landscape. In the second situation, when the person is the subject of the photograph, the figure should normally be close enough for its features and expression to be recognizable.

Perspective plays an important role in the relationship between a landscape and the human figure. From a distant viewpoint the impression of scale is closer to reality. The landscape is seen nearer to its true proportions in comparison with the subject, but as the camera is moved closer to the person so the relationship alters and the true scale is lost.

When you want to maintain a relatively large image of the subject, but not lose the impression of scale, it is far better to use a long-focus lens than to move closer to the person. Conversely, when you want to increase the scale of the human figure in relationship to the landscape you have to move closer to the figure and yet retain the full sweep of the landscape. In this case a wide-angle lens can be used to good effect.

By varying the camera position and the focal length of the lens you can have a wide degree of control over the scale of figure and landscape, and over the relationship between them.

The very small figures included on the same plane as the landscape (left) achieve a similar effect of scale to the mountain picture alongside it, but in a different way. A long lens was used to retain a satisfactory image size from a distant viewpoint.
Nikon F2 with Vivitar 70–210 zoom lens at 200m; 1/250 at f5.6; Ektachrome 64; polarizing filter.

With figures close to the camera, and using a normal lens, the landscape in this picture (right) becomes a secondary element. An even closer viewpoint would result in the landscape being further diminished in relation to the size of the figures.
Pentax with 50mm lens; 1/250 at f5.6; Kodachrome 25.

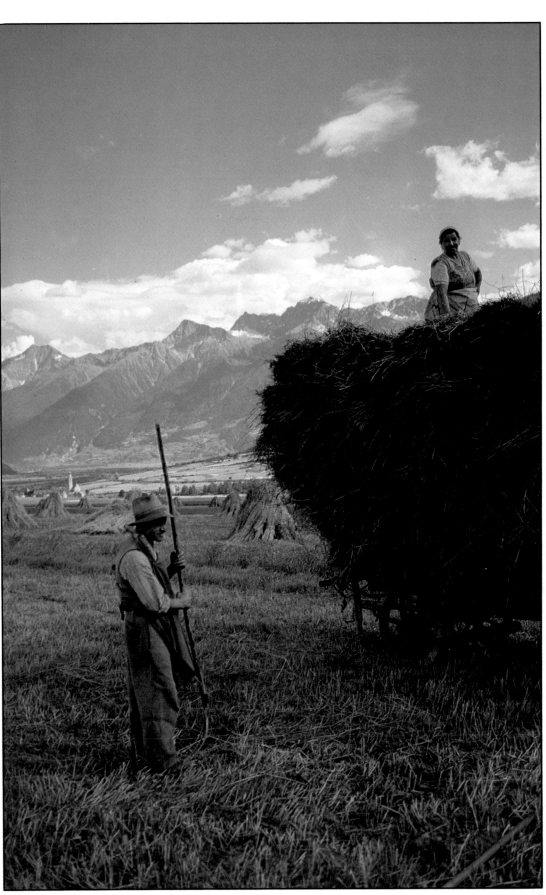

The urban setting

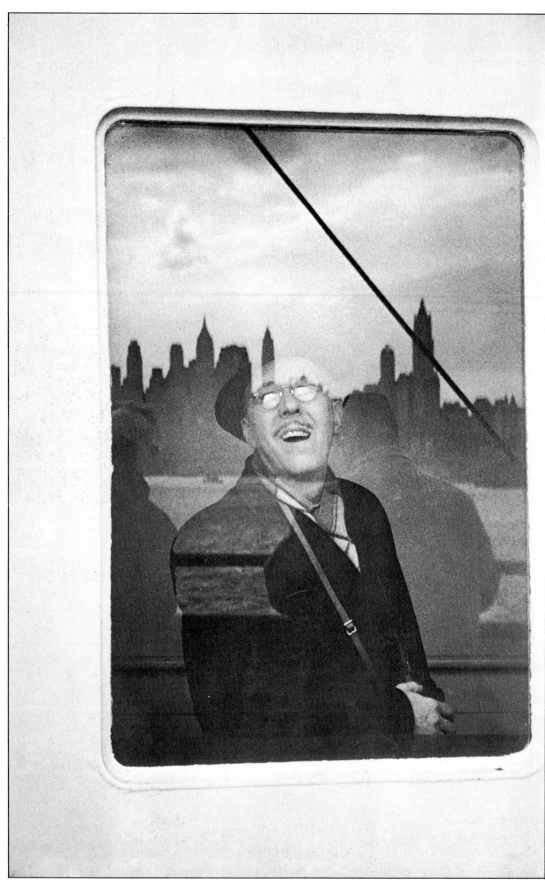

Henri Cartier-Bresson
combines a homecomer's
exhilaration with the skyline
he is so pleased to see (left).
It is seldom possible to
photograph a person's
reaction and also show what
he is reacting to without
being too gimmicky, but the
photographer has achieved
this with a superb picture.

The urban environment
abounds with graphic
images, offering countless
opportunities for interesting
compositions. In this coastal
resort scene (right) the people
are almost a secondary
element in a photograph rich
in graphic quality.
Pentax with 135mm lens;
1/250 at f5.6; Ilford FP4.

TOWNS AND CITIES can be a great source of inspiration and present many opportunities to those interested in photographing people.

City life is much more concentrated and far more visible than life in the rural environment, and there is also a tendency for town dwellers to be less inhibited than country people. It is easier to mingle with the crowds in a city street, and to take pictures where people are unconcerned or unaware of the camera than it would be in a small village.

The life of a city can also appear more vigorous and visually exciting. There is always something happening somewhere; even at night or in the early hours of the morning there are people around – going to work, cleaning the streets, setting up a market.

Although it can be quite rewarding simply to wander around more or less aimlessly looking for pictures, many people will work more effectively when they have a specific objective, so it may be beneficial to set yourself a project or a theme that you can work on.

A series of pictures of a street market, for instance, or of commuters travelling to work, or a collection of pictures of all the shop-keepers in a town, could be challenging projects to photograph. It could also be interesting to take a sequence of pictures of the same location, a square for example, during the course of a day to show how its appearance, and the activities of people using it, change as time passes.

Pictures taken in this way often have a more durable appeal than random shots.

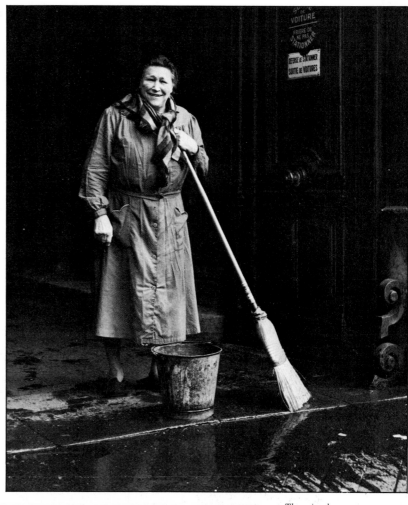

There is always someone up and about in a city – like this concierge in Paris (above) whose early morning cheerfulness and pleasure at being photographed provided a good example of an urban setting. Less extrovert country folk are not usually so easily photographed.
Rolleicord; 1/125 at f4; Ilford FP4.

People in close-up

IN ALL AREAS of photography the picture that has the most immediate impact is frequently the one which ruthlessly excludes extraneous detail and concentrates attention on the subject itself. With people, it is invariably the face which conveys the most expression, and is their most interesting aspect; so pictures that successfully capture an expression or a gesture are often enhanced by cropping tightly.

Close-up pictures require perfect technique to achieve the most effective results. The human face contains a mass of fine detail, and unless this is recorded sharply the picture will lose a great deal of impact. The textures of skin and hair are extremely difficult to record well, but doing so can give very powerful results.

The camera needs to be focused absolutely accurately with close-up subjects, and the slightest degree of movement by camera or subject can be disastrous. It is wise to use the fastest shutter speed possible to avoid this problem – that means a wide aperture, and you must remember that the closer you are to your subject the smaller will be the depth of field, regardless of aperture.

A long-focus lens is a positive asset for this type of picture as it enables you to work at a greater distance from your subject. Shooting from too close can create an unpleasant exaggeration of perspective on a face, and apart from that, the close proximity of a camera could seriously inhibit the subject. A long lens will also help to separate the subject from the background, especially when wider apertures are used and this can add even more impact to the picture.

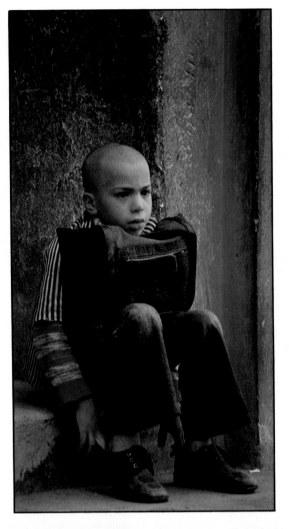

The intimacy of the young boy in pensive mood (left) is emphasized by cropping extraneous detail, while keeping the rough wall in focus accentuates the smooth, youthful face.
Nikon F2 with Vivitar 70–210 zoom lens at about 135mm; 1/125 at f4; Ektachrome 64.

This is an example of how a wide-angle lens (below left) captured a close-up shot that would have been impossible with the shallow depth of field of even a normal lens.
Nikon F2 with 24mm lens; 1/250 at f5.6; Ektachrome 200.

Textures give this picture its quality (below) achieved by a long lens, wide aperture and accurate focusing in strong light. Always try to focus on the eyes for close-ups.
Nikon F2 with Vivitar 70–210 zoom lens at 150mm; 1/250 at f8; Ektachrome 64.

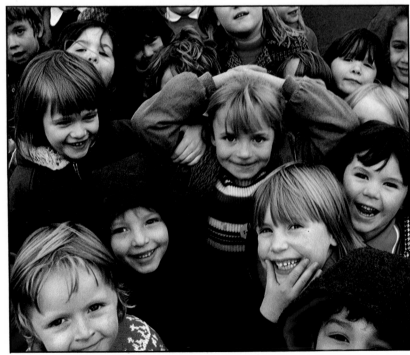

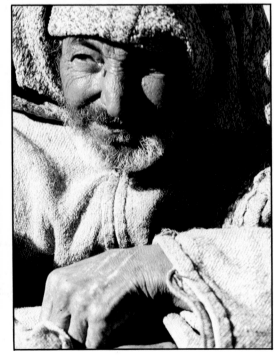

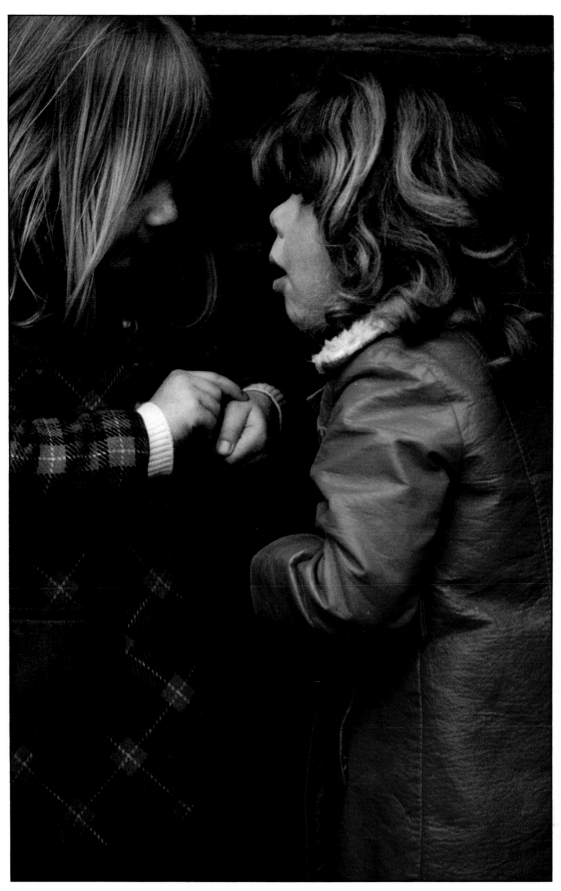

A close-up taken with a normal lens, and made possible by the two girls being totally engrossed in their conversation (left). The tight composition, without any other detail, emphasizes the secretive atmosphere. Nikon F2 with 105mm lens; 1/250 at f5.6; Ektachrome 200.

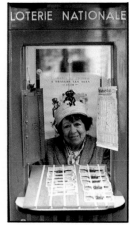

A close-up cannot always be unobtrusive, but here the lottery ticket seller (above) has welcomed the photographer. Although this is not a true close-up, the framing of the kiosk gives it a strong close-up appearance. Nikon F with 105mm lens; 1/125 at f4; Ektachrome 64.

People & their occupations

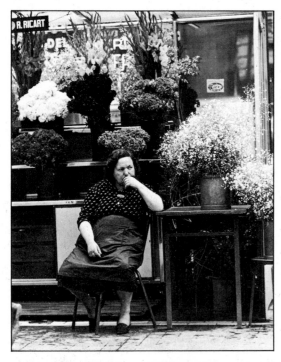

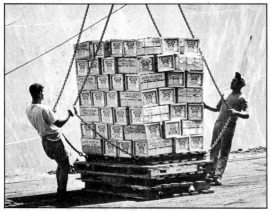

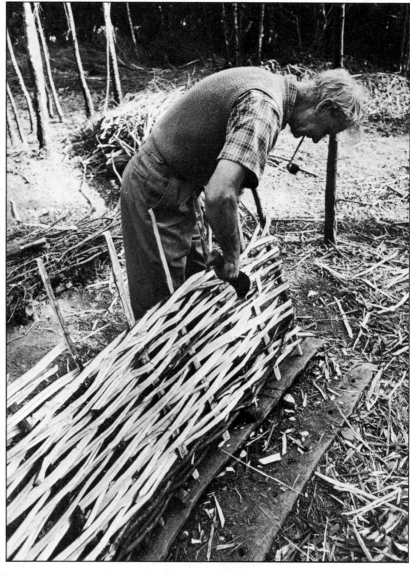

A long lens can isolate a subject, but the inclusion of this Barcelona flower seller's stall (top) makes it a more meaningful picture than a straightforward portrait. Nikon F with 105mm lens; 1/250 at f5.6; Kodak Tri-X.

The timing of the exposure gives this picture of dockyard workers in Haifa an impression of action (above). A long lens is almost essential in such a busy and hazardous setting. Nikon F with 105mm lens; 1/250 at f8; Kodak Tri-X.

ONE OF THE MOST frequent questions that people ask when meeting for the first time is what they do for a living. This inherent curiosity about a person's occupation is also reflected in photography; not only is a picture of a person carrying on his trade or skill often more interesting than a neutral one, but it can also say more about the person himself.

There is often a strong visual relationship between an individual and the tools of his or her trade, or the place of work, which can be used to good effect in the composition of a photograph. People who might be inhibited by the presence of a camera frequently seem to gain confidence, and are more able to relax, when surrounded by the evidence of their own abilities. In this context they can be more easily photographed – photographers themselves often prefer to be photographed behind a camera.

The approach you use can vary. You could simply pose your subject against a background which does little more than establish his occupation or, at the other extreme, actually take pictures of him while he is working.

Most people will be flattered by an interest in their activities and will be only too pleased to demonstrate their skills or interests – and of course it is also much easier to take pictures of people who are engrossed in what they are doing and are unaware or unconcerned about being photographed.

Some occupations themselves have strong visual elements. Steel foundries, mines, dock-yards, ship-yards, and so on, offer many striking settings, although it may be dangerous to photograph people in such conditions and difficult to get the necessary permission. As a study of a person, however, it could well be that a picture taken of a foundry worker at the end of a shift would have as much impact as an 'action' shot.

A wide-angle lens allowed
the photographer to take a
close-up picture of a wattle
hurdle maker (left) that also
includes a scene of his craft.
Although the man was well
aware of the photographer,
pride in his work made him a
willing and relaxed subject.
A normal lens would have
only included the area shown
in the diagram (above).
Nikon F2 with 24mm lens;
1/250 at f8; Kodak Tri-X.

Newspaper sellers, such as
this one in Jerusalem (right),
are often sufficiently extrovert
to make suitable close-up
subjects, and often they are
too busy to pay much
attention to a photographer.
A degree of isolation is
achieved by shooting from
shade against the light,
which reduces background
detail.
Nikon F with 105mm lens;
1/250 at f5.6; Kodak Tri-X.

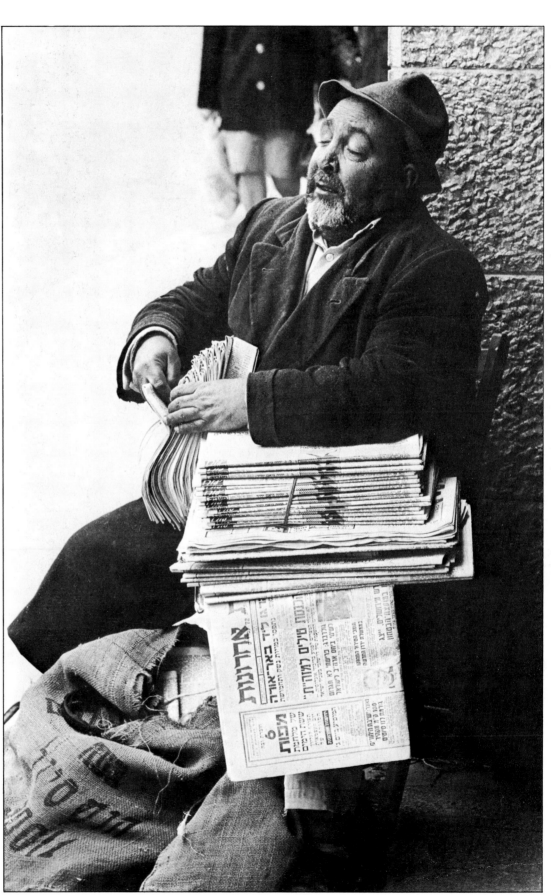

Using colour

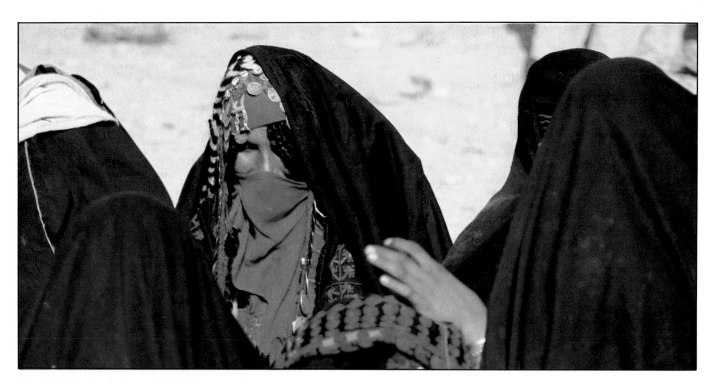

MANY INEXPERIENCED **photographers believe that a good colour photograph requires a subject with an abundance of brilliant colours and the lighting of a bright sunny day. In fact, these conditions will virtually guarantee a disastrous result for the unwary.**

A successful colour picture requires the same careful thought and choice of colour that you would give to decorating a room or co-ordinating clothes. It is vital that the colours in a photograph work together with each other and with the other elements of the picture to form a balanced composition, rather than be allowed to compete with each other and to create a confused image.

In a colour picture all the individual colours visible in the scene will have as strong an influence on the construction of the picture as will the other elements of composition, such as shape, tone and perspective. In fact where a dominant colour such as red is present, it can easily override other factors and unless cautiously used will cause a conflict within the picture.

To use colour effectively, it is necessary first to understand the nature of colour, and the way in which individual colours react with each other. All visible colours and hues are found in the spectrum – which ranges through red, orange, yellow, green, blue, indigo and violet. The way in which colours react with each other depends on their relative positions in the spectrum.

Colours which are far apart, such as red and blue, are said to be in contrast with each other, and colours which come from adjacent sections of the spectrum are described as being in harmony –

as are hues or tints of the same basic colour.

In terms of its effect on the composition of an image, contrast is the most important colour reaction. In a picture where a small area of colour is in contrast with all the other colours, that area will automatically attract the strongest attention. It follows, therefore, that if this colour does not coincide with the main point of interest an imbalance will be caused. Very bright and fully saturated colours will have an even more dramatic effect when viewed against opposite colours.

A colour picture will always have more impact when it has a single well-defined subject having a dominant colour which contrasts against that of the surrounding subject matter. This technique will work just as effectively if the overall colour of the image is subdued or even neutral – in fact greater restriction on the use of colours in a picture will cause the colours that are used to have a far more dramatic effect.

The control that a photographer has over the colour content of a picture is generally limited, with the exception of, for instance, model pictures and studio situations where clothes or the background can be changed at will. In outdoor locations the main control is by the choice of viewpoint and the framing and selection of the image area.

The need for careful framing and the ruthless exclusion of unwanted detail is even more vital with colour pictures than with black and white, because very little control can be exercised over the colour content of a picture other than by initial selection.

Although the red veil and embroidery form a small part of the composition, they dominate this image (above). Red is so strong a colour that it will usually attract most attention, and should be used with restraint.

An infinite variety of colour normally appears confusing, but here the coloured wools are contained within the dominant blue (right). The lighting is soft, giving a flat, shadowless wash that lessens the conflict of colour. With a multitude of colours, open shade or the lighting of a cloudy day will give the best results.
Nikon F2 with Vivitar 70–210 zoom lens at about 180mm; 1/250 at f5.6, Ektachrome 64.

The large expanse of red in this Paris scene might have been overwhelming without the contrast of the blue dress and the distant door frame (above). Cooler colours and various tones of tans and browns can completely dominate a picture and still be very attractive, but a 'red' photograph would need a dramatic composition that suited the atmosphere given by the colour.

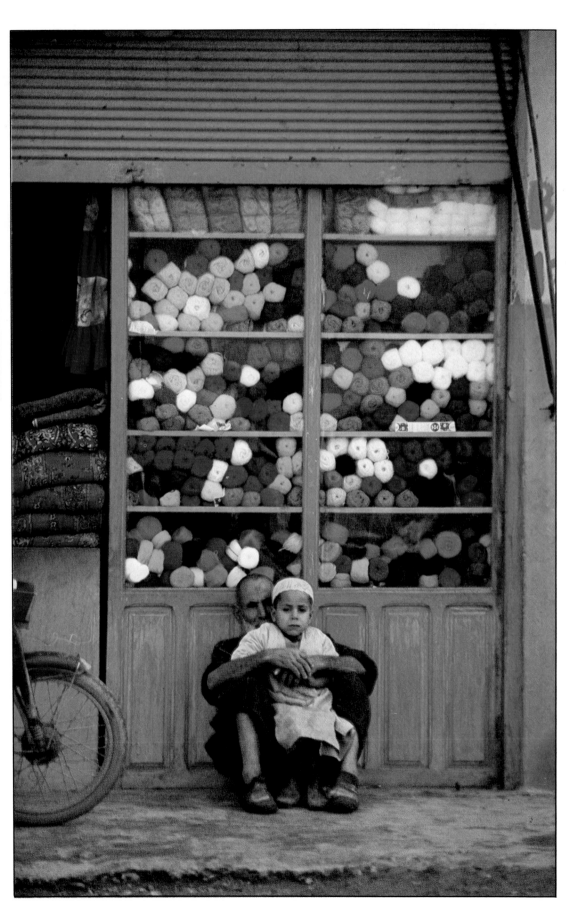

19

Creating mood

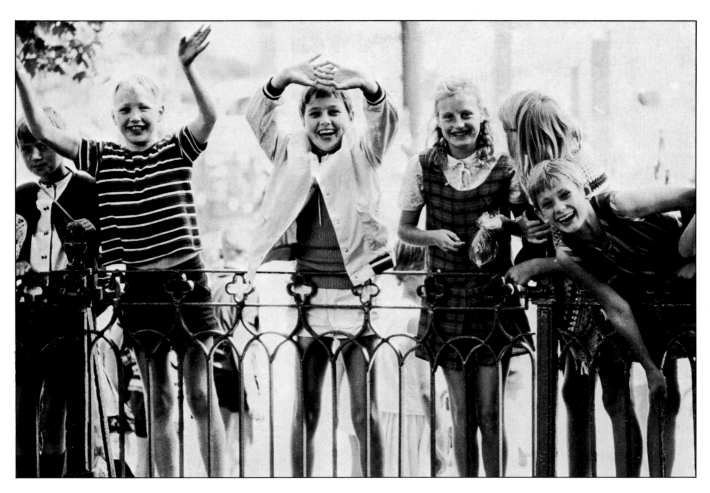

Bright sunlight creates an image with a full range of tones and strong highlights (above) that emphasize the happy, carefree quality of these young children. Nikon F with 200mm lens; 1/250 at f8; Kodak Tri-X.

PHOTOGRAPHY IS capable of recording only the visual details of a scene. It cannot represent any of the other qualities which help to create atmosphere or mood, and yet these other qualities – like temperature, sounds and smells – play a large part in the way we react to a particular situation. It is therefore necessary for a photographer to concentrate all his feelings about a particular scene into purely visual terms, to create a visual impression of the other senses.

A photograph can be a simple record of a situation, making no attempt to convey anything more than a clear and accurate representation of the camera's view. But a photographer can also attempt to convey more than this; by the use of visual techniques it is possible for a photograph to produce an emotional response which goes beyond that invoked by the subject alone.

Most of these techniques are dependent on suggestion. Rather than presenting a scene in terms of bald facts, aspects of it are left to the viewer's imagination. In most photographs which are strong in mood, there is a degree of ambiguity, an element of mystery, something that stirs the viewer's imagination. In fact it is often by withholding some of the visual information that a

photograph evokes an emotional response.

Lighting is perhaps the most basic method of controlling the amount of detail in a photograph. Large areas of shadow tones, where only a suggestion of detail is visible, are frequently used in mood pictures, tending in these cases to create a sombre atmosphere. But a picture which has large areas of light tones and bright highlights will imply a more gentle or happier mood.

In black and white photography considerable control can be exercised over the tonal range of an image at the printing stage, by varying exposure and contrast and by techniques like dodging and shading. With colour transparencies, however, the control must be made in the camera itself by the choice of exposure and the use of filters.

Where and how the camera is focused will also have a considerable effect on the detail in a picture. Indeed, the ability of a camera lens to create 'out of focus' zones in an image can be a very useful creative tool. In a purely 'record' photograph the objective is to retain all the visible detail as clearly as possible. To create mood, however, it is often preferable to select which parts of the image are recorded sharply, and which have their detail subdued or even lost completely.

The control of 'unsharp' areas of the image can

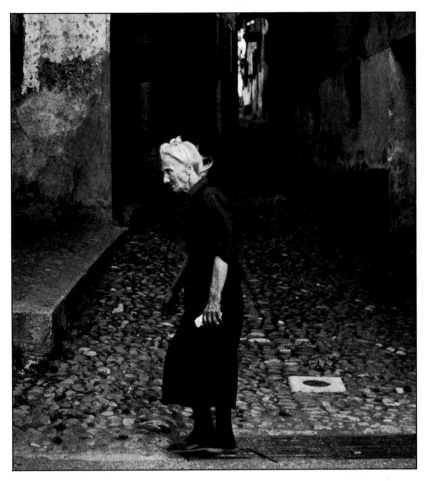

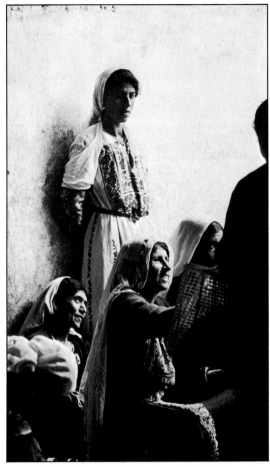

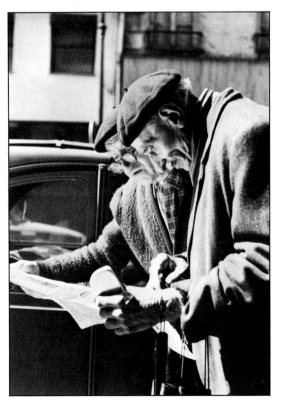

be made initially by selecting the point at which the lens is focused, and further by the choice of aperture, which controls the depth of field. This control can be extended even more by the use of soft focus techniques, which can be used either over the whole image or selectively.

Composition, such as the way shapes are used in a picture, can also play an important role in creating mood. A number of similar shapes which repeat throughout an image to suggest a pattern, like a group of people, for example, create a restful and harmonious mood. But many different shapes and indiscriminate placing imply a more restless and aggressive quality.

A photograph which is dominated by parallel or horizontal lines, such as in a landscape, will also have a more peaceful quality, while strong diagonal lines will appear more vigorous.

It is only rarely that one single factor is responsible for creating the mood of a picture, and it is usually by combining several elements that the most effective photographs are made. The person being photographed is obviously the starting point; each of the mood elements which can contribute to the desired effect must first be identified and then used in such a way that enables their contribution to be cumulative.

The predominantly dark tones of the scene (above left) were retained in the exposure to give a sombre picture that befits the slump of the old woman's shoulders. Rolleicord; 1/125 at f4; Ilford FP4.

Shadows created by strong sunlight in the open area of a market (above) convey a relaxed, tranquil atmosphere that is enhanced by the expression of the standing girl. Nikon F with 105mm lens; 1/125 at f4; Kodak Tri-X.

Early morning sunlight reflected off the newspaper on to the faces of these elderly Parisians (left) makes a warm, happy picture, and the tight cropping detaches the subjects from the hustle and bustle around them. Rolleicord; 1/250 at f5.6; Ilford FP4.

Colour harmony

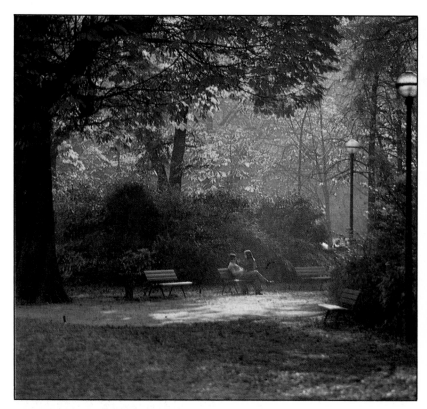

ALTHOUGH A PICTURE that contains two or more strongly contrasting colours may have a powerful initial impact, there can be many situations where the use of colours which harmonize with each other can be more appropriate. This is particularly true of images in which there is a full range of tones from bold highlights to strong shadows, or where the subject is composed of varying shapes and fine detail. In these instances the addition of bold, contrasting colours is likely to produce a confusing and unbalanced image.

Colours which harmonize either come from the same section of the spectrum or are tints of the same basic colour. It is, however, possible for a picture to have colour harmony even when its colours come from different parts of the spectrum, provided that the transition from one colour to another is quite gradual, and the distribution evenly balanced.

Harmony will also exist more easily when colours are not fully saturated, either being paler tints or darker and subdued tones. This quality of colour is less predictable and more subtle than colour contrast, and many factors other than the actual colours of the subject can contribute to creating a sense of colour harmony.

Lighting and exposure can both be factors in reducing the strength of colours in a scene. Strongly lit, over-exposed areas, for example, can even result in bright, strong colours being recorded as pale pastel tints which will blend with

each other. And the darker, shadowed areas of a subject which have been given less than the correct degree of exposure will become slightly degraded, causing a similar balancing-out effect.

Light which produces a slight colour cast, such as late afternoon sunlight, or dusk or dawn light, will also have a tendency to create a harmonious colour quality. Such light literally lays a colour tint over the whole scene – an effect which can be artificially produced by using colour filters.

Areas of an image that contain contrasting colours can also be subdued by having them out of focus, or unsharp. This tends to reduce the colour saturation slightly by allowing the colours to 'run together'. Blurred images created by subject or camera movement have a similar effect, and techniques such as soft focus and the use of fog filters, both of which reduce contrast and colour saturation, also tend to produce colour harmony.

Other factors which influence image and colour contrast are the effects of atmospheric conditions, such as mist, fog or even rain. These can often 'tone down' the strongest colours and create images with very soft and quiet tones.

Shooting into the light can be used in some circumstances if you allow a degree of flare by letting the sun shine directly on to the camera lens. This can cause a drastic reduction in both image contrast and colour saturation, but it is rather difficult to control. A single-lens reflex or a view camera is practically essential in order to judge the effect on the viewing screen.

In this tranquil park scene (above left), harmony has been created by the autumn colours, the soft misty lighting, and the colour warmth of late afternoon sunlight.
Nikon F2 with 200mm lens; 1/250 at f5.6; Ektachrome 64.

Back lighting and the resulting degree of flare (above) reduces colour saturation and further softens colours that are already muted.

The slight soft focus used in this picture (above) has muted the greens in the background, reducing their contrast with the dominant foreground colours, which are all in close harmony.

Fairly tight framing of the flower seller and her wares (right) with a longish lens isolated colours from the overall scene to achieve harmony, and slight under-exposure has made the colours less vivid.
Nikon F with 105mm lens; 1/125 at f5.6; Ektachrome 64.

The white and tanned skin of the girl (top) is mirrored by her hair, the colour of her blouse and the white wall to give a pleasant, warm picture that might have been spoiled by a sharply contrasting colour.

Soft focus and the flare caused by back lighting (above) can considerably reduce colour contrasts which might otherwise distract from the main subject.

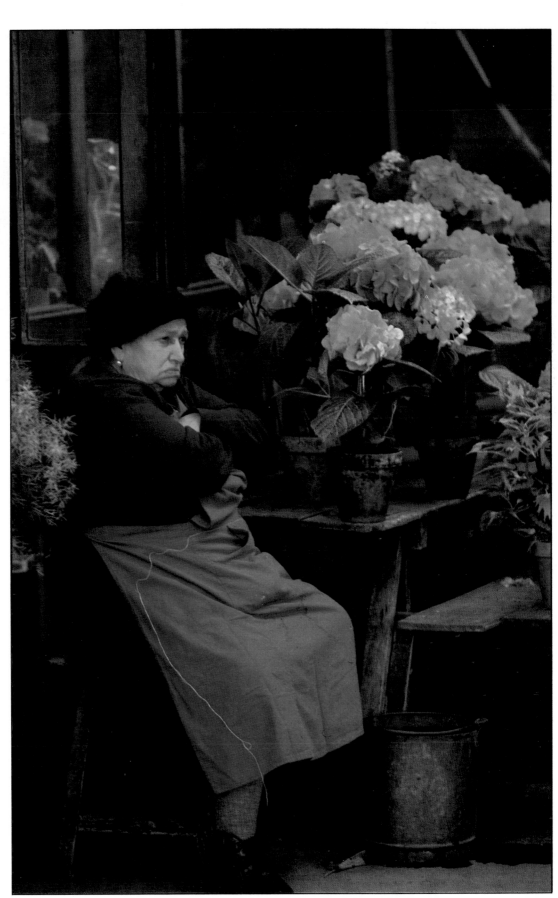

Judging the moment

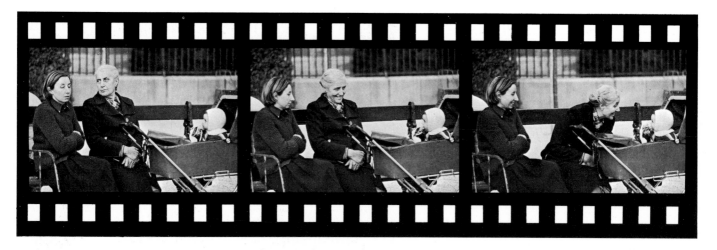

This illustration shows how patience can be rewarded, with the scene improving until a far more interesting image is captured (above). Contact sheets can be very informative in showing how elements change and combine to provide the right moment. Nikon F2 with Vivitar 70–210mm zoom lens at 135mm; 1/250 at f8; Kodak Tri-X.

THE ABILITY of photography to make an instantaneous, accurate record of a scene at the press of a button is unique, though it is now taken for granted. A painter or sculptor must labour for days or weeks before he can consider his work complete, and he may continue to make refinements almost indefinitely.

Very few situations remain totally static; a landscape, for example, can change dramatically over even a few minutes. The movement and formation of clouds, the effect of lighting, reflections in water, the combination of elements which exists at a particular moment will never be repeated exactly.

When photographing people the change during the merest fraction of a second can be even more significant. In the majority of great photographs the actual moment of exposure is the crucial factor which singles out that one particular image from the merely 'almost greats'. Henri Cartier-Bresson, one of the greatest photographers of people, has called it 'The Decisive Moment' and it is the recognition of this moment that is one of the true skills of photography.

When preparing to take a photograph it is essential to become aware of the elements within the image which are being affected by the passage of time. The composition, for example, will be affected by the movement of people, or even of their limbs. The lighting will be affected by the movement of a cloud, or by the turn of a head. The whole meaning or significance of a picture can be altered by a change of expression on the subject's face, or by a gesture.

Once you have become aware of these changing elements, it is a relatively simple matter to see

In this picture (right) the camera was lined up and the photographer waited until the couple arrived at the right position to complete the picture. The composition would have been considerably different, and probably far less pleasing, at a different moment.

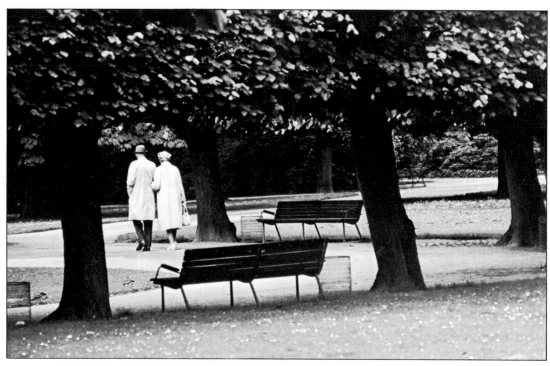

whether the quality of the image is improving and moving closer towards the picture you want, or whether by waiting the picture will be lost.

It should also be remembered that the camera itself is a moving element in the pattern – but is one that can be controlled. By watching the pattern of the picture developing it becomes possible to anticipate the moment when all of the elements will combine to their greatest effect and it is to this moment that one should work. The actual exposure is really the culmination of a series of events, rather than an event in itself.

Most photographers prefer to make exposures throughout this build-up period, particularly when the subject is co-operating with the photographer, as with portraits or glamour. This is partly because the very use of the camera, firing the shutter and winding on – and in the case of a model also offering verbal encouragement – actually helps to develop a rapport.

It can be very instructive to select a film sequence from which one good picture has emerged, and to analyze why that one particular frame is so much more successful than the others. Sometimes you are not aware that you have taken the best frame, or even that the decisive moment has arrived.

The 'right' picture may have come by luck or by instinct, but you can learn a great deal by working out afterwards why that one was so successful – and why the others were not. Often it is something quite subtle, like the turn of a head or even the twinkle in an eye, but invariably there is a particular factor which singles out that one good picture from all the others.

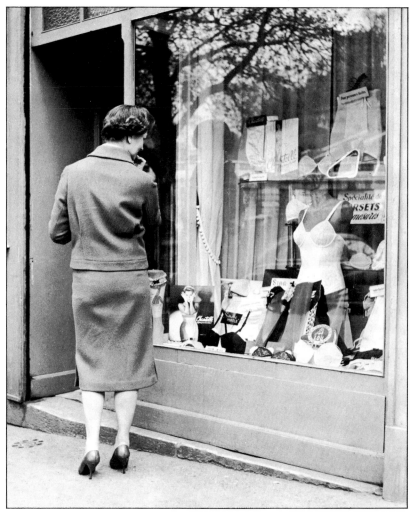

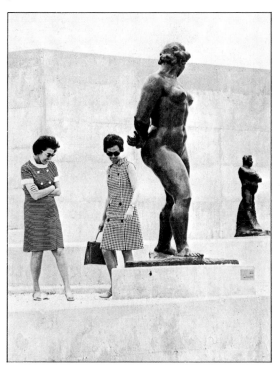

This picture of a Parisian window-shopper (above) is made successful by the small gesture of a finger to the lip – a tiny but vital part of the image.
Rolleicord; 1/125 at f5.6; Ilford FP4.

Both these pictures (left) were taken when a number of variable elements coincided, and show how awareness of moving figures and gestures can give a more interesting shot.
Nikon F with 105mm lens; 1/250 at f11; Kodak Tri-X.

Composition & emphasis

A GREAT MANY PICTURES are disappointing because the photographer has not tried to visualize the completed photograph, but instead has simply responded to a situation and shot the picture without thinking how and why he wants to take it.

It is essential that before you start making exposures you should understand exactly what it is you have found stimulating in a scene, why you find it interesting, and what there is about it that you do not like.

What you leave out of a picture can be just as important as what you include. Unfortunately, however, you can easily become so preoccupied with the exciting aspects of a scene that you do not notice the other things which the camera will record with equal clarity – things which do not contribute to the photograph, and usually spoil it. Those embarrassing photographs where trees seem to grow out of people's heads are a direct result of the photographer not thinking clearly about the picture he wants to take, or looking properly at the whole view.

First, identify the components of your picture. It may be a market square, for example, where crowds of people jostle around the stalls. Farther away is a distant church, and on one side of the square, behind a stall piled high with fruit, an old lady serves a customer. Perhaps there is also a battered old truck and a pile of broken boxes. These are the elements that compose the scene you want to shoot, and you have to decide what you want, which element is the most important, and what aspects of the scene you want to exclude.

Emphasis is achieved by deciding what will comprise your main subject, and then which of the remaining elements will contribute to the picture. One mistake that is a common cause of bad pictures is to attempt to get too much in. Although the complete scene may have inspired you, in purely visual terms it may appear as a confusing jumble of detail. There may be two, three or even four pictures in the scene which could be successful individually but a collective disaster; on the other hand, it is possible that the whole scene makes the picture.

There is no easy answer, no formula to follow. It is ultimately a question of your own preference and taste, and the decision you make will be a step towards developing your own style as a photographer. The most important thing is to be aware of your options, to be able to see what your alternatives are. Indeed, if you can spare the film, shoot them all – it is the best way to learn. You will have taken a significant step when you can accurately visualize the way your completed picture will look at the moment of shooting, and the experience gained by shooting and then comparing results is the most valuable form of instruction.

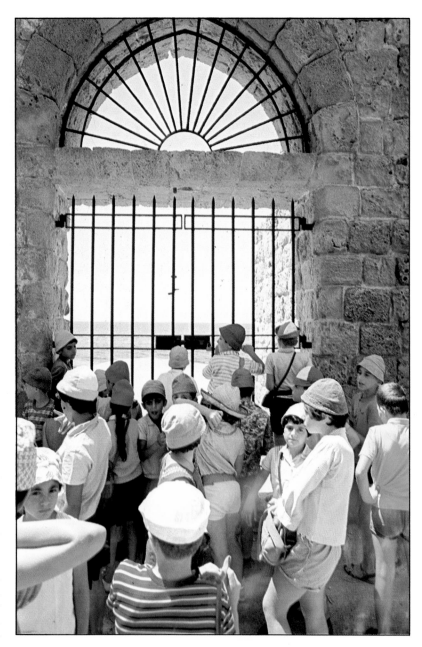

Composition is simply the technique of combining the individual elements of an image into a single balanced and harmonious picture. The basic method is first to establish the main subject at the most dominant position in the frame, and then to ensure that the other elements complement the subject and do not compete for attention. You should not include anything that does not make a contribution to the effect of a picture.

It must also be remembered that in photographic terms the subject and secondary elements of a scene must not only be considered as shapes or objects but also as tones and colours. The lighting must therefore also be considered as an element of composition, because highlights and shadows can be dominant forces in a picture.

The inclusion of the organized formality of the archway (above) emphasizes the random aspect of the children, preventing this being a rather uninteresting and untidy picture. Nikon F2 with 24mm lens; 1/250 at f5.6; Ektachrome 64.

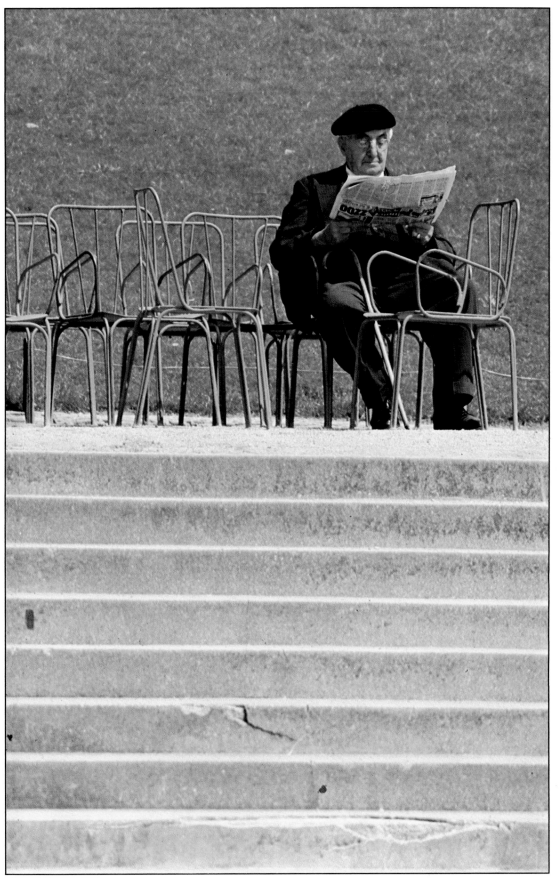

The deliberate inclusion of a large area of steps (left) not only leads the eye towards the subject, but also results in an appealing contrast between the strong horizontal lines and the spidery jumble of the chairs. Note also the classical positioning of the subject on the intersection of thirds.
Pentax with 135mm lens; 1/250 at f5.6; Ektachrome 64.

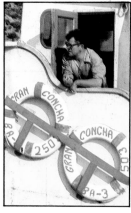

A more closely cropped picture would be just another portrait, but the inclusion of the life belts (above) establishes location, occupation and interest. The appearance of the man within the frame of the doorway prevents too much scattering of interest, however.
Pentax with 135mm lens; 1/250 at f8; Ektachrome 64.

Isolating the subject

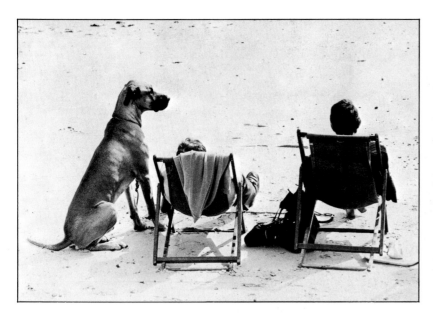

THERE ARE MANY occasions when you want to single out a particular element of a scene to give it prominence, or to avoid it being lost in the surrounding details. It may be a single face, a figure or a small group of people, but the ability to use techniques that isolate your subject can be invaluable in producing pictures with a strong impact.

The first, most elementary control available to a photographer is his choice of viewpoint. This is particularly true when no other control of the subject is possible, as in sport or documentary photography.

By carefully positioning the camera it is usually possible to find a background against which the subject can be seen clearly. Even a very small area of contrasting tone or colour may be all that is necessary to bring out a vital detail in the subject, and give the picture additional impact.

In most instances the object is to find a contrasting element which can be used in juxtaposition with the dominant element. For example, a subject that has intricate detail or texture will be more effectively displayed against an area of bland even tones; a subject with a strongly dominant colour such as red will show more clearly when a neutral or contrasting colour such as green is positioned behind it.

An even-toned area can often be found by using a low viewpoint, with the sky as a background. On the other hand, a high viewpoint can separate the subject from confusing background detail in the mid-distance, or on the horizon.

Lighting is another effective method of isolating the subject – again by using contrast. A very effective way of achieving a strong impact with a subject in shadow is to create a semi-silhouette, particularly when the shape or outline is an important element, by using a sunlit area as the background. This can often be done by shooting from a doorway or a window into the light.

The opposite technique can also be applied where the subject is in bright sunlight or well lit. Manoeuvring so that an area of shadow is behind the subject, and exposing for the highlight tones, will result in a black or very dark background.

Shooting in shadow towards the sun is another lighting technique which can effectively separate the subject from surrounding details. Back lighting provides a rim of light around the subject which will create a strong degree of separation, even with a dark-toned subject. It is important however that the exposure should be measured from the subject itself towards the camera (incident method); if back lighting is allowed to influence the reading, under-exposure will result.

You will also find that background details are usually considerably subdued by shooting into the light, so this is a useful technique in situations that might create a fussy and confusing image.

Perhaps the most under-used method of isolating the subject is provided by the camera's focusing control. In situations where other methods of separating the subject from its surroundings are not effective, it is often possible to focus on the subject and allow the background (or foreground) to remain unsharp. This requires the subject to be on a different plane of focus to the area you want to lose – the greater the difference, the more effective the separation.

The effect can be strengthened by moving closer to the subject, and by using the widest possible aperture – both result in decreasing the depth of field. A long-focus lens will exaggerate this effect even more, especially when used at a wide aperture. Accurate focusing is vital, however – if the subject itself is not needle sharp the whole effect will be lost.

The light background provided by bright sunlight on the street (above), and an exposure for the low lighting of the foreground, gives a bold outline, almost a silhouette, without any distractions. Rolleicord; 1/125 at f5.6; Ilford FP4.

Isolation of the subjects in this seaside picture (above left) is achieved by the light background against which the darker shapes and figures stand out clearly. A slightly high viewpoint ensures that distant distractions, such as the horizon line, are avoided. Nikon F2 with 200m lens; 1/250 at f11; Kodak Tri-X.

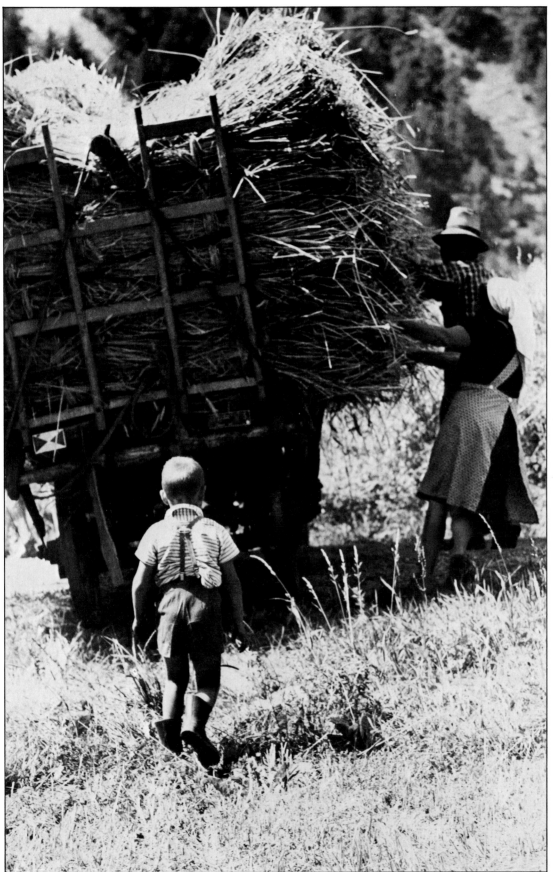

Slight back lighting creates a rim of highlight around the child's figure (left), and the careful choice of camera position achieves subject isolation by setting the figure against a dark background. Pentax with 135mm lens; 1/250 at f5.6; Ilford FP4.

A close camera position, the use of a longish lens, and a wide aperture separate the man's face from a confusing background (above). The closer to the subject, the more restricted is the camera's depth of field – an effect that is increased by a wide aperture and a long lens. Nikon F with 105mm lens; 1/250 at f4; Kodak Tri-X.

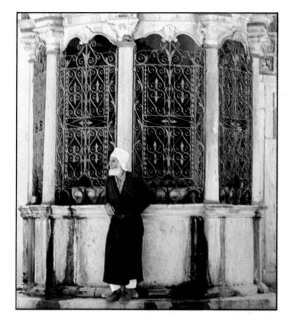

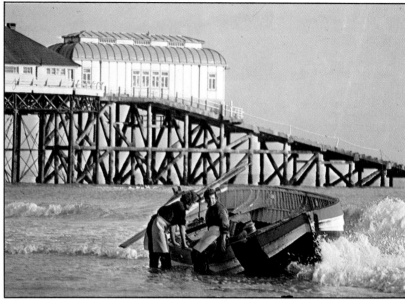

THE BACKGROUND of a photograph is often negatively thought of as an area which just happens to be there, simply something behind the subject. But nothing should be included in a picture unless it makes some contribution, and this applies as much to the background as to anything else.

There are two basic ways in which the background can contribute to a picture. It can provide a contrasting element against which the subject of the picture can be more clearly seen, or it can provide additional information about the subject. Which role the background plays should not be a matter of chance, but the result of a conscious decision by the photographer.

When you want the background to underline the importance of the subject, you should look for a form of contrast that will accentuate a particular aspect. A total contrast is perhaps the most straightforward. A light background will give additional impact to a dark subject, such as a whitewashed wall behind a dark-clothed Greek peasant; the same degree of contrast would come from a dark wood door as the background to the white habit of a nun. This effect can of course be achieved in colour, where the colour of the subject is accentuated by using a contrasting colour in the background.

Background contrast can be achieved in other ways – through shape for example. When the subject is formed largely of curves – as in a picture of a nude girl – you can effectively use angular shapes in the background to enhance the body's curved contours.

Relative size is another way of using a contrasting element in the background. The smallness of a young child, for example, can be accentuated by a large tree dominating the background.

The background, however, can also be used in harmony with the subject – the most obvious instance of this is where it contains information which tells us more about the subject itself.

This is often used in portraiture, where the background is used to help establish the personality or occupation of the model. A portrait of a man posed against a plain background would tell us little about him apart from his appearance and expression. Photographed against a background which represented his interests or skills, however, such as books for a scholar, or an office for a businessman, the picture would be much more informative.

The background can also be an important factor in helping to establish the atmosphere of a picture. A shot of a person against an industrial landscape of factories and chimneys would create a totally different impression from one of the same person, with an identical expression, but set against a background of woods and fields.

There are occasions when the background can, if allowed to, neither accentuate nor complement the subject. Then it can be a negative influence, resulting in an indifferent picture. The most common example is where the background contains details or information that have no relevance to the subject, and simply distract from it.

Our eyes have the ability to 'home in on' the main point of interest, ignoring distracting background elements; but a camera will relentlessly record everything, and often the background will be more distracting in a photograph than at the time of shooting. It is vital to be constantly aware of what is going on in the background of your pictures, and not to allow anything to remain there which is not making a positive contribution.

The intricate pattern of the background could almost make a picture of its own (above left), and although the old man is a secondary element, his presence makes a strong contribution.
Nikon F with 105mm lens; 1/125 at f8; Ektachrome 64.

Without the background, this could be a picture taken at almost any fishing village (above). The inclusion of the pier, however, makes it as essentially English. The use of a long-focus lens and a distant viewpoint gives an interesting juxtaposition of the crab boat and Cromer pier.
Nikon F2 with 150mm lens; 1/250 at f5.6; Kodachrome 25.

The importance of viewpoint

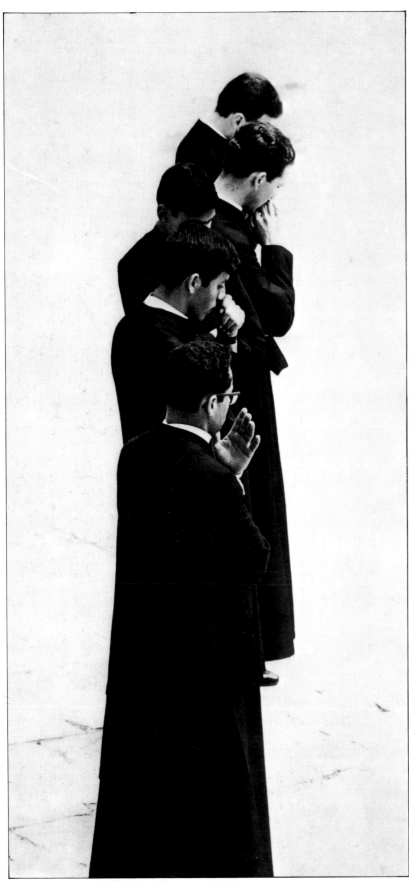

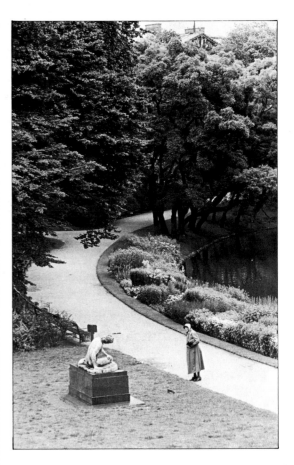

THE POSITION from which the camera is aimed is perhaps the biggest single influence on a picture, and many unsuccessful pictures are a result of not giving the viewpoint proper consideration.

If you take a scene which has a fairly close foreground – the frame in the view from a window for example – and look at it with only one eye and then with the other, you will notice a significant change both in the relationship between the foreground and distant objects, and that occurs with a shift of viewpoint of only a couple of inches.

Many inexperienced photographers are prepared to shoot a picture from the position they first saw it, without considering how it might look from a few paces to the left or far to the right, from ground level, or high off the ground. It may well be that the first position you saw it is the best viewpoint, but you cannot be sure until you have explored other possibilities.

Viewpoint influences most of the vital elements in an image – composition and perspective, foreground and background, and even lighting. When choosing a camera position all of these elements should be studied, and the likely effects of a change of viewpoint should always be considered, and preferably explored.

The influence of viewpoint on composition is

A distant, slightly high viewpoint emphasizes the scale of the small figure in relation to the large park (left). A lower viewpoint, as in the diagram above, would not have given the effect of the path, and the lady would have been indistinct against a confusing background. Nikon F2 with 200mm lens; 1/250 at f8; Kodak Tri-X.

A wide-angle lens enabled a very close viewpoint (above right) that makes a strong feature of the two children in the foreground, while still retaining a broad view of the other figures. Close viewpoints invariably create a more intimate feeling than distant viewpoints. Nikon F with 20mm lens; 1/250 at f8; Kodak Tri-X.

A high viewpoint created this unusual composition, enabling the heads to be above each other (far left), and giving a plain background that does not distract from the strong composition. Nikon F with 200mm lens; 1/250 at f11; Kodak Tri-X.

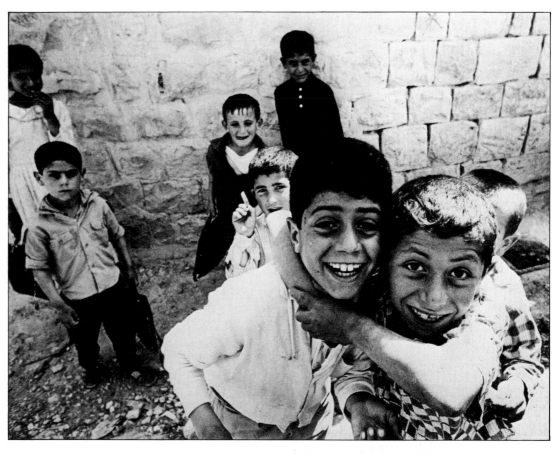

easiest to judge, as it will have the most dramatic effect on the content of the picture. Imagine a situation where you are photographing a man ploughing a field. A five-bar gate dominates the foreground, and a church the background. By moving to the right you effectively move the man to the left of the church, and by moving to the left you can reposition him to the right. By stepping back a few paces you can include the gate in the foreground, whereas by moving closer you can exclude it. A low viewpoint would enable you to shoot through the bars of the gate, and by standing on the gate you would be able to look down on the farmer, and exclude the church.

The possibilities are numerous even without moving much from the first position – you could still consider how the picture might look from the tower of the church, for example, or from ground level looking up at the approaching plough.

Perspective is controlled exclusively by viewpoint, for the relative size of the objects in the viewfinder are dependent on where you place the camera. From a distant viewpoint the man with his plough would appear much smaller than the church, but moving closer to him would make him appear progressively larger, until from a very close viewpoint he would literally dwarf the distant church.

Lighting can also be controlled by the position

of the camera in relation to the subject. If the sun was behind the camera when shooting from the five-bar gate, then a shot taken from the church tower would have the sun behind the ploughman, which would totally change the lighting quality of the picture. But even a small change of camera position can make a significant change in the angle of the lighting, particularly in bright sunlight. Soft light, as on an overcast day, is less dramatically affected by a shift of viewpoint, but some change will still occur.

The lessons learnt for composition apply, as we saw, to the control of both foreground and background. Foreground detail (such as the gate) can be excluded or included by changing your viewpoint, and so can backgrounds (like the church). If left or right movements are not suitable, a very low viewpoint can make the sky the background and distracting detail can be hidden behind the main subject. A very high camera angle will exclude both sky and distant backgrounds by shooting down onto the subject.

One final consideration of viewpoint is its effect on how the frame is filled. One of the common causes of disappointing pictures is that too much has been included, simply because the photographer has not been close enough to the subject. So a question that even experienced photographers should ask is, 'Am I close enough?'

Being unobtrusive

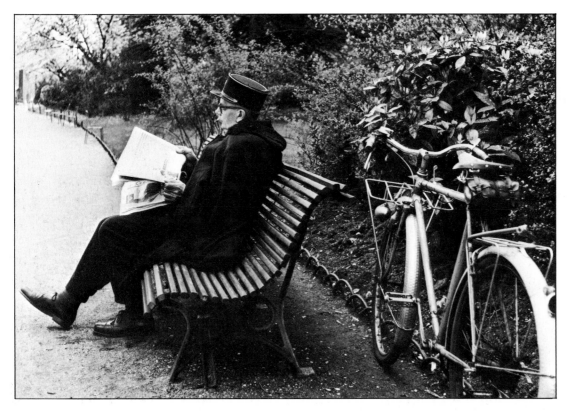

The photographer was able to get close to the subject (left) by appearing to be more interested in other scenes. When the gendarme went back to his paper, it took only a moment to make the exposure with the pre-set camera.
Rolleicord; 1/125 at f5.6; Ilford FP4.

This was a fairly easy photograph to take (right), because the two old ladies were engrossed in conversation. A long lens enabled the photographer to make a number of exposures without attracting attention.
Nikon F with 105mm lens; 1/125 at f5.6; Kodak Tri-X.

The presence of a photographer in a dockyard attracts attention, but an hour or so spent photographing ships and cranes establishes familiarity, whereupon unobtrusive pictures can more easily be taken (top right).
Nikon F2 with 105mm lens; 1/250 at f8; Kodak Tri-X.

THERE ARE BASICALLY three ways to take photographs without unsettling your subject. Most people react in some way when they suddenly notice a camera pointed at them, and this reaction (whether favourable or unfavourable) could easily spoil the picture you wanted to capture.

The first, perhaps most obvious way, is to ensure that the person you want to photograph cannot see you, or at least cannot see your camera. This involves a fair degree of stealth, and you need to work quickly and smoothly, especially if you want to have more than one attempt.

It is most important to be totally familiar with your equipment; you must be able to select a viewpoint, without using the viewfinder, which will give you the right composition with whatever lens you are using. An accurate estimate of the focusing distance enables you to preset the focus, and unless you use an automatic camera you must also judge exposure. This is best done by taking a reading of an area with comparable lighting and tonal range, out of sight of your subject.

The ideal situation is that you should have prepared your camera, without drawing attention to it, to the point where it needs only to be raised to the eye and triggered. It has been said that the great master of reportage, Henri Cartier-Bresson, could fully prepare his camera while it was still in his raincoat pocket – familiarity like this can come only from practice and experience.

If you intend to use this approach, you obviously have to dispense with such conveniences as elaborate compartment cases. It is vital to travel light – with the camera carried in the hand or pocket, and not slung round the neck. Spare lenses and film should be carried in pockets or in an unobtrusive bag, such as a canvas haversack or an airline bag.

You should also keep well out of sight of both your subject and people nearby when loading film or changing lenses. It is not always enough to be unseen by your potential subject alone; if bystanders see your camera and become aware of your activities, their interest may also attract the attention of your subject.

If you are spotted as you take your photograph, don't turn your back and walk away, but smile and say 'thank you' or 'I hope you don't mind' – and if they do mind, apologize. Being a photographer does not give anyone the right to violate other people's privacy.

Alternatively you may allow your intended subjects to be aware that you are taking pictures, but set out to convince them that something else is going to be photographed. There are a number of ways to do this, but all depend on the assumption that ordinary people will seldom believe that they warrant the interest of a photographer.

So you direct your attention elsewhere, over their shoulders to some distant object, for example, or to one side of them, and make a show of peering through the camera as if waiting for

In this picture taken with a twin-lens reflex (right), the waist-level viewfinder and comparatively silent camera mechanism allowed surreptitious exposures to be made from close to the subject.
Rolleicord; 1/250 at f5.6; Ilford FP4.

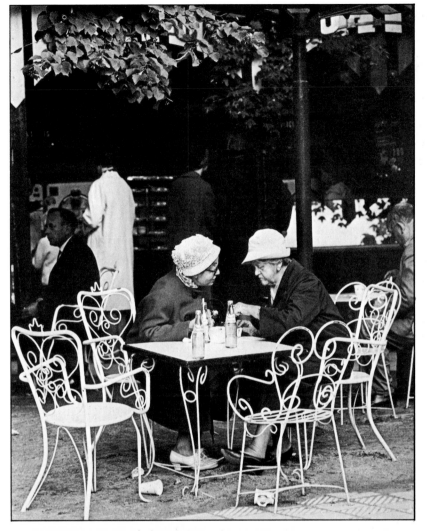

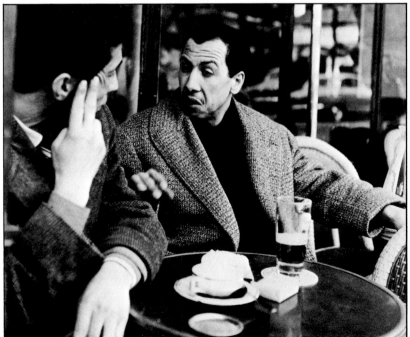

something to happen. What you are really waiting for is for them to lose interest in your activities, and to go back to what they were doing before – at which moment you can swiftly aim the pre-set camera at them, frame and fire, and immediately point it back at your imagined scene, waiting for another attempt.

This method of bluff will not work with people who expect – or hope – to be photographed. A snake charmer in Marrakesh would probably get up and drag you over to take a picture if you pretended not to be interested – and would then charge a fee.

Perhaps the best method is simply to allow your presence and your camera to become familiar. Do not make any attempt to be unobtrusive, but wander around in sight of your subject, take a few pictures – read a book even. Allow yourself to become part of the scene, for people become bored at the sight of someone unfamiliar surprisingly quickly. Very soon you will not be given a second glance, even if, initially, you had to endure being stared at, perhaps with hostility.

Once you have established a presence people will return to their other interests and activities and then you can begin to take the pictures you want. It must still be done quickly, quietly and smoothly, however. Do nothing to rekindle their interest in you. It is still advisable to change lenses or film in a quiet corner. And if you are caught shooting a picture eye to eye, smile, do not turn away.

Photographing primitive societies

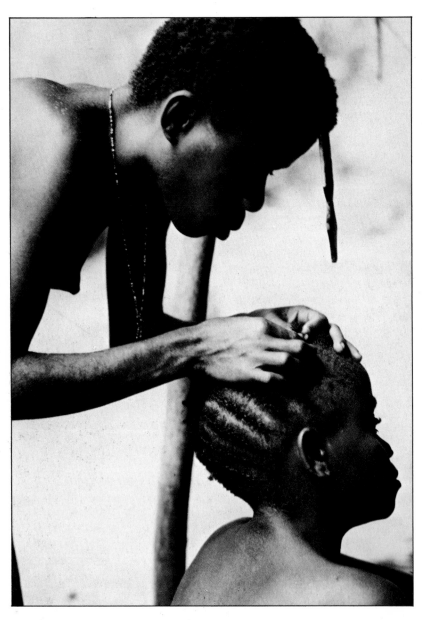

These Pygmy women in Zaire were so absorbed in their activities (above) that the photographer was able to get very close for an unposed picture.

ONE OF THE MOST exciting prospects for a photographer interested in photographing people is available to only a few, and that is the opportunity to travel in really remote areas and be able to photograph societies that have been virtually untouched by time and civilization. These societies are becoming more rare as each year passes, but if you are fortunate or determined enough to undertake such a venture and overcome the problems that the project would entail, the potential rewards will make it all worthwhile.

Obviously, from a photographic point of view, the most important consideration is that you are totally self-contained, that all your equipment is thoroughly tried and tested, and that you are adequately prepared for any breakdowns – the thought of being in a position to take rare pictures and being prevented by malfunctioning equipment is too horrible to imagine. It is also necessary to take special precautions to protect cameras and film from extreme climatic conditions, such as high temperatures, excessive humidity and sub-zero weather.

If it is to be a long excursion, it will be well worthwhile to consider taking along a small developing tank and a changing bag, with enough chemicals to put through one or two black and white films, just to reassure yourself that everything is working properly.

There is no way that your activities can be carried out unobtrusively in societies where a visit from someone in the next village is normally enough cause for celebration. The approach that is most likely to succeed is to attempt to become a familiar presence until the people treat you at least with indifference, and hopefully with tolerance. This will avoid the distracting expressions of interest or even hostility that the 'hit and run' approach is likely to produce.

It is extremely unlikely that you will come across any tribe or group of people who have never even seen a camera, however far into a jungle you venture. This may be disappointing to an explorer or an anthropologist, but to the photographer it means that much intrusive curiosity will have dwindled – some societies are not so much untouched by civilization as indifferent to it and may treat both the photographer and his equipment with disinterest. If excessive curiosity and hostility does prevail it could be worth trying the magical novelty of the instant camera, though that is not without some risk.

Posed pictures are best avoided unless the subject is really relaxed and you treat it like a portrait; otherwise it is best to shoot pictures when people are temporarily distracted by some other interest or activity. A long lens can obviously be quite helpful in many circumstances, but it is important to retain a sense of location and the background and surroundings will usually be necessary parts of the picture. It is worth remembering that a wide-angle lens can include figures in the frame while giving the impression that your attention is directed farther afield.

It is also important to avoid any form of direction – never tell people to move around simply to suit the composition. This will almost certainly appear disrespectful and patronizing, and will inevitably result in pictures that look contrived.

Poor lighting conditions can be a problem even in countries which are blessed with constant sunshine, since many community activities take place in shaded areas and in tents and huts, so a supply of fast film is essential. A small flash-gun can be useful but it should be introduced with great discretion and only after you have won your subject's confidence.

These nomads in Afghanistan (right) show complete disregard for the camera, although aware of its presence. The choice of viewpoint gives an impression of their habitat.

A posed picture can result in awkward self-consciousness, but in the case of this Yanomamö mother in the Amazon (below), the photographer has captured charm and spontaneity.

An established presence – and a longish lens – can avoid the hostility that insensitive intrusion is bound to cause (below right). These Dani tribesmen, in Indonesia, seem not to mind a minor disturbance of their moment of relaxation.

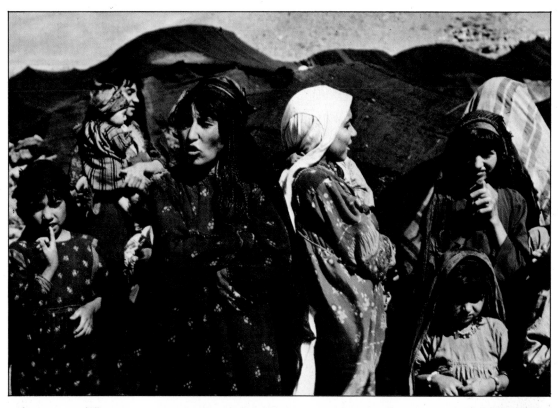

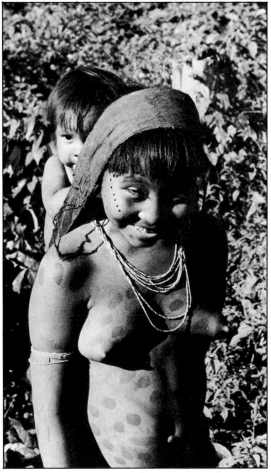

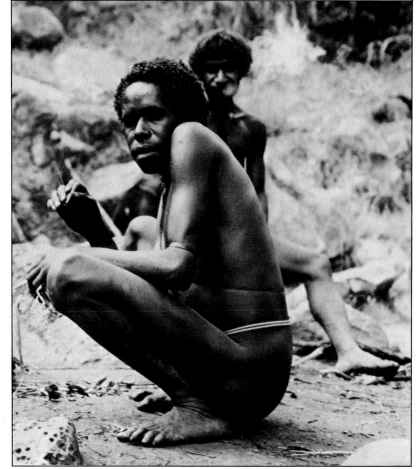

Choosing a Camera

The formal portrait (right) is an ideal subject for the view camera. The very large format negatives or transparencies produce exceptional image quality allowing fine details of skin texture and hair to be recorded. A static subject like this allows the camera to be left in position without readjustment, while attention is given to lighting.
Arca 5 × 4; f22 with studio flash; Kodak Tri-X.

FOR ALL THE VARIOUS **shapes, sizes, and specifications of available cameras, they all fulfil the same basic functions. A light-tight container houses the film, a mechanism replaces an exposed piece of film with a new piece, there is a method of aiming the camera and of focusing the image, and devices to control the amount of light which reaches the film. The functions themselves have not changed since the camera was invented, only the degree of ease and convenience of their operation.**

The most elementary camera, still little different from the early devices, is the view camera, which uses sheet film carried in light-tight slides. The lens, mounted on an interchangeable panel, and the detachable focusing screen are connected by light-tight leather or plastic bellows, and can move independently along a geared track. View cameras are invariably used on a tripod, and viewing and focusing are carried out with the image upside down. To make an exposure, the lens shutter is closed, the screen replaced by the film pack and the protective sheath removed; only then can a picture be taken. Not the equipment for rapid or spontaneous pictures, but the large transparency or negative – up to 8 × 10 in (200 × 250 mm) – ensures an image of superb quality. Where subject movement is not a problem, as in formal portraiture, the view camera can be invaluable, particularly if very large prints are required.

The viewfinder, or rangefinder camera uses either roll, cassette or cartridge film. Separate optical systems are used for viewing and for projecting the image on the film; focusing is therefore done either by setting the estimated (or measured) distance or by sighting through a rangefinder which is connected to the focusing ring. The most significant difference is that, unlike the view camera or the single-lens reflex, you see only a view similar to (but not exactly the same as) the one which will be exposed on the film.

Viewfinder cameras range from the very inexpensive, with limited uses, to top quality instruments such as the Leica M4-2, which will give superb results and which has a wide range of accessories and lenses. Expensive viewfinder cameras are available with motor drive, built-in light meters, and automatic focusing devices.

The twin-lens reflex camera (TLR) is designed to take roll film, and is similar to the viewfinder camera in having two different optical systems for the film and the view screen.

However, the lenses are identical and mounted close together on the focusing track. The viewing screen, viewed from above (waist-level viewfinder), therefore enables accurate focusing, as well as showing the correct field of view – the image is shown the right way up, but reversed left to right. Though most makes have fixed lenses, the Mamiya has a system with interchangeable lenses.

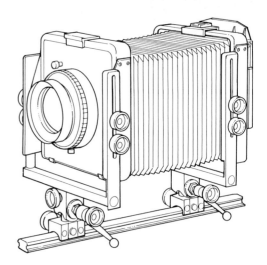

Advantages of the View Camera
Highest possible image quality due to large format film.
Total accuracy of both focusing and viewing.
Ability to fit a wide range of lenses.
Control over plane of focus and perspective possible by independent movement, swing or tilt of the focusing screen and lens panel.

Disadvantages of View Camera
Cumbersome, heavy to use and carry.
Must be mounted on tripod.
Viewing screen shows subject upside down; difficult viewing in bright light means a dark cloth usually required.
Preparation to shoot is slow; image on viewing screen lost for considerable period.
Changing film after each exposure is slow; amount of film available for immediate use limited by number of dark protective slides you possess.

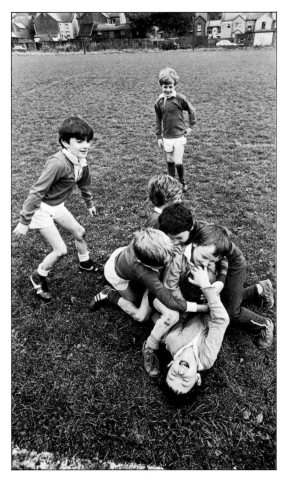

The viewfinder/rangefinder camera is well-suited for casual photography where simplicity and accuracy are an advantage, as in this picture of boys at play (far left). It is quick and easy to aim and focus, and precise enough to give good results with close to medium distance subjects. Its low price makes it a popular camera, but it can give results far superior to mere snapshots.
Olympus RD; 1/250 at f5.6; Kodak Tri-X.

The twin-lens reflex camera can be effective for photographing people in almost any situation, and the large format makes it ideally suited for recording fine detail with high image quality (left). It is easily hand held for continuous viewing but the waist level viewfinder makes the use of a tripod especially easy. The image quality is as good as a large format SLR, but the TLR is much less expensive.
Rolleicord; f16 with studio flash; Kodak Tri-X.

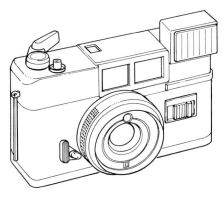

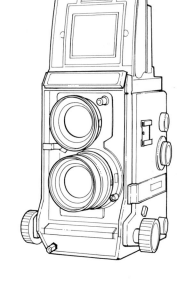

Advantages of the Viewfinder/Rangefinder Camera
Can be light and small.
Quiet and unobtrusive to use.
Can be inexpensive.
Quick and easy to change film, particularly cartridge version.
Rangefinder focusing in poor light can be more accurate and faster than with cameras using a focusing screen.

Disadvantages of the Viewfinder/Rangefinder Camera
Viewfinder area not as accurate as a screen, particularly when used close-up, through parallax error.
Choice of lenses more restricted than with SLR.
Choise of accessories more restricted than with SLR.
Unable to see effect of different lenses or filters.
Depth of field through aperture range not visible through viewfinder.

Advantage of TLR Cameras
Solid reliable design – little can go wrong.
Easy and comfortable viewing and focusing: no need to operate with eyeball glued to camera – good for model rapport.
Large picture size can give very fine quality prints and enlargements.

Disadvantages of TLR Cameras
Rather bulky.
Subject image reversed left to right.
Viewing system produces parallax error, producing inaccuracies especially at close range.
Restricted choice of additional lenses and accessories.
Depth of field through aperture range not visible on screen.

39

Choosing a Camera

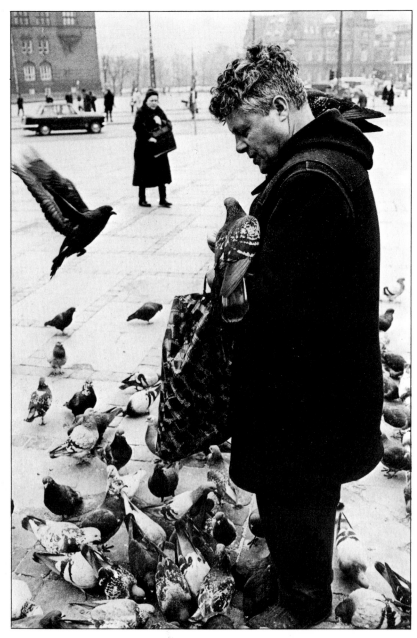

BY FAR THE MOST CONVENIENT, logical and comprehensive camera is the single-lens reflex (SLR), a format which can use roll film, 35 mm cassette or cartridge-loading film. The major difference between the SLR and the TLR and viewfinder cameras is that both viewing and focusing are carried out through the lens which actually takes the picture. A mirror between the lens and the film projects the image on to a viewing screen, and a prism then turns the image the right way up and right way round. Triggering the shutter momentarily flips the mirror out of the way, allowing the image to reach the film.

Apart from the enormous advantage of viewing through the camera lens itself, the design allows a vast range of lenses, filters, and close-up attachments to be used with confidence, for everything from depth of field to the effect of a soft-focus filter can be seen almost exactly as it will appear in the photograph.

Because the SLR has, inevitably, become the universal camera, technological advances have concentrated on it. Consequently the most significant developments, from high-speed motor drives to remote-control shutter release systems using radio transmitters or infra-red beams, can be found on modern SLRs.

Extremely accurate exposure readings through the lens are also now possible. The Olympus OM2, for example, achieves this by measuring the light reflected from the film in the instant the shutter is open, and adjusting the exposure accordingly – while giving the photographer a read-out on the viewing screen of aperture and shutter speed. The present developments in micro-electronics using the silicon chip are likely to lead to even more advances in SLR camera systems.

The standard 35mm SLR camera with a 'normal' 50mm lens (right) gives an angle of view approximately that of the human eye. This, combined with its lightness and its ease of operation and image composition, makes it suited for almost any subject, including quick, fairly close-up pictures of people (above). A small flash-gun (right top) which attaches to the camera's hot shoe solves a variety of lighting problems, and an auto-winder (right bottom), less expensive than a motor drive, allows the user to concentrate on taking photographs without being distracted by having to wind on the film.

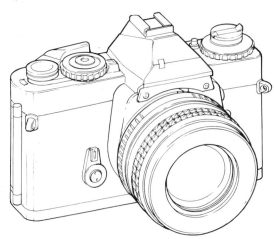

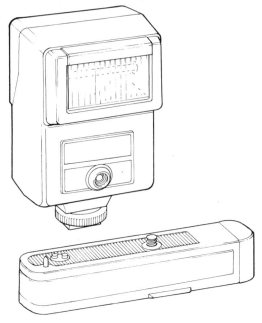

The photographs on this page illustrate how the versatility of the 35mm SLR can be extended by using a long-focus lens (top), a wide-angle lens (middle), or a medium long-focus lens in a studio (below).

The illustrations show (bottom left, from left to right) popular lenses for a 35mm SLR system: a 35mm wide-angle lens; the versatile 135mm lens (a 105mm lens may be preferred if a lot of portraits are planned); a 300mm long-focus lens; and a 20mm wide-angle lens giving a 94° angle of view. Zoom lenses, such as a 80–200mm lens (above) are gaining in popularity as good optical quality becomes available at reasonable prices.

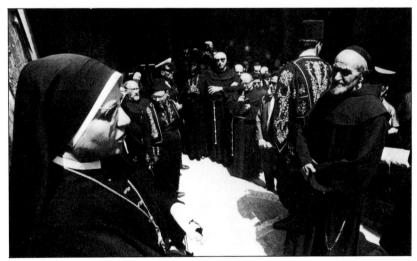

Camera systems

A SIGNIFICANT DEVELOPMENT over the last two decades has been the evolution of the camera system, in which the basic camera body is simply the starting point for a vast number of accessories and attachments which extend its use into a wide range of specialist fields.

Most camera systems are based on the SLR camera, though a notable exception is the Leica M series. This is the descendant of a long line of small-format cameras, which on their introduction by Oscar Bernack in 1925 revolutionized the attitude and style of many great photographers.

The rangefinder/viewfinder system of the current M4-2 Leica still has advantages to offer. It is almost totally silent in operation, which is an invaluable asset in theatre photography, for instance, where the photographer wishes to be unobtrusive. The precision engineering of a Leica is unmatched and its reliability is renowned; photo-

journalists often favour the Leica for this reason, and also for the more positive and more accurate viewing and focusing system under poor lighting conditions than can be found on the SLR.

The Hasselblad system is probably the most widely used in the roll film range. The larger format, 6×6cm, provides a potentially higher image quality than 35mm film, and there is a comprehensive range of accessories. These include interchangeable film backs which enable a photographer to change from, for instance, black and white film to colour in mid-roll. Polaroid film in a special pack is also available, an invaluable facility for checking set-ups, or for showing 'roughs' to the client or art director before the actual shooting.

The Hasselblad is also available with motor drive, can be used underwater, coupled to a microscope, fitted with a bulk film magazine enabling up to 70 exposures from one loading, and fired by remote control using a small radio transmitter up to 1,000ft (300m) away.

There are several other systems, based on a similar design to the Hasselblad, which give twelve 6×6cm pictures on a roll of 120 film. In addition to these, there are cameras which provide sixteen 4.5×6cm, and ten 6×7cm pictures. The Bronica ETR is a very comprehensive outfit using the 4.5×6cm format, while the Pentax 6×7 and the Mamiya RB 67 produce the larger format. The 4.5×6cm format is rather more of a compromise since the camera is not a great deal smaller or lighter than the 6×6cm type, and, in fact, the

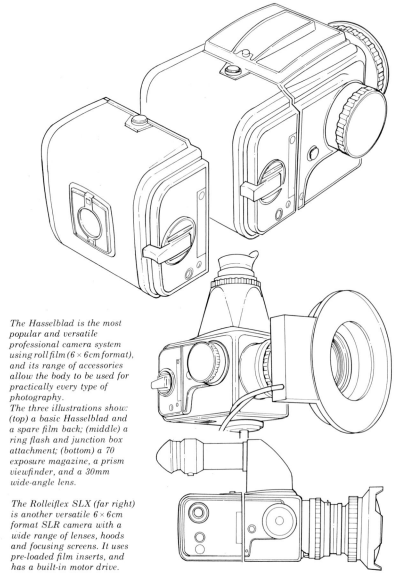

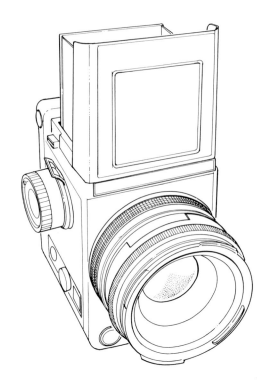

The Hasselblad is the most popular and versatile professional camera system using roll film (6×6cm format), and its range of accessories allow the body to be used for practically every type of photography.
The three illustrations show: (top) a basic Hasselblad and a spare film back; (middle) a ring flash and junction box attachment; (bottom) a 70 exposure magazine, a prism viewfinder, and a 30mm wide-angle lens.

The Rolleiflex SLX (far right) is another versatile 6×6cm format SLR camera with a wide range of lenses, hoods and focusing screens. It uses pre-loaded film inserts, and has a built-in motor drive.

film economy is not as great as using 35mm.

The 6×7cm format, however, provides a substantially larger image area than 6×6cm and many photographers prefer to work with a rectangular format. The Mamiya RB 67 is really a studio camera which is best used on a tripod as it is quite large and heavy. The Pentax 6 × 7, on the other hand, although quite weighty, is designed to be used in a similar way to the 35mm cameras, and is comfortable and convenient to operate as a hand-held camera.

In the majority of cases, however, the 35mm SLR is the first choice of photographers. The smaller size reduces bulk and costs, the popularity of the system ensures many manufacturers and strong competition on design and prices, and modern fine-grain film, as well as modern printing methods, mean that picture quality in most cases is scarcely any different from the larger formats.

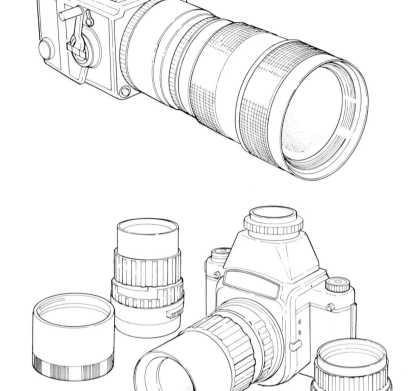

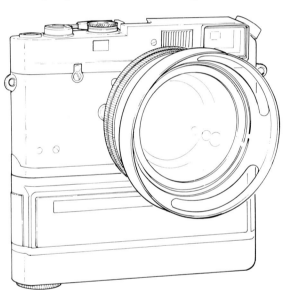

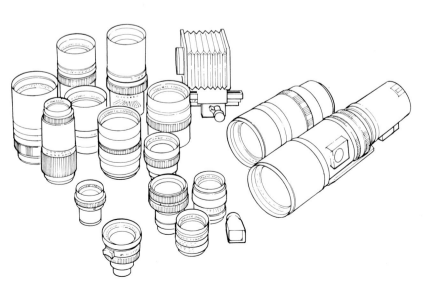

The Leica M4-2 (left) is the one rangefinder camera system that is widely used by a great number of devotees, professional and amateur. The very bright viewfinder automatically compensates for parallax and will indicate the field of view obtained with 35, 50, 90 and 135mm lenses. The winder, shown fitted in the top illustration, operates on all shutter speeds.

The range of attachments and lenses available with this Leica are as comprehensive as found with practically any other system, and some of the lenses, such as the Noctilux FL 50mm, are extremely 'fast'. This feature, and the silence of the camera's operation, makes the system very versatile in many low light situations.

Similar in appearance to the Hasselblad, the Bronica (top) is slightly smaller and lighter, and is less expensive. It has a rectangular, 4.5 × 6cm format, and a comprehensive range of lenses, film backs, viewfinders and other accessories. It is shown here with a prism viewfinder and a 500mm lens.

The Pentax 6 × 7 (above) uses the larger 6 × 7cm format, and looks and handles like a big 35mm SLR. Many photographers prefer to use a rectangular format and the Pentax, Mamiya and Bronica are often selected for this reason. The Pentax 6 × 7's lenses range from 35mm to 1000mm, and numerous other accessories include interchangeable viewing systems.

Exposure meters

IN THE EARLY DAYS of photography judging exposure was a matter of experience gained through trial and error. But modern films, particularly colour, require quite accurate exposures to produce acceptable results. At the same time, the range of lighting conditions under which it is possible to shoot pictures with these films has increased – consequently it is much more difficult to estimate the right exposure without using a metering instrument.

Exposure meters operate on the electrical effect of light on photo-sensitive cells, the effect being greater in proportion to the amount of light. In nearly every case the cell modifies an electric current which is supplied by a minute, long-life battery, but the selenium cell responds to light by generating its own electricity. Meters using this cell are usually less sensitive and more bulky than battery-powered meters, and are not often found built into the camera.

For the photographer, the fundamental choice in meters is between a separate, hand-held instrument and one that is built into the camera. Most modern small-format cameras above the low-price range now have a meter incorporated into the design. In its simplest form this may just give a reading which is then set manually on the camera. In more expensive cameras the meter may automatically set the shutter speed for a chosen aperture (aperture priority), or vice versa (shutter priority). An over-ride facility is usual, allowing fully manual settings from the readings displayed on the viewing screen.

In an SLR the meter is built into the optical system, so that the reading is made after light has passed through the camera lens. In most cases the cell is 'weighted' to give a reading mainly from the centre portion of the image, which is where the main subject of the picture is normally placed. Through-the-lens metering (TTL) also means that the light absorption of any filters or attachments used will be allowed for by the meter.

Although built-in meters are very convenient to use and cut down on the pieces of equipment a photographer needs to carry, the hand meter does have some advantages. The most obvious is that if the meter goes wrong you do not send your camera to the repair shop as well.

Built-in meters can only measure the light which is reflected back off the subject towards the camera. The hand meter, however, can be used to measure the light falling on the subject. A light diffuser is placed over the cell, and the meter pointed towards the light source from the subject position. The incident light method is especially useful when the subject has an extended tonal range, which would give a misleading reflected light reading.

Another advantage of the hand meter is when

working with a tripod mounted camera. It is often desirable to take readings from quite close to the subject – the face in a portrait, for example – and a separate meter enables the readings to be made much more easily.

Using the meter

The modern exposure meter is an extremely accurate instrument; but it can only measure, and its readings must be interpreted correctly to give consistent results.

Exposure meters are calibrated on the assumption that the subject from which the light is being reflected consists of an evenly balanced range of tones, so that if all the tones were mixed the result would be a medium grey. If this is so, the meter will give a reading which requires no modification.

In practice, however, the balance of tones in a subject is frequently irregular. There may be an excess of dark shadow, or a great number of bright highlights or the subject may be nearly all dark tones, or mostly light tones. If the meter reading is slavishly followed in these cases, the exposure will be wrong.

Generally, if the subject has a disproportionate number of dark tones, then the exposure should be less than that indicated by the meter. If there are large areas of light tones, or many bright highlights (as in a backlit shot) then the exposure reading should be increased. Whenever possible, close-up readings should be taken from both the darkest and lightest tones of a subject, and the average of the two used for the setting.

In normal circumstances, and with subjects of average tones, the readings given by an integrated, centre-weighted meter will be quite accurate. Miscalculations are most common when shooting into the light, when a fairly large area of sky is included in the frame, or when light sources are in the picture, such as at a concert or in a city street. In these cases, more exposure will be needed than is indicated by the meter.

The most common way of taking a light reading is by reflected light (above left). When through-the-lens (TTL) metering is used instead of a light meter, a measurement is taken of reflected light. A more accurate method, especially with subjects of extreme tonal range, is to measure the incident light (above right), by placing the diffuser over the cell and pointing it at the camera instead of at the subject. When the subject is a person, the incident method is generally suitable only for posed shots.

In this subject of normal tonal range (right) an integrated meter with centre weighting would give an accurate result without interpretation. Nikon F with 50mm lens; 1/250 at f5.6; Kodak Tri-X.

Subjects that include large areas of brightness (below right) result in under-exposure unless an allowance is made by increasing the exposure by one or two stops. Nikon F with 105mm lens; 1/250 at f8; Kodak Tri-X.

Subjects that consist predominantly of dark tones (below) can create a grey, over-exposed result unless compensated for by decreasing the exposure. Nikon F2 with 200mm lens; 1/250 at f5.6; Kodak Tri-X.

Strong back lighting (bottom right) can need as much as two stops more exposure than the meter indicates to give a correctly exposed image. Nikon F2 with Vivitar 70–210mm lens at 150mm; 1/250 at f8; Kodak Tri-X.

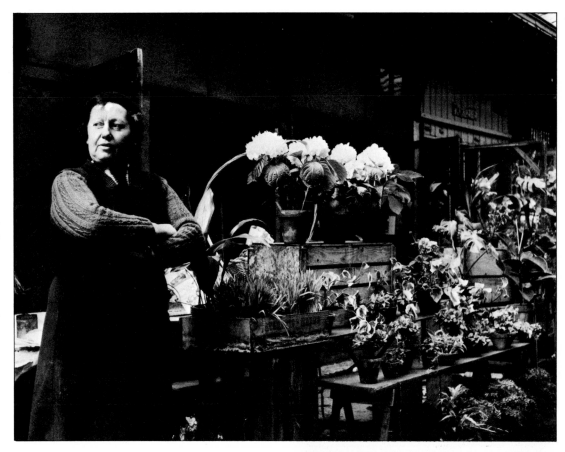

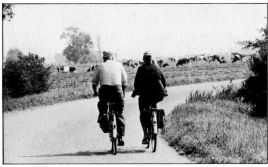

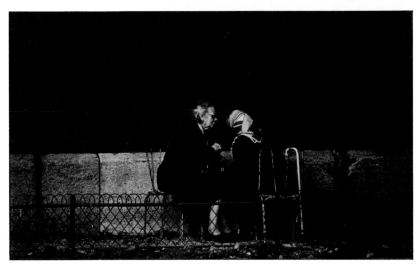

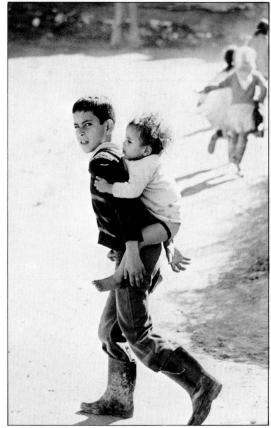

Choosing film

THERE IS an extremely wide choice of film available, but the three basic types are black and white negative, colour negative and colour transparency. Each is available in a wide range of formats, although the cartridge loading films are far more limited in choice than 35 mm or 120 roll film.

Black and white films vary mainly in their speed or sensitivity. Slow, less sensitive films have a much finer grain than faster films, and therefore can give sharper results, especially when enlarged. When the lighting is good, or there is little concern about subject movement, or when a tripod is used, the slow- to medium-speed films can be used to advantage – particularly if the subject contains fine detail or texture. When the light is poor, or there is a risk of either subject or camera movement, a fast film is advisable.

Speed is measured in terms of a film's ISO rating: a medium-speed film is 100 ISO, while a film of 50 ISO is only half as sensitive and requires twice the exposure under the same lighting conditions. Four times the exposure would be needed for 25 ISO film, whereas a fast film, of say 400 ISO, requires only a quarter of the exposure required by the medium-speed film. (ISO numbers are the same as ASA.)

Most fast black and white or colour films can have their speed further enhanced by 'push processing', but any way of getting faster film speeds will mean coarser grain and poor image quality.

In addition to speed variations, colour negative films can also be bought for either short or long exposure work. The normal short exposure film is the one most widely used in photographing people, as it is designed for use at speeds faster than about $\frac{1}{8}$sec. Long exposure film is best for static subjects, like still life and architecture.

Colour transparency films are available in a similar speed range to black and white films, but in addition they are designed for use under different lighting conditions. Daylight film, as its name suggests, is balanced for use under daylight conditions, and also with electronic flash and blue-tinted flash bulbs.

Artificial light or tungsten film is designed for use with tungsten halogen lamps or photoflood bulbs; the light from these sources is much warmer or more orange than sunlight, and would give a pronounced orange colour cast on daylight film. Correction filters can be used to enable daylight film to be used under tungsten lighting and vice-versa but they require a considerable increase in exposure, and it is generally preferable to use the correct film for the particular light source.

Apart from the difference in speed and colour balance, the actual colour quality of individual films can vary considerably from one type or make to another. A picture taken on Kodachrome 25 ISO will look substantially different from the same subject shot on Fuji 400 ISO for example.

Leading film manufacturers produce a variety of special films with characteristics that make them particularly suitable for certain projects. They usually require special developing and may not be widely obtainable. A small selection is given below.

Agfa-Ortho 25 – approx. 25 ISO black and white film not sensitive to red (orthochromatic). Very high contrast and lack of grain gives special quality to portraits of rugged faces, reproducing every bristle and wrinkle, and darkening skin tones.
Kodak Recording Film 2475 – very fast black and white film (1000–4000 ISO) ideal for shooting in low light, giving grainy but sharp prints.
Kodak Ortho 2556, and **Kodalith Pan 2568** films give stark, high contrast prints that are ideal for silhouettes or for rather ghoul-like portraits.
Agfa Dia-Direct is a slow (32 ISO) 35 mm black and white transparency film with a fine grain. It is process paid, like colour transparency film.

It is wise to explore the colour qualities of different films, since the results given by a particular film under certain conditions may be more to your taste. One film, for example, may give an effect you like in bright sunlight, but be less pleasing in dull, overcast weather.

It is a mistake to think that the purpose of a photograph is to slavishly and accurately reproduce the colours of a subject. In creative terms at least, it is more important that you are able to use the characteristics of your equipment and film to create the image that you have visualized.

Instant Picture Film
This is available in a variety of formats and in film packs or boxes of individual sheets. All require a special camera or film back and the 8 × 10 in sheets require a processing unit.

There are two basic types – the 'peel apart' variety which is available in black and white positive, black and white negative, and colour, and is processed between 15 secs and one minute. The other type is available in colour only, and is actually processed inside the camera. It is then automatically ejected, and up to five minutes elapse before the image is fully formed.

With the exception of the black and white instant negative film, it is not possible to get copies of an individual picture without conventional copying techniques – with the inevitable loss of quality.

The advantage of the instant picture system is partly the novelty value in seeing the photograph only a few minutes after taking it, and also the considerable benefit of being able to preview a large or complex set up before shooting it on conventional film. Most professional photographers use instant picture film for this purpose as a matter of course, and most system cameras have a special back available to use this film.

Low light levels combined
with bright areas (above)
make a fast film (400 ISO) the
ideal choice. A fast shutter
speed permits hand held shots
and the lower contrast of a
fast film copes with the
brightness range.
Nikon F with 24mm lens;
1/60 at f5.6; Kodak Tri-X.

A medium speed (125 ISO) in
bright light (right) still
permits shutter speeds fast
enough to stop moderate
movement, yet there is good
definition allowing
enlargement without too
much grain.
Nikon F2 with 105mm lens;
1/250 at f8; Ilford FP4.

When the camera can be
mounted and high powered
lighting is available (far
right) a slow film (50 ISO)
can be used. The very fine
grain is ideal for recording
detail and textures in portrait
and figure photography.
Pentax 6 × 7 with 150mm lens;
f16 with studio flash, Ilford
Pan F.

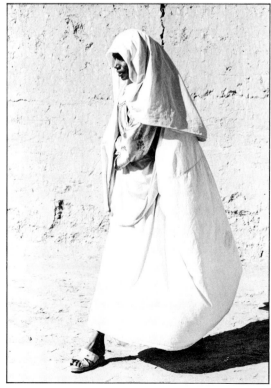

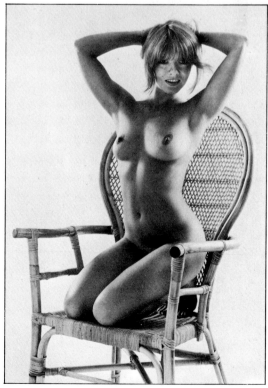

STUDIO PHOTOGRAPHY

THE ESSENTIALS of studio photography are convenience and control, and the main purpose of a photographic studio is to provide an environment in which you can work when you like, how you like, and with complete control over lighting, props and backgrounds.

The way in which a studio is planned and equipped will obviously be dependent on the type of work a photographer does, and the way in which he likes to operate. A number of photographers, for example, prefer to use daylight whenever possible, even when working in the studio, but most studios are planned around the use of artificial lighting.

The main choice that has to be made is between a tungsten or a flash system. The latter offers considerable advantages, particularly in the context of photographing people. With flash, the exposure is made by a very brief and powerful discharge of light. The amount of light which is provided by the modelling lamps for setting up, viewing and focusing is far less than is required for shooting with a tungsten system – consequently the model is not subjected to the constant glare and heat which such lighting produces.

A further advantage is that the very brief exposure of a flash virtually eliminates the effect of subject or camera movement. The colour quality of a flash tube is also constant throughout its lifespan, whereas tungsten lamps diminish both in intensity and colour temperature as they age. And with flash equipment it is possible to use the same film for both outdoor and studio work.

Flash equipment does have some disadvantages. It can be extremely expensive, particularly for high output units, and when lighting large areas, such as a set or a group of people, a lower-powered system may require the use of excessively large apertures or faster and more grainy film.

As well, at a particular aperture, exposure with electronic flash can be controlled only by the distance the lamps are from the subject, and by the power of the unit being used. With a constant light source, however, you can simply use a faster shutter speed.

Another potential disadvantage with flash is that you have to wait for the unit to recharge between exposures. It may be only a second or so with low-powered lamps, but it can be several seconds with some high output units. This can be inhibiting when shooting with a small-format camera which normally allows rapid firing and winding on, while motor drive sequences are impossible with such lighting.

This drawback is improving with the new designs, but at the present time only quite low-powered flash units are capable of recharging in much less than a second.

Another point to be considered between flash and tungsten lighting is the question of power supply. A relatively powerful flash unit can be run quite safely from an everyday power socket, but even a modest tungsten set-up can easily amount to 10 kilowatts or more, requiring a far more substantial power supply.

Choosing & using reflectors

WHATEVER LIGHT SOURCE is chosen, lighting quality and its effect on the subject is controlled by reflectors and diffusers. Without a reflector, light from a small source such as a tungsten filament or a flash tube will radiate more or less evenly over 360°. Obviously more than half of this light will not reach the subject, and will be wasted.

The first function of a reflector, therefore, is to direct as much light as possible towards the subject, and it is designed to concentrate light emitted from a source into a specific area evenly and efficiently. A reflector that spreads the light over an angle of 50° will obviously provide a higher lever of brightness than one covering 90°, but will light a correspondingly smaller area.

The efficiency of the reflector will also affect the quality of the light it gives. A small source of light without a reflector will create deep shadows with hard, well-defined edges, and a reflector with a polished or silvered surface will reflect the maximum light, retaining its hard-edged quality.

A 'softer' reflector has a diffused surface, such as matt aluminium or white enamel. This type of reflector will disperse the light which it reflects, but it will not affect the light radiating directly from the source. Its shadows will have softer edges, but a degree of brightness is lost.

For an appreciably softer lighting quality, you should use a reflector where the light source itself is prevented from shining directly on to the subject. This can be achieved by using a reflector in which a small cap or mini-reflector reflects the light back into the bowl of the main reflector.

An 'umbrella' can also be used. This is literally a large white or silvered umbrella which fits on to the front of the lamp, with its inner curve facing it; the lamp is then turned around to face away from the subject. All the light is reflected back by the umbrella, and this creates a very soft light which casts shadows with highly diffused edges.

The lighting quality is also dependent on the relationship between the size of the reflector and the size of the subject. The softest effect is found when the source of light is as large or larger than the area you are lighting. This is best achieved by diffused rather than reflected light.

A simple method is to place a large diffusing screen between the lamps and the subject, so that the screen itself becomes the light source. The screen can simply be a frame over which is stretched a diffusing material, such as tracing paper or frosted plastic sheet. Most studio lighting manufacturers have more sophisticated devices as single units, versions going by such names as window lights, bank lights, fish fryers or soft boxes, but they do the same thing.

Sometimes a very hard and much more restricted light is required, and you can get this by using a spotlight. This lamp has an optical system in front of the light source, rather like a slide projector, enabling it to produce a focused and tightly controlled beam of light which can be used to illuminate a very small area.

A spotlight gives a concentrated pool of light (left) that creates shadows with sharp edges, and is ideal for lighting a restricted area and for giving bright highlights.

A standard reflector, or key light, gives a fairly broad coverage with a moderately hard-edged shadow (right) and is a good unit for the main lighting in portraits.

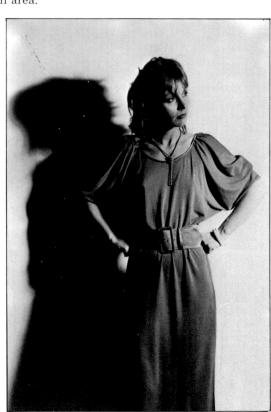

Diffusing screens (above) can be bought ready-made or easily constructed by fixing tracing paper or translucent plastic over a wooden frame.

The principal sources of studio lighting are (clockwise from top left): soft focus reflector, key or standard light, window or bank light, umbrella reflector, spotlight.

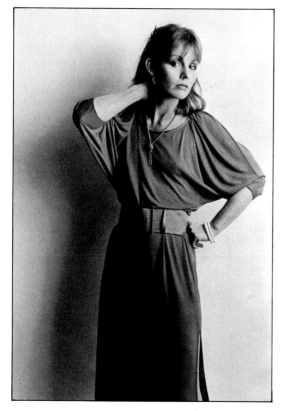

A diffuser placed between a light and the subject softens and spreads the light into an even flood (left) with little directional quality and gives very soft shadows.

A window light is a more convenient source of broad light than the diffuser/light combination, but it gives a more defined shadow (right) and a higher degree of modelling.

Lighting stands & accessories

LIGHTING STANDS **are of considerable importance because you depend on them when manoeuvring and positioning your lamps. There is a wide range of stands available, ranging from those with a simple tripod base and telescopic sections, to very heavy wheelbased contraptions that have counterbalanced controls.**

The simple folding stands will support fairly lightweight lamps at a height of 3–10 ft (1–3 m), but they are stable enough to hold the larger reflectors. Wheel-based stands are very convenient to manoeuvre, and can support heavier lamps.

Useful alternatives, which occupy less floor space and cannot easily be moved out of position accidentally, are the spring-loaded 'vendor' poles which are held in place between floor and ceiling. Overhead rails and wander arms fixed to the wall are other ways of keeping the floor uncluttered.

The boom stand is a particularly useful piece of equipment. A lamp can be supported above the subject on the long arm, while the stand itself is kept well out of the picture area. A boom is essential for providing top lighting, lighting the hair in a portrait for example, and its counterbalance allows it to support a fairly heavy lamp.

A very small stand that can hold a lamp between floor level and 3 ft (1 m) is very useful for positioning a back light, and for lighting the background.

There are a number of other accessories which can increase the flexibility of a lighting system. Barn doors are perhaps the most useful of these.

They consist of a pair of moveable panels or 'wings' fitted to the front of the reflector, and which can be moved into the lightpath to prevent it spilling beyond the required area.

A similar device is the snoot, a conical metal tube whose larger opening fits onto the reflector. The light is therefore confined by the smaller hole which gives a small pool of light, similar to a spotlight, though it cannot be controlled in size other than by moving the lamp to and fro.

Filter holders can also be fitted on to all but the largest reflectors, making it simple to use either coloured acetates or diffusers in front of the light source; these are often combined with barn doors.

When using several electronic flash units in a lighting set-up, a small portable flash-gun fitted on the camera will trigger slave-cells on the main lights, obviating the need for a synchronizing lead between the camera and one of the lamps. Some systems use an infra-red transmitter on the camera with receivers built into the lamps.

A flash meter is a vital piece of equipment when working with flash lighting, since an ordinary exposure meter will not respond to the extremely brief duration of the flash. While you can calculate exposure using the guide number method with a single source of light, this is not possible with a more complex arrangement using several lamps.

Overhead lighting is frequently used in portrait and fashion photography when the photographer wants to accentuate the model's hair (right). Overhead rails are one way of supporting the lights, but a boom stand gives greater flexibility at less cost. Nikon F2 with Vivitar 70 – 210 zoom lens at 180 mm; f16 with studio flash; Kodak Tri-X.

The illustrations below show (from left to right): two lightweight telescopic stands that will support standard lamps (or reflectors) – their legs, which can be in the conventional tripod form or fitted with casters, can be folded for storage; a small back light stand that is frequently used in photographing people; and a strong, counterbalanced stand on casters that is used for heavy window or bank lights or floodlights.

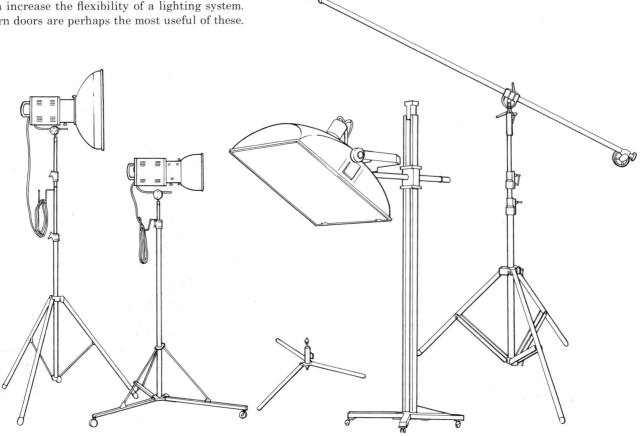

The main requirement of studio lighting is that it should be flexible enough to achieve any complex lighting arrangement that the photographer requires to take the best picture of his subject (above), and a variety of types of stands is essential studio equipment.

A flash meter is indispensable when more than one flash unit is being used. It is shown (above) fitted with a trigger flash-gun that allows a reading to be taken at one operation from the subject position.

Barn doors and a snoot (above) are useful accessories for controlling the direction of light when only small areas need to be lit.

Camera & studio accessories

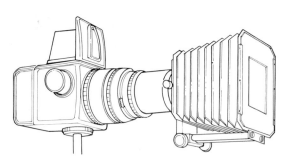

The heavy column camera stand (below) is extremely rigid, offering a secure mount for even the heaviest camera in the studio. Its controls allow extremely fine adjustment to the camera position from almost ground level to nearly 10ft (3m).

A good, solid tripod (below right) can offer almost as much rigidity as the heavy column stand, and the geared centre column also allows fine adjustment. Its portability makes it the best choice for the photographer who also does a lot of outdoor work.

THE USE of hand-held cameras in studio photography has become much more feasible with the advent of electronic flash, and there are many situations where the mobility of an untethered camera is an advantage. A firm camera support, however, is considered an essential piece of equipment in most studios.

There are a number of positive advantages in using a camera stand, apart from avoiding camera shake. The picture area in most studio photography is usually fairly restricted, for instance by the width of a roll of background paper or by the extent of a room set, requiring conscious effort to maintain the correct camera view. You can get round this by mounting the camera on a solid support; once the picture is framed and focused you can give full attention to the subject.

A camera stand also enables the photographer to have a better rapport with the model. The need to be constantly looking into the viewfinder with a hand-held camera often prevents a fully relaxed atmosphere developing, particularly with a portrait session, for instance.

A camera stand needs to be heavy and firm enough to prevent it being too easily moved accidentally. It must also allow you to adjust the

camera's height and angle swiftly and smoothly; and it should not impede access to any of the camera's functions – it is, for example, a nuisance to have to remove a camera from the stand in order to reload the film.

The column stand fulfils all of these requirements. It is a wide diameter steel pole, mounted on a very heavy wheel base, and capable of extending to 10ft (3m) or more in height. The camera is mounted on a platform, usually counterbalanced, and it can be moved from ground level to the top of the column in a couple of seconds with little effort. This stand is designed primarily to support large-format view cameras, but it can be used with equal convenience with all medium and small-format cameras. Its disadvantages are that it is not at all portable, and that it is very expensive.

A good compromise is to use a medium to heavy tripod stand with a geared centre column. These stands can be collapsed and carried for location work, yet are still capable of supporting all but the largest cameras.

The concertina or bellows lens hoods is a useful piece of equipment in the studio, where a great deal of stray light is scattered around. Often the light sources are very close to the edge of the picture, and this device is adjustable by the means of a rack-and-pinion track which can be set to provide optimum protection for the lens. Most of these units are also designed to accept the acetate filters used for colour correction and for various special effects.

With the system cameras such as the SLR the combination of a long cable release and a motor drive enables you to move away from the camera while still being able to make exposures. A motor drive is also a very useful accessory when shooting pictures in quick succession, as with fashion photography. With a hand-held camera, it allows more attention to be given to framing the picture and focusing the image.

A very useful device for fashion and beauty photography is the wind machine, which is simply a rather large, high-powered electric fan which can be mounted on a stand and directed at the model to create movement in her hair and clothes. Its speed can be regulated by a switch, and one can generally be rented.

This type of lens hood (left) is widely used by professional photographers, among whom it is frequently known as a 'compendium' (it is shown here fitted with a filter holder). This accessory is especially suited for studio work, where the close proximity of lights to the camera calls for fine adjustment of the lens hood. Even slight movement of a light could require readjustment of the protective hood, but with the bellows this can be done without changing the camera's position.

A wind machine enables interesting and unusual photography to be taken indoors, particularly with models who have long hair or who are wearing light, loose clothes. The speed of the fan is infinitely variable and the air flow can be aimed to achieve the desired effect. Nikon F2 with 105mm lens; f16 with studio flash; Kodak Recording Film 2475.

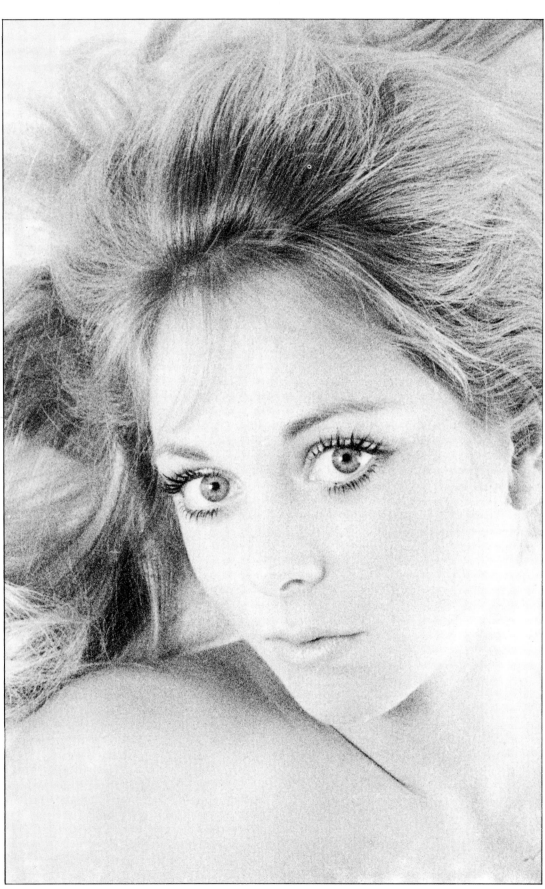

The improvised studio

A PHOTOGRAPHER who occasionally wants to use a studio either for pleasure or as a part-time occupation would hardly feel that it was worthwhile setting up permanent studio facilities. With careful planning and a little inconvenience, a great deal can be achieved with a modest set-up on a temporary basis.

The main requirement, of course, is a room of adequate size, though to some extent this is dependent on the type of work that is planned. Head-and-shoulder portraits, for example, could be photographed comfortably in a fraction of the space required for fashion photography.

There are three factors to be considered in terms of space requirements – the distance between the camera, the model and the background; the space above the model's head; and the area on either side of the model in which to position the lighting equipment. As a general rule, at least one third of the camera-to-model distance is required behind the model, and half the camera-to-model distance on each side of the model. Full-length figure photography requires a ceiling height of at least 10 ft (3 m), though this will not permit even moderately low camera angles.

As most of the width requirement is needed on either side of the model there is no reason why the camera should not be placed outside a doorway, shooting into the room. The lighting area can be reduced by using pole support lightstands instead of the conventional tripod bases; you can then position the lamps almost against the wall.

Unless you have a very large room, you will probably use the smallest wall as a background. If it is plain, windowless and painted an even matt tone, it can be used for many of your pictures exactly as it is. White is the best finish, as it can be varied from white to dark grey or even black by controlling the lighting. You can colour a white wall by using coloured acetates over the background lights.

Shooting full-length pictures poses a problem, as the angle between wall and floor can create an awkward, unattractive line along the base of a picture, particularly if there is a skirting board. The simplest solution is to use a roll of seamless paper fastened to the wall as close as possible to the ceiling, meeting and running along the floor in a smooth sweep. It is important however, for such a background to be laid over a hard floor, otherwise it will mark easily when stood on.

You should be able to black-out all windows to prevent them complicating or spoiling the lighting, especially in a small area. Another lighting problem in a confined space is that a large amount of light gets scattered indiscriminately by being reflected off the walls, which makes it difficult to create more dramatic lighting effects. A simple solution is simply to drape reflective areas with a dark, preferably black, fabric.

Electricity supply need not be a great problem. It often helps to run an extension cable in from another room, as frequently the sockets in the studio room itself will be in the wrong place – behind the background for example. You should, of course, make sure that the power requirement of your lighting equipment does not exceed the capacity of either the cable or the socket; in any case it can be more convenient to have two, or even three separate lines.

One of the easiest backgrounds is a dull black, such as black velvet (right), and this picture shows a typical effect that can be achieved in a temporary studio. The background does not reveal tone or texture, and offers a good contrast with skin tones.
Pentax 6 × 7 with 150mm lens; f16 with studio flash; Ilford FP4.

A white background (far right) needs more space to allow it to be lit independently of the model. If the space is very limited, a soft light bounced from the ceiling will light the subject without casting shadows on the background. Nikon F2 with 105mm lens; f16 with studio flash; Kodak Tri-X.

Even a small room can make an adequate temporary studio. 'Vendor' poles, internally sprung, secure themselves between the floor and ceiling to support lights and reflectors, without the problem of base legs intruding into the working area. The camera can be positioned in the doorway or beyond. The windows can be used for additional lighting, or blanked off entirely.

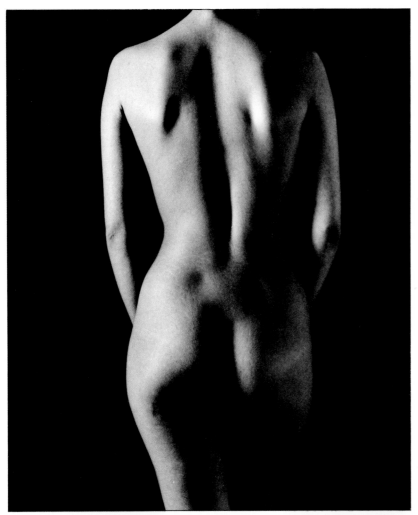

With more restless subjects (far left) a portable background, such as a sheet of white card or foam polystyrene, allows a greater variety of camera positions to be used.
Nikon F2 with Vivitar 70–210mm zoom lens at 150mm; 1/125 at f8 using window light; Kodak Tri-X.

When there is very close cropping in the composition (left) the background becomes almost irrelevant, and almost anything will do as long as it has a moderately even tone. As in all four pictures on this page, only one light source was used, with either a reflector or a diffuser to provide fill-in light.
Hasselblad with 150mm lens; f16 with studio flash; Ilford FP4.

The permanent studio

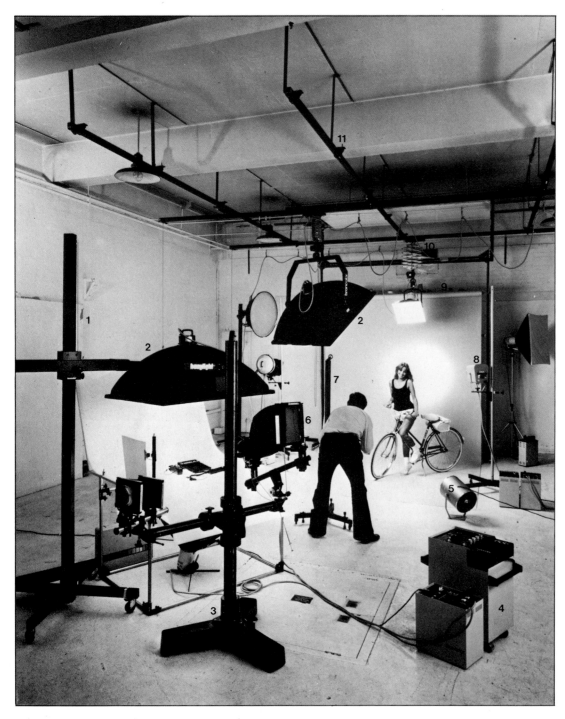

A fully equipped studio, containing:
1. *Counterbalanced column light stand on casters.*
2. *Window, or bank light.*
3. *Large column camera stand.*
4. *High output electronic flash unit.*
5. *Wind machine.*
6. *View camera.*
7. *Small column camera stand.*
8. *Background paper.*
9. *Support for background paper rolls.*
10. *Wander arm for overhead light.*
11. *Overhead rails for supporting lights or reflectors.*

THE IDEAL photographic studio enables a photographer to operate with the maximum degree of freedom in terms of lighting, camera angles and the choice of subject matter – and to do so with comfort and convenience. Few photographers enjoy such luxury, but there are many ways in which a suitable space can be converted into something approaching the ideal.

Space is naturally the most important factor, and many planning considerations are based on fully exploiting the space available. Ceiling height is nearly always the most difficult requirement to meet, particularly in more modern buildings, and many premises which otherwise would be ideal are ruled out for having low ceilings.

A ceiling height of about 13 ft (4 m) is necessary if you intend doing a great deal of full-length work, such as fashion photography. This is particularly so if two or more models are being used, but even this height is inadequate for camera positions below about waist level. It is possible to manage

with less than this, of course, but a lower ceiling will impose considerable restrictions.

The length of the studio will be dependent to some degree on the number of people likely to be included in any one shot. For a single full-length figure, allowing for adequate separation from the background, you will need 25–30 ft (8–10 m) – and this would not allow you to use a lens longer than a standard lens.

Two, or even three figures could be photographed in a similar area, but larger groups would need a considerably longer throw to allow adequate control over composition and background.

The width of the studio needs to be such that lighting equipment can be a comfortable distance from the model, particularly when side lighting is used. It should also allow adequate manoeuvrability of the larger lighting units.

If there are windows or skylights, you should be able to black them out quickly and effectively, especially if techniques such as multiple exposure and projection are envisaged. Roller blinds or window shades are most suitable, and they also offer a useful control if you use daylight.

Decoration of the studio should be planned with an eye on function rather than on aesthetics, a possible exception being a purely portrait studio where a homely and relaxing decor is more suitable. In other cases it is more important that the walls, ceiling and even the floor should be of a neutral tone that will not create a colour cast.

Some photographers prefer to have a white-painted studio in which unwanted reflected light can be masked off by screens or curtains; and others opt for black, where masking unwanted reflected light is not necessary. A black studio, however, can be a rather dismal atmosphere in which to work, and it also means that more use has to be made of reflectors and fill-in lights. It is often very convenient, for example, to be able to bounce a lamp off a white painted ceiling, whereas in a studio with a dark ceiling a white reflector would have to be supported above the model's head.

Where white walls or ceilings are to be used this way, it is important that they are frequently repainted, as otherwise they will become discoloured and affect the lighting quality.

The one big advantage that studio photography offers is total control over the elements of a picture, and the contribution that the background makes is one of the most important elements.

The most widely used general-purpose background in professional studios is the seamless paper roll. These are normally 9 or 10 ft (3 m) wide and are available in various lengths from about 36 ft (11 m) to as much as 150 ft (45 m). They can be bought at most professional photographic stores in a wide range of colours – as well as black and white.

The paper is of quite heavy quality and will last for a considerable number of sessions if it is handled carefully, especially if aided by an efficient support system. A number of custom-made units are available; some are free-standing, which enables the roll to be positioned anywhere in the studio, while firmly fixed bracket units will hold the roll against the wall, as close to the ceiling as possible. A chain and pulley is sometimes used to wind up the paper rolls.

White or black paper rolls are usually available in slightly wider rolls. To get an even larger coverage it is possible, though a little difficult, to run the paper horizontally, making careful butt joints with double-sided tape. The most vulnerable part of the paper is the length on the floor when shooting full-length figures. Above all, it must be laid on a hard, smooth surface such as vinyl flooring – the paper is easily marked or torn if the floor is soft or uneven. Most surface marks can be removed by rubbing gently with an eraser, but an effective method of avoiding marks being made by the model's shoes is to cover the soles with tape.

Where a background is in constant use, or there is a regular need for a wider expanse, it can be worthwhile building a permanent sweep. This can be done by covering the required wall and floor areas with sheets of hardboard, masonite or strong cardboard, leaving a gap about 3 ft (1 m) wide between the edge of the floor board and the lower edge of the wall boards. The gap can be filled by cutting a long strip of board so that it forms a gentle curve between the wall and the floor. All joints can then be carefully filled, and the whole sweep painted any colour or tone using a matt emulsion paint. Any marks made on the floor can simply be touched out before the next shot.

A completely black background can be provided very easily by making up the required area in a non-reflective black fabric – velvet is ideal. This can be conveniently stored by fixing and winding it onto a wooden pole, which also enables it to be suspended from the background unit.

For portrait photography you may often want a background with a rather more 'painterly' quality than that provided by an even tone. While it is possible to create tonal variations by lighting a plain paper roll, it can be more convenient to have ready-made backgrounds of this type.

Draped fabric is favoured by many photographers, or you could have a canvas screen with just a suggestion of pattern and tone painted on to it. This can be done in such a way that it provides an aid to composition, by providing a lighter tone in the centre to help concentrate attention on the face, becoming darker at the top and sides – it will also simplify the background lighting.

With a little imagination and ingenuity, the wide variety of fabrics, together with the printed and textured papers which are available, can be used to produce a limitless range of effects.

Studio sets & wall flats

Wall flat frames are easy to construct (above) and need not be very strong. They can be clamped together in groups, or can incorporate old door or window frames. When constructing a set, look through the camera frequently from the viewpoint that you will be using, focusing for the subject distance – a perfect finish on the sets and props is not always necessary.

The reception area of the 'Fawlty Towers' hotel (left) was recreated in the author's studio (right) for the book of the popular BBC TV series. John Cleese, star and co-author of the comedy, is leaning on a board supported at the right height; the background was made from two quite simple flats, careful framing and the camera position providing just enough information for a viewer to imagine he is seeing a doorway and a wall beyond.

Using the background

The old world dignity of the lady in the Baden Baden gardens (right) is emphasized by the formality of the background, but the use of a long-focus lens and a wide aperture reduces the depth of field to soften distracting detail, which has been further softened by slight over-exposure of the background.
Nikon F with 105mm lens; 1/125 at f5.6; Ektachrome 64.

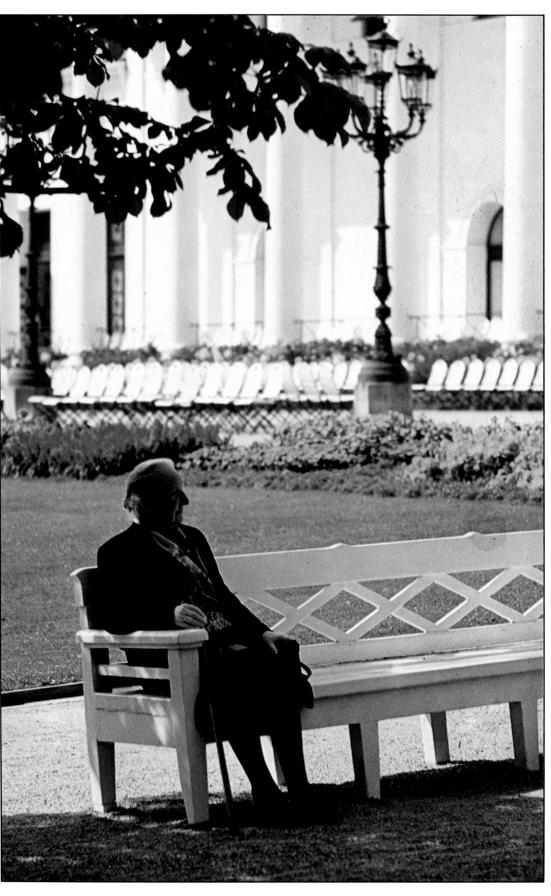

A low camera angle allowed these Moroccan children (above) to be photographed against the neutral sky, allowing the simple main subject to be seen without distraction.
Nikon F2 with Vivitar 70–210mm zoom lens at 150mm; 1/250 at f8; Ektachrome 64.

THERE ARE OCCASIONS **when a picture calls for a more elaborate background than can be provided by a roll of paper or a painted screen. This may take the form of a simple three-dimensional structure, or a quite elaborate large room setting.**

Most studios that use backgrounds of this type have a number of wall flats, which are simply prefabricated panels that can be joined together to form a variety of structures. They are easily made by constructing a sturdy, rigid frame of timber batten, 1×2in or 25×50mm is normally used, on which is fixed a sheet of hardboard or masonite 4×8ft ($1,2$m $\times 2.4$m). These panels can be joined together either by screws, or they can be held by clamps. A number of 2×4ft (0.6×1.2m) and 4×4ft (1.2×1.2m) flats are also built so that a window frame, for instance, can be inserted.

A demolition site can often provide useful material for making sets. Old doors, for example, can be stripped and painted, and old window frames, fireplaces or even wooden panels can often be obtained for a token payment. It is often possible to find items that are too damaged for use in a home but which would not be noticeable in the background of a picture.

Once the flats are clamped together to form the shape you want, it only remains to decorate and dress the set. Decoration often need not be done too painstakingly – after all you are not going to have to live in the room. It is always advisable, before you start, to place the camera in approximately the position you are going to shoot from, as this will make it easier to see where you can cut corners.

Two extremely useful items in the set builder's tool kit are a roll of double-sided adhesive tape and a staple gun. The latter is very good for hanging curtains in neat pleats, and it can even be used for hanging wallpaper in the darker corners of the set. Adhesive tabs are also very useful for fixing small items into position, such as a dummy light switch which would otherwise need to be screwed on.

It is vital to constantly view the progress of the set through the camera, as the ideal position for props and fixtures from the camera's point of view is by no means always the same as it would be visually. When you are building the corner of a room, for example, it is not always desirable to have the flats at exact right angles to each other.

Floor covering for a room set can be accomplished by using rolls of felt; it photographs rather like an expensive carpet and can be bought quite cheaply from most large fabric stores. Felt is available in a wide range of colours, can be stretched quite easily to give a smooth, wrinkle-free surface, and can be stapled into position.

Foam polystyrene (styrofoam) is a very useful material for building sets, being quite cheap and very light. It can be bought in sheets, blocks or tiles, which can be used to simulate a variety of items. The tiles, for example, can be painted and laid to create the impression of a flagstone floor.

In this type of simulation work it is important to be constantly aware of how you want the picture to look, as opposed to thinking in terms of objects. It is, after all, only the way that it appears to the camera that matters, and it is very often possible to create an illusion in a set without having to construct everything in a completely literal way; and the final appearance of the picture will also be a product of lighting, composition and other photographic techniques.

This diagram (below) shows how, with a little imagination, you could create a set with a distinctly Oriental atmosphere. The broad lattice frame can be made from narrow wooden slats nailed together, care being taken mainly to keep the size of the squares even. By attaching tracing paper or a translucent plastic sheet behind the frame, the flat could also resemble a wall inside a traditional Japanese house, and a few props would provide the finishing touches. The screen could also double as a large diffuser, and could be used as a frame from which to suspend other materials and backgrounds.

PORTRAIT PHOTOGRAPHY

THE HUMAN FACE is composed of the most subtle contours and textures. One of the most important skills of a portrait photographer is the ability to control the relationship between the light he uses and the constantly changing nature of his subject, not only to create an interesting and exciting photograph, but also to present a sympathetic and meaningful likeness of the model.

Portrait photography is particularly challenging because there are so many variable factors, a large number of which are very difficult to control and all of which are interdependent. The studio photographer does have the advantage of being able to exercise a fine degree of control over his lighting, but in order to exploit the possibilities fully it is vital that he fully understands his equipment and the techniques which can be used to control and exploit its effects.

Mrs. C P Cochrane, by E O Hoppé (1911).

Portrait lighting in the studio

THE GOLDEN RULE of all studio lighting techniques is never to use more light sources than are necessary. It is therefore essential to be fully aware of the effect that each individual lamp is creating, and how the lamps affect each other.

The first step is to establish the position and nature of the main light. This is the lamp which will be responsible for creating the basic form of the face, and it will also determine how and where additional light sources should be used. Both the angle and the quality of this key light will depend on a number of factors – the angle of the model's head relative to the camera position, the type of face (angular, round, young, old, male, female), even the colour and texture of the skin must be taken into account as well as, of course, the mood or effect you want to create.

The angle of the main light will initially establish the nature of the shadows which are created within the face. With the model turned full face to the camera, for example, and the main light close to the camera position and at the subject's eye level, there will be virtually no shadow. But as the lamp is moved away from this position, either to the right or left, or higher or lower, the shadow areas will begin to increase. It is by observing the shape and direction of these shadows that you can understand how to control lighting effects.

The shadow cast by the nose is the simplest way of judging the best height for the main light. In most portraits it is positioned just above the eye-level of the model, and this creates a nose shadow which does not extend as far as the mouth. If the subject's head is tilted, however, the key light will have to be raised or lowered correspondingly to maintain this degree of shadow.

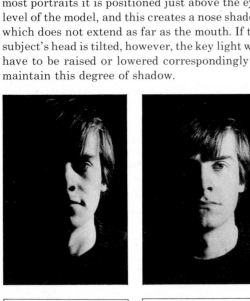

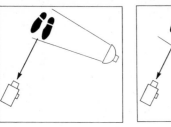

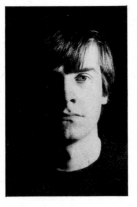

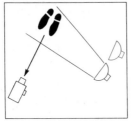

Elaborate lighting need not be a prerequisite for effective portrait photography, as this appealing picture shows (left). Soft, diffused front light, coming from the right of the model and slightly above her eye level, has created gentle shadows, while subdued fill-in light has prevented there being too much contrast.

If the light is too high in relation to the angle of the model's head, shadows will form in the eye sockets in addition to the nose shadow becoming greatly extended; but if the main light is too low the result can look a little eerie, reminiscent of a Count Dracula film still. It does not mean that this type of lighting should not be used, for it may well create the effect which you need to establish a particular mood, or to reveal a certain aspect of the subject's features or personality; but it is vital that you are aware of the constantly changing relationship between the light and the subject which results from even the slightest change in their positions.

In addition to the height of the main lamp, its horizontal direction in relation to the camera – subject line is also of crucial importance. As the light direction moves towards a right angle with this line, the opposite side of the model's face will become progressively more shaded, until at the extreme point only one side of the head will be lit when the subject faces the camera.

When the light is back at the camera position, the lack of shadow creates a very flat image with little or no impression or form. But as the angle is increased the contours of the face are revealed and the image takes on a more three dimensional appearance. It is at this stage that you must consider the quality of the light source, as well as its direction.

A hard light with no diffusion will create dense shadow with a clearly defined edge. The transition of light tones into darker will be abrupt, and there will be no detail in the shadows. If, however, the light is diffused, its effect will be more gentle, the shadows will be less dense, the tonal range will be greatly extended, and the shadows will have soft

edges and will contain more detail. The choice of angle at which such light is used will be less critical, and the model will have more freedom to move without causing a drastic change in the nature of the lighting.

In addition to the effects of lighting angle and quality on the 'modelling', or form of the face, they will also control the way in which skin texture is recorded. A hard, strongly directional light will accentuate texture, while a soft frontal light will almost eliminate it.

It is of course vital that you consider the effect of the lighting not only in purely visual terms but also in the way it is recorded by the film. There is a well defined limit to the brightness range of a subject that can be successfully reproduced by a photographic emulsion.

This varies a little depending on the make and type of film and on processing techniques, but there can be a wide gulf between what the eye sees as an acceptable range and what the film will accept. It is easier to judge this visually if you view the subject through half-closed eyes, which will accentuate contrasts. Of course it is possible to measure the difference with an exposure meter by taking very close-up readings of the two extremes (a spot meter is ideal for this) but it requires only a little experience to be able to judge this quite adequately.

Unless you are intending to create a specific effect, it is almost always necessary to reduce the brightness range which a single light source produces, in order to record adequate detail in both highlight and shadow areas. This can be done in two ways.

A second lamp can be directed from the opposite side to the main lamp, or from the camera position to 'fill-in' the shadow areas. This lamp should either be of lower power than the key light or positioned farther away, otherwise the shadows will be completely eliminated and the modelling effect will be lost.

The balance between the two lamps will be partly dependent on the effect you want to achieve, but the second lamp should do no more than supplement the main light by relieving the shadows. It should not create noticeable shadows of its own, for example – a common error with those inexperienced in studio lighting. Nothing looks worse than a number of divergent shadows criss-crossing a face.

A second method of reducing the brightness range is to use a reflector. A largish piece of white card or foam polystyrene will do, positioned on the shadow side of the model and angled so that it reflects back the light from the key lamp into the shadows. Its effect can be controlled by simply moving it farther from or closer to the subject. This method has the advantage of requiring fewer lamps, and it avoids secondary shadows.

In this five-picture sequence (left) the effect of moving the position of the main light source can be seen clearly. The hard, strongly directional light produces sharp, unpleasant shadows – until it is shining straight at the subject, when it removes almost all the modelling.

In the two pictures (right) the light was placed at the same position as in the third picture in the sequence, but first mounted low and pointing up at the subject, and then moved higher on the stand to point downwards.

Appreciating the way that shadows change as the relative position of the lighting changes is an invaluable step in taking good portraits.

Back lighting techniques

Back lighting has been used in a subdued way in this photograph (above), but it nevertheless contributes significantly to the composition. The front light was used mainly as a fill-in (incidentally livening the eyes with catch lights), while the principal lighting was provided by side lights, particularly from the left. The back lighting has been used to separate the subject from the dark background, and the gradual darkening towards the top right of the picture helps to frame the composition.

WHILE IT IS POSSIBLE to light a portrait quite adequately with just a main light and a fill-in, there are a number of other factors to consider. The use of additional lighting can dramatically extend the possibilities offered by such a basic arrangement.

In addition to allowing more flexibility in lighting the subject, extra lamps also enable you to control the overall effect of the picture more fully. The lighting you use will have a significant effect not only on the mood and composition, but also on the background – you should therefore learn to use it to create a harmonious image, and not simply a photograph of a face. Arnold Newman reminds photographers that 'A good portrait must first be a good photograph'.

An extra light source can be used effectively to increase the three-dimensional quality of a picture. The effect given by the basic set-up of a key lamp to one side of the model and a fill-in will produce an image where the illusion of depth is created by the transition of tones from the brightly lit side of the face to the shadowed side.

It is often possible, however, to create an even stronger three-dimensional quality by adding highlights to selected parts of the image. This is most easily achieved by using a lamp with a confined or controllable beam of light, such as a spotlight or a snoot. This type of light is most effective when it is positioned slightly behind the model, and directed so that it just glances off the area where the highlight is needed.

Essentially, this light should not be too strong, as you are, in effect, creating a specular highlight which will quickly become bleached-out and devoid of detail. If the lamp is too powerful, it will be preferable to allow only the edge of the beam to reach the subject. When using a light in this way, it is particularly important to make sure that stray light does not fall on the camera lens and create flare. An efficient lens hood is helpful, but it is safer to mask off light spill with a piece of card, or with barn doors.

With a full face portrait this type of lighting can often create a highlight down the side of the nose as well as along the cheek or forehead, which invariably looks unattractive. It can be avoided by moving the light even farther round behind the model, reducing its direct effect.

Careful use of a small spotlight will enable a photographer to give prominence to any part of the subject, and this can be an important element in the composition of a picture. A hand, or a bare shoulder for example, can be picked out of the surrounding details by the discreet addition of a few highlights.

Back lighting can also help to create separation between the subject and the background where it is comprised of medium or dark tones, but it is also possible to achieve this effect by directing a lamp at the background itself. When using a plain, even-toned background such as a seamless cartridge paper roll it can often be beneficial to introduce a tonal gradation with your lighting.

A lamp on a small stand can be hidden behind the subject and aimed towards the paper; by using a snoot or barn doors the beam of light can be controlled so that it creates a pool of light behind the model's head. Alternatively, making the tone of the background progressively lighter towards the base of the picture will not only help to separate the subject from the background, but will also help to contain the composition by creating a darker toned 'frame' along the top or around the sides of the image.

A snoot attachment (above) reduces the spread of light and is frequently used to direct a narrow area of light at a specific part of a background, or at part of the model. It is far less heavy than a spotlight, but cannot produce such a concentrated or variable pool of light.

In the first picture (left) the dark background causes a very sharp outline on the model, producing a rather stark composition. By directing a pool of light on to the background from a snoot mounted on a low stand behind the model (below left and diagram) a far more pleasant photograph was achieved.

This close-up portrait (above right) appears rather flat and uninteresting, being lit solely from the right, and slightly above the model. In the second picture back lighting, as shown in the diagram (bottom), has created a totally different composition with a high degree of modelling and a fine line of light along the nose and chin. The composition also gains from the extra degree of texture produced by the back light.
Nikon F2 with Vivitar 70–210mm zoom lens; f16 with studio flash.

Lighting a model's hair

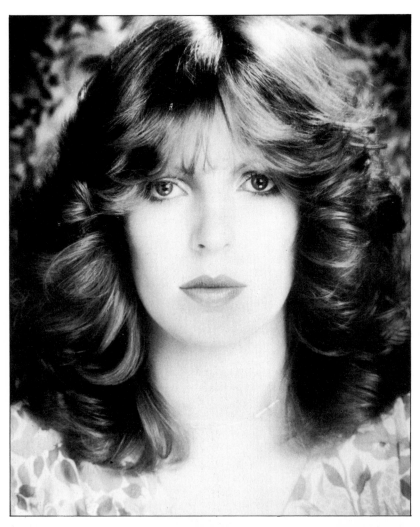

YOU MAY OFTEN want to give special attention to lighting your model's hair, and the most convenient method is to use a boom to suspend a lamp directly above the model. The boom enables both the stand and the lamp to be kept well out of the picture area, and offers a simple means of controlling the position and direction of the lighting.

It is best to use a lamp and a reflector which enables the spill of light to be carefully controlled – a snoot, for example, or a flood fitted with barn doors. A cone of thin card can be taped into an ordinary reflector if nothing else is available.

The power of the lamp, or the distance at which it is used, is very much dependent on the colour of the hair. Blonde or fair hair, for instance, needs

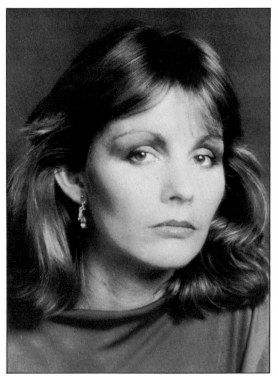

A model's hair can be the dominant feature in a picture (above). The highlights were created by a light directly above the model, mounted on a boom and positioned so that it did not fall onto the face, which has been softly lit from near the camera.

A light on a boom arm, above and slightly to the right of the model, lit the side of the hair and the beard (right). The dark brown hair of the model required a powerful lamp mounted close to the subject to achieve this effect.
Pentax 6 × 7 with 150mm lens; f16 with studio flash; Kodak Tri-X.

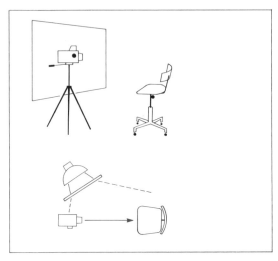

only a small amount of light to create highlights, but very dark hair will absorb light and a high level of brightness will be needed to reveal its texture. The lamp must be positioned so that it does not spill on to the front of the face, and you should take care that it does not create unwanted highlights on other parts of the subject.

Another method of lighting which can be particularly effective if a more dramatic effect is required is to place a lamp on a small stand directly behind the model's head and aimed towards the camera. It must of course be positioned in such a way that the lamp itself is not visible to the camera, and this can be more easily achieved if it is placed some distance behind the model, using a small reflector or a snoot.

This lighting will produce a rim or halo of light around the hair, and with a profile shot it will also create a rim of bright highlight along the outline of the subject's face. The dramatic quality of such lighting can be increased by having a dark background and by reducing the fill-in light.

In colour photography it is possible to experiment with the effect created by placing coloured acetates over the rim light. It is of course necessary to control the model's movements carefully, as only a slight shift of position will reveal the lamp.

It is important to take care when reading exposures with any form of back lighting, as direct light falling on the meter cell will distort the reading – it is much safer to switch off these lights while the reading is made.

In this picture (left), front lighting only was used, provided by a diffused light. A reflector was used to fill-in the unlit side giving a pleasing picture, but the hair plays a secondary role.

A spotlight or snoot mounted on a small stand directly behind the model, and aimed towards the camera, created a rim of bright light, as seen here (right), when the front lighting was left off.

The combined effect (far right) of front and back lighting, is a picture with considerably more appeal than the first picture in the sequence. Experimenting with the degree and angle of front lighting, while leaving the back lighting on, could create interesting results.

Lighting for dramatic effect

The strong lighting from slightly behind the model, and the choice of his clothes, has resulted in a hard picture with practically no grey tones (right). The slight scattering of the harsh light on to the background behind the man's head has given a slight outline to the part of his face in shadow, giving the head a valuable degree of form.

The flat front light, and the face-on pose adopted by novelist Ethel Mannin in this 1930 photograph by Paul Tanqueray (far right) has resulted in a stark, threatening portrait. The lighting emphasizes the bold geometrical pattern in the background, but the subject's steady gaze dominates the composition.

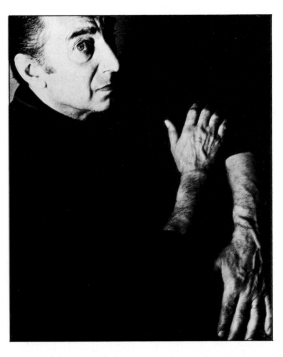

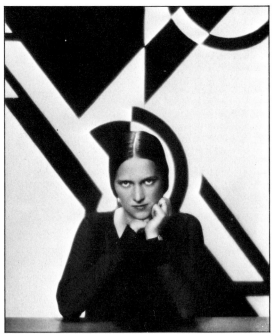

IN THE MAJORITY of portrait photographs the lighting is arranged in such a way that it does not draw attention to itself. In such cases the intention is to create a natural quality in the lighting, so that the viewer is not aware that any particular technical skills have been used. Fashionable trends also apply in lighting, and it is true to say that many of the great portrait photographers of the last decade or so have preferred to use lighting which has simulated the effect of daylight – particularly in fashion photography and the family type of portrait where a soft light can produce a more flattering effect on the subject.

There are many occasions where a more dramatic result is required, however. Sometimes this may be to create an image with a high degree of initial impact, or sometimes simply to inject excitement into what otherwise might be a rather mundane picture. Such effects are often achieved by using lighting in a way that it becomes a recognizable part of the picture; the lighting, and the effect it creates, becomes almost as important an element as the subject.

Most of the techniques which are used on these occasions are dependent either on creating a surprise element in the picture, or on revealing or accentuating a particular aspect of the subject. A good example is the typical picture of an elderly man whose face is lit to reveal every line and wrinkle – the exact opposite of any method that would be used if the aim was to flatter the model.

Karsh is a photographer who used this technique extensively, and although the result is not flattering in a cosmetic sense, it can greatly enhance the visual qualities of character and

personality which are present in a person's face.

A directional light is necessary to reveal skin texture and it needs to be angled in such a way that it skims over the surface of the face, creating a full range of tones on the skin itself. A hard source is often most effective when it is used at an acute angle – a back light for example – but it must be used gently. If it is too strong it will simply burn out the subtle detail which creates the impression of texture on the face.

Exposure too, is critical, as any degree of over-exposure will result in a loss of vital detail in the highlights. In general, a smoother surface requires a harder light source to reveal texture, whereas it would create excessive shadow and contrast on a more craggy face, for which a softer light is preferable.

The most effective way of creating an element of surprise with lighting is to use it so that it unbalances the tonal range of the image. Most 'normal' pictures have a full, evenly distributed range of tones without excessive areas of shadow or extremely bright highlights, but when lighting creates an image which departs radically from this, the result is often a picture with more impact.

A low key picture, for example, where the majority of tones are at the darker end of the scale, will create a more dramatic impression on the viewer – as will a picture of high contrast, with bold black shadows and stark white highlights.

It can be a very useful exercise to use your lighting at one of your sessions to produce the widest possible range of effects with the same subject. The experience gained from this can be a vital step in the understanding and development of portrait lighting techniques.

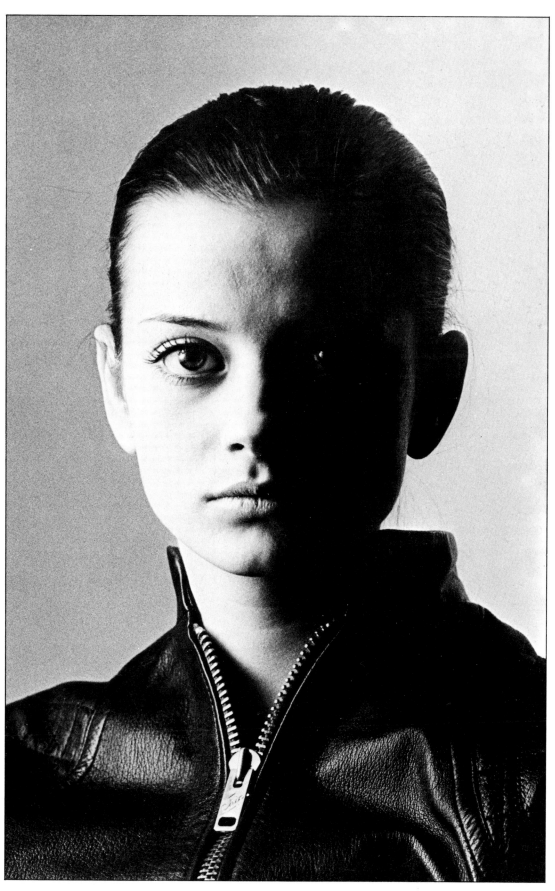

This striking portrait (left) uses lighting to accentuate the symmetry of the girl's face, giving a bold, unromantic but strongly appealing composition. The lighting on the background is a reverse of the lighting on the model, and reflects a slight line of light on her left cheek.

In this photograph of Sir Henry Taylor by Victorian photographer Julia Margaret Cameron, the lighting is unusual in that it is brightest on the side of the face that is farthest from the camera. The slight spill of light on the subject's left eye gives a degree of modelling without detracting from the dramatic effect, but the picture is dominated by the subject's magnificent beard.

Portrait composition

In this classically composed portrait of Rebecca West (above) taken by Hoppé in 1918, the shoulders of the subject provide a base leading up to the main point of interest, with the face positioned at the intersection of thirds, rather than in the centre of the picture.

The horizontal format (above right) is not frequently used for portraits, but here the picture shape and the cropping of the head has been used to emphasize the thrusting expression and the character of the model.
Nikon F2 with Vivitar 70 – 210 zoom lens at 180mm; 1/60 at f11; Kodak Tri-X.

PORTRAITURE IS ONE FIELD of photography where the photographer has almost total control over his subject matter, and the way in which he frames his pictures and arranges his subject within that frame is a vital consideration.

The first decision to make is how much of the model is to be included. It may be a tightly cropped image with only part of the face shown, or it may be a full length figure, but it is vital that everything in the picture area contributes to the effect the photographer wishes to create. The elements of the image which are included should be arranged to create a balanced and harmonious photograph.

There are a number of rules which have been established, and like most rules they are based on sound experience. If carefully followed they will limit the risks of producing a bad picture, but it is equally possible to produce excellent photographs by breaking the rules. However, this needs to be done in a considered and conscious way to be effective, and not simply as the result of carelessness, with no contribution to the overall effect of the picture.

One of the golden rules of composition is that the centre of interest of a picture should be at the meeting point of two lines drawn from points one-third of the way along two adjacent sides of the frame. In a head shot the most important feature is usually the eyes, and in a longer shot it will be the face, which consequently will not be at the centre of the frame, but offset left or right, and above or below the centre.

If you look at a number of nicely composed portraits, most of them will conform to this rule, but you would almost certainly find that successful pictures which had not followed this principle had done so for a specific reason. In most head and shoulders portraits, for example, the model's eyes are usually the main point of attraction, and they are often placed on the intersection of thirds. But if you want to take a picture in which you intend the subject's mouth to be the most dominant feature, then the most effective result may be achieved by composing the image in a completely different way.

The rules are designed to avoid symmetry, because a picture that tends to be too evenly balanced can be rather boring. For this reason it is usually advisable that the model's shoulders should be angled so that they do not face the camera squarely, and the face is placed so that it is not in the centre of the frame. There are, however, occasions when symmetry can be made the feature of a picture, and it can be effective precisely because it is evenly balanced.

It makes good sense to be aware of the rules of composition and to follow them to the point where they contribute to the picture, but do not hesitate to break them if they become inhibiting and prevent you from creating the effect you have visualized.

The best way to learn is by practice and experience. Where you are able to have control over the composition of your pictures it is invaluable to experiment as much as possible by trying alternative ways of framing and arranging.

A personal style in photography is very dependent on a good sense of composition, and this is achieved as much as by being able to bend and break the rules as it is by slavishly following them.

Although the hands have been cropped, they play an extremely important role in this portrait of WH Auden (right); conceal the hands, and it becomes a far less striking picture. The poet's face, however, dominates the picture by the sheer strength of its lines.

Karsh of Ottawa used an approach frequently encountered with theatrical portraits (above) in this study of mime artist Marcel Marceau. The diagonal line of the shoulders, often achieved by tilting the camera, creates a vigorous, extrovert quality.

Relaxing your model

Mutual respect between photographer and model does a great deal to relax the subject, as it has in Cecil Beaton's portrait of the artist Graham Sutherland, each a master of his craft (above). Allowing the model to adopt poses that he feels relaxed in is better than giving constant specific directions, and the use of familiar surroundings, in this case Sutherland's studio, further encourages a sense of ease.

WITH MANY TYPES of work the photographer is simply an onlooker, someone who observes and records but is not in any way involved with the subject he is photographing. But in portrait photography the relationship between photographer and model is crucial. It is an essential element of the picture, and if the photographer fails to establish a good rapport the result can easily be poor photographs.

Few people really like being photographed. They often feel self-conscious or vulnerable, and if the photographer does not make a positive effort to overcome these feelings it will be impossible for the model to relax and to project his or her personality. Many people regard a session with a photographer as they would a visit to a dentist or a solicitor – someone is going to pry, and reveal things about them that they would much prefer to remain private.

It is therefore vital that a photographer is able to inspire confidence in his subject, to reassure him that in his capable hands everything will be fine and that the results will be pleasing.

If you are going to take pictures of someone who is a stranger to you it is far preferable to have a preliminary meeting to establish a basic knowledge of each other and to overcome any in-

hibitions your subject may have. It is a good idea to show your prospective model some of your best work so that he or she will see that you are able to take good photographs, and that you are sensitive and perceptive.

It is not even necessary that these should be portraits – a good landscape picture can still be evidence of your aesthetic abilities. This initial meeting can also be a good opportunity to make a few discreet observations concerning your subject's features and mannerisms, which will assist you during the session.

Having established the fact that you are artistically gifted it is also necessary to demonstrate that you are technically competent and are in complete control of your equipment. This is easy enough for a professional photographer who is constantly using it and to whom it is mostly a subconscious effort, but the less experienced worker should be prepared to go to some lengths to ensure that things run smoothly in the studio, particularly if the model is a stranger.

The lighting should be set up and even positioned roughly, the camera loaded and mounted on a tripod, and everything checked over to make sure it is working properly. There is little possibility of inspiring confidence in your model if you are unsure yourself.

The more you are able to prepare in this way the greater freedom you will have to concentrate your attentions on your subject. It is particularly useful to use a tripod or stand as it enables you to communicate more directly with your model, instead of constantly going behind the camera.

Conversation is also important. Awkward silences will breed self-consciousness, and it is vital that you find some topic that will enable your model to forget the threatening presence of the camera. It is also important that when you are actually taking the pictures you offer some verbal encouragement. Every two or three frames you can say something like 'Oh, that was really nice'; it may be a cliché, but it can be very reassuring to those on the receiving end.

It is best to avoid giving too many outright directions regarding head and body positions. Try to achieve them indirectly – encourage the model to look in a different direction, for example, rather than ask him to move his head in a certain way. Once you keep asking the model to move a little this way or that way the results will invariably be stiff, and it is best to start afresh by letting him, or her, adopt another more comfortable position.

Another thing which can be disconcerting to someone who is not a professional model is to be asked to 'hold it'. If you see a fleeting expression or a gesture and you are not quite ready, it is far better to let it go and try to get it to happen again naturally. A really relaxed and spontaneous picture cannot be achieved by blatant direction.

Some models will more readily adapt to 'free expression' than to posing, and the encouragement of movement will not only help to overcome awkwardness but may result in an unusual portrait, as in this photograph (above) of a girl which makes good use of her pride in her flowing hair.

Given suitable words of encouragement, a professional model will soon respond to a photographer (far left) relaxing into poses and expressions that are pleasing and unforced. It is usually better to take a number of photographs, even if you know that some will not be suitable, than to give your model the impression that the session is not being productive.

If the model is ill at ease, a few shots with her looking away from the camera may help her to relax, as in Julia Margaret Cameron's portrait of her niece (left). There should never be too long a pause between a pose being held and the exposure being made, however.

75

Flattering your model

THERE ARE A NUMBER of ways of approaching a portrait session, and they are mostly related to the purpose of your pictures. You may, for example, be taking a photograph of someone you know, aiming to create a particular effect for your own purposes – an exhibition perhaps; or you may be taking pictures at the request of the model, who has some other purpose in mind. It is more than likely that these two briefs would be totally incompatible, and that you would need to approach each session in a completely different way.

If the prime purpose of the pictures is to please the person you are photographing, the objective will invariably involve a degree of flattery. Almost everyone has something about their appearance which they dislike, and which, if featured too strongly, will result in them hating the picture.

With someone you do not know it can sometimes be impossible to tell what this feature is, but in most cases it is possible to see which aspects of a person's appearance are the ones best subdued. At the same time it is usually possible to see quite easily which features or characteristics are the most attractive and capable of being exploited. It is interesting to note that the pictures the model likes best are frequently the ones that friends and relatives like least, and vice versa – which is probably why this type of portrait requires a completely different approach from that followed by a photographer who produces personality portraits for magazines and newspapers.

Having established the features you wish to project, and those you intend to play down, you must then decide how you can best use the elements of your picture to achieve your aims.

Camera viewpoint can be used very effectively to create certain effects. The shape of a person's face, for instance, can be enhanced or exaggerated by the camera angle. A heavy jaw-line would be given greater prominence by using a low angle, while a high viewpoint would play it down. Similarly a round face would benefit by the perspective of a high camera angle, while someone with a broad forehead and a narrow chin may look better from a lower position.

Once you become aware of the interaction between facial characteristics and the camera viewpoint, it becomes an almost subconscious act to make compensations when setting up the camera and positioning the model.

It is not only facial features that you must be aware of, but also the model's posture, mannerisms and gestures. Some people screw up their eyes when they laugh, for instance, and sometimes this can look very unattractive, while someone with round shoulders would look better sitting back in a chair, rather than leaning forward.

Flattery also requires a positive attitude, so as well as subduing some features you should look out for some aspects of the model that can be given a more dominant role. It may be lovely hair or big eyes, and it could be a particular expression – but there is always at least one feature which can be used to create a more pleasing likeness, provided you are sufficiently aware to recognize it.

Other techniques can be used to flatter a model – diffused lighting, for instance, will diminish wrinkles and blur the edges of shadows, and a soft focus filter will create a more romantic image.

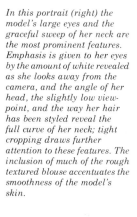

In this portrait (right) the model's large eyes and the graceful sweep of her neck are the most prominent features. Emphasis is given to her eyes by the amount of white revealed as she looks away from the camera, and the angle of her head, the slightly low viewpoint, and the way her hair has been styled reveal the full curve of her neck; tight cropping draws further attention to these features. The inclusion of much of the rough textured blouse accentuates the smoothness of the model's skin.

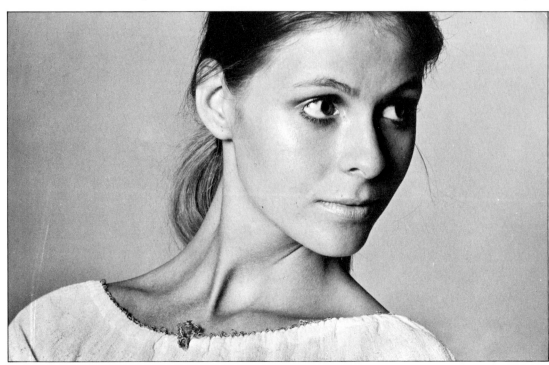

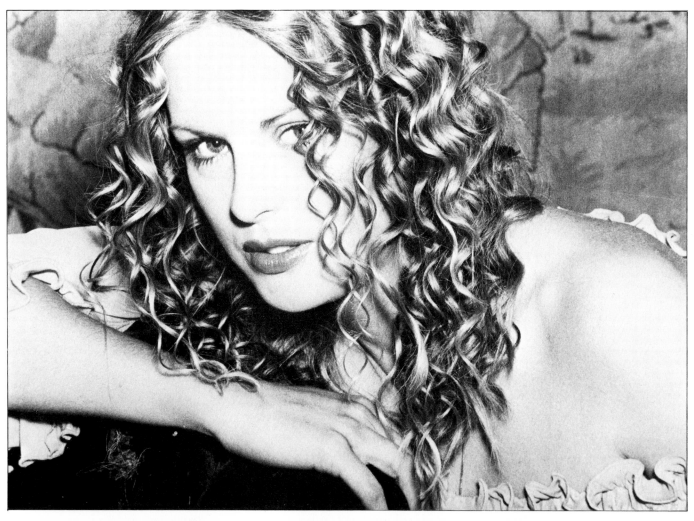

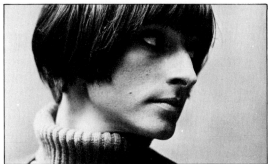

This model's most noticeable feature is her attractive and unusual hairstyle, and both the pose and the lighting have been arranged to emphasize it (above). Other attractive features or expressions are often revealed as a session progresses.

The pose and low camera position accentuate this model's finely chiselled features (far left). An attempt to take a 'pretty' portrait may not have been as attractive or flattering.

A portrait of a fashion-conscious woman should show more than simply head and shoulders, and in a seated pose most of her dress can be shown without the face becoming too small (far left).

Stronger, more direct lighting is more frequently used with male than female models (left), and the strong shadows accentuate this model's rugged masculinity.

Using eyes & hands in portraits

THE MOST IMPORTANT aspect of a face is the eyes – they are the most expressive of all the features. A person can adopt any expression from wild happiness to the depths of despondency but if it is not genuine it will always show in the eyes. If a picture is to be dependent on the model's expression, then it is important that it is mirrored in the eyes.

A photograph in which the model's eyes are directed into the camera will always have a more direct impact on the viewer, while one in which the subject is looking out of the picture will invariably seem less personal, with a more ambiguous quality.

There are a number of ways in which the eyes can be given more prominence in a picture, apart from having them looking into the camera lens. They will, for instance, look bigger when photographed from slightly above when the head is tilted down a little, causing the eyes to look up into the camera. This can also be combined with having the model's head slightly turned away from the camera, so that the eyes are looking back; but you should not overdo this as the result can seem contrived, rather like a 1940s film still.

Blue or light-coloured eyes tend to photograph rather better than dark eyes, even in black and white pictures, because dark eyes can absorb a lot of light and so appear dead on film. Film still photographers often use a tiny spotlight near the camera to create small highlights in the eyes and give them a little sparkle. With close-up head shots it can be very helpful to position a small white reflector quite close to the model at about waist level, and angled so that it reflects light

back into the eyes, making them appear livelier.

It is often very effective to use a model's hands as part of the composition of a portrait, for they can be quite expressive as well as being a useful device for creating a more interesting arrangement.

Most people have a way in which they use their hands in contact with their face to relax or to reinforce an expression, but it is important to make sure, if you suggest this to your model, that it is a natural gesture, otherwise the result can easily look artificial and contrived.

Hands can be quite difficult to photograph as they have a tendency to look awkward, or even ugly if seen from the wrong angle, and they also need to be lit quite carefully.

In general the back view of a hand is best avoided, for it can easily appear as a rather featureless blob in a picture. A side view is preferable and it looks better when the fingers are slightly separated or flexed at different angles.

If you intend to make a fairly strong feature of a hand in a picture it is wise to be quite critical of its appearance. What might not be very noticeable in normal circumstances, such as an untidy manicure or a scratch, can become all too prominent in a photograph – nicotine stains for example, can record far more strongly than they appear visually, especially in colour.

If you keep your model in one position for some time it is advisable to keep an eye on the veins in a hand as these can swell up and look very unattractive. If this does happen, you should let the model get up and wave the arms about to restore an even circulation.

Twiggy's naturally large eyes have been made even more dominant by this pose (right). The slight downward angle of the head has caused her to look up, revealing white below the irises which gives her eyes an extra large appearance. Her make-up is deliberately exaggerated, and the presence of her hand avoids the 'disembodied' quality of a shot that includes a head and very little else.

This model was caught in a characteristic gesture (below right). Although the hand obscures the mouth, there is a definite sparkle of humour in the expression and there is little doubt that the hidden lips are breaking into a smile. The atmosphere, in the end, is conveyed almost solely by the subject's right eye.

Such a theatrical gesture as this (below far right) could only be used by someone to whom it was completely natural – such as Jean Cocteau, in this photograph by Cecil Beaton. The hands here are as expressive as the face, but it would be useless to try to arrange such a pose.

This picture (left) combines the dramatic qualities of using hands and eyes. Lighting on the hand has given it a strong texture, and the hand has further importance in this composition from the way it is distorting the subject's expression. The lighting also powerfully emphasizes the single visible eye, especially with the sharp highlights on the iris. Finally, the picture has been cropped to deliberately focus attention on these elements.

Seating the model

THE WAY IN WHICH the model is seated can have a considerable influence on a photograph, both on the composition and the mood of the picture. The way the subject responds will also be affected by the way in which the body is positioned.

If you intend to do regular portrait sessions it is worthwhile giving some thought to the way in which you can provide a convenient and variable means of seating your model. An ordinary lounge or dining chair is generally far from ideal, as it does not allow the body to adopt a variety of positions; as well, the high back which these chairs usually have can intrude on head and three-quarter length shots. A stool avoids this problem and can be useful for some shots, but the lack of supports can easily produce a rather stiff and unrelaxed attitude.

Probably the most useful type of chair for occasional sessions is one that has a small, low back and similar arm rests. Such a chair will not encroach unduly on the picture area but will provide some support and enable the model to relax into a number of positions. It is an added bonus if the chair is also variable in height – some typist or office chairs are able to fill these requirements particularly well.

The most effective and inexpensive solution is to build a number of rectangular boxes of varying sizes from chipboard or pinewood. The shapes and sizes should be planned in such a way that they can be placed together to form a series of surfaces of different heights on which you can place cushions, or drape with fabric. The more flexible the system the more scope you will have for creating different shapes and more interesting compo-

sitions in your photographs of people.

Even in a tightly-cropped head shot a surprising number of different effects can be achieved by having the model sitting in an upright position, and then leaning back on to a cushion, or forward on to a knee. Of course with three-quarter or full-length pictures the body positions can have much more influence on the nature of the image.

It can be particularly useful to have some means of supporting the model at a height of 3ft (1m) or so from the floor. A bench-top across two equal-sized boxes can provide this, allowing low-angle shots to be made much more conveniently. A couple of cushions and some fabric can convert this bench into a sofa, which is a very good way of getting really relaxed reclining body angles, particularly ideal for nude and glamour work.

These methods are concerned only with providing a means of varying the position of the body in a way that does not intrude on the content of the picture, but there are occasions where the furniture used can contribute to a photograph. A really attractive chair with an interesting shape or texture can become an important element of the image. Even the fabric or the pattern of the cushions with which you cover the boxes can be designed to create a certain effect, and it is a good idea to accumulate a few attractive bits and pieces to 'dress up' your pictures.

It should be remembered that in most cases only small parts of the furniture or props are visible in a shot. It is often actually easier to create the impression of a particular setting by using small objects and pieces of furniture and fabric, simply positioning them exactly where they are needed, than to have elaborate real sets.

Seating poses can give an extra element to portraits, with the body forming shapes (above) that are more interesting than in a standing pose. A simple small stool was used in this picture of Terence Stamp – any appearance of a chair back would have ruined the stark simplicity of the outline.

When the whole body is to be an important element in the composition (above left), the seating chosen should enable the model to relax comfortably, and to adopt a variety of positions with ease. In this picture the texture and tones of the couch add to the image.

In this very posed, formal portrait of Sir Noel Coward by Karsh of Ottawa (right) the chair provides an essential aid to the pose, and contributes its own element of dignity.

Choosing the angle of the head

QUITE OFTEN the way in which the model's head is presented to the camera is the result of a quite arbitrary decision. It may simply be the result of the way in which the chair had been placed or because it creates a pleasing lighting effect. Many good pictures are the result of purely chance occurrences, and of course an important part of a photographer's skill is in being able to recognize a good thing when he sees it.

However the more a photographer is able to understand and control the elements of his pictures the more luck he is likely to have. The angle of the model's head can have a considerable effect on the quality of a picture. It will affect the composition, the mood and, by no means least, the appearance of the model.

The most basic yet quite often the most unattractive angle is full face. Most people hate their passport pictures, and this often has as much to do with the head position as anything else. There are two main problems with this angle. One is that it tends to create an image which is too symmetrical, which makes it less interesting, and the other is that it is difficult to light a full face portrait in such a way that the bone structure is adequately revealed – consequently it can easily be unflattering.

A girl with a face of classic shape and a good bone structure can be photographed very effectively in this way, as her features will need only a soft frontal light to reveal their shape and form. The symmetrical quality of the image will usually enhance a beautiful face, and such features will also provide the visual interest of the picture. Most people, however, are more likely to look better, and create a more interesting image, when the head is turned slightly away from the camera. Immediately the line of cheek and jaw takes on a more interesting shape, the contours of the face become more pronounced, and it is possible to create more depth with the lighting.

A complete profile, like the full-face picture, is less likely to create either a pleasing likeness or an interesting image. Without considerable help from the face itself, there is far less opportunity for the lighting to produce an impression of depth, and even the model's expression is able to play only a minor role, as it is the actual outline of the profile which must provide the main visual interest of the picture.

The relationship between the subject and the background becomes a major consideration in a profile shot, and it is vital that the face is isolated in some way so that the shape of the profile is allowed to become a dominant element. This can be done by creating a tonal contrast – a darker background behind a well-lit face, for example, or a silhouetted face against a light background. Alternatively, back lighting can be used to create

an attractive rim-lit effect around the head.

The tilt of the head is another important factor to consider. When the head is tilted slightly down the effect can often be rather quiet or submissive, while a chin thrust forwards and upwards creates a much more assertive or aggressive mood. If you look at pictures of politicians and leaders of industry you will see that they are very frequently photographed in this way, often from a low viewpoint and with a wide-angle lens to accentuate it even further.

Photographers shooting model girls, on the other hand, sometimes prefer a slightly higher viewpoint with the model's chin tilted down. This is often done quite subconsciously, but the more you are aware of the ways in which you can control the effect of a picture the easier it becomes to produce consistent results.

In this picture (above) the camera was considerably lower than the subject's eyes, creating an aggressive mood, emphasized by positioning the face on the diagonal.

A three-quarter portrait (right) not only enables the photographer to put more shape into the picture, but it is the most pleasing pose for most people.

Full face portraits (top) should be attempted with caution, but this one is successful because the girl's face has such good proportions and structure.

A profile portrait (above) is dependent on the subject having clean, even features.

Different approaches to lighting

The lined, experienced face of writer Violette Leduc (left) has been strongly lit to emphasize its strong features (above). The use of softer lighting in an attempt to flatter would almost certainly have resulted in a nondescript photograph.

Very soft front lighting (diagram above) combined with back lighting from a window, creates a high key, deliberately romantic picture (right). Everything in the photograph, from the model's hair to the flowers, is pale in tone, adding to the soft, light image.

THE ABILITY TO PRODUCE **an enormous variety of effects and moods by controlling studio lighting is a tremendous advantage to the portrait photographer, but the best photographs are a result of not only good lighting technique but also the ability to apply it in the right way.**

It is quite possible for a photograph to be spoilt by inappropriate lighting, as well as by being badly lit. A picture which was dependent on a lively and spontaneous expression, in a child for example, could easily be made less appealing by the use of overly clever or dramatic lighting. Similarly, an interesting, world-worn face may produce a boring picture if lit in a way that attempted to flatter.

It is also important to consider the effect that the lighting has on the way the model responds. Very directional lighting, for example, can restrict the way in which the subject is able to move without unpleasant effects being created. When the success of a session is likely to be dependent on the model's ability to move freely, a soft, more frontal light may be more appropriate. It can be very inhibiting for the model if you frequently have to request a change of angle because unpleasant shadows are being created by strong directional lighting.

In general, young faces seldom benefit from lighting that emphasizes skin texture in an excessive way. This is not a question of flattery, but the fact is that with an older skin, which has a more pronounced texture, strong directional lighting will produce a rich range of tones, whereas with a young child or even a young woman the much smoother skin can easily record as a rather flat, muddy tone under this type of lighting.

The colour of skin will also have an effect on the reaction of the light source. Dark, suntanned skin or black skin will usually record well when lit by quite a hard light, such as an undiffused flood or even a spotlight, but very fair, pale faces can often look unattractive when lit in this way.

In many ways the reaction between the lighting and the skin is more critical in black and white photography than it is when working with colour film. This is because the impression of skin colour and texture can be created in a black and white print only by the extremely subtle gradations of tone that are produced by the effect of light on the skin, while with a colour photograph the element of colour is seen and not simply suggested.

Dramatic lighting effects can also look noticeably more artificial in colour pictures, because the eye is not distracted by the need to imagine the quality of the skin. Consequently, you should tend to be more discreet in the use of lighting techniques when working in colour, unless you are deliberately setting out to create a more theatrical effect.

Many photographers who work frequently in colour do go to some lengths to simulate the effect of daylight when working in the studio. This is not very difficult to achieve. The simplest method is to bounce several lamps off a very large white reflector, or alternatively you can diffuse your light sources by the means of a large screen. The intention is to create as large and as even a light source as possible – similar, in fact, to that created by a bright but cloudy sky.

Harsh directional lighting can be very effective on dark skin (above), and has been used here without any softening diffusion of light to emphasize the texture of the skin as well as to create an impression of hardship and suffering.

Totally indirect, bounced light (left) has created diffused, soft lighting with no deep shadows, suiting the tenderness and happiness of the subject. An additional benefit of this lighting is that it allows considerable movement by the woman and child, without the photographer having to alter the position of lamps or reflectors.
Nikon F2 with 105mm lens; f16 with bounced studio flash; Kodak Recording Film 2475.

INDOOR PHOTOGRAPHY

CONSIDERING THE AMOUNT of time we spend indoors, very little informal photography is taken under these conditions – especially if studio-type work is discounted. Yet there is a vast choice of subjects; people at work and at leisure offer many opportunities for interesting pictures, yet the non-professional is frequently put off by problems that do exist.

Foremost of these problems, of course, is lighting. The average beginners' experience with under-exposed indoor pictures, with colours that do not ring true at all, and with the disappointing results of straightforward flash pictures, often puts them off trying anything at all ambitious.

Yet very often excellent results can be got by relatively simple techniques and without expensive equipment. Even the common flash-gun can be used to good effect, and a modest outlay on filters, lenses and films can open a whole new field of photography. Whereas black and white images offer the greatest potential (with fewer likely problems), a lot can be done with colour film.

Interior of a hilltop villa in Andalucia, Spain, by Michael Busselle.

Using daylight indoors

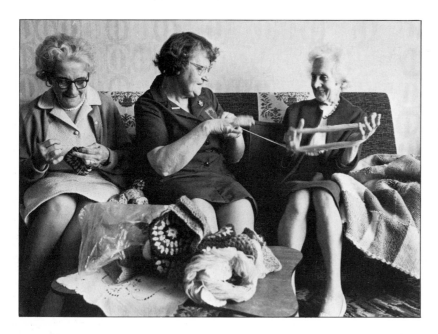

DAYLIGHT CAN STILL **be a very effective and convenient means of illumination when working indoors – in fact many professional studio photographers prefer to use natural light whenever possible, and have designed their studios with this in mind.**

The main requirement for using daylight indoors is a window or skylight of large enough size for the room you use as a studio. It is sometimes thought best if this window faces a direction that avoids direct sunlight, for this will give a light of more constant quality – although direct sunlight can nevertheless be used to good effect.

The studio window will in fact become your main light source, and the more control you have over it the more useful it will be. If it is a very large window or skylight it would be helpful to have blinds which enable you to mask-off different areas of the window. Large sheets of diffusing fabrics or paper stretched over the window will give you extra control over the quality of the light.

It follows that since your light source (in this case the window) is in a fixed position, the only control you have over the direction of the light is by altering the positions of the camera and the model in relation to the window. However, a surprising variety of lighting effects can be achieved in this way. If, for example, the window is at a right angle to the model, the lighting will be strongly directional, creating quite dense shadows on the side away from the window. As the model and camera are moved so that the model faces the window, the lighting will become progressively less directional, with more gentle modelling and with smaller and softer shadows.

The distance at which the model is positioned from the window will also affect the lighting quality. A position close to the window will

produce a pronounced 'contrasty' result, but the effect will be much softer with the model farther away. An additional degree of control over the degree of contrast can be achieved by using white reflectors. Large sheets of 1in thick (20–30mm) polystyrene are ideal for this purpose, as they are reasonably rigid and very light and can simply be propped against a chair or a tripod. A large mirror on a stand can also be useful, as it will enable you to reflect back quite strong localized areas of light to create highlights in a similar way to a studio spotlight, although of course with less control.

With black and white pictures it is possible to use a table lamp or desk lamp to act either as a fill-in light for shadow areas or to create highlights; of course the difference in colour quality will make this impractical when shooting colour film.

Because you need to have the freedom to move both model and camera it is important that you are also able to move your background. It is possible to buy a small lightweight unit with telescopic stands which will support a 6ft (2m) wide roll of background paper. Alternatively it would be simple enough to build a wooden frame over which you could stretch paper, fabric or even painted board, and this could be supported from behind by a light stand or tripod. Rolls of paper are an advantage when shooting full-length or even three-quarter length figures as they can be continued along the floor in a curved sweep to provide a seamless, continuous toned background.

It can be a definite advantage to work with a tripod-mounted camera when using daylight indoors. Exposures will inevitably be longer than in brighter outdoor lighting, and the risk of camera movement will be greater. In addition it is useful to be able to leave the camera in position while adjusting reflectors and backgrounds.

The indirect light from a window considerably softens the harshness of sunlight (above left), but the loss in brightness does mean that slower shutter speeds are inevitable. In this case, however, the slightly blurred hands add to the atmosphere of the picture. The degree to which light softens away from its source is apparent in comparing the face of the woman on the left with the far more contrasty face of the woman nearest to the window.

Judging the right exposure can be a problem with some indoor subjects, when there is often a considerable brightness range between the subject, lit from the window, and the much darker shadow areas of the room in the background (above). TTL metering and a long-focus lens will set the reading automatically if you are unable to use a light meter close to the subject.
Nikon F with Vivitar 70–210mm zoom lens at 180mm; 1/60 at f5.6; Kodak Tri-X.

In most cases the only way to get front lighting from a window is for the photographer to be between the window and the subject – this can reduce the amount of light falling on the model. In this instance (right) a novel approach has been used, the photographer taking the picture through the window. The reflections in the window pane have added an extra element to the composition.

Daylight indoors can be used very effectively as a back light (above) and the effect can be altered by varying the exposure. Exposing for the ambient light will create a near silhouette of the model, with a few highlights on her hair and body. Increasing the exposure by two stops will reveal the features in shadow but make the background very bright. In this photograph the exposure has been increased only slightly, emphasizing the highlights on the model. A small amount of extra light has been reflected on to her face from the page of the book she is reading.

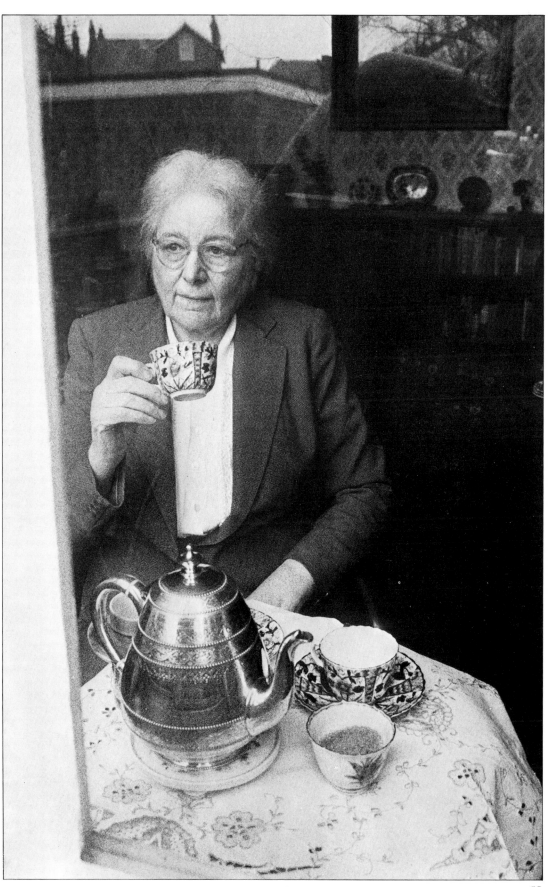

Portable lighting techniques

ALTHOUGH DAYLIGHT can provide a simple and inexpensive source of illumination indoors, it does have some drawbacks. It is by no means constant either in terms of brightness or colour quality, control over lighting effects is restricted, and of course shooting after dark is altogether impossible as it may be when the weather is just too dull. The use of portable lighting equipment allows you to shoot at any convenient time, and will also make possible a wider range of lighting effects.

You can build a quite flexible and very inexpensive system by using either normal domestic light bulbs or photoflood lamps. All that is really required is a method of supporting the light source, of adjusting its height and angle, and of controlling its quality.

If portability is not a major consideration, a wooden stand is simple enough to make. Height and angle adjustments can be provided by holes drilled in the wood, and the joints and separate sections tightened and held in place with bolts and wing nuts. Alternatively, instead of a base, you can simply fix the upright to a chair or a table leg by using a clamp.

Lightweight folding stands, however, can be bought from most of the larger photographic supply stores and are not very expensive. The cheapest method of providing a light source is by using domestic spotlight bulbs attached to the stand by means of a lampholder and bracket. A reflector is not required as these are internally silvered, and the brightness given by a 100W or 150W lamp of this type will be more than adequate for head and shoulder portraits, using only medium-speed film. With faster film it is also possible to shoot full-length pictures.

More brightness can be obtained by using photoflood bulbs. Their size and appearance is similar to an ordinary 100W bulb, but they are 'overrun', which means that they give a greater output of light, equivalent to about 1000W, though with a very short life normally only a few hours. Such lamps require a reflector, and a variety of these can be bought.

It is of course possible to buy complete units and systems using both photoflood lamps and quartz halogen bulbs, and various different types of reflector are available. Ideally you should have at least three lamps and stands one lamp fitted with a fairly narrow-beam reflector, one with a broad reflector, and possibly a spotlight as well. It is also useful if one stand is fitted with a boom arm for overhead lighting.

The flexibility of such a system is considerably increased by having a diffusing screen made by stretching tracing paper or sheets of frosted plastic over a wooden frame about 3ft (1m) square. In addition you would also need at least one reflector, and the larger the better. One of 3 × 6ft (1 × 2m) is ideal; it can be made from a sheet of white painted hardboard, thick card or a sheet of white polystyrene about 1in (20 30mm) thick.

A very convenient portable lighting system is now produced by a number of electronic flash manufacturers. Based on a similar principle to the tungsten kits, with lightweight stands and a range of reflectors, this system provides a small electronic flash unit for each stand. Each has its own built-in generator and modelling lamp.

Only one light needs to be synchronized to the camera, the other lights being fired simultaneously by slave cells which pick up the flash from the main light. These systems can be bought relatively cheaply in the case of the lower powered versions, which are quite adequate for use in the home, while the more powerful types of 1000 or more are effective in a medium-sized studio.

These two photographs (right and far right) illustrate the sort of pictures that can be taken indoors using lightweight portable equipment, and show that effective portrait and full-length photography need not be dependent on expensive equipment. The lighting behind the diaphanous dress could be provided by a household spotlight on a small stand, and a fairly strong flash could provide the main, strongly directional light from the right. For the portrait, a broad, fairly soft light and a fill-in reflector would be all that is needed.

Lightweight portable stands for lamps, reflectors and even background paper rolls (left) are invaluable when space is at a premium. The umbrella reflector (far left) is white or silver, and will give a broad, soft light, and the boom stand is ideal for holding a lamp above the model. The square, silver reflector can be used as a fill-in reflector or for bouncing the main light.

Home made lighting equipment (right) can be cheap but effective, especially with the variety of household light bulbs that are available. The frame for a portable diffuser (top) could be used for a reflector by exchanging the sheet of tracing paper for a more reflective material, such as white card or aluminium foil.

Small flash-gun lighting

A SMALL PORTABLE FLASH-GUN has become almost a standard piece of equipment for most enthusiastic photographers. It can be tucked away into the corner of a compartment case and gives the reassuring knowledge that extra light is always available if required. At the very least it is possible simply to record an image in situations in which a picture could not otherwise be taken. But it is possible to use this equipment to produce pictures with a good lighting quality, and you can avoid the unpleasant 'black hole' effect of flash with a little care.

Most small flash-guns are designed to fit on to an accessory shoe on the camera body. It can, however, be a distinct advantage to use a separate bracket which enables the flash-gun to be supported at some distance away from the camera lens – about 18 in (300 mm – 400 mm) is ideal. This ensures that you do not get the 'red eye' effect which is a result of having the flash too close to the camera lens, and has the further advantage in that by moving the flash-gun above or to the side of the camera you will introduce a degree of modelling into the subject. When the light source is very close to the camera the result is extremely flat lighting with no suggestion of form.

The main cause of the typical 'flash on camera' look, with white faces and jet black background, is the absence of any allowance for the inverse square law – i.e. that the brightness of a light source diminishes in direct proportion to the square of the distance of the subject. In practical terms this means that if a flash-gun is giving a correct exposure at say 10 ft (3 m), then an object 20 ft (6 m) away will receive only a quarter of the light and will consequently be two stops underexposed. If a black background is to be avoided it is vital that the subject should be quite close to surrounding details and that objects in the background should be no more than half the subject-to-camera distance farther away – preferably closer, particularly if the background is a dark colour or has a dark overall tone.

Where the ceilings and walls of a room are of a fairly light and neutral tone (with colour film, white is safest) it is possible to reflect light from the flash-gun off these surfaces on to the subject by aiming the flash at the wall or ceiling at a point about one-third of the distance from the camera. It is important that this distance is great enough to ensure that angle of 'bounce' is not too acute. When using a ceiling, for example, a sharply-angled bounce would produce a strong top-light effect, causing deep shadows in the eyes and under the nose and chin. Some flash-guns have two reflectors, one that can bounce the light, which helps to overcome the top-light effect, and one that stays directed at the subject.

When using a flash-gun with other lighting – domestic lighting at a party, for example, or the lights at a discotheque – it can be very effective to make use of this lighting in addition to the flash, rather than to ignore it completely. The X-synchronisation setting on most cameras with a focal plane shutter is between 1/60 and 1/125 sec. This, combined with an aperture of, say, f.8 will lose the effect of all but the brightest ambient light, giving a mainly dark background.

If you have a camera with slow speeds you can produce a much more effective picture if you use a slower shutter speed – say 1/8 or even 1/4 sec. This will not affect the flash exposure and it will still synchronize, but it will enable the existing light in the scene to record on the film, as well as the flash. If necessary you can also reduce the power of the flash by either switching it down or by using a diffuser and then opening the aperture to a wider stop. Where the background light is very poor and the subject can be kept fairly still, even longer exposures of a second or more can be used with a tripod-mounted camera.

Flash can produce unwanted effects – in informal and 'spur of the moment' photography a direct reflection from a mirror or a window often ruins a shot. When shooting with direct flash at a party, it is important to be aware of any cigarette smoke as this can bounce the flash light back at the camera, and can cause a very flat grey and foggy effect on the image.

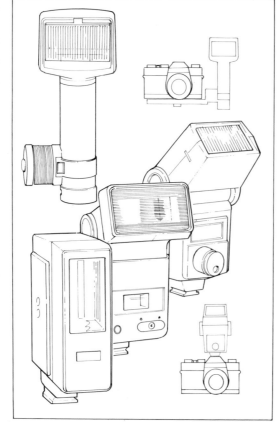

A wide variety of flash-guns is currently available, and four are illustrated here (right, clockwise from top left). The more powerful, dry-cell battery models can be fitted to the camera base, to a lightstand or be hand held. They are triggered via a connecting cable from the camera and usually are powered from a separate, re-chargeable powerpack.

The self-contained, clip-on units are powerful enough for most amateur photographers' needs, and a model with a pivoting head enables softer bounce flash to be used.

Some models have a small second reflector that can be used when the main light is pointed up, to provide a fill-in effect.

If flash is only going to be used infrequently, you may settle for a small 'mini' flash unit – though this type can also be used as a fill-in light in daylight or when another, more powerful flash is being used.

The black background effect that often spoils photographs taken with single flash units can be avoided by placing the model close to the background and by choosing backgrounds that are pale in colour (left). If this is not possible, try to place some props within the flash's range.

If the model can keep still, and the camera is tripod-mounted, more background detail can be recorded by using a very slow shutter speed and a wide aperture. If the combined effect of this and the flash will cause the main subject to be over-exposed, the power of the flash can be lessened by placing a diffuser over the reflector, or by moving the flash unit further away from the subject.

When the flash is bounced off the ceiling or a wall, a more diffused light results (far left). A bright flash bounced off a fairly low white ceiling at a sharp angle, however, can cause downward shadows on the model's face.

Direct flash (left) has a harder light than bounced flash, and is more likely to cause shadows on the model or on the background. Nikon F2 with 105mm lens; far left f8, left f16, Kodak Tri-X.

Using a setting

Cecil Beaton's photograph of Alberto Giacometti (above) includes the cluttered surroundings of the sculptor's studio. They not only tell you more about the subject but also contribute significantly to an interesting composition. The high viewpoint and the position of the artist in the frame, however, ensures that the surroundings do not detract unduly from the main subject.

The formal dignity of the setting (right) adds considerably to Martine Franck's portrait of Sir William Pennington Ramsden at Moncaster Castle. The positioning of camera and subject, and the lighting have allowed the setting to influence the composition without being intrusive.

TAKING PHOTOGRAPHS **indoors is often simply a matter of convenience, and the room in which the pictures are taken is required to do no more than provide a suitable space for the model and the equipment. There are occasions, however, where it can do much more than this and become an important element of the picture.**

The setting's role can range from a suggestion of tones and shapes in the background of a portrait to being the major part of a composition, of which the model is only one component. Such use of a room can help a picture in a number of ways – it can contribute to the mood you wish to create, it can help to supply more information about the subject of your portrait, and of course it can simply make the picture more interesting.

Mood is sometimes a difficult quality to create or imply in a photograph, and the right setting can often lift a portrait out of the ordinary by conveying mood. A room with sombre decor, dark mahogany furniture and pieces of Victoriana could make a portrait of an old lady far more evocative and telling than if she were photographed in a bright, sparsely furnished room, no matter how well the picture was lit and composed.

Sometimes just a fold of velvet curtain, the corner of an ornate picture frame and a piece of antique furniture are all that is needed to produce this type of effect, whereas on other occasions a more powerful image may be wanted, using a much broader sweep of the room and allowing it to almost dominate the picture. In the latter case very careful control of the composition is necessary to avoid a fussy and confusing photograph where the attention is divided between the setting and the subject.

Confusion can be avoided by composing the picture so that the model is in the most dominant position within the frame, and by ensuring that there is adequate separation between the subject and the background. A tonal contrast is an effective way of doing this; alternatively the background can be slightly subdued by not having it in perfect focus – focusing on the model and using a wide aperture will limit the depth of field and achieve this effect.

It is vital to be aware of confusing elements in pictures of this type as often only one small, out of place or distracting object in the picture can spoil a photograph. A small, bright highlight near the edge of a picture frame, for example, or an unwanted reflection on a piece of furniture, can seriously upset the composition. It is often necessary to remove some ornaments or items of furniture to avoid this.

Lighting a setting that occupies a relatively large space can present special problems, particularly when you need to give special attention to only one part of the picture, namely the model.

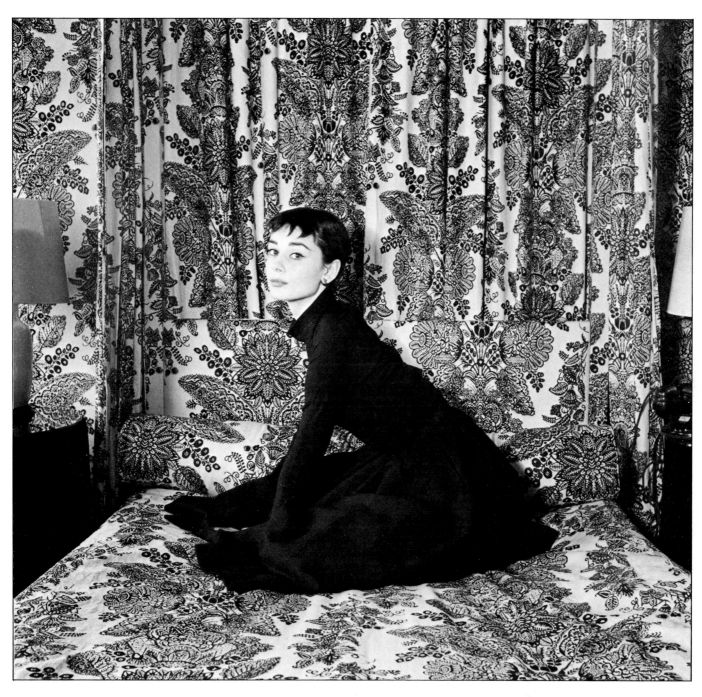

In most circumstances it is preferable to light the main subject first of all, positioning the lights to achieve the effect you want on the subject's face or body. Then carefully study the relationship between the subject and the background – ensure that it has not created any distracting highlights or shadows, and judge (or measure with an exposure meter) the difference in brightness level that you have created between the areas of light and shadow.

On many occasions it will be found necessary to add lighting to the background to prevent it recording excessively dark. This should be done in such a way that the background light does not adversely affect the subject – pieces of black card can be taped or clipped on to the reflectors to prevent excessive spill from the lights.

It may well be found that in large rooms, or rooms which have dark furniture and decor, a substantial amount of additional light on the background will be needed to record adequate detail and tonal gradation. Reducing the level of the subject lighting can help in some circumstances, and if flash is being used it is possible to set a longer shutter speed to make use of suitable ambient light.

The extravagant fussiness of the surroundings (above), photographed in perfect clarity by Cecil Beaton, is a perfect foil for Audrey Hepburn's elegant beauty and the simple symmetry of her pose.

Making use of available light

A situation like this dance studio scene (above) creates exposure problems because primary light sources are included in the picture area (diagram below). Compensating by over-exposing the background lights, however, ensures that important foreground detail is captured.

WHILE THE USE of portable lighting equipment or a flash-gun can make photography in poor lighting conditions easier to control and also improve the technical quality of a picture, there are often occasions when it is impossible or inadvisable to introduce additional lighting. It frequently happens that the existing lighting in a situation is largely responsible for creating the mood or atmosphere of the scene – at a discotheque or in a restaurant, for example; totally changing the effect of such lighting by the use of additional illumination would completely change the picture's mood.

Modern equipment and films have made it possible to shoot pictures even under conditions where it would be difficult to read a book, but making effective use of available light does need special care and consideration.

The use of fast films is an obvious advantage when working in low light levels, and although there is an increase in grain and a corresponding loss of image quality, quite often this can be turned to advantage by contributing to the atmosphere of a scene. The speed of both black and white and colour films can be further increased by processing techniques, either by giving extended processing times or, in the case of black and white films, by using specially formulated speed-enhancing developers.

It is advisable to carry out tests when intending to make use of such darkroom techniques. A particularly useful method is to make a clip test.

This involves making a few exposures at the beginning (or end) of a roll at the exposure you intend to use and under the same lighting conditions; then, having completed the roll, clip off the test frames in the darkroom and process them first. It is therefore possible to make any adjustments to the processing times before running the important part of the film. If you do not do your own developing this service is provided by professional laboratories.

Another obvious advantage is to use fast lenses when working with poor light, and if this is a regular feature of your work the additional one or two stops that such lenses provide will make them a worthwhile investment. Extremely wide-aperture lenses contain a great deal more glass and usually more optical elements than conventional lenses, and these areas of glass make them prone to flare – consequently extra care should be taken to shield them from extraneous light, and an efficient lens hood is an invaluable accessory.

One of the hazards that is frequently encountered in available light photography is the problem of excessive contrast. This often is due to the denser shadows that exist in low light and the light sources that tend to be included in the picture area. This excessive contrast can easily be overlooked at the time of shooting, because our eyes have a tremendous capacity for making rapid and continuous adjustments to different brightness levels. However, the true effect of the contrast of a scene can be more easily seen by viewing it through half-closed eyes.

In this picture of a casino (left) no attempt was made to record detail in the dark foreground figures, since doing so would have resulted in considerable over-exposure of the background. This would have burnt out the detail, which was considered to be an important element of the image.
Nikon F with 50mm lens; 1/60 at f4; Kodak Tri-X.

Large areas of dark tones with little or no detail are common problems in available light photography (right). In this superb picture by David Hurn, the photographer has made use of a large area of featureless dark tones to add strength to the composition and to accentuate the expression and action of the man.

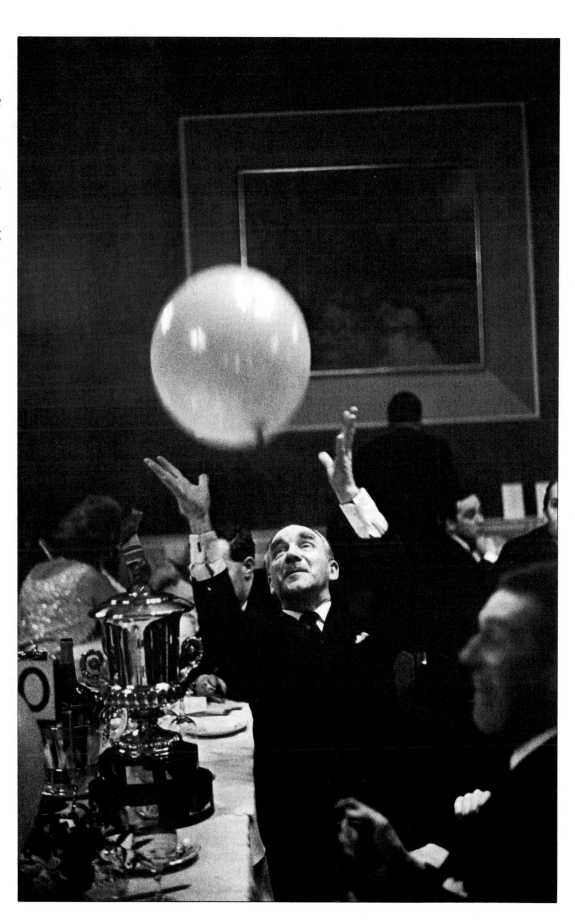

Mixed lighting techniques

IN BLACK AND WHITE photography light is just light as far as its source is concerned, and only its direction and quality control the effect on the film. When shooting colour, however, the source of the illumination is of vital importance.

Colour film is manufactured to give correct results in relation to light of a specific colour temperature – consequently it is not possible to mix light sources of different colour temperatures without the effect being visible on the film. If for example you wanted to take a photograph of a person seated by a window, and who is also illuminated by tungsten lighting, the effect with daylight film would be a distinct orange/yellow colour cast on the model, though the scene through the window would be recorded correctly. If, however, you were to take the same picture on tungsten light film you would obtain an image of normal colour balance on the subject, but with a strong blue cast on the view through the window.

To achieve no colour cast in any part of the image involves altering the colour quality of one of the light sources. This can be done by using coloured acetates or gels of the correct filtration values either over the window or over the tungsten lamp. A bluish acetate over the artificial light would give an overall correct balance on daylight film, while an orange/yellow acetate over the window area would enable you to shoot on tungsten film. These gels can be bought from a number of art supply stores or photographic suppliers.

Where it is not possible to alter the balance of one of the light sources, all that can be done is to ensure that the light source for which the film is balanced is the one which dominates the scene, and to remember that skin tones are extremely sensitive towards a colour bias – it is most important that these should be recorded correctly. A degree of colour cast in background areas, for example, will probably go unnoticed provided the main subject of the picture is recorded accurately. Another consideration is that skin tones will still appear quite acceptable with a degree of orange colour bias, but will invariably look unattractive if a blue/green cast is present.

Lighting balance, or relative exposure, will also have an effect on the colour casts created by mixed lighting – these will be lessened if the picture is over-exposed. The appearance of a tungsten light source in the background of a daylight shot, for example, will be less noticeably orange if it is over-exposed than if it were under-exposed.

Unless you wish to create a particular effect, it is preferable to allow the alien light source to be at a rather higher level of brightness than that of your main light.

One very common cause of unexpectedly disappointing results is shooting in situations in which fluorescent lights are present. The majority of

such lights used in shops and offices are called daylight-matching; to the eye they are virtually indistinguishable from daylight itself – but when recorded on the daylight colour film they often create a most unpleasant greenish colour cast. The effect varies depending on type and make but fluorescent light is always a potential hazard.

It is possible to buy custom-made correction filters to fit over the camera lens for fluorescent lighting, but experience has shown that they frequently are not strong enough. With daylight film filtration in the order of CC20 – 30 Magenta will usually be required. Where possible it is wise to make an exposure test with polaroid film.

In situations where the fluorescent lighting is in the background only, it is possible to light the foreground subject with, for instance, a small flash-gun. When this is filtered by a green acetate of the same strength as the magenta camera correction filter, it will neutralize the effect on the foreground but leave the more distant background details unaffected.

The deep yellow glow of the tungsten light in this picture taken with daylight film (above) perfectly complements the room's furnishings and the warm glow of the girl's skin, which is lit mainly by daylight.

The pale faces of the women in this picture (right), the pink blouse and the white columns were lit by daylight. The tungsten light has only affected a part of the background, where its colour, on daylight film, has a pleasantly warm fill-in effect.
Nikon F2 with 105mm lens; 1/60 at f5.6; Ektachrome 64.

Fluorescent light on daylight film gives a green cast that is unwelcome in most photographs of people (top). If that form of lighting is unavoidable, a filter, such as the Hoya FL-Day filter used here, should be selected to reduce its effect (above).

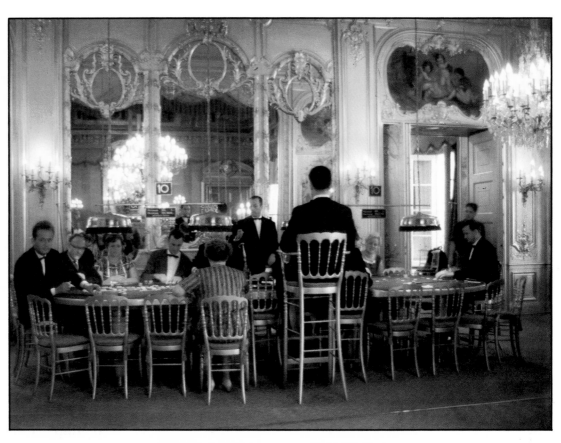

In this picture (above) practically all the lighting was provided by tungsten light, but the resultant gold cast on daylight film has added to the opulence of the setting. Nikon F with 50mm lens; 1/60 at f2.8; Ektachrome 64.

The lighting in this picture (left) was provided solely by the fluorescent panels. Its effect on daylight films has been reduced by the use of a filter, but the remaining green cast suits the setting admirably.

The effect of daylight on tungsten film is to produce a definite blue cast (left) which can be corrected by the use of a filter or left, as here, to add an extra element to the picture. Nikon F2 with 105mm lens; 1/60 at f4; Ektachrome 160 Tungsten.

Using long exposures

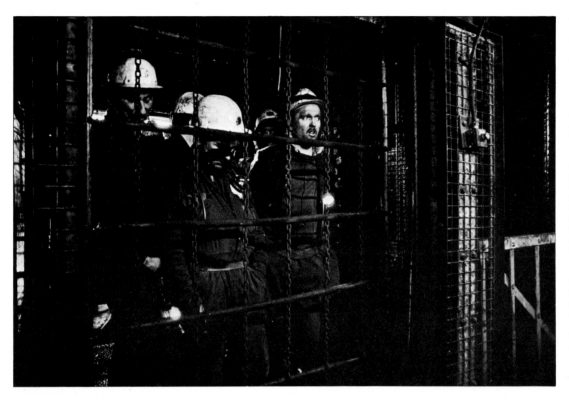

A flash could not be used in this picture of coal miners (left) because of underground safety precautions. An exposure of ½sec, with the camera braced against a metal pole, was given as soon as the lift stopped, and before the gates opened.
Nikon F2 with 24mm lens; 1/2 at f2.8; Kodak Tri-X rated at 1000 ISO.

Various different stances can be used to steady a camera for long exposures (right) when it is not practical to use a tripod. With a waist-level viewfinder, for example, pull down on the straps. A monopod (last illustration) gives considerable support and is very portable.

The stillness of the fortune teller (far right) enabled the photographer to take a number of exposures at 1/15 sec, bracing his arms against his chest. The sharpest frame was then chosen from the contact strips.
Nikon F with 50mm lens; 1/15 at f1.4; Kodak Tri-X.

EVEN WITH THE HELP of high-speed films and wide-aperture lenses, working in poor lighting conditions invariably means longer exposures – and that means the greatly increased risk of camera shake.

It is impossible to give a sensible indication of what consitutes a 'safe' shutter speed to avoid camera movement; there are so many variable factors, not least the abilities of the individual photographer. Many photographers prefer to have their shutters set on 1/250 wherever possible, yet even this cannot be considered completely safe if the camera is handled badly, particularly if a long-focus lens is used. In general terms, the longer the focal length of the lens being used, the greater the care that needs to be taken.

Holding the camera correctly and releasing the shutter smoothly are vital techniques when using longer exposures. With an eye-level camera the best method is to hold the camera in such a way that one or both of the forearms form a strut, with the camera pressed firmly but gently against the cheek bone, and the upper arm against the chest. The shutter release should always be squeezed rather than pressed. Although it is a temptation, it is not a good idea to hold your breath, particularly if you have to wait a while for the shot.

With a waist-level camera it is best to hold it with the supporting hand partly under the camera, pusing it firmly back against the chest. If you prefer to hold the camera lower it can be pressed steadily down against the neck strap.

As the way in which you hold your camera most comfortably and steadily is in the last resort dependent on your anatomy, it is worthwhile practising with a few positions to judge their effectiveness. This can be done by sticking a small hand mirror on to the front of your camera in its most comfortable position so that a small spot of light is reflected on to a distant wall. By releasing the shutter, and at the same time trying to hold the spot of light steady, you will quickly see how effective your technique is.

A dramatic improvement in camera steadiness can be achieved by making use of any existing supports. In a room, for instance, the camera could be braced against a door post, or held down on the top of a chair. Where nothing else is available and a lower viewpoint is more acceptable, it can be useful to sit on a rigid camera case and steady the camera with your elbows propped on your knees.

In terms of accessory equipment, nothing can beat a good, solid tripod. Modern materials and design have made it possible to obtain a firm tripod which will hold most small-format cameras quite steady and still be easily portable.

Where greater mobility is required, or where a tripod would get in the way, it is possible to get considerable benefit from other devices – a monopod, for instance, which is simply a single telescopic leg upon which the camera can be mounted and pressed down against the ground. A rifle-grip enables the camera to be held like a rifle, with the butt pressed against the shoulder and the trigger connected to a cable release.

A flash would have been very intrusive in this setting (right), and would have destroyed the atmosphere of the picture as well, so the photographer squatted on his camera case, resting his elbows on his knees, and made a ⅛ sec exposure. The light weight and compactness of a wide-angle lens makes it very suitable for long exposures, and it diminishes movement whereas a long lens magnifies it.
Nikon F with 24mm lens; 1/8 at f2.8; Kodak Tri-X.

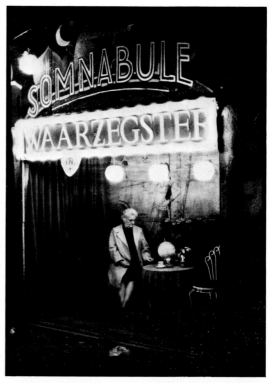

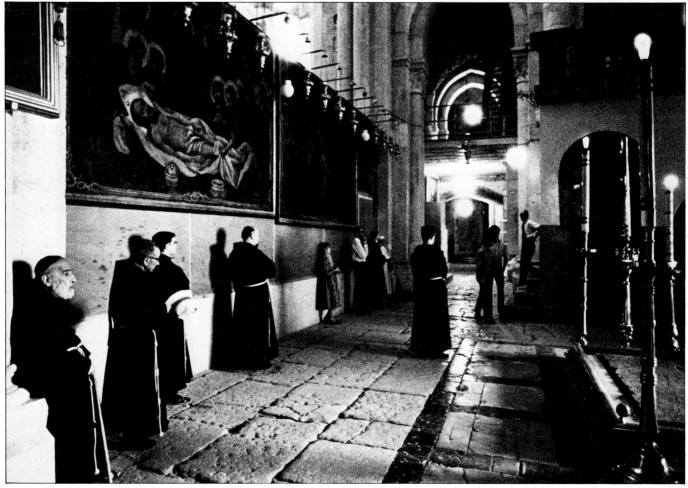

Photographing indoor events

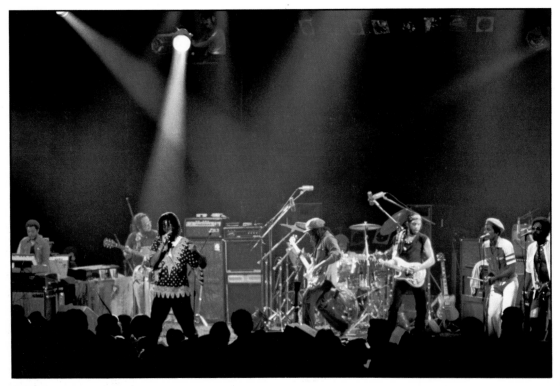

Daylight film would be acceptable for photographing many indoor performances when the resulting warm colour bias suits the atmosphere (left). There is no worry about camera noise at events such as this pop concert, but it is always best to find out if photography is permitted.

The presence and noise of a camera would be intrusive at many performances, such as ballet (right), opera and stage plays, but you may be allowed to photograph rehearsals. Familiarity with the programme allows you to plan your shots, and to try for special effects with slow shutter speeds, long-focus or zoom lenses.

Stage lighting varies considerably, as shown by these pictures of pop singers Debbie Harry and Elton John (above), and the use of flash is usually inadvisable – as for the performers' sake as for the effect on the image. A long-focus lens of about 135mm is necessary for close-ups, though a 70–150mm zoom lens would allow you to fill the frame for the best composition.

PHOTOGRAPHY at indoor events such as concerts and stage productions (where it is permitted) has become very popular. It is quite common to see many members of the audience at a pop concert, for instance, carrying cameras, obviously with a serious intention of producing pictures.

The informality of something like a pop concert makes photography possible provided that the promoters do not object. On the other hand there are occasions where the sound of a camera would be intrusive, and spoil other people's enjoyment. It is always preferable to obtain permission beforehand. This will not only avoid problems later, but may also result in greater freedom – the opportunity to shoot from the wings, for example.

Working with colour film under stage lighting can be a problem since the colour quality of such lighting is almost impossible to assess – and it is also changed many times during a performance. Stage lighting is usually created by mixing heavily filtered light from many different sources and there are often multi-coloured shadows and highlights. As it is the over-all effect of a picture that is of prime importance, rather than any attempt to achieve a faithfully accurate image, the choice between daylight or tungsten film should be based on this objective.

Since it generally will be found that a picture with a warm bias is more acceptable than one with a blue or green cast, it is often preferable to shoot on daylight film. The fast films, such as Kodak Ektachrome 400 ISO, tend to have a greater tolerance to different colour qualities of light, and so can be a good choice.

The brightness range of stage lighting can often be very high, and this will make the assessment of exposures a difficult matter – especially as the light sources themselves frequently appear in the picture area.

With a camera that has an integrated centre-weighted meter it is usually sufficient simply to ensure that no light sources or excessively large areas of shadow are included in the picture area while the reading is made. A zoom lens can be a considerable asset in composing a well-framed picture and because it is possible to zoom-in to take a close-up reading of a small area, and then pull back to take the picture.

A method which can be used effectively in high contrast situations where close-up readings are not possible, is to take an average by aiming the meter at both the brightest part of the image and then at the darkest area. By taking the average between the two extremes it is possible to obtain the correct exposure for the mid-range.

It is important to be aware, however, that high contrast lighting will produce an image that is beyond the acceptance of the film, and although it is possible in black and white work to reduce contrast during processing and at the printing stage, there is no comparable technique with colour. In these circumstances it is necessary to sacrifice the detail in either the highlight area or the shadow area in order to obtain a satisfactory range of tones in the other.

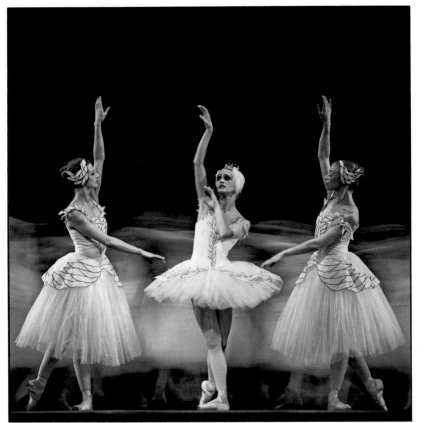

The strong lighting used for television performances – such as the BBC show 'Twigs' (top) – can be ideal for still photography, but care must be taken that the exposure reading is not influenced by direct light.

A friendly approach to the management may give you an unusual viewpoint, as in this photograph of a stripper (above). The extreme contrast between the direct spotlighting and the dark auditorium conveys what the performer sees, rather than the usual audience view.

For an accurate rendering of a colourful stage setting, such as this scene from 'Cinderella' (left) a tungsten film is necessary. A scene that includes a large number of the cast is more likely to be evenly lit over the whole area than if only one or two actors are on the stage, and this will also make exposure judgments easier.

FASHION & BEAUTY PHOTOGRAPHY

A VERY LARGE PART of the photographic industry is involved in producing images which are more concerned with projecting a fantasy rather than a reality – 'selling the sizzle rather than the sausage' – particularly when recording and creating the trends and fashions that colour our lives.

Not surprisingly this is the field to which is attributed the most glamour, often depicted in the media as hardly being like work at all. The truth is that a great deal of effort and expertise is required to produce fashion and beauty pictures, and the methods and techniques that are used need to be as finely controlled as in any other field of photography.

Although any competent photographer can occasionally produce a picture with a touch of magic about it, to do so tomorrow afternoon at half-past two, come rain or shine, often with a dozen or so very critical people waiting to see the results, is a different matter.

The photographic model is a key element in this type of work, and the process of finding, organising and supplying people for photographic sessions has become a large international business. The model agency is responsible for the initial choosing and vetting of potential models, and in many cases agencies specialize in models of a particular type – fashion models for glossy magazines, those who look a little more ordinary for mail-order catalogues, or in children, or older 'character' types and so on.

The model agencies provide their models with the names of photographers, art directors and fashion editors, and they are encouraged to make personal visits ('Go Sees'), taking a portfolio of pictures and leaving a composite card containing a few pictures, personal measurements and any special abilities, such as horse riding or water skiing. The larger agencies also publish books or large posters called head sheets which show all the models they represent.

Many agencies encourage new, less experienced models to arrange test sessions with a photographer for which they do not receive a fee but are given a selection of pictures for their portfolio. This enables both the photographer and model to experiment and to build up their portfolios with the minimum cost. A new model and a new photographer can even start successful careers simultaneously.

Fees vary considerably from country to country, for the type of work, the purpose of the photograph, and even from one model to another. They are usually based on an hourly or daily rate, although a longer assignment may have a negotiated fee. The model may be expected to supply a basic wardrobe with a reasonable choice of style and colours, but all special clothes or other requirements are bought or hired by the client or photographer. The model is also expected willingly to do whatever is necessary for the shot, whether that means getting up at four in the morning or jumping into an ice-cold sea in the middle of winter – and to look relaxed and happy doing so, while also being able to repair the damage and look good for the next shot as quickly as possible.

A good, successful model must be as professional and dedicated as the photographer, and just as concerned about the results. An attractive physical appearance is only one of the requirements of potential models – it is how good they look in a photograph that is important, not how good-looking they are.

From a colour transparency by James Wedge, for a Mamiya advertisement.

Make-up for photography

THE MAKE-UP that a model applies for a normal photographic session is rather different from the make-up she would use for simply going out. The main requirements for photography are a smooth and blemish-free skin, with a matt surface that will not create unwanted highlights, and a clear definition of the eyes and mouth. The required appearance usually demands a heavier hand in applying the make-up than would normally be used.

The main purpose of fashion and beauty photographs is to be reproduced in magazines or books, and the process of printing can easily cause a loss of fine detail – therefore it is vital that the print or colour transparency has as much definition as possible. Clearly defined features are particularly important in three-quarter or full-length shots where the model's face occupies only a small proportion of the image.

Most professional models are quite experienced in applying their own make-up to produce a normal, every day effect in a picture, but it is important that the photographer should be able to judge it critically in relation to the shot, the film and the lighting. A close-up head shot, for example, requires the make-up to be applied rather more softly than for a full-length shot – it is best to err on the side of discretion with close-up pictures, particularly where a soft frontal light is used. Lipstick colour and eye-shadow need to be considered carefully in conjunction with the colour of the clothes, fashion accessories and the backgrounds.

Most models like to use a little blusher or shading to accentuate their cheekbones, but this can also create problems – particularly with colour film. It is essential to judge the result very carefully under the lighting conditions you will use for the shot in case the effect is exaggerated. It is a good idea to use instant film to check the effect of shading because film can sometimes produce a colour difference which is not visible to the eye, and what looked like delicate shading can come out as a brownish smudge.

If in any doubt, and if the model is not very experienced, it is far safer to restrict the make-up for anything closer than a three-quarter-length shot in colour to a neutral toned matt base, with eye liner, mascara and lip colour lightly applied simply to give a little more bite.

When shooting in black and white it is important to remember that normal panchromatic film is sensitive to red. A bright red lip colour may appear as a dark tone visually but will record dark on the negative and therefore be substantially lighter on the print. For this reason it is preferable to use a colour which is either darker than you might think necessary or one that has more blue in it, such as a deep pink, when you want the lips to record strongly.

 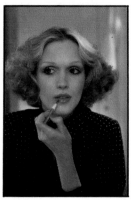

All these preparations are concerned with creating a 'normal' effect where in fact the viewer is not aware of the make-up. But there is considerable scope for those with experience – or the will to experiment with elaborate make-up, wigs and lighting – to produce pictures with quite amazing effects.

The range of products available from ordinary cosmetic stores is wide enough to provide a wealth of ideas and these can be supplemented by make-up stocked by theatrical or art material suppliers. Professional photographers use make-up artists for any picture that requires special treatment, but if you and your model are prepared to invest a little time and patience, imagination becomes the only limiting factor.

A young unblemished skin (top) needs no more make-up than a little powder to dull unwanted highlights, and slight lip colouring for a pleasantly natural look.

Eye make-up, cheek shading and lip colour can usually be applied by the model herself (above).

In some pictures, like this stunning photograph by Stuart McLeod for 'Now!' magazine (right), the make-up can dominate the composition. The toneless make-up was emphasized by strong front lighting.

Choosing clothes

Most models would include a white dress in their wardrobe (left), and one has been chosen here in order to emphasize the girl's tanned skin. The choice of a white wall as a background ensures that there is no distracting element.

In fashion photographs, the clothes should select the setting (right) – unless some shock element is required. A setting of stables for the model's casual riding clothes helps the viewer to form an opinion on the appearance of the clothes.

Every girl has a selection of casual clothes. In a suitable outdoor setting, such as against an old barn door (above), and with informal or exaggeratedly casual poses, even the tattiest clothes can help create an attractive picture.

WITH THE EXCEPTION of head-only photographs, the clothes that a model wears will be an important element of the picture. Unless it is purely a fashion photograph, where the garment is the principal reason for taking it, the clothes must be chosen with care so that they contribute to the effect of the image.

Most models tend to collect a wide assortment of clothes and accessories for this purpose, and it is always worth discussing with them beforehand the ideas that you have and the type of picture you want to produce so that they can suggest suitable items to bring to the session.

Professional photographers often use a stylist to help with this selection, especially when the type of clothes needed are unlikely to be found in a model's wardrobe. Quite apart from being able to visualize from a verbal brief the type of garments needed, a stylist is also able to know where the clothes can be obtained, and will have a mental inventory of a number of suitable suppliers and fashion houses.

If a shot is being taken for another company's advertisement or brochure, clothing suppliers are often prepared to lend garments free of charge – it is considered a useful method of promotion when the picture will be seen by a wide audience, and sometimes it is possible for the supplier to be credited in the copy. Obviously a photographer who is taking pictures for his own pleasure or speculatively will be unlikely to obtain such co-operation, but often it will be found that small

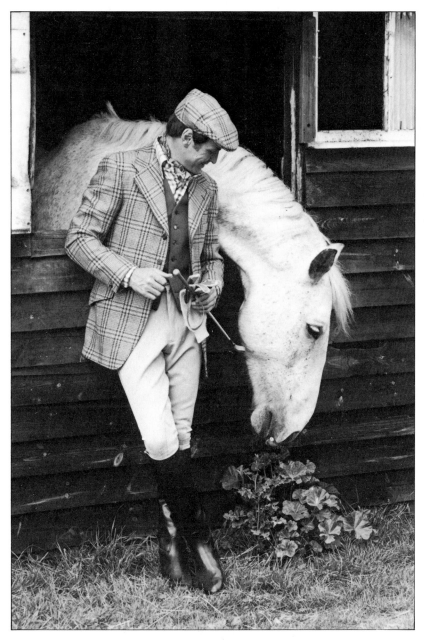

independent boutiques will lend clothes in exchange for a few enlargements to display in their shop window.

Other possible sources are the theatrical rental companies who have a wide range of clothes, from period costumes to exotic modern creations designed for film and television productions. An advantage is that these are available on a weekly-rental basis, which saves having to buy expensive clothing. There may, however, be a limitation on available sizes.

The actual choice of the clothes will naturally be dependent on the mood and colour quality of the image that you want to create, but, as with all aspects of photography, it is the way they will appear on film that is important. It is not even

necessary in some circumstances for clothes to fit perfectly, as long as they can be made to look right for a specific picture. In fashion photography for example, seams are frequently split open to get a better line, or garments are pulled in at the back with clothes pins to make them fit tighter.

In addition to the clothes, accessories can be used most effectively to add a little extra to a picture. Hats, scarves, shoes and jewellery can all on occasion provide the vital detail that makes all the difference to a picture. A good model who understands what the photographer is trying to achieve will usually be able to come up with just the right accessory, and her involvement and enthusiasm in the session can make all the difference to the success of the pictures.

This fashion shot (top) uses a simple but evocative country setting to emphasize the visual quality of the clothes and to create a suitably sultry mood for the gipsy-inspired fashion.

Often the most successful photographs come from the most straightforward compositions. A simple white dress, a dark toned contrasting background and a beautiful girl (above) were all that were needed for this picture.

Directing the model

THE RELATIONSHIP between photographer and model can be quite varied and sometimes complex; but if a picture is to stand any chance of being more than simply a picture of a person, then it is vital for a genuine rapport to develop between photographer and model, if only for the few minutes or seconds required to make the crucial exposures.

Modelling is an occupation that has to be learned and developed through experience, just as photography is, and while many people believe that anyone can be a model this is certainly not true. Most people are in fact unable to relax and project even their own personalities in front of a camera, let alone spontaneous expressions or the image of some figure of fantasy.

It is probably true to say that a successful model is someone who has learned how to master such projection with a large number of different photographers, but it is still possible for her to fail to perform well if she has to work with a photographer who cannot provide the right atmosphere, or if the situation is wrong for her. However, it is equally true to say that while you may be able to take beautiful pictures of the girl next door, a professional photographer may not be able to.

It is also important to remember that models do not suddenly stop being human beings – like most people they also are capable of feeling vulnerable in front of a camera, and need to be encouraged and made to feel that they are 'looking great'. The constant patter of the fashion photographer, 'super . . . super . . . great', etc, is not an affectation but a frequently effective means of spurring on and encouraging someone who is making a vital contribution to his pictures – and also to his reputation as a photographer.

Directing a model is primarily a question of creating an atmosphere in which the model is able to relax and project the feeling that you need for your picture. Although the composition and the lighting will impose some restrictions on the way a model moves and reacts, it is best to avoid the use of very specific directions. These are sometimes unavoidable, of course, especially in very tightly cropped shots, but in most great pictures the button is pressed at the moment when some quite spontaneous reaction occurs.

It may be a flicker of an expression or the movement of an eye that 'makes' the photograph, but directing a model should be so done as to allow spontaneity, rather than making the model strive slavishly for a picture you have in your imagination. An experienced model, or someone you have developed a good rapport with, often will know instinctively what you require, how to move and when to turn or to smile, and will need little more than the sounds of ecstatic approval and a steadily firing camera to keep going enthusiastically throughout the modelling session.

110

A picture like this requires a genuine and spontaneous effect (left), and a posed situation would never achieve the same quality. The model's personality becomes as important as her looks, and her ability to involve herself in the session is essential.

For this picture the model was asked to adopt a slightly sad, lonely expression (left). This is not the sort of response that you can create in a natural way, therefore the photographer is dependent on the model's ability. The composition of this studio shot was aided by placing a sheet of glass, sprayed with water, in front of the model, and a slightly blue cast adds to the effect.

A model needs to feel that she is pretty and alluring if the photographer aims for that impression (right). So the clothes she wears, the setting that is used, and the photographer's attitude are important elements in creating a suitable response.

When a particular pose is required (above), rather than an expression or mood, more specific directions are likely to be necessary. Even then, a good model will alter her position or expression almost imperceptibly between each picture that is taken.

111

Working with more than one model

Directing two or more models can cause confusion, and it is better to give a general instruction to the group, and to shoot a greater number of pictures than you would with only one model. Involving them in an activity (above) is one way of ensuring that they are less conscious of the camera, and are not waiting for the photographer to take a shot.

Composition can become complicated with a group of models, especially when you want a fairly close shot, but this tightly framed picture (right) shows a successful approach. Less is shown of the model in the middle than of the other two, but by having her looking directly at the camera instead of away from it, she becomes almost the dominant figure.

WORKING WITH MORE than one model can present a different set of problems, because quite often it is the relationship between the models themselves that becomes more important. The photographer must concentrate on establishing a situation in which the models can relate to each other. In a picture of a single model the purpose often is to enable the viewer to identify with the person illustrated; but usually in a picture with two or more models it is the situation that the models are establishing which the audience is invited to identify with – this may be two people walking along a beach (for a holiday brochure) or a crowd of people in a bar (for a beer advertisement), and so on.

Directing a large group of models in a setting is in principle not unlike directing a film – with the important and welcome difference that the scene has to work convincingly for a fraction of a second only, and that there is no need to worry what sounds are being made. In many ways directing a group of models, or even two, can be easier than working with one model because you are dealing with something much more tangible than the rather tenuous model-photographer relationship in single model circumstances. Two or more models are more easily able to relate to each other and identify with the roles they are playing and with the situation they are creating. The photographer and the camera also tends to become less dominant for this reason, and therefore it is much easier to work with ordinary, non-model people in situation photography, providing the setting is one with which they are familiar.

One new problem created when two or more models are working together is that the photographer has to be aware of the facial expressions and gestures of several people at once, whereas with a single model it is possible to be aware of the slightest change of expression, and of movements of the head and hands and the effect this has on the lighting and the composition of the picture.

Although it is possible to scan the image rapidly through the viewfinder, the chance of one of the models being caught with an awkward gesture or an unsuitable expression increases in proportion to the number of models in the shot. Generally it will be found that it is necessary to shoot more film than you would for a single shot, to ensure that allowance is made for some pictures being spoilt by not everyone being quite 'right'.

In many locations, and especially in the confines of a studio, there will be considerably more restrictions on the freedom of the models to move at will. Not only can the composition be changed drastically by too great a movement of one model in relation to another, but there is the danger of lighting stands, ceilings, background supports, etc, encroaching on the picture area.

A photograph such as this (above) is almost a double portrait, and by placing the two models close together it is easier to judge when both their expressions are suitable. The whole atmosphere of a photograph is changed by having two models, however, because the image becomes one of a situation rather than simply a scene.

A dramatic lighting effect is more difficult to achieve when more than one model is being photographed, but in this effective picture (left) it has been managed by having the models so close together. Keeping the models close to each other and restricting their movements will simplify lighting problems.

Creating background effects

Various materials can be used in a number of ways to add interest to indoor photographs (above). In the top picture a fine net was suspended in front of the model. Different effects can be obtained using coarser or finer nets, and by adjusting the lighting. Stage effects often make use of this technique – by front lighting the net and not the person behind it, and then gradually switching the lighting over, the person can be made to 'appear'. In the bottom picture the crumpled aluminium foil reflects brilliant highlights, and provides an interesting contrast with the model's skin.

WHILE PLAIN **colour paper rolls provide a convenient and relatively unobtrusive background tone for many pictures, there are often occasions when something more interesting and contributing more to the picture is called for, but when an outside location is not possible or convenient.**

The simplest way of creating a more exciting background is by lighting. The paper rolls can be used to provide a basis for a wide variety of effects, and the most straightforward way is to create pools of light or tonal gradations by directing one or more lights from behind the subject onto the background. A spotlight is ideal as it can be adjusted to give a finely controlled circle of light, or alternatively a lamp fitted with a snoot can be used. These lamps can be hidden on a small stand behind the model in fairly closely framed shots or, as in a full-length picture, they can be suspended from a boom above and behind the model's head and aimed down to the backdrop.

With colour shots the possibilities can be greatly increased by using coloured acetates or gels over the lamps, and a slightly different quality can be given to a plain background by lighting white paper with coloured background lights, instead of using coloured paper. It is of course vital to ensure that there is no spill from these lamps creating unwanted effects on the subject. The use of coloured acetates or gels tends to have a more pronounced effect on the film than appears visually, so it is best to make some test exposures, or to check the result with instant film, particularly when a fairly subtle result is required.

A method of producing a more elaborate lighting effect on plain paper is to project a light pattern on to the surface. This can be done simply by cutting out a pattern in a large sheet of black card and positioning it about half way between the background lamp and the paper. A small hard light source, such as a spotlight, is best as this produces a more strongly defined pattern, with sharper shadows. To increase the effect it is necessary to shield the background from stray light spilling from the main subject illumination.

A more elaborate technique is to use a slide projector to illuminate the background, and to make high-contrast slides of the patterns you want to project by photographing a painted design or by drawing a pattern directly on to a piece of clear film. A fairly high-powered projector is necessary, and the effect will be easier to judge and control if the subject is lit with tungsten light – in colour photography it would not be possible to mix flash with the tungsten-powered projector without causing a colour distortion.

A much more lively effect can be created by using fabrics with a reflective surface and combining this with background lighting. Sheets of glossy plastic are easily and cheaply acquired and they can be stretched over a wooded frame, or simply allowed to drape loose from a cross-bar, with folds and creases 'teased' into them to create highlights and shadows.

Another fabric which can be used in a similar way is aluminium foil, which can be used smooth or crumpled to produce specular highlights. This – as with any other fabric which produces small bright highlights – can look very effective with a cross screen or star-burst filter over the camera lens. A variation on foil is to use a metallic spray paint on old paper rolls, first crumpling the paper and then spraying it gold or silver.

Almost anything with an interesting surface or texture can be used in this way. Old egg boxes stapled to a board, for example, and then painted and lit to create shadows can produce an interesting textured background. Another simple method which has been popular with fashion photographers is to cover a wall-flat or a large board with a stipple-effect wallpaper, and then to paint it with high-gloss paint. When this is lit with a fairly hard light from close to the camera position it can produce a bright, sparkling background with an interesting gritty quality. It can look equally effective in black and white, and it is often used with the model positioned right up against the surface. Both ring-flash and star-burst filters can be used to heighten the effect.

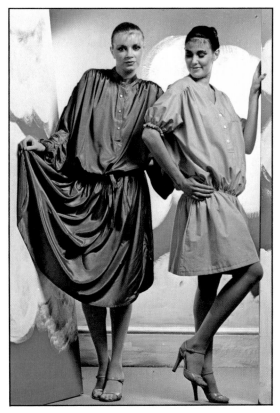

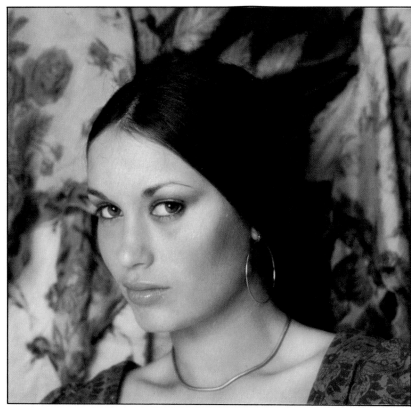

Wall flats and sheets of paper – or even walls themselves – can be painted boldly (above) to create interesting backgrounds, and not much artistic skill is needed. You should always judge your efforts through the camera lens, and remember that the background will often be slightly out of focus.

The rich textures, colours and patterns of many materials can form ideal backgrounds (above right) but they should complement the subject, and not distract from it.

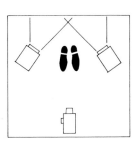

The diagram (above) shows how acetates or gels on two lights were used to colour a fairly reflective background (right). Background lights must be positioned to avoid any clash with the effect of the main subject lighting.

Shooting a model composite

This model composite (two sides of the four-sided composite are shown above) used pictures that were all taken by the same photographer, and indicates the model's range by a variety of poses. Whenever possible it is a good idea to show a publication that the model has appeared in – provided, of course, that it is not recognizably very old, and that there is not the risk that typecasting will jeopardize new work.

THE COMPOSITES **or index cards which models give photographers as references for selection and reminders are very important to them. One of the problems that models have when they begin their careers is to accumulate a good selection of photographs for this purpose – and later they periodically need to update the composites.**

The ideal method is to collect a number of pictures from assignments that they have worked on; this gives a wide variety of pictures taken by different photographers, with different clothes, lighting, locations and situations – and it helps if some of the pictures have been used in advertisements or magazines.

This, however, can take a long time, particularly when a model is a beginner, and quite often a photographer is asked to take pictures specially for a composite, either as a test session or as a commission. It can be a good way for an inex-

perienced model and a photographer who is trying to become involved in model photography to produce work for their portfolios, and most model agencies will put models who need pictures in touch with photographers who are prepared to work on this basis.

There are a number of requirements which a composite should fulfil, and as it can be helpful for a test session to have an underlying motive it is a good idea for the photographer and the model to sit down together beforehand and work out ideas. A card should have at least one good, fairly close head shot with the hair style normally worn by the model, and photographed in such a way that it gives a good indication of the model's natural look. If the model is going to the expense of having at least one side of the card in colour, then this picture is best shot in colour as hair, skin and eye colour are among the most important factors in much model selection.

There should also be a good body shot, one that will give a prospective client a fair impression of shape and proportion. Naturally the pictures on a card should be produced so that they show both the model's and the photographer's ability to the best advantage, but pictures which deliberately misrepresent a model will ultimately waste her time, as well as that of other photographers. The body shot should be three-quarter or full-length, and the model should normally wear a bikini or lingerie. If the model is intending to do nude or topless work then obviously one shot should be done in this way.

For normal photographic work some attempt should be made for the card to have a reasonable variety of fashion styles – something quite casual, jeans and a T-shirt perhaps, and something fairly sophisticated, such as evening wear.

A good variety of expressions is also important. A series of shots with the same expression, no matter how good or different they are in other ways, can limit the model's appeal to prospective clients; although she will make personal visits and attend casting sessions, it is the composite that will provide the most lasting reminder.

It is also quite important for a girl model to include a variety of hair styles as the ability to alter her appearance can be quite important for many assignments, particularly on jobs of longer duration, like trips abroad. Although the card should attempt to give a good general impression of what types of image a particular model is capable of projecting, it is also important fully to exploit any special qualities, such as a really good body, nice hands or legs.

If the pictures on the composite are to be taken by only one photographer it is advisable for him to vary his technique and style as much as possible – as well as being helpful to the model it will also provide an interesting challenge for him.

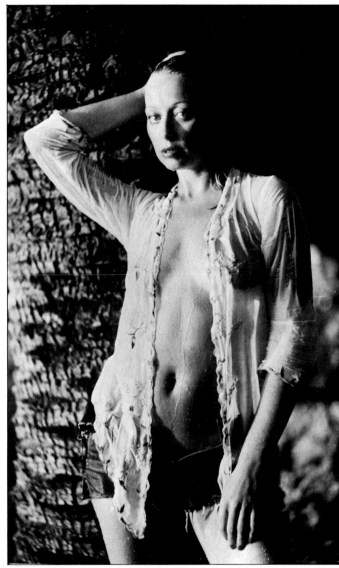

These two pictures (above) are the sort that a photographer might take to build up a selection for a model's composite. The photographs ideally should cover outdoor, indoor and studio locations, and any special features, such as long hair, good legs or bright, even teeth should be emphasized. If the model does nude or semi-nude work, one photograph at least should show her figure to advantage.

Every model dreams of being a cover girl, so a shot such as this is a natural choice for a composite (left). The copy on composites is usually limited to the model's measurements and the agency's name and address.

Louise Scott

Height 5'7½
Bust 32 Waist 24 Hips 34
Shoes 5
Hair: Light Brown Eyes: Blue

Grosse 1.71
Oberweite 81 Taille 61
Hufte 86 Schuhe 38
Haare: Hell Braun Augen: Blau

«SELECT»
MODEL AGENCY
100 Baker Street London W1
01-486 9296

Choosing & using locations

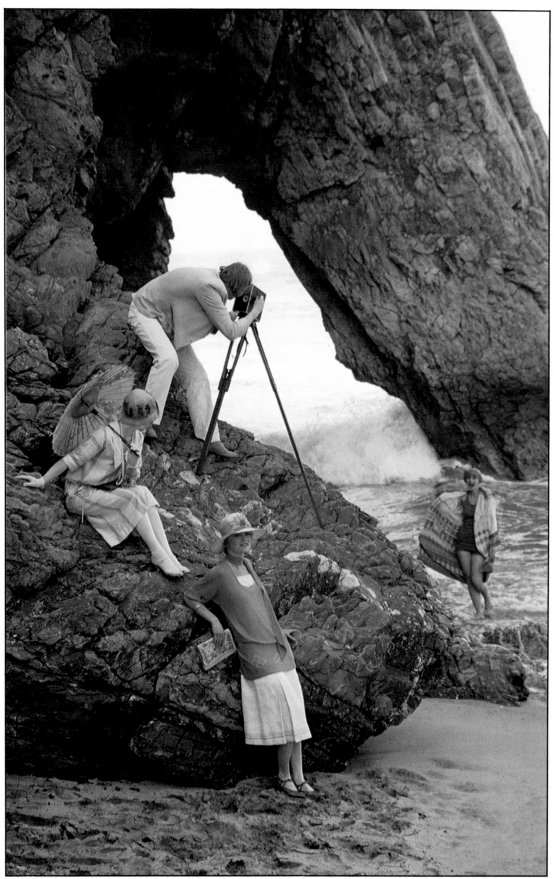

The Kodak centenary calendar's June picture by Andreas Heumann was given a 1923 atmosphere by the choice of the models' clothes and accessories – and the inclusion of the first amateur movie camera. There is a pleasant colour harmony in the image, but the striking location, near Sintra in Portugal, plays a dominant role in the composition.

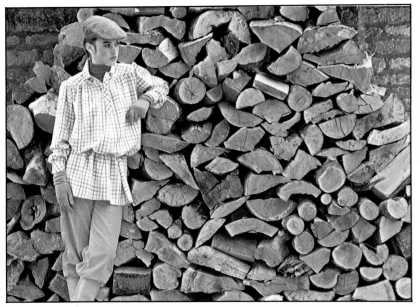

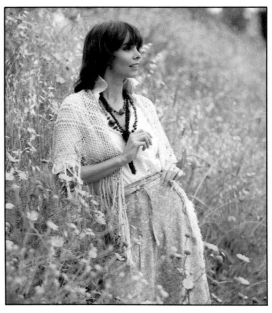

These two pictures (above) are good examples of the countryside providing different opportunities for settings within a very small area. A well-chosen location of this type can provide enough settings for a day's photography without moving far.

WHILE THE STUDIO provides a convenient and controllable method of working, and it is possible to construct settings and hire props, there are many pictures that simply have to be shot on location. Quite apart from shots which need sea and sky, there are many occasions when a picture that requires only a small area of vague background will still be better for being shot on location. Finding the right location can be the key factor in the success of such photographs.

The value of reconnaissance cannot be over-stated. People you know will often give advice and recommend places they have visited, but it is very unwise simply to arrive on the day with the models without having made any prior investigation and made sure of any necessary permission. The basis on which you choose a location will of course depend on the pictures you want to produce. It may be, for example, that you have a specific idea for one particular shot which you then may be able to do in a couple of hours in the right setting; on the other hand you may need a location to provide a variety of possibilities and to stimulate ideas for a whole day's shoot or even longer.

Some pictures may need only a suggestion of background detail to create the right ambience, whereas another type of photograph might call for the location to be seen in detail. Professional photographers often use a specialized agency or a stylist to help find the right location, but it requires only a little time and effort (which they often cannot spare) to find your own.

Apart from the suitability of the place as a setting, you should also look at it from the point of view of lighting to see if daylight will be adequate and if you will need to take reflectors, diffusers or additional lighting – in which case you should check the availability of a power supply. When working with models it is also important to see that there will be a convenient place to change clothes and make-up, and possibly somewhere to plug in hair rollers.

If a countryside location is being used it can also be helpful to make sure that you can take a car close to the spot you intend to use, partly to avoid having to carry equipment and clothes, but also because the car can be used as a base for the models. For a full day's shooting, it is also important to make provision for refreshments and other creature comforts, as hunger and thirst can quickly dampen enthusiasm and dull the creative impulse. Even a flask or two of coffee and a simple picnic lunch can ensure that the ideas run out before the enthusiasm does.

There can be many things to remember to pack and take on a location session – camera equipment, lighting, props, etc – and it is an excellent idea to make a check list beforehand of everything you may conceivably need, and to check each item on the day as you load the car. If it is an important session, and if you will be travelling some distance, it is highly recommended that you take two of everything vital – camera bodies, exposure meters, sync-leads for flash, spare bulbs and batteries, etc – and it is also useful to have plenty of pins, clips, rolls of adhesive tape and anything else you tend to take for granted at home, and make sure that your models are equally well-prepared.

When you are taking a number of different shots under varying conditions it is important to keep a close check on your exposed films. Identify them by writing a number on each roll with a marking-pen, and put them somewhere safe and light-tight until you get back. This makes it easy if you later decide to make clip tests.

119

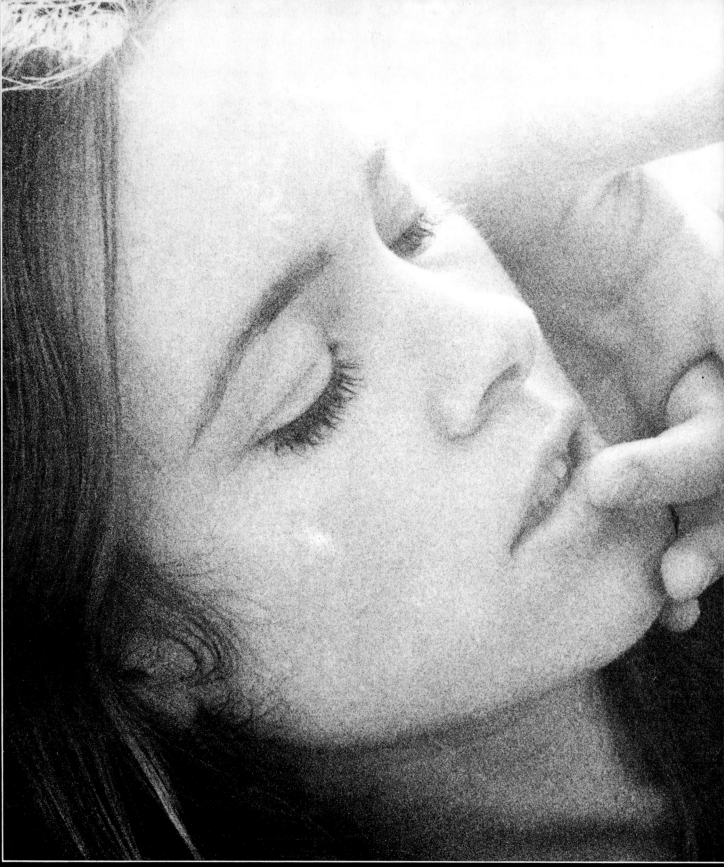

SPECIAL EFFECTS

THE FASCINATION of the very first photographs was largely due to the novelty of having images which were so like reality. While this is still the most common use of photography – capturing images that appeal, so that we can enjoy them again and again – no photographer is ever content simply to be a recorder. The creative use of the camera is, in fact, its most enduring appeal.

The combination of curiosity, artistic talent and technological development has enabled the modern photographer to create an enormously diverse range of effects with a camera, as we see throughout this book. But there are also occasions when special effects are specifically created for themselves – the special effect becomes as important, sometimes even more important than the subject.

Very often these special effects can be achieved easily and cheaply, as with the soft-focus effects given by a little petroleum jelly on a filter, at other times special effects can be achieved through the use of special lenses, filters or films. With imaginative use – and some restraint – they can add considerably to a photographer's range of expression.

Grain effect, by Michael Busselle

Films for special effects

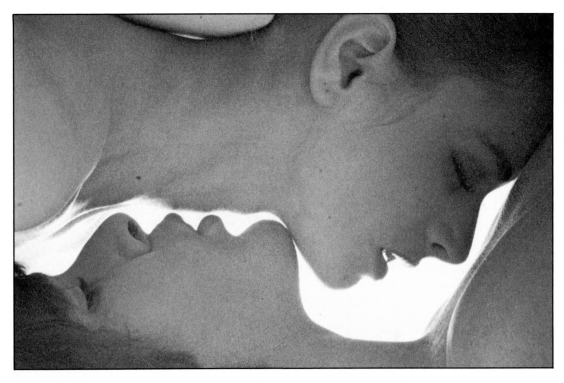

Although grain effects are more frequently found in black and white photography, they can be just as attractive in colour (left). You need to use a fast film (400 or 500 ISO, if possible) and to rate it two or three stops faster when taking the exposure reading – then ask the laboratory to increase the speed correspondingly in processing.
Nikon F2 with 105mm lens; f11 with bounced studio flash; Ektachrome 400 rated at 1000 ISO.

Andreas Heumann superbly captured the 'Swinging Sixties' atmosphere in this extremely colourful picture for 'October' in the Kodak Centenary calendar (right). The lighting used in Heumann's studio was solely ultra-violet light (colloquially called black light) and he used two ultra-violet filters on daylight film. The materials for the clothes and for the angular, repetitive set (designed to suggest the music of the period) were chosen for their fluorescent quality. The glowing make-up on the model's faces was a fluorescent powder on an oil base.

THE CHOICE OF FILM can have a marked effect on the quality of an image, and it is possible to harness the characteristics of individual emulsions and to use them to create pictures which are far removed from a conventional photographic record of the subject.

One way of achieving this is to make use of the process by which the film is manufactured, and to use the grain structure of the photographic emulsion as an element of the image.

This technique can be used effectively both in black and white photography and in colour. Kodak make a black and white film listed as Kodak Recording Film 2475; this has an initial speed of 1000 ISO but it can be increased in processing to over 3000 ISO, resulting in a very pronounced grain with an attractive, gritty texture.

Overrating and push-processing significantly increase image contrast, so it is advisable to light the subject in such a way as to produce a low brightness range, otherwise an excessively contrasty picture will result.

When you intend to make enlargements it is an advantage to keep the subject of your picture quite small in the frame as this will enable you to enlarge to a greater degree, which will considerably enhance the grainy effect. It is vital, however, that the print is perfectly sharp, as otherwise the grain will have an unpleasant, woolly quality.

Infra-red film is available in both black and white and colour emulsions. The black and white version can be used with a red filter to produce pictures where the tonal range of the subject can be drastically altered. For example, in a landscape photograph the sky will record as nearly black and the foliage as white.

Infra-red colour emulsion produces images which bear little resemblance to the colour content of the subject. The effect can be considerably varied by the use of different filters, and there are limitless possibilities for those who are prepared to experiment. It should be noted that infra-red radiations are focused at a slightly different point to the visible spectrum; this is not critical in the longer focusing range provided that a small aperture is used to ensure adequate depth of field, but at close distance one should use the alternative focusing mark provided on most lenses.

Although it is not necessary to use special film, it is possible to make use of ultra-violet light under studio conditions. This can be done by using an ultra-violet lamp of the type found in the theatre, and by choosing clothes or paints which have fluorescent characteristics. These can be easily identified simply by directing the UV lamp at potential props or clothes – those that contain fluorescent dyes will be seen to glow.

It is of course necessary that the UV lamp is either the sole or the dominant light source so it is necessary to work in quite subdued lighting. Exposures of probably several seconds are usually required, and this is dependent on the nature of the dyes, the power of the lamp and its distance from the subject. It is wise to make some experimental exposures and you will need to use an UV filter over the camera lens, combined with daylight colour film.

Infra-red film can be used in the dark with an infra-red light source to record images that are invisible to the eye. Used with daylight or artificial light, however, the colour version produces strange and often attractive effects (above middle). In the top picture the scene has been recorded on ordinary colour film, and for the bottom picture, also recorded on infra-red film, an infra-red filter was used.

Lenses for special effects

ONE OF THE ADVANTAGES **of modern camera systems is the wide range of lenses which are now available to the photographer, resulting in a variety of effects which can be created by exploiting their characteristics.**

The most straightforward way of using lenses to produce more dramatic images is through their ability to create strange or unfamiliar perspectives. This is sometimes described as distortion, but with the exception of specially computed lenses, such as the fish-eye, it is simply the combination of an unfamiliar viewpoint and an unexpected perspective that creates the unusual pictures.

The wide-angle lens, for example, enables a photographer to approach his subject extremely closely, and still be able to include most or all of the image in the frame. An extreme wide-angle lens, such as 18 mm or 20 mm on a 35 mm format camera, can create quite bizarre images when used in this way. The effect will be increased by the choice of viewpoint – a very low or very high camera position, for example. A full-length figure shot from close-up and from above the head will look very strange indeed.

A long-focus lens can be used to create the opposite perspective effects. A very distant viewpoint and a lens of a focal length long enough still to give the impression of being close to the subject produces images with an unusual visual quality, particularly when different parts of the image are placed in unexpected juxtaposition.

The fish-eye lens is designed to give an angle-of-view of 180°, producing a circular image in which any straight lines in the subject are depicted as progressively increasing curves the farther they are from the centre of the image. This effect, combined with the exaggeration of perspective which is obtained from a lens of extremely short focal length, produces an image similar to that seen in circular convex mirrors. This type of picture is so obviously contrived that such equipment needs to be used discreetly and sparingly, and with subjects which genuinely lend themselves to such treatment, otherwise the result is likely to be seen as pure gimmickry.

The zoom lens can also be used to produce an unusual and interesting effect, in addition to its usefulness and convenience. By framing and focusing on the subject with the zoom set at the longest focal length, it is then possible to create blurred streaks radiating outwards from the central image by moving the zoom forward to the shortest setting during the exposure. This is best carried out with the camera mounted on a firm tripod, as an exposure of $\frac{1}{4}$ sec or longer will usually be necessary; it is most important to carry out the zooming operation as smoothly as possible. This technique is much more effective when you have a light toned or brightly coloured subject against a darker background, and a background of varied tones will produce a streaky effect.

This illustration (below) shows some of the more unusual lenses which give effects that are considerably different from those experienced by the human eye. They are (clockwise, from top left): a 400mm telephoto lens; a 500mm mirror lens; a 15mm wide-angle lens with 110° angle of view; a 20mm wide-angle lens with 94° angle of view; an 8mm fish-eye lens with 180° angle of view (a disc in the lens body accomodates a filter).

A 15mm lens is an extreme wide-angle lens. The closer the subject is to a lens of this type, the greater is the apparent degree of distortion (below right), accentuating the part of the subject that is nearest the camera – as in this photograph of a scholar, where there is apt emphasis on the head.

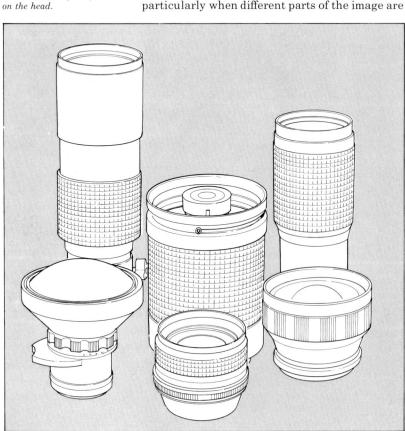

With a fish-eye lens, the most notable effect, apart from the very large area covered, is the barrel distortion of all straight lines (left). The effect becomes more pronounced in lines that are closer to the edge of the frame, as can be seen in this photograph taken in London's Downing Street.

An extreme long-focus lens creates a marked foreshortening of perspective, and this can result in strange juxtapositions, such as a ship appearing to be almost on top of bathers in the sea. In this photograph (below left, from a colour transparency) the people seem to be only a very short distance from the antelope. The circular highlights are given when a mirror, or catadioptic, lens is used.

Apart from its conventional advantages, a zoom lens can be used for creating its own special effects (below). It requires an exposure of about ¼ sec, so ideally the light should not be too bright, and you should use a slow film and mount the camera on a tripod. Focus the subject at the lens's longest focus setting, then during the exposure move the zoom control to its shortest setting. If there is no camera movement, the centre of the image will stay comparatively sharp.

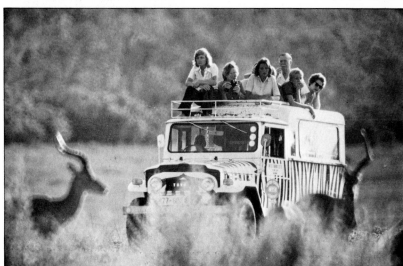

The multiple image

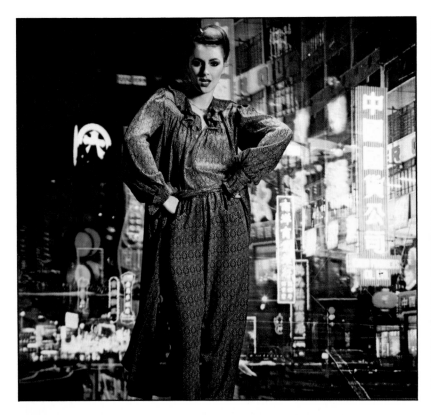

ONE OF THE RESTRICTIONS of photography as a creative medium is that it can be too literal. Techniques that produce images in which the photographer has had more control over the content and construction often can enable him to make a more personal statement. One of the most versatile of these techniques is to combine two or more separate images on to one piece of film.

Some multiple image pictures are achieved at the printing stage, but there are a number of techniques which can be employed to produce multiple images in the camera.

The most straightforward method is by simply making a double exposure. While it is obviously preferable to use a camera which enables two or more exposures to be made without advancing the film, it is possible, but very difficult, to run the film through the camera twice after carefully marking the start position. The process, by either method, involves the careful juxtaposition of images so that the second or subsequent images do not erase or unduly confuse the first.

One way of achieving this is to ensure that one of the images is more dominant than the other. This can be done most easily by exposure or by tonal contrast. If, for example, you wish to superimpose an image of a nude girl on to a textured fabric, such as a piece of sacking, using a fabric of the same tone or colour as the model's skin will result in an image where the details of both elements are lost. If, however, the fabric is of a

much darker tone than the girl, or if it is given proportionally less exposure, the result will be a picture where the image of the girl is shown fairly clearly against a textured background.

The difficulty of double exposures is that the effect is neither visible nor totally predictable at the time of exposure. A method which enables the effect to be judged is to use a small piece of glass. A square of thin, blemish-free glass, about 10 in (250 mm) square, should be positioned quite close to the camera at an angle of 45° to the main subject-camera line. The second element of the picture should then be positioned at right angles to the camera, facing the obtuse angle of the glass and at the same focusing distance as the main subject. Each of the two subjects should be lit independently, with a black or dark background used for both. By carefully manoeuvring the position of the subjects it is possible to superimpose them quite accurately.

Slide projectors can also be used to combine two or more images in the camera. This can be done either by projecting a second image directly on to the main subject, or by projecting two or more images on to a piece of white card and photographing the result. Front projection is used frequently by professional photographers to provide exterior backgrounds in studio shots. The method uses a high-powered projector to project the background transparency via a semi-silvered optical mirror on to a highly reflective screen which is positioned behind the subject.

Front projection equipment is costly but can be used to startling effect, such as in this photograph by Sam Sawdon (above left). The bright, exotic city lights, projected from in front of the model on to the special screen, do not show up on the model.

Multiple exposure in the camera (above) requires careful attention to the positioning of the subject in each exposure. On some cameras a grid can be placed on the viewing screen, and a reference sketch will then facilitate accurate composition.

This image of a single face (above) was actually formed by the faces of two models, using a glass screen at an angle of 45° in front of the camera lens, in the method described in the adjacent text.

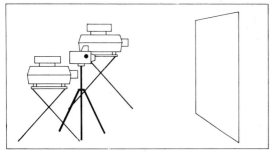

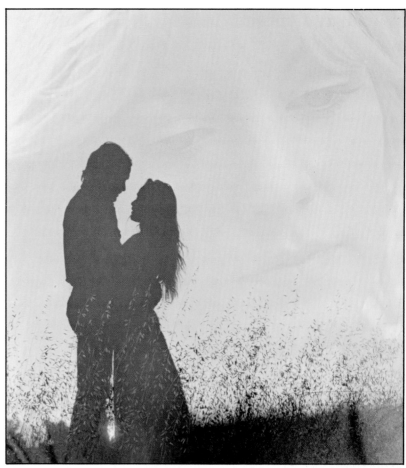

A variety of multiple image effects can be created using projectors and a screen. In this picture (above) a slide was projected onto the girl's body, and another slide of the same scene was projected from a second unit directly on to the screen behind the model, forming the cover illustration for a book.

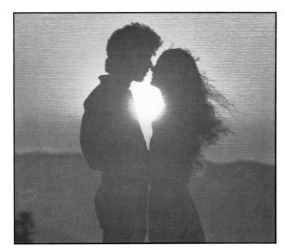

Multiple images can be created by sandwiching together two or more transparencies and photographing them in a slide copier, resulting in images such as the romantic silhouette (top right) and the ski scene (far right). Rejected overexposed transparencies can often be made use of in this way, or shots can be taken specially – e.g. a pattern of leaves, a bird flying against a clear sky, etc.

Special textured images (right and above) can be made by projecting a slide onto the chosen surface, such as a piece of coarse cloth or some suitably draped material. A plain material normally gives the best results.

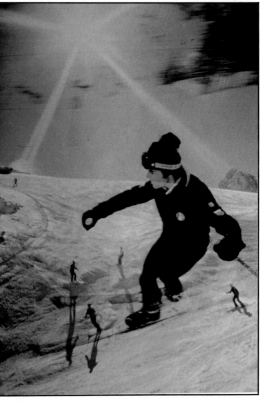

Flash to freeze movement

THE DEVELOPMENT of electronic flash has made a large contribution to the techniques and effects that are available to the photographer. Most of these are a result of the very brief exposures that are possible, and this has had a significant effect on the ability of the camera to freeze and record an image of even the swiftest movement.

The effective exposure of duration of the flash varies according to the individual make and to the power of the unit. A studio unit with an output of 1000 joules may have a flash duration of 1/1000 sec at full power but only 1/5000 sec at quarter-power, for example; this information is available from the manufacturers or given with the equipment.

With very short-duration flashes it becomes possible not only to stop the movement of the model's head and limbs but also to freeze the movement of wind-blown hair or falling drops of water. The effect of such images can be extremely dramatic, as they show aspects of movement which are not visible to the naked eye, or to the fastest shutter speeds of conventional cameras.

An extension of this technique is the strobe effect, where a complete sequence of movements can be recorded on one piece of film. This is done by using a stroboscopic light source, similar to those encountered in discotheques but of a greater power. The stroboscope can be set to flash at a predetermined rate depending on the time it takes to complete the action you want to photograph and the number of images you wish to record. A golf swing, for example, may take one second, and if you wanted to capture ten images you would need to set the strobe to give ten flashes per second, and expose the film for one second.

The exposure must be made with all other lighting extinguished, particularly where a sequence of several seconds is involved, The picture has to be shot against a black or very dark background, otherwise the effect of ambient light and background tones will build up during the exposure and obliterate the image.

It is also possible to create the effect of a stroboscope on less rapid actions by firing a number of ordinary flash heads in sequence, either manually or by making a rotary switch. With some actions it is possible to cheat quite effectively by slowing the movement down and firing a single flash head in rapid sequence – some portable flash units are capable of firing two or three times a second at low power.

The ring-flash is another piece of specialist equipment that can be used to create an interesting lighting effect. It is designed for use in close-up and macro photography, and is simply a flash tube formed into a circle and mounted around the camera lens. At close focusing distances this gives a shadowless light, but when used on subjects at greater distances it causes a small shadow to be cast all around the subject into the background, creating a soft, flat lighting effect.

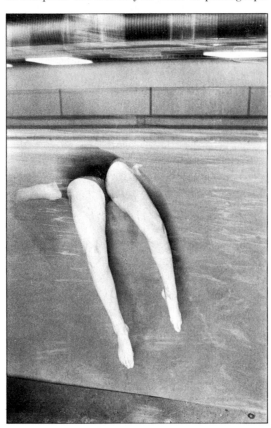

Mixed daylight and flash was used in this photograph (right) of a girl diving, creating a rather dreamlike effect of movement combined with suspension. By firing a flash during part of the exposure, some of the background details that are not lit by the flash will be recorded.

While the modern flash units that fit on a camera's hot shoe are suitable for a great deal of flash work, more adventurous photography is possible with special equipment. A ring-flash (far right, top) is really meant for shadowless close-up photography, but it can be used for its effect of producing an even dark rim around, for instance, a full-length figure.

More powerful flash units (middle) are necessary for most studio work, and several can be fired at once using synchronizing leads or slave-cells triggered from one unit. Some powerful portable units of around 200 joules (bottom) use dry cell batteries that can be recharged overnight from the mains.

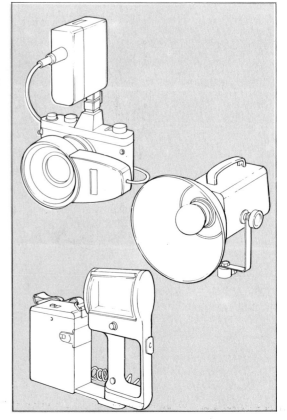

This unusual portrait (left) of architect Jorn Urson, creator of the Sydney Opera House, used stroboscopic lighting, when a bright light flashes at a set frequently while the camera shutter is held open. A dark background is essential to avoid it recording during the exposure and ruining the multiple effect.

The inky black background that often is so unwelcome in flash photography has created an attractive effect in this picture of a swimmer (left), originally shot as a colour transparency. The ability of flash to freeze drops of water, or wind-blown hair, extends a photographer's range for daylight photography, and flash should not be thought of as only being suitable for low light or night photography.

Filters & attachments for effect

A fog filter and a very fast film were used in this photograph, creating a grainy image with a distinct period atmosphere. The fog filter softens contrast and in this case has spread the light from the lamps into the darker parts of the picture. Unlike a soft focus filter, the fog filter softens contrast without reducing definition. In bright sunlight it will lightly cover the image in a veil of white. Nikon F2 with 35mm lens; 1/60 at f4; Ektachrome 400.

OF THE WIDE RANGE of filters and attachments that are available, many can be used to create specific effects that considerably enhance the visual quality of a picture.

With black and white film, for example, it is possible to control the tonal range of an image by the use of colour filters. These work on the principle that they freely pass light of the same colour but prevent light of a different colour from reaching the film, the effect being controlled by the density of the filter. A deep red filter, for example, does not allow any green or blue tones in the subject to record on the film, so these are reproduced as black on the print.

A black and white portrait taken with a red filter records red lips as nearly white, but blue eyes as much darker than they would appear without the filter. A deep blue filter can be used to create a quite dramatic effect in portraits by increasing the tonal range and texture of skin, and this is particularly useful in character pictures.

Filters such as these require an increase in exposure – a filter factor that indicates the increase is given for each filter, for example a x2 factor requires an increase of one stop and a x4 factor an increase of two stops, and so on.

With colour films much paler filters can be used to alter the colour balance of the film, and only a slight degree of filtration is required to produce a significant effect. Colour correction filters can be bought in a variety of strengths and colours, and either as glass, gels or acetates, or plastic screens.

In addition to the colour correction filters it is also possible to buy a very wide range of special effect filters. These include the graduated types which are quite clear in one half of the glass or plastic but are tinted in the other half. The transition from clear to colour is gradual and the effect is either to darken or to add colour to one half of the image. A variation of this filter is one with a clear central spot surrounded by a tint.

Another filter which can be used effectively, particularly with colour film, is the fog filter. This has a milky appearance which results in a considerable reduction in image contrast and colour saturation, producing images with delicate pastel colours. It can often be used to advantage with grain enhancing techniques.

The effect of a starburst filter is well known as it is popular with the producers of television spectaculars and it can be very effective with the right subject. For maximum effect it requires an image with a number of very bright highlights or light sources in conjunction with a fairly dark background. These filters are available in a variety of configurations and either thick or thin streaks. The effect is also dependent on both the focal length of the lens and aperture used.

A diffraction grating or colourburst filter produces rainbow coloured striations radiating from or around bright highlights or light sources in the picture area. Again a variety of configurations is available and it is of course necessary to use colour film to record the effect.

A number of repeated images can be created by using a multiprism attachment. This is a glass or plastic device which has a number of facets moulded into it, either in a circular pattern with a central facet, or laterally. This causes the image of the central part of the subject to be repeated a number of times, according to the number of facets on the attachment. It can be rotated to vary the effect and this will in turn be affected by the focal length of the lens to which it is fitted, and by the aperture being used.

The use of SLR camera is practically essential for special effect photography that relies on filters, lenses or other attachments which alter the appearance of the image itself.

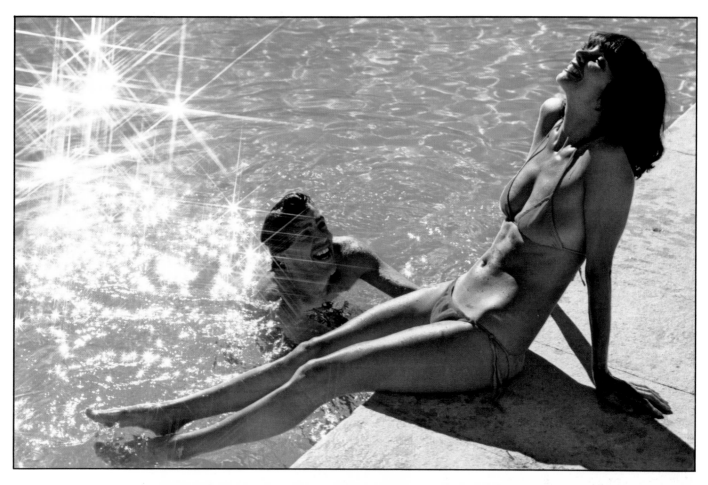

Attractive effects on reflections (above) are given by star filters, which can produce up to sixteen points, while a cross screen filter gives four-pointed stars. City lights, sunsets and candles are some point sources of light often photographed with star filters.

The Cokin system uses a filter holder (above) to permit rapid changing of filters, whether for special effects or for conventional photography.

A diffraction filter breaks bright lights and reflections into spectrums (right), and filters can also be bought which give multi-image effects (far right). A very large number of special effect filters are now available.

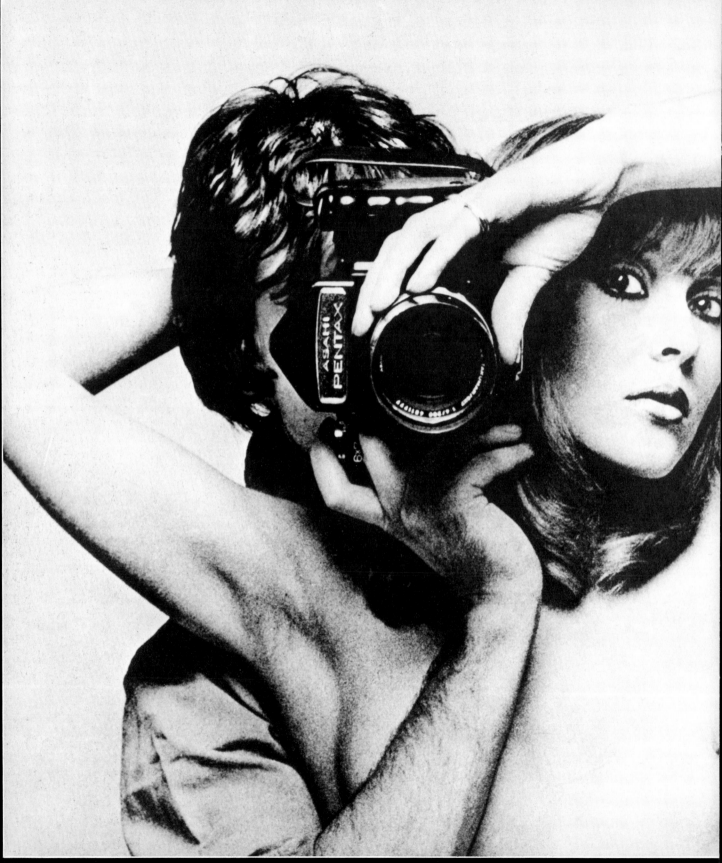

NUDE & GLAMOUR PHOTOGRAPHY

ONE OF THE ENJOYABLE aspects of photography is that it can be used to express ideas and attitudes while simultaneously providing a means of indulging in the visual pleasures of the world in a more practical and participatory way than just by looking. This is demonstrated very clearly in the relationship between the camera and the often elusive attraction of women.

Most men, and many women, find an attractive girl sexually as well as visually stimulating, and it is not surprising that if they also happen to be photographers there will be more than a moderate interest in the female form as a subject for their work. Few photographers have been able to resist this double attraction that a beautiful or interesting woman can project. Photographers who have not been noted for their work in conventional portraiture have made some memorable images when presented with an inspiring model. Bill Brandt and Edward Weston are two photographers who have produced compelling pictures of the female nude, without in any way being specialists in that field.

Most photographers would agree that the act of seeing and taking any sort of picture can be a quite sensual experience, and an inherently sensual subject like an attractive woman is bound to make it more so.

It is important, however, to be aware of the motive for taking nude and glamour pictures. It would be senseless to pretend that sexual pleasure does not affect both the viewer and the photographer to some extent, and it would be equally absurd to suggest that this was not a good enough reason for wanting to take such pictures. But while this may be a very pleasant way of passing the time, good pictures require a strong degree of objectivity on the part of the photographer, as well as enthusiasm and inspiration.

If the purpose of a session is to produce pictures of more than superficial appeal, it is vital that the sexual aspect of the inspiration occupies a more passive role in the proceedings – after all, many exceptional pictures of nude women have been taken by photographers, male and female, whose interest in their subjects has been purely aesthetic.

Photographer and model,
from a transparency by Bob
Carlos Clarke

Choosing a model

Deliberate titillation, emphasized by the model looking directly at the camera (above) requires a model who is totally confident about her body. The camera exaggerates dimensions, so a quite slender girl may look well-proportioned on film.

A clear, unblemished skin is one of the first requirements for a nude model (above). The model and the pose should suit the image you try to convey – in this case almost that of an innocent 'girl next door', despite her nudity.

THE HUMAN FORM, **particularly female, has been a source of inspiration to artists and would-be artists from the earliest efforts to record images on cave walls. It is hardly surprising that photography, which has been called the folk art of the twentieth century, should have shown similar enthusiasm in exploring and capturing the visual pleasures of a woman's body.**

However, photography has unfortunately created a situation in which there is a much more noticeable distinction between the various aspects of nudity – possibly because a photograph can so closely resemble the original subject that viewers are tempted to draw a too literal conclusion from it. It is much easier to see a photograph of a nude as a picture of a particular individual with no clothes on than it would be to see a sculpture, for example, in the same way.

This directness makes it vital for a photographer to know precisely what he is trying to achieve with nude photography, both in his approach and in his choice of a model. A photograph of a woman can range from the purely abstract where the body is little more than a still-life subject to a deliberately titillating picture, with the model relating to the viewer on a very personal level.

When choosing a model, therefore, one of the most important considerations is the model's own attitude to the session. Most people feel somewhat

vulnerable when naked – and the presence of a camera is unlikely to alleviate that feeling. A photograph of a nude has little chance of success if there is any degree of self-consciousness on the part of the model.

It is also important to remember that with many people there is a considerable distinction between being nearly naked and completely naked – a girl who may be perfectly relaxed and happy to be photographed while very scantily dressed, may be quite the opposite when nude. Your own attitude will be an important factor in relaxing the model. If you are confident and know what you want to achieve from the session, and are able to communicate this to the model, you can overcome a great deal of inhibition.

If, on the other hand, you have had little experience in nude photography, it may well be preferable to begin by using a professional model. Most model agencies have on their books models who do nude work, but their fees are likely to be considerably higher than for normal modelling. The agency will also want to know the purpose of the pictures, in particular if they are intended for publication. However, a professional model's relaxed assurance will survive a little awkwardness and inexperience on the part of the photographer, and even a brief session with a good model can prove highly instructive.

It is, furthermore, important to ensure that the model you choose aids the type of picture you want to take. In all but the more abstract type of nude study the model's personality and appearance will go a long way to establishing the mood of your picture. The work of well-known photographers of nudes – David Hamilton is a good example – demonstrates how close the relationship is between the picture and the choice of model.

It can be a mistake to allow yourself to be too influenced by stereotypes. This is particularly true when using non-professional models, when you may reject certain girls because they are not enough like the girls in the magazines. If you are taking pictures for publication, then it is important that both your pictures and your models are in keeping with the style of the publication. But if your pictures are for more personal use then it can help to get away from the more commercially associated images. When you are striving to create an approach of your own it is what you find attractive that is important, and there is no reason why this criterion should not be applied to your choice of model.

Although currently it does not seem too popular, at least in the medium of photography, the male nude has possibilities that are worth considering. What it lacks as a subject in terms of soft, smooth contours can be more than compensated for by the potential for creating more strongly textured, angular and muscular images.

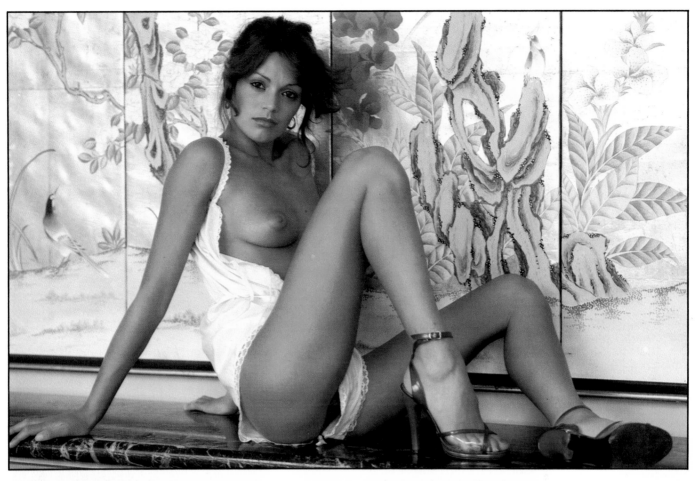

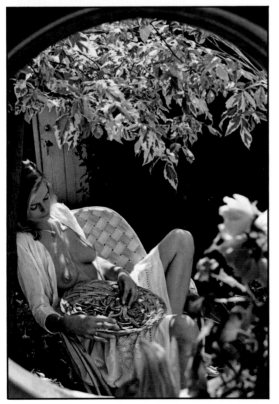

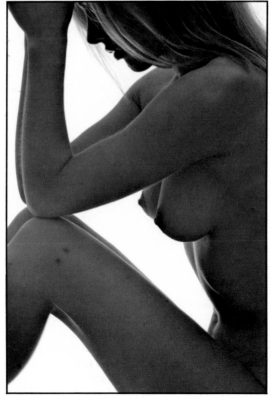

A particular model often will seem best suited for a certain type of setting. The girl in this photograph (above) looks as sophisticated as her surroundings, and her clothing has been chosen to complement the overall mood of slightly decadent opulence.

A model who is inexperienced in nude photography will be far more at ease if she is able to wear some clothing (far left). A relaxed setting, something to occupy her hands, and a pose that allows her to avoid looking directly at the camera will overcome awkwardness even more.

Abstract poses, such as for this photograph (left), where the body is practically a still-life subject, allow many experiments with lighting and texture, and are often a good starting point for inexperienced photographers and models.

Creating eroticism

Posing only one girl in this photograph with the slight soft focus and hazy window light, would have resulted in a purely romantic image; but Caroline Arber has added an element of eroticism to the wistfulness of the composition by the inclusion of a second nude girl, creating a situation rather than a simple nude study.

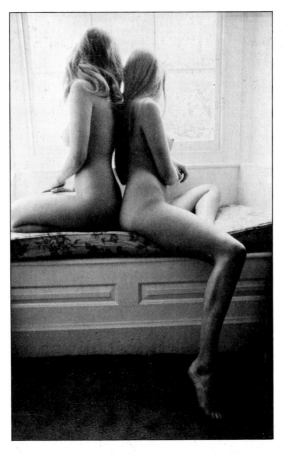

THERE IS NO EASY ANSWER to the question of what gives a photograph an erotic quality. The response to almost every nude or glamour photograph is inevitably subjective – and eroticism, like beauty, is largely in the eye of the beholder. A photographer who sets out to create a picture which stimulates sexually as well as visually will, to a large extent, do so in a way that he himself finds appealing.

The starting point of creating an erotic image is obviously the model herself. The choice of a girl with a lively personality and a full, rounded body, or a quiet, enigmatic girl with a slim, boyish figure will depend on the photographer's own personal taste, or on the preferences of the publication to which he hopes to sell the picture. A large proportion of the magazines which use erotic photographs prefer those in which the model is quite openly provocative, dressed and posed in a way that unmistakably invites a sexual response – and usually with her eyes directed into the camera.

The way the eyes are used has a considerable effect on the viewer's response. A picture in which the eyes are directed down or away from the lens, for example, has a far less explicit, more ambiguous quality, whereas one in which the girl's eyes are directed towards the camera has a much more immediate impact. Photographs taken for the covers of books and magazines invariably use this device since they need to have a compelling quality to be effective on display.

In pictures such as these, the model is obviously aware of the camera and the viewer, and any eroticism is induced largely by her expression and physical appearance; but an equally and often more erotic quality can be conveyed by pictures in which the model seems unaware of the camera, and the viewer has the impression of observing an intimate moment. In this type of picture the element of fantasy becomes much more important, and the image needs to have a more evocative quality to be successful. As well, 'indirect' photographs usually require at least a suggestion of location – a room, or simply a piece of furniture – because the viewer is invited to imagine being in a situation, and not simply to relate to the model alone. In the more obvious, directly provocative pictures it is not always necessary to have any background or setting, and consequently they are often taken in a studio, with just a plain toned background and perhaps a simple prop.

To a large extent, creating a sense of eroticism in a photograph is similar to creating a mood – it is very dependent on suggestion and often the vital factor is what the camera does not show. A picture which is totally explicit is very rarely truly erotic. For this reason clothing can play an important role. A nude picture can certainly have an erotic appeal, but it often helps to use some clothing to create an effect where the viewer is allowed to see so much of the model's body, but no more.

Clothes also help to enhance the tactile quality of a picture, and textures are an important element in nude photography. The contrast between silk and skin, for instance, can create a much more sensual quality than bare skin alone, and fabrics that are almost transparent can evoke a sense of touch as well as create the teasing quality of almost, but not quite, revealing the body. Similar effects can be created by lighting, which can be used to enhance the textural quality of skin and, through carefully controlling the shadows, to produce an element of mystery.

There is frequently an element of fetishism in most sexual responses, whether it involves long hair, wet skin or clothes, a particular type of clothing, and so on. There is no reason why elements like these cannot also be employed in searching for an erotic response, providing it is done with taste and some discretion. The line between pornography or banality and eroticism can be quite fine, and the attitudes of individuals towards such pictures will also vary considerably. Several photographers, however, have successfully used these and other methods to produce their highly acclaimed pictures – the work of Helmut Newton, for instance, is a good example of fine photography with a stong and often very personal attitude to eroticism.

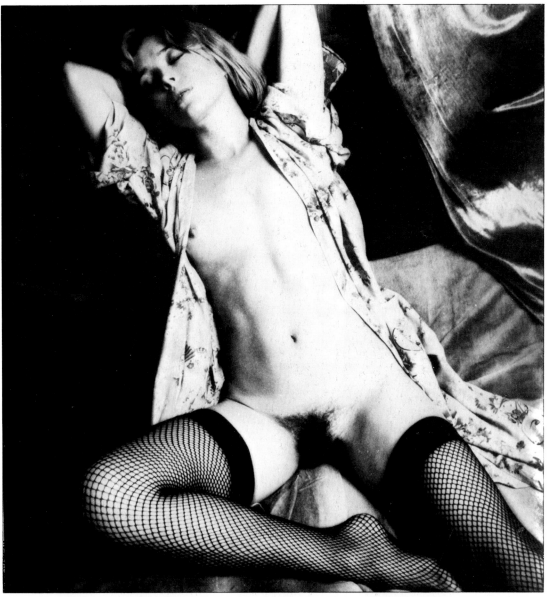

This picture (from a transparency by Bob Carlos Clarke) is rich in sensuality, and relies mainly on the model's provocative pose for its erotic effect (left). The textural contrasts provided by the stockings and the sheen of the velvet contribute strongly to the overall effect.

Clothing can convey eroticism with as much effect as nudity (bottom left). The choice of clothing is vital, however, and a satin bra is more sensual than a bikini top – though in this case the partial revealing of a breast adds a voyeuristic element that would have been equally attractive whatever she was wearing.

In this picture (bottom middle), unlike the previous one, the baring of a breast is deliberate and blatant, and combines with the model's direct expression to create an aggressive, challenging atmosphere that is the opposite of the conventional coy outdoor nude.

A photograph of a naked girl asleep on a rumpled bed (below) conveys an aura of sensuality that would be lacking entirely if an identical pose was taken with the girl asleep on a beach. The most effective eroticism invariably is conveyed by suggestion rather than by bald statement, and even the most startling work by the leading photographers of women relies strongly on mystery and imagination.

137

Emphasizing texture

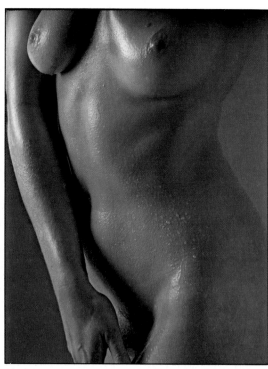

PHOTOGRAPHY CAN BE USED **to create some quite effective illusions. The ability to give a three-dimensional effect on a flat piece of paper is more or less taken for granted, and the way that movement can be suggested by the use of blur is often impressively used. Another capability of photography which can have an almost uncanny effect is the reproduction of texture in a way that gives a picture such a pronounced tactile quality that the viewer can experience a sense of touch, just from looking at the photograph.**

Photographic reproductions are used so effectively in some manufacturing processes that it is virtually impossible to distinguish an imitation finish without running your fingers over it. This quality can be exploited effectively in many areas, and it can create a particularly powerful impression in nude and glamour photography, for sensuality has as much to do with touch as it does with sight – if not more. A photograph that invites the viewer to imagine how skin or hair would be to touch, as well as conveying how it looks, can be very powerful indeed.

Lighting is the key factor in creating this quality in a photograph, and it is the careful control of the effect of light on the surface of the subject that is so important. With a subtle texture like youthful skin or fine hair the light must just skate across the surface, the beam of light almost parallel to it. The strongest effect is given when the subject is lit from the side, or by back lighting that just glances off the skin.

In general, more directional and harder light results in a more pronounced effect, but the light that is most effective in revealing texture will often be less effective in other respects. Form, for example, may well be diminished by hard and strongly directional lighting.

The lighting has to be balanced so that it achieves the textural effect you want without losing other qualities. It is often adequate to create an impression of texture in only one part of the subject. A small spotlight positioned behind the model, for instance, could be used to enhance the textural quality of her shoulder or breast, while a softer and more frontal light could illuminate her face and the rest of her body.

Remember that any directional light that is used to create texture will be much more affected by slight changes in body position or camera angle than the softer and less directional lighting, and therefore it is vital to keep a close eye on the effect of the 'texture light' as the model moves around. Remember too that this type of light will accentuate any blemishes on the skin, and you have to be very critical in this respect.

Another problem that can result from this type of lighting is that contrast is invariably increased. Unless a particularly dramatic effect is required it is usually necessary to use a reflector or a fill-in light to reduce the brightness range. Exposure is also very important, as even a small degree of over-exposure will greatly reduce the detail in the lighter tones upon which the effect of texture is so dependent. On the other hand, slight under-exposure will usually enhance the effect, particularly when back lighting is being used.

The textures that need to be emphasized for male nudes (above left) are the opposite of those sought for in female nudes, though muscles, ruggedness and hairiness are frequently most effective when they are slightly muted, as here, rather than exaggerated.

The smooth sheen and highlights that are obtained when a body is lightly oiled are particularly effective on a model with fairly dark skin (above). Drops of water, which can be lightly sprayed on if you are shooting indoors, stand out clearly on an oily skin and provide another element that draws attention to the smoothness of the skin itself.

This charming picture by Michael Boys (right) is practically a study in textures, and emphasizes the model's flawless skin by the patterns of light and shadow, and by the contrasting texture of the materials. In spite of the many nuances in the picture, it relied purely on daylight and on ordinary household items for its effect.

In this picture (above) the tactile sensations are conveyed almost entirely by the daylight coming through a narrow gap in a curtain, which makes the golden skin stand out vividly against the dark surroundings. The highlights accentuate the curves and smoothness of the skin.

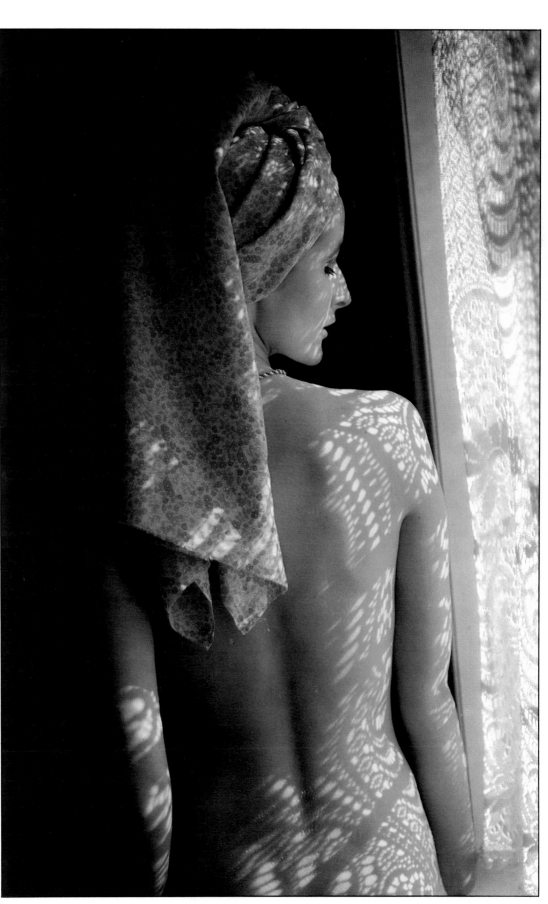

Emphasizing texture

In this picture (left, from a transparency by Bob Carlos Clarke) tones play almost as big a role as textures. The model's white skin contrasting with her black leotard and with the fish net pattern of her stockings, and the rich sheen of velvet on the cushions is ideal for evoking sensuality.

The oblique lighting in this photograph (right) catches the drops of water and emphasizes the smooth skin by causing the viewer to register different textures. Light, such as in this picture where it highlights the girl's breast, can strongly accentuate texture.

Strong contrasts, such as gritty sand and smooth skin (far right), will always accentuate texture, but in general the contrast, as here, should be natural. The model's action of brushing off the sand adds an element of touch, and the light has been perfectly caught.

Textures can also be emphasized by using complementary elements, as in the velvet cushions, or in the variety of fabrics (right bottom), where the overall impression is of whiteness, softness and smoothness.

GOOD PHOTOGRAPHIC **technique is vital to get the fullest effect from the camera's ability to capture texture. Apart from accurate exposure, it is essential that the camera is accurately focused, and the image perfectly sharp. Texture effects demand that the finest detail is sharply recorded, and the slightest subject or camera movement will reduce the impact considerably (flash is particularly useful in reducing this risk). Care should also be taken that there is adequate depth of field, and it is best to use the smallest aperture possible.**

It is also possible to plan the strength of the tactile quality of a picture when first setting up your shot. Skin, in particular, can be made to look

even more sensual by using other things to accentuate it. A little oil, for instance, can be rubbed into the skin to give it a very slight sheen. Only a tiny amount should be used, not enough to make the skin shiny, and it should be completely absorbed – unless of course you are aiming for a really oily look. In that case some suntan oils are ideal as they have the benefit of giving the skin more warmth in colour shots.

Skin can often be made to appear more smooth and supple by using contrasting textures in contact with it. Small drops of water on brown skin in a bikini shot, for example, can produce a much more evocative image than the same picture with the skin dry. The viewer senses two different

Although the first impression in this photograph (right) is of the coarse metallic net, enough of the model's skin is visible to cause the viewer to experience two distinct and contrasting tactile sensations. The soft curls of hair add a further textural element.

textures, and in distinguishing between them the effect of each is given more emphasis.

A similar and sometimes stronger effect can be created by using a contrasting juxtaposition of textures – hair on bare skin, for instance, or silk next to skin. These are more in keeping with the sensual and feminine aspects of the image, but it is also possible to use more extreme contrasts with skin, such as leather, sand, stone or fur.

Used in a reasonably discreet way, such devices can create very effective and quite erotic pictures. But, as with many such techniques, it is important not to overstep the mark because the margin between a successful picture and something banal or simply a cliché can be quite narrow.

Soft focus techniques

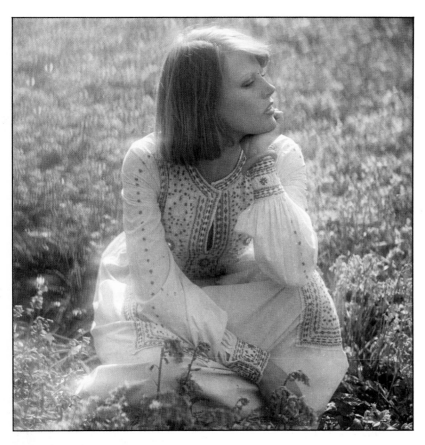

WHILE EXTREMELY SHARP focusing is necessary in achieving certain effects, such as emphasis on textures, there may be other occasions when you want to create a softer, more romantic image. The soft focus approach is one of the most successful in conveying such atmosphere. Soft focus is considerably different from out of focus; the conventional causes of unsharp images, such as camera shake or inaccurate focusing, seldom create a pleasing effect, and different methods must be used to produce a controlled result.

The simplest and most common method involves using a soft focus attachment in front of the camera lens. This is a disc or square of glass or plastic of optical quality that has an interference pattern engraved or moulded into it. There are several versions – some are engraved with concentric circles, some have small bubbles in the disc, and others have a slight frosting or a special coating. The principle, however, remains the same, which is simply to impair the ability of the lens to record fine detail.

Most proprietary attachments are available in several different strengths, each one introducing a progressively stronger degree of interference. The resolving power of the lens is not totally destroyed, the attachments being designed to allow a core of sharpness to remain, with a softer, diffused image overlaid. This is a quite different effect to bad

focusing or camera shake, where nothing at all is completely sharp.

Soft focus attachments, in addition to affecting the definition of the image, will also affect contrast and colour saturation. A photograph of a nude will therefore have a softer quality in terms of colour and contrast as well as sharpness. The diffusing effect spreads light from the highlight areas into the darker tones, and where very strong highlights exist against a darker toned background, as in back lit hair for example, the result can be like a halo of light.

It is possible to produce soft focus effects by other methods, although the principle remains the same. A piece of fine nylon, for example, can be stretched across the front of the lens and held in position by an elastic band. Petroleum jelly can be smeared on a piece of glass or a UV filter in front of the lens, and the effect can be varied by 'teasing' the jelly around with a finger tip. The important thing to remember is that whatever you use a small hole should be left in the centre to allow the image to retain a core of sharpness.

As with any special effect, some restraint is advisable. While soft focus can certainly add a romantic atmosphere, soften unavoidable harsh backgrounds, or introduce a pronounced erotic element by concealing at the same time as it reveals, a complete series of soft focus pictures of the same model would be tiresome.

A slight soft focus in bright sunlight outdoors (above left) conveys the atmosphere of a drowsy summer afternoon. Although soft focus images are hazy, the focusing must still be sharp, and in this case the narrow depth of field of a long-focus lens, separating the girl from the background, demonstrates the difference between soft focus and out of focus.
Pentax 6 × 7 with 150mm lens; 1/250 at f4; Ektachrome 64.

Although this picture uses only a very slight soft focus effect (right) it is enough to change a faintly aggressive pose into a more gentle one. This degree of soft focus emphasizes the back light's halo on the hair without producing an intrusive flare.
Pentax 6 × 7 with 150mm lens; f16 with studio flash; Ektachrome 400.

A soft focus attachment that is more concentrated away from the centre (far right) can produce a romantic cameo effect that is particularly pleasant in portraits. The importance of accurate focusing through the clear centre of the filter is apparent in this picture.

Direct light, as in this strongly back lit shot (left), is accentuated by a soft focus attachment, as can be seen in this photograph by comparing the filter's effect on the girl's arms and head with that on her legs.

The softening effect of a soft focus attachment is used frequently in nude photography, as it can convert starkness into seductiveness or, in this case (right), emphasize the romantic atmosphere of a pose. A single-lens reflex camera with TTL metering is most suited to this technique, because it allows you to see the effect being created and the metering compensates for the light absorption by the gauze or filter being used.

The abstract nude

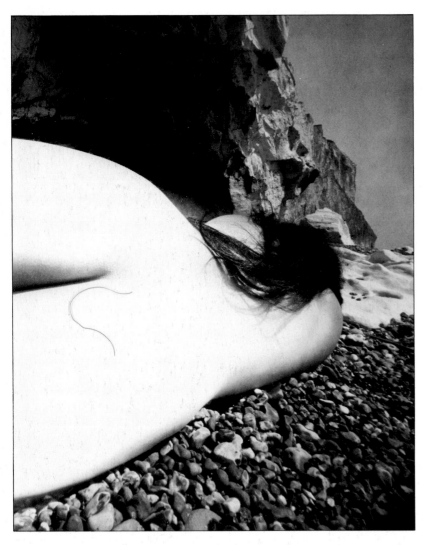

Apart from his other photography, Bill Brandt is famous for his superb abstract nudes, such as this surrealistic photograph (above). The distortion provided by the proximity of the camera would be unacceptable in a conventional nude study, but the greatly exaggerated flowing sweep of the model's hip contrasts vividly with the jagged cliff face. The smoothness of the skin, in which practically all texture has been eliminated in the print, is accentuated by the hardness of the pebbles.

ALMOST ALL SUBJECTS **that interest photographers can be approached in many different ways, and the opportunities that exist for a photographer to create personal and interpretative images are far more numerous than the mechanical nature of the medium may at first suggest. The ways in which the nude can be used to produce interpretative images are probably more diverse than with any other popular subject.**

In most pictures of a person the identity and personality of the individual are usually important elements of the image, but the abstract nude offers a way of working in which the model's role is limited purely to the way in which the contours of her body create an image for the camera. In many ways photographing the nude in this manner can be likened more to still life photography since it is possible to control both the composition and lighting to a fine degree.

The studio is obviously the most convenient situation for this type of session because artificial lighting offers the greatest variety of effect, but it is still possible to produce abstract nudes with daylight outdoors or with natural lighting in an indoor setting.

There are a number of ways in which the body can be photographed in an abstract way. The most straightforward is in the framing of the picture by carefully selecting the most significant parts of the body, and excluding irrelevant areas. This can range from a simple de-personalizing of the model by omitting her head or face, to quite drastic cropping and the use of close camera positions. It is most important that you are able to make fine adjustments to the positions of the model and your camera; for this reason it is best to have the camera mounted on a firm tripod which has an easily manoeuvrable head, and to have your model comfortably seated or lying in a way that makes it possible for her to move her body into a variety of positions.

A lens of somewhat longer than standard focal length (105mm or 135mm with a 35mm camera for example) is preferable since it enables you to work at a comfortable distance from the model. It also provides tight framing without the awkward perspective effects which would be created by having the camera too close to the subject.

In addition to careful framing, it is possible to create an abstract quality by arranging the body in such a way that it presents an unusual angle or juxtaposition of limbs to the camera. It is much easier overall to change the angle by moving the model instead of re-positioning the camera. It then becomes a relatively simple matter to take a shot that appears to come from 'above' the head towards the legs, especially if the background is excluded or is a neutral tone.

Lighting can also be used most effectively to produce more abstract pictures. It is possible, for example, to light the model so that a very high brightness range is created, and for the film to be exposed in such a way that a complete range of tones is lost. In this manner a picture can be reduced to a simple series of shapes and lines with no suggestion of form or texture. In black and white photography this effect can be further controlled by printing techniques, such as printing on high contrast grades of paper, or even using lith materials where the image is reduced to pure blacks and whites.

Very subtle but equally abstract effects can be achieved by allowing the light to illuminate small selective areas of the body. This can be done by allowing the light to filter through the gaps between limbs and body, or round the edge of contours; combined with close cropping, this can be very effective indeed. Another way of achieving a selective or abstract lighting effect is to project a light pattern onto the body, either by using a large sheet of card with a cut out pattern, such as parallel slits, or by using a slide projector to

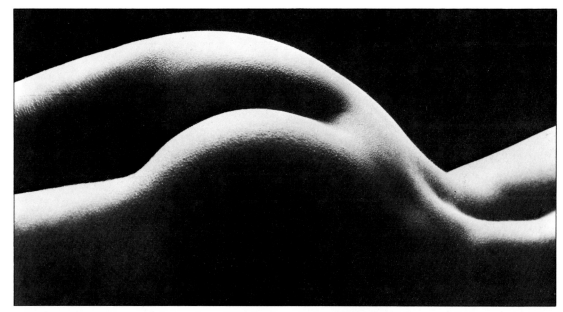

Highlights from the strong
direct lighting, and a
pronounced degree of contrast
(left) make this picture as
much a study in form and shape
as it is a photograph of a nude.
The slight degree of tonal
gradation between highlight
and shadow bring out a second
element, that of texture. The
wide variety of lighting that is
available in a studio favours
this setting for abstract nude
photography, but with high-
contrast black and white film
similar effects could be
achieved indoors with even
simple artificial lighting, or
with direct sunlight.
Pentax 6 × 7 with 150mm lens;
f16 with studio flash; Ilford
FP4.

The complex shapes and
textures of the human body
(far left) make the nude a
fascinating subject for
techniques that more closely
resemble still-life photography
than portraiture, or even
glamour photography.

Abstract nude photography
need not concentrate on light
and shadow. In this
photograph (left, from a
transparency by Bob Carlos
Clarke) the emphasis is on
texture, in the comparison
between the velvet and the
model's skin, and on a sense
of movement, from the curve
of the brilliant highlights on
the beads. The anonymity of
abstract nudes removes many
of the uncertainties that so
often confront models and
photographers – and viewers.

Light patterns projected on to
a nude body can produce
interesting effects, such as in
this photograph (left) where
the straight bands of light
emphasize the model's
roundness as they curve
around her body. This effect
could be produced away from
the studio by direct sunlight
coming through part of a
venetian blind, if necessary
suspending a black drape
behind the model to darken
the background. The closer the
model is to the blind, the
sharper the edges of the
shadows will be.

illuminate the model with a pattern that has been
photographed on a slide or drawn onto a piece of
clear film. If the cut out card method is used it is
necessary to use a hard light source, such as a
spotlight, and the card needs to be positioned at
some distance from the lamp. The further the card
is from the light source, and the closer it is to the
subject, the sharper will be the pattern.

The abstract approach to photographing the
nude is an excellent way of developing a sense of
composition and an understanding of lighting, as
the abstract nature of the image enables you to see
your picture in terms of pure shapes and tones.
The ways in which you can control the elements of
your picture are virtually limitless.

Since abstract nude photographs invariably
exclude the model's face, or make it unidentifiable
through the lighting effects, it is sometimes easier
to find a model willing to do this type of nude
photography. With the emphasis more on com-
position and lighting, there may also be less need
for exacting standards of shape and proportions,
though a good skin would still be a requirement.

Outdoor locations

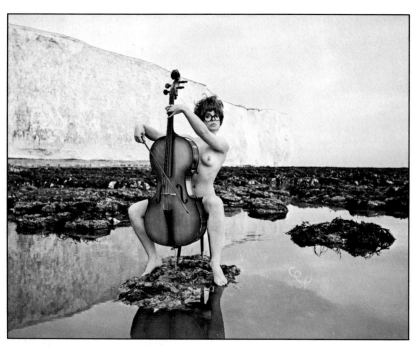

In this picture the location has been used to create a deliberately incongruous quality (above). The surprise element in such a juxtaposition is often used when the aim is primarily to attract attention. Hasselblad with 80mm lens; 1/250 at f5.6; Ektachrome 64.

The simple basic colours and shapes provided by a Mediterranean location (above), plus the benefits of a pleasant climate, are ideal for nude and glamour photography. The lighting encountered in this sort of setting is an added bonus. Pentax 6 × 7 with 150mm lens; 1/250 at f5.6; Ektachrome 64.

USING OUTDOOR LOCATIONS **for nude and glamour photography has a number of advantages. It provides a natural setting in which the model can relax, daylight is a very convenient and effective way of lighting the model, and the method of working is less contrived and complicated than the sterile and technical environment of the studio.**

The disadvantages are mainly the unpredictability or unsuitability of the weather (it has to be warm and pleasant for this type of work) and the problem of privacy, since the presence of onlookers can be very distracting for both the model and the photographer – particularly with a nude session. It is usually fairly easy to find quiet countryside locations, but when a beach or buildings are needed for a setting of a shot there can often be a problem. One solution is to shoot either early or late in the day when few people are around, but it is always essential to do a reconnaisance so that problems are anticipated.

A glamour photograph can be taken in most situations without the logic of the location being questioned. With a nude picture, however, you must decide whether the background or setting is to play a role in the picture or whether it is simply to create a vague suggestion of tone. A picture of a nude in a woodland setting, for example, is unlikely to appear as natural as one of a nude on a beach might, and as a result such pictures can look rather contrived and even a little silly if not treated in the right way. The pastoral type of nude picture can in fact produce an effective image if approached in a romantic, or slightly whimsical way, but could just as easily look banal if an obviously sexy and deliberately provocative shot

was attempted.

For a more provocative picture it is usually preferable to use an outdoors setting only as out of focus tones in the background. It can sometimes help to have some props in the picture, a garden or beach chair for example, and to keep the picture quite tightly framed. The problem of reducing the background to a vague suggestion of tones can be overcome by using a long-focus lens, such as a 135mm with a 35mm camera, and to work with a fairly large aperture in order to restrict the depth of field. This type of lens will also have the advantage of allowing the picture to be closely framed yet still allow the camera to be kept at a comfortable distance from the model. Additionally, close camera viewpoints can easily result in unpleasant perspective effects, and a long lens will prevent this happening.

The soft light of a slightly overcast day is often preferable for outdoor nude and glamour photography as it creates more subtle modelling, and also tends to be more flattering. With colour photography, however, it is important to be careful of colour casts on the skin tones. A cloudy day often creates a slight blue cast which looks very unattractive on skin; and even on a sunny day there is a danger of colour casts being created by reflected light – from a blue sky, or, in a woodland setting, from foliage.

A slight degree of warm filtration will seldom adversely affect the picture, and it is worth fitting, say, a Wratten 81A or a CC 05 red or magenta filter to guard against cold colour casts. A slight warm cast is much more acceptable on skin tones than a blue or green cast, and it is always better to err on the side of too much filtration rather than too little if you suspect that a colour cast exists.

Bright sunlight can be a positive advantage, and also quite flattering, on the beach or by the sea, particularly with a model who has a tanned skin. The problem of the excessive contrast and dense shadows that can be created by bright sunlight is usually alleviated by the amount of naturally reflected light from a large expanse of sand or water. The light encountered generally seems more appropriate to the situation – the sea, for example, is much more blue on a day when there is a clear sky, and it is possible to get sparkle and highlights on the water by shooting into the light (remember to compensate by one or two stops for the exposure readings in these conditions and to use a lens hood).

For a softer and warmer lighting effect it is often preferable to shoot either in the early morning or in the late afternoon. This type of light is also better for creating a strong textural quality on sand and skin, and it is often possible to create some very erotic images with close-up pictures of a nude body, especially if it is suntanned and slightly oiled, or still wet from the sea.

Often nothing more than a suggestion of a background is necessary to provide an effective foil for a pleasing composition (right). The dark wood of the door provides a contrast both in tone and texture with the girl's body.

Informal clothes like those worn by this model (above) look their best when photographed in an equally informal setting. Unless a particularly dramatic effect is wanted, it is best to choose a background that suits the appearance and clothes of the model.

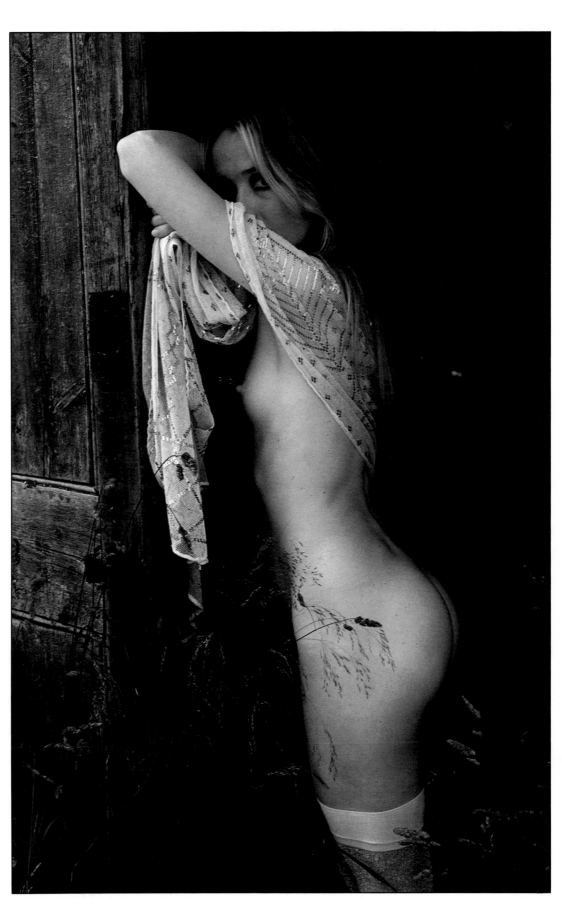

Nude & glamour in the studio

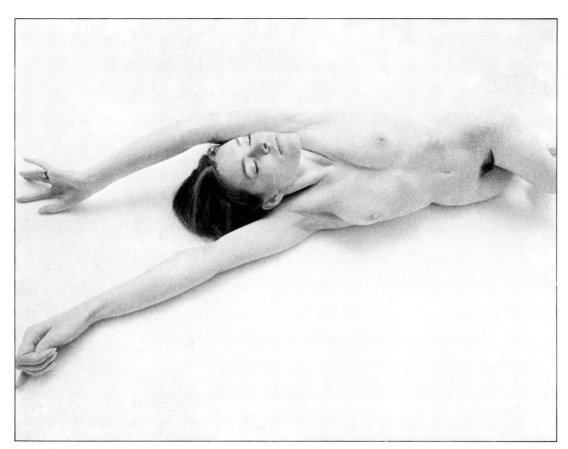

The studio can be a restrictive setting for nude photography, and there is a limited amount that can be done with nothing but a plain background. In this picture, however, a wide-angle lens has created an entirely new aspect, and a flagging session could be revitalized by changing lenses to get a new perspective on the model. Nikon F2 with 20mm lens; f16 with studio flash bounced from ceiling; Kodak Recording Film 2475.

Simple props like jewellery and small fashion accessories (right) can be used to advantage in a studio, and lighting conditions are likely to favour close-up photography. A 105 or 135mm lens should be used for close-ups if the model feels uneasy about the proximity of the camera. Nikon F2 with Vivitar 70–210mm zoom lens at 150mm; f16 with studio flash; Kodak Tri-X.

WHILE THE STUDIO is a very convenient and controllable situation in which to shoot nudes or glamour pictures, it can be a rather unsympathetic environment that offers little inspiration to a photographer, and it is necessary for both the photographer and the model to work quite hard at creating ideas and giving a sense of purpose to the session.

Unlike using a location, where the surroundings themselves can contribute and inspire ideas for pictures, it is vital for the photographer to have a very clear idea of what he wants to achieve when planning a studio session. There is nothing more daunting for both model and photographer than to be confronted with a roll of background paper and no firm idea of what to do.

This does not mean that every studio shot needs to be an elaborate and complex set-up, but it does mean that some basic idea should be evolved, if only as a starting point. This could be, for instance, a small prop such as a chair or a piece of clothing, or a particular lighting effect. It may be that as the session gets under way other ideas will come to mind and the original concept be abandoned, but without a definite starting point it can be very difficult to start anything at all.

Many attempts to take studio glamour pictures fail because they attempt to simulate the effect of an outdoor location, and unless you are prepared to go to considerable lengths to make it really

A choice of clothing will help the photographer and the model to bring variety to a session (left) where there are no items to give spontaneous ideas, such as would be found in an indoor location. The ability to vary the lighting at will should be fully exploited.

convincing it is far better to concentrate on those aspects of the studio that can contribute to the picture. The limitations of simply having the model in a standing position in front of the background are quickly discovered, and it is preferable to think of ways in which she can use her body to create a variety of shapes and positions – by using the floor area or some simple prop.

Lighting, of course, is something that can be fully exploited in the studio. Although a large soft source such as a window light or bounced light can provide a flattering and effective way of lighting the body, it is also rewarding to experiment with a more creative approach. Try back lighting or rim lighting, for example, and also explore the possibilities of controlling image contrast by lighting the model to create a very soft high-key effect, or use dramatic and contrasty lighting to produce images with bright highlights and rich shadow tones.

One of the problems of a studio session is that it can easily produce pictures which lack atmosphere. There is no opportunity to use the 'instant' props and backgrounds that are available in most location sessions, and the rather sterile atmosphere can easily produce pictures of a similar quality. One way to overcome this is to design and construct a setting for your picture with the use of backgrounds and props, but this is both time consuming and expensive.

An alternative way of creating more atmospheric pictures in the studio is to concentrate on close-up techniques where you can exploit the personality and expressions of your model. Lighting effects can be more finely controlled to produce a more moody and evocative image – in short

you can look for ways in which you can create more intimate pictures. This makes it possible to introduce elements found in outdoor locations without the result looking contrived – a wind machine, for example, or a powerful electric fan can be used to create movement in the model's hair or in her clothing, or the skin can be lightly oiled and then sprayed with a little water. Techniques like these can be used to imply the existence of something beyond the picture area in a fairly tightly cropped shot, whereas in a longer shot it would be recognizably artificial.

It also becomes possible, with close-ups, to make very effective use of quite small props or jewellery, and the basic concept of a picture could easily be built around a small item such as a hat, a necklace or a bracelet. Close-up pictures often have more impact, and in the studio it can be particularly advantageous to think small.

It is time consuming and costly to create an imitation outdoor or indoor setting in a studio, but a great deal can be achieved by suggestion and by the use of simple props and close-up shots. In this picture (above), in which water was sprayed on to a lightly oiled skin, there is no reason to believe that the model has not just stepped out of her bath. Nikon F2 with 105mm lens; f22 with studio flash; Kodak Recording Film 2475.

149

Indoor locations

Shooting with the subject against a window is an effective way of creating bold outlines when there are interesting shapes, as in the composition by Michael Boys (above). The proximity of the girl to the large window ensured that adequate frontal lighting was provided quite naturally.

Even as confined a setting as the back seat of a car (right) can provide interest and a sense of location for this tightly cropped picture by Bob Carlos Clarke, where a feeling of intimacy is important. The colouring and the choice of a period car finely complement each other to create considerable charm and impact.

SHOOTING NUDE or glamour pictures in indoor locations often combines many of the greatest advantages of both the studio and outdoors. The same degree of comfort and privacy as in a studio is available, and at the same time there can be the ease and convenience of daylight, together with the opportunity for more natural settings for many pictures.

For someone who is inexperienced in such work, whether the model or the photographer, the indoor location can be a good place to start. If natural light is being used the photographer does not have to be so concerned with lighting techniques and with moving and adjusting equipment. Most rooms have enough in the way of furnishings and props to provide a nucleus of ideas, and an inexperienced model is much more likely to feel relaxed in such a situation, as both the starkness of a studio and the exposed setting of an outdoor location can be rather daunting.

If the intention is to use natural light, then the presence of a suitable window or skylight is the major concern in choosing a room to shoot in. If, however, you plan to use portable lighting then the character of the room itself can be given the first priority. This can have a considerable influence on the mood of a picture, and if you look at the work of some of the leading photographers in this field you will see how frequently the nature of the setting becomes a dominant element in creating atmosphere. David Hamilton's soft and romantic waif-like nudes are often photographed in cottage interiors with whitewashed walls, simple wooden furniture and natural fabrics, whereas the much harder, jet-set pictures of Helmut Newton are usually shot in rich and lavish settings with highly polished furniture and velvet drapes.

It is important that you should consider your choice of location as a balance of all the elements of the picture – the personality of the model, the lighting and the atmosphere you want to create. It is not necessary to consider the whole room in this way for it may simply provide a convenient space for your pictures, into which you can bring props or furniture from outside; indeed, the quality of the light from the window may be the room's only significant contribution.

In fact it is often the nature of the lighting that makes indoor nude or glamour pictures successful, and frequently a very simple and ordinary room can provide a setting for an out of the ordinary picture if effective use is made of the lighting. A single window can be used to produce a wide range of effects by the choice of model and camera position, together with a reflector or two or some fill-in flash. You can, for example, create a near silhouette by positioning your model against the window and shooting from inside the room, or you could achieve a totally different effect by

A location, such as this interior of a gypsy caravan (left) can give a picture a quality all of its own, while the mirror adds an extra dimension and gives an impression of more space than actually existed. The slender model has been chosen well by Caroline Arber to suit the setting.

Some locations need do little more than provide colours and textures, and a place for the model to be positioned (above). The careful selection of props in this picture formed an attractive picture in a very limited area.

shooting from outside the window with the model in the same position, and the glass creating a soft and diffusing effect.

Window light can also look very effective when it is above the model; you could, for example, position your model so that she is lying on the floor, or on a sofa below the level of the window ledge and quite close to it, and then shoot against the light. This is an effective way of enhancing texture with natural lighting and it can also be used effectively to produce quite abstract images.

There is a good case for fully exploring the possibilities offered by daylight indoors, therefore, and it is also worth considering the effects that can be created with colour materials by mixing daylight and tungsten lighting; 'correct' colour is not always a desirable quality in creative photography, and often the presence of some tungsten lighting in a daylight shot, or vice versa, can add considerable atmosphere.

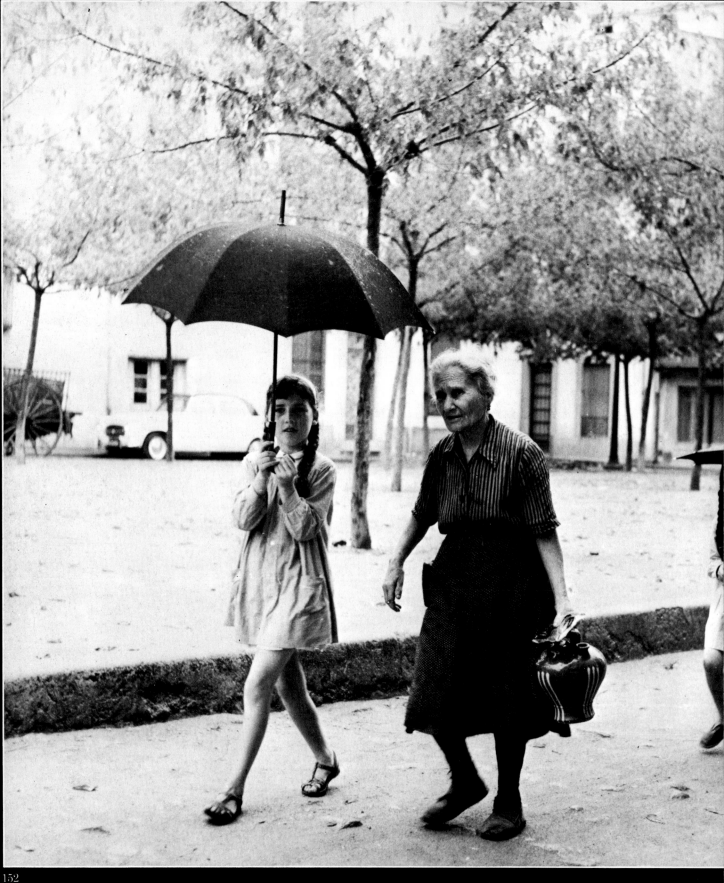

OUTDOOR PHOTOGRAPHY

BY FAR THE GREATEST number of photographs are taken outdoors using daylight, and with modern films and equipment it is almost impossible not to get some sort of result. This, in a way, is the danger. In a studio, or when using lighting indoors, it is necessary to take considerable care simply to ensure an image on the film, and this tends to make the photographer more aware of the relationship between the lighting and his subject.

The fact that virtually no care at all is needed in outdoor pictures tends to produce a large number of passable pictures, but with no thought as to the quality of the lighting. The advice that used to be given with the early films and cameras was simply to keep the sun behind the camera and slightly to one side – sound advice which would almost guarantee

an acceptable result, even within the limitations of the early materials and cameras.

But those early handicaps have disappeared, and now even a simple camera is capable of producing a good image under a wide range of lighting conditions if used with a little care. The emphasis, therefore, should not be on producing an acceptable result but on achieving the best result possible.

An understanding of light is vital to a photographer, and daylight is capable of being controlled and used advantageously just as effectively as studio lighting. All that is required is for the photographer to be aware of its effect on his subject, and to know how to change and control the relationship between the subject and the light by using a number of simple techniques.

Afternoon scene in the Spanish village of San Feliú de Guixols, by Michael Busselle.

Using daylight

SOMEONE ONCE DESCRIBED **photography as 'painting with light', and while this may be a rather pretentious description it is a fact that the relationship between light and the subject is the most vital aspect of photography. When working outdoors, an understanding of how daylight can be used and controlled is as important as is a knowledge of lighting equipment to a studio photographer.**

The sun is a point source of light that, if unobscured, casts a bright hard light comparable to that of a studio spotlight, throwing a sharp, dense shadow. The shadows created by a subject, and those on its surface, give the impressions of shape, form and texture in a photograph. Outdoors these shadows are affected by the position of the sun in the sky, the layers of atmosphere and cloud that filter its rays and by the amount of light that is reflected from surrounding objects.

Even a subject of completely even tones, such as a man in a white suit standing in front of a white wall, can be transformed into an image consisting of a wide range of tones from white to black when lit by sunlight, but the tones will be totally dependent on the angle of the sun, the degree of diffusion caused by cloud, and the amount of light reflected into the shadows.

Daylight varies in three ways – in strength, direction and quality. Its strength will of course determine the exposure you give to the film, but it is the other two factors that influence its effect on the subject. Direction is governed by the angle formed between the camera, the subject and the source of light, whether that is the sun itself or cloud illuminated by the sun. The source obviously cannot be moved, but by moving either the camera or the subject, or both, the direction of light can be controlled in daylight photography. The quality of daylight is dependent upon the degree of diffusion and reflection created by cloud and atmospheric conditions, or artificially.

Hard, unobscured sunlight is perhaps the most difficult to work with since the well-defined and dense shadows that it casts can easily dominate and confuse an image. When you can control the position of your subject – as with a portrait – a solution is to work in an area of open shade cast by a building, or perhaps by a tree. Bright sunlight is rarely attractive for portrait photography; the contours of the face and the features can create ugly and unflattering shadows, and its brightness can cause the model to squint or frown.

When it is not possible to move your subject into open shade it is preferable to position your camera so that the sun is at an angle to the subject so that the proportion of light and shade is not equal. It is better to shoot with a larger proportion of shadow area in your subject and expose accordingly, or to keep the area of shadows as small as possible and expose for the brightly lit part of the image, than to attempt a balance between the two.

When the sun's rays are diffused by atmospheric haze or cloud the shadows that are cast will be less dense and will have a softer edge. The transition of tones from highlight to shadow will be more gradual and the overall contrast of the image will be lower. On a cloudy day the sky becomes one large soft light source and the direction of the light becomes far less critical than with the small, point light source of direct sunlight.

Very strong contrast between light and shadow can make photography in the sunnier, hotter parts of the world more difficult, and in inexperienced hands this photograph (below) could easily have been ineffective. However, by increasing the exposure to compensate for the greater shadow area, and so over-exposing the foreground, the result is an interesting picture; the man's face was also brightened by light being reflected from the foreground. Nikon F with 35mm lens; 1/125 at f11; Ektachrome 64.

The direct sunlight on the vivid warm colours of the walls and the girl's clothes has made this picture attractive (below right). When the angle of the sun casts a shadow over the subject's features, it is necessary to emphasize other aspects in the composition. Nikon F with 105mm lens; 1/250 at f8; Ektachrome 64.

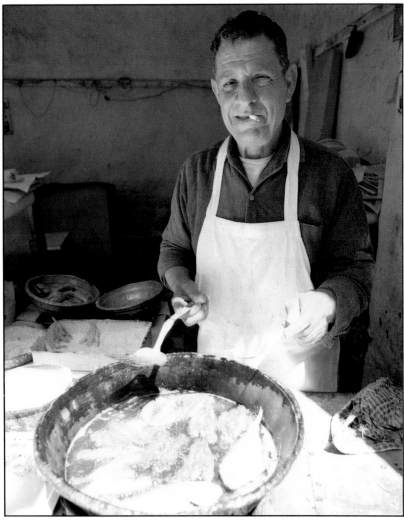

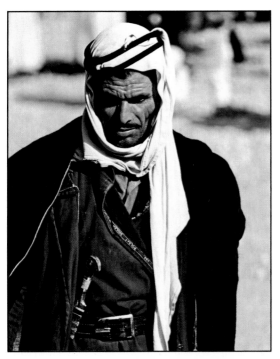

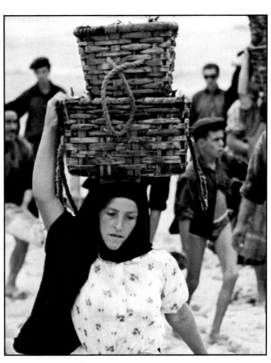

The bright midday sun was ideal for this hard, somewhat threatening subject (far left), but would have been most unsuitable for an attempt to take a softer, more romantic picture.

The much softer evening light (left) produces a far more pleasant light for recording features, and its more diffused quality enables expressions to be seen on people who are at different angles to the camera.

On a bright, sunny day, open shade usually provides the best conditions for photographing people. The more even light under the trees in this photograph (below) has allowed the photographer to capture the girls' expressions and the richness of the blue uniforms. In direct sunlight exposing to record the facial details (shaded by the hats) would have bleached out the colour of the dresses.

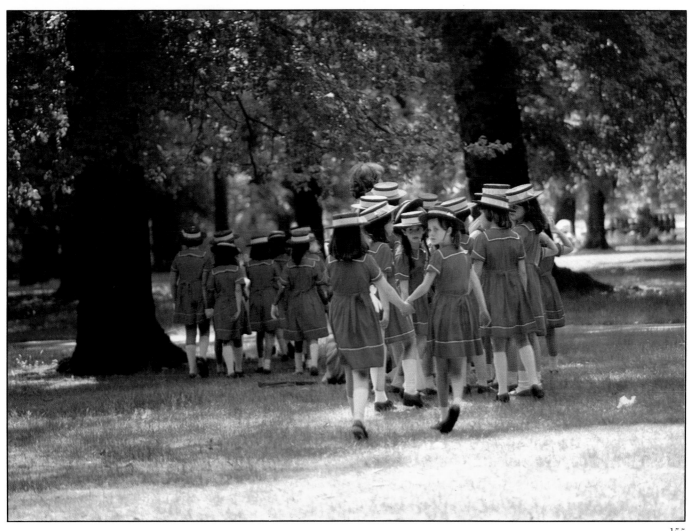

Shooting against the light

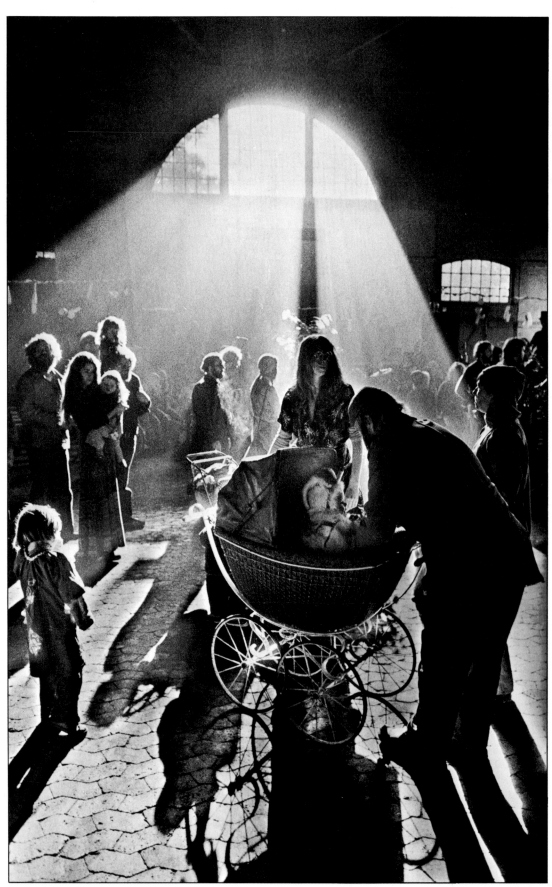

In this picture by Mark Edwards the back lighting itself has become the main part of the picture (left) creating a dramatic image with strong highlights and outlines. The exposure, calculated for the areas of highlight, has allowed the foreground figures to become near silhouettes.

The back lighting in this photograph of a farmer in the South Tyrol (right) has been partially balanced by light reflected against his face from a white wall in the foreground.
Pentax with 135mm lens; 1/125 at f5.6; Ilford FP4.

THE GREAT MAJORITY of outdoor photographs are taken with the sun at an angle of up to 90° to a line drawn between the camera and the subject. There are many occasions, however, when it can be very effective for the sun to be behind the subject, with the camera pointing towards it; this can create images with a dramatic impact and can produce very pleasing lighting effects.

One problem with shooting into the sun is that it can produce flare which is caused by the sunlight falling directly on the camera lens and results in light being scattered indiscriminately inside the optical system. The effect is to drastically reduce the contrast of the image, creating a fog-like effect and often causing the shape of the iris diaphragm to appear as a hexagonal or circular highlight.

Modern camera lenses are given a special coating which greatly reduces this effect, but it can still occur if the lens is not protected from the direct light of the sun. An efficient lens hood is a useful accessory, but it is possible to get even more effective protection when the sun is very close to the edge of the picture by using your hand as a shield, or by 'hiding' the camera in the shadow of some other object in front of the camera – the branch of a tree for example.

When the sun itself is actually included in the picture area it is impossible to use these techniques, and you must either hope to turn the effect it creates to a pictorial advantage or, by manoeuvring the camera, hide the sun behind some object within the picture area. Flare can be used to create a very pleasing effect – especially with colour film as it also reduces colour saturation, producing images of delicate pastel hues. But it is difficult to control and a camera with a through

the lens viewing system, as in a single-lens reflex, is necessary to be able to anticipate the effect.

Another problem with shooting into the sun is that of judging exposure. Because the light is shining towards the camera and is also creating bright highlights, the meter will indicate an exposure somewhat less than that actually required, and it will be found that one or two stops more exposure will be needed. An alternative method is to take a very close reading from the most important part of the subject, ensuring that the meter is shielded from direct sunlight. With a separate exposure meter, the incident light method could also be used.

One considerable advantage of shooting against the light occurs in bright sunlight, where heavy shadows would be created by front or side lighting. Shooting from the other side can produce a softer image with more evenly balanced tones.

Back lighting will also help to isolate a subject from a confusing and distracting background. In a portrait, for example, this technique can produce an attractive rim of light around the hair or profile which will effectively separate the model from surrounding details.

Shooting against the light can, however, produce excessive contrast, beyond the limit of the film's tolerance. The solution is either to give sufficient exposure to record the shadow areas of the subject and allow the rim lit details to bleach out, or to expose for the highlights and allow the remainder of the subject to record as a silhouette. A further possibility is to reduce the lighting contrast by the use of reflectors or fill-in flash, and this effect can often be achieved naturally when shooting in very bright surroundings, such as on a beach or in snow.

The exposure used in the photograph of actress Jane Seymour (above) correctly captured the details of her face and her skin tones, and as a result her back lit hair was over-exposed, creating a rim of highlight and an isolation from the background.

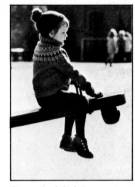

Strong back lighting creates a rim of highlight around the child's face (above) separating it from the dark background at the top of the picture. The lower, darker part of the subject is silhouetted against its bright background.
Nikon F with 105mm lens; 1/250 at f5.6; Kodak Tri-X.

157

Daylight & colour

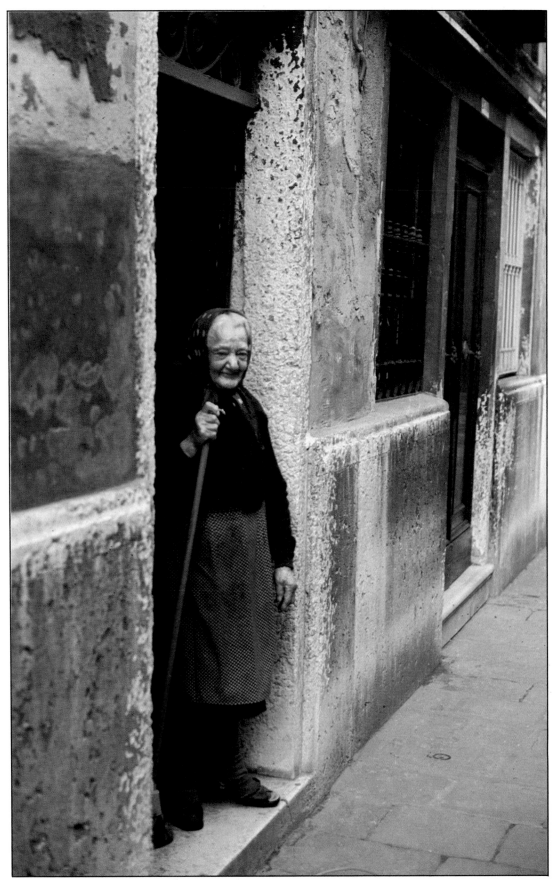

The neutral grey that this picture depends on for its effect (left) would be disturbed by a warm colour cast in the lighting. The same scene photographed in late afternoon sunlight would gain a warmer colour, giving the image a quite different quality.

The blue cast that results from shooting in open shade, particularly when there is a deep-blue sky and bright sunshine, can be a hazard but in this Moroccan market scene (above) the blue cast has enhanced the image.

The warm quality of late afternoon sunlight has created a pleasant glow in this picture of a Brittany farmer (right), enhancing his ruddy complexion and the colour of the horses' coats.

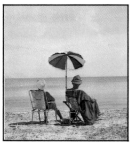

Sea, sky and bright sunlight could ruin an attempt to capture soft colours, and a preponderance of cool blue would conflict with the expected warmth of the setting. In this picture (above) the bright beach umbrella, although small, adequately conveys an impression of a warm day.

COLOUR TRANSPARENCY FILMS **are manufactured to give an accurate colour rendering under very specific conditions. Tungsten film for example is balanced for a colour temperature of 3,200° Kelvin, while most daylight films are balanced for 5,500° Kelvin, which is the colour temperature produced by noon sunlight in summer. Our eyes are very tolerant of shifts in the colour quality of light and it takes quite a dramatic change for us to become aware of it. Colour film, however, is not so tolerant, and even a small change in the colour temperature of the light source will be recorded; this is particularly true of skin tones, where only a slight colour cast becomes very noticeable.**

It is possible to buy a colour temperature meter that is similar in operation to an exposure meter but measures the colour quality of the light source instead of its strength. The reading enables the user to calculate what strength of filter is required to offset the colour cast that would otherwise be caused by the light source.

Such an exact method is seldom necessary for any but the most critical work, and in most circumstances it is sufficient simply to be aware of the possible variations in the colour quality of daylight and to be able to predict the colour cast likely to result from a set of circumstances, even if it is not possible to see any effect.

Daylight, as we know, becomes more orange, or warmer, as the sun gets closer to the horizon, although the effect is minimal until within about two hours of sunset. Pictures taken at this time of day will have a distinct orange/yellow cast unless a colour correction filter is used. The filters needed to correct this cast have a bluish tinge and can be bought in the Wratten 82 series – 82A, 82B, 82C etc, each being progressively stronger.

The colour quality of daylight can also become more blue, or colder, than that for which the film is balanced. Various conditions can create this problem – overcast skies with thick cloud, for instance. In high altitudes and near the sea there is an excessive amount of ultra-violet light, which is not visible but will be recorded by the blue-sensitive layer of the colour film. In these situations the colour cast can be avoided by using correction filters with a yellow/orange tint in the Wratten 81 series – 81A, 81B, 81C, etc.

A blue cast can also result when pictures are taken in open shade on a sunny day when there is a bright blue sky and little cloud. Because the subject is shielded from the direct light of the sun, the illumination comes mainly from light reflected from the sky, and a blue cast will be recorded unless a correction filter is used.

Any situation where sunlight is reflected from large surrounding areas of strong colour onto the subject is a potential cause of a colour cast – taking pictures under trees, for example, can create a green cast. In general, skin tones which display a blue or green cast are noticeably unusual and rather unpleasant, whereas a warm cast tends to be more acceptable – and in some cases can contribute to the effect of a picture. The 'cold' colour casts should be considered a greater hazard to the portrait photographer.

Reflectors and diffusers outdoors

The lighting outdoors is seldom exactly right for photographing people, even on a fairly overcast day, but a photographer can use a variety of accessories and exposures to get the effect he desires.

In the first picture in this sequence (right) the exposure was set to record the sunlit highlights, resulting in a contrasty picture with deep shadows. Exposing to record more detail in the shadow (bottom left) burns out the highlights. To keep the highlights, but record detail that is in shadow, light has to be added to the shadow areas. This can be done by using a reflector to direct light into the shadow, or by using a small flash unit as a fill-in light, as has been used here (bottom right).

WHILE IT IS USUALLY possible to achieve an adequate degree of control over outdoor lighting by the choice of camera viewpoint, it can be well worthwhile considering artificial aids when you have more control and the model can co-operate with you, such as in portrait or glamour photography.

By far the most useful accessory is a simple white reflector. This can be anything from a piece of white card or foam to a sheet of white fabric stretched over a metal frame. With tightly cropped pictures, as with a close-up head shot, even a very small reflector can be effective if used close to the subject – the pages of a book or magazine can provide a considerable improvement. The reflector should be positioned on the shadow side of the subject and angled so that the optimum degree of light is reflected into the shadow areas. The closer the reflector is to the model the greater the fill-in effect will be.

Where three-quarter or full-length shots are being taken a larger reflector will be required as it will need to be farther away from the model in order not to encroach on the picture area. A stronger effect can be obtained by using a reflector with a metallic silver surface, and sometimes a metallic gold finish is used to create a slightly warmer effect in colour photographs. These shiny reflectors are more directional than matt white

Direct sunlight on to a model's face can result in unpleasant shadows, or cause the model to screw up her eyes against the glare. Shooting into the light, even on a hazy day, and using a reflector or a mirror to bring out detail in the shadows, can be an ideal solution to outdoor lighting problems (left and far left).

Various arrangements of reflectors are possible using collapsible lightweight units (below) and simple reflectors can be made from paper or plastic stretched over a wooden frame. Some reflectors use a silver or gold metallic finish for a stronger reflection, and the latter gives a warm glow with colour film. If a translucent material is used, the reflector can double as a diffuser by placing it between the main light source and the subject. A black reflector is usually identical in shape and construction, but covered with a dull black material.

If you do not have even a makeshift reflector handy, such as a newspaper, a portable flash-gun can be used to light the shadow areas.

versions and the angle needs to be adjusted more critically. An ordinary mirror can be used to create even more noticeable concentrations of light – to highlight hair, for example.

A black 'reflector' can also be a useful device. It is positioned to prevent light being reflected from surrounding objects in order to create a more dramatic effect, or to shield the model from some of the light source itself. Often in outdoor locations, even out of sunlight, there can be too much top light from the sky, which can create unpleasant shadows under the eyes, nose and chin. An opaque or black reflector can be supported above the head to alleviate this effect.

Diffusers are large sheets of white translucent fabric, paper or plastic which are positioned between the model and the main light source. Their effect can be particularly useful in bright sunlight conditions where a diffuser will soften shadows and reduce lighting contrast. Diffusers are widely used by professional photographers shooting fashion or glamour pictures, and lightweight portable kits can be bought with telescopic stands and frames to support the fabric, enabling them to be used as reflectors or diffusers. Even a modestly talented handyman should be able to put together a useful lightweight reflector/diffuser system at little expense.

One other convenient method of providing additional control in daylight situations is to use electronic flash. Where the subject is fairly close to the camera – up to say 20ft (6m) – even a small flash-gun can be used effectively to balance excessive lighting contrast, and of course on colour film flash will match the quality of daylight. Use the guide number of the flash-gun to calculate the aperture required, then set it at one or two stops less than the correct exposure. This is to ensure that the flash remains a secondary light source – to give the correct flash exposure would result in a picture with a noticeably artificial lighting effect. Having decided on the aperture, the shutter speed should be selected which gives the correct exposure for the highlight areas of the subject that are lit by daylight.

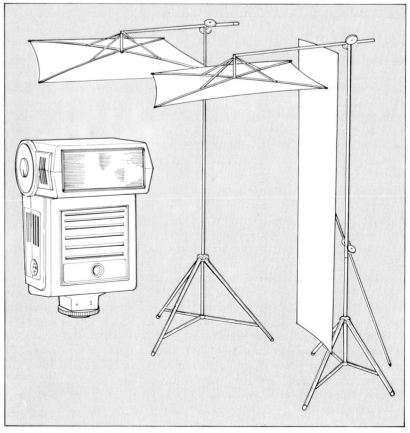

Colour & mood

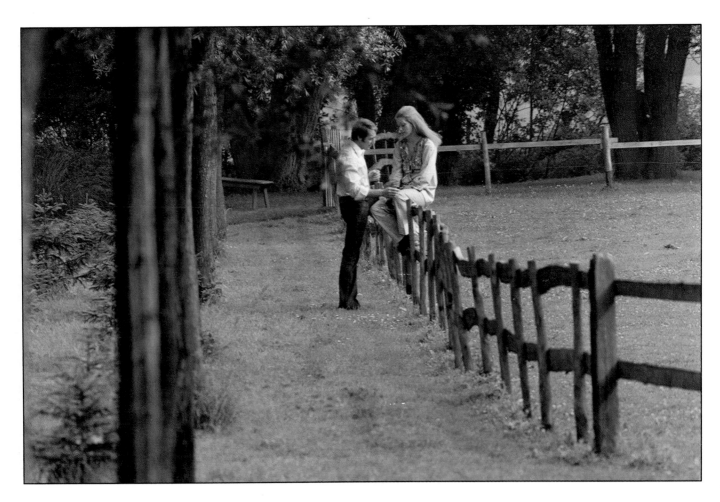

THE USE AND CONTROL of colour is an effective method of helping to create mood in a picture. The way we react to an object or a scene often has as much to do with its colour content as with other factors.

In terms of emotional response the colours of the spectrum can be considered in a number of ways. The colours at the red/orange/yellow end of the spectrum are called warm colours, and those from the blue/indigo/violet sector are considered cool. Of the warm colours, orange and yellow have an inviting and comfortable quality, reminiscent of log fires or summer sunlight, whereas red has a more aggressive and assertive nature, with connotations of danger. The restful and reassuring qualities of green and blue associate with the colours in a peaceful landscape – green fields and trees, blue skies and calm seas – but the darker hues of indigo and violet take on a more sombre and depressing aspect.

The tone of a colour will also affect its contribution to the atmosphere of a picture. Bright, fully saturated hues, for instance, will create a lively and exciting image, whereas pale pastel tints will suggest a rather more delicate, romantic mood and the darker tones will imply mystery or intrigue.

The skillful use of colour has long been recog-

nized and exploited by the image makers of the media – the bright bold colours used in advertising posters, for example, are so full of visual excitement and vitality that they compel you to look at them. On the other hand, photographers like David Hamilton and Sarah Moon have developed the romantic qualities of the softer, gentler hues to create ethereal, pastel images that seem almost like paintings.

It is vital that the colours you use in a picture contribute to the mood of the subject or to the atmosphere you wish to create, as just one splash of inappropriate colour in a picture can totally destroy a mood. The obvious method of controlling the colour content of a picture is by careful selection of the image area, being sure to exclude any parts of a scene containing colours that conflict with the mood of the picture. When planning and shooting pictures with a model, of course, it is possible to select background colours and clothes that will contribute to the atmosphere you want to create.

A degree of control over the colour quality of an image can also be achieved by the use of camera techniques. Exposure adjustment can be used, for instance, either giving less than the meter indicates to create more subdued colours, or slightly

The gentle green and the soft lighting of this picture (above) creates a relaxed, pastoral quality that is enhanced by the models' informal pose.

Bright, saturated colours invariably create a more lively and vigorous image (above right) that has been strengthened in this urban scene by a slight degree of under-exposure. Hasselblad with 80mm lens; 1/125 at f5.6; Ektachrome 64.

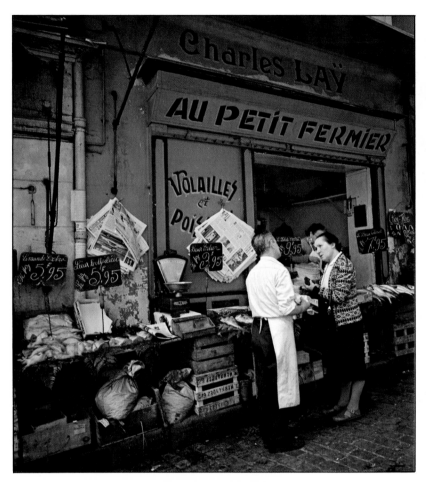

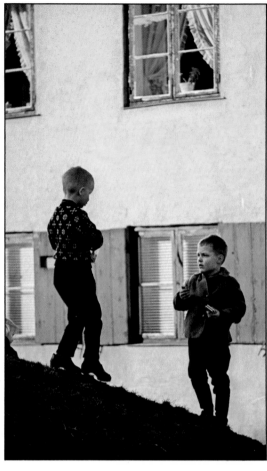

over-exposing to obtain paler, softer hues. This needs to be done in a considered way; under-exposing a subject with a high contrast range where there are dense shadows would result in an image with the darker tones 'blocked up' and devoid of detail. In a subject with bright highlights, over-exposure will cause these to bleach-out. In general both extremes of exposure are more effective when the subject has low contrasts, without excessively dense shadows or bright highlights, and it also helps to use a softer film with a greater exposure tolerance.

Effective use can be made of colour correction filters to create or enhance an existing colour bias in a picture. The cool blue quality at dusk, just after the sun has gone down, can often benefit by being made a little more blue by the discreet use of, say, a CC10 blue filter. Graduated filters can also be useful since they enable a colour cast to be introduced into only a part of the image, leaving the remainder unaffected. A bright blue sky in what is intended to be a sombre picture could be subdued by using a grey, violet or even a brown filter, for instance. A polarizing filter can also be used to accentuate bright colours in a picture by subduing the weakening effect of surface reflections.

The effect of the warm-toned background in this urban scene (above) was retained by allowing the foreground figures to become near silhouettes. Exposing to give foreground detail would have given the colours of the building a more pastel quality. The diagonal created by the camera's position has added to the strength of the composition.
Nikon F with 105mm lens; 1/125 at f5.6; Ektachrome 64.

Over-exposure and the soft focus effect have created a rather romantic picture of a girl (far left) with pastel colours of a limited range. Pentax 6 × 7 with old magnifying glass lens mounted on extension tube giving blue edging; 1/500 at approx f2.8; Ektachrome 64.

Photography in poor weather

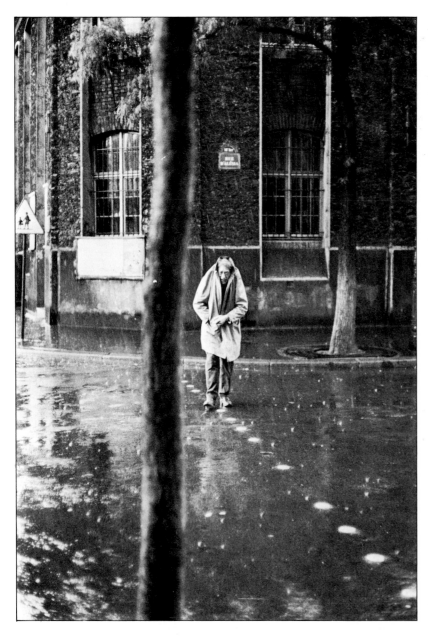

A wet Paris street (above) provided Henri Cartier-Bresson with an effective setting for a slightly surrealistic picture of Giacometti hurrying through the rain. In an urban environment rain can add sparkle and highlights to a scene that would otherwise be rather dull.

MANY PHOTOGRAPHERS tend to be conservative in their attitude towards the weather and lighting conditions in outdoor photography. This is perhaps a consequence of the early days when it was simply not possible to record an image unless there was bright sunlight – and until recently a simple camera would give satisfactory results only in the brightest conditions. But modern high-speed films have now made it possible for the owners of even the most inexpensive cameras to take pictures at quite low levels of illumination.

Because the vast majority of amateurs' photographs are taken in sunny or bright conditions, it is likely that any photograph taken in rain or snow will automatically produce an image that attracts attention. Such conditions do, however, require special consideration if the best image quality and pictorial effects are to be achieved.

The advantages of shooting even on a merely dull day can sometimes be quite considerable. For instance, a subject that is rather fussy and contains much detail, such as a crowd scene, may well produce a more effective image on a dull day, when the light is very soft and flat, than it would under brighter conditions that would produce too many shadows or too much contrast.

Most 'adverse' lighting conditions produce a softer light with a corresponding reduction in image contrast, and this will benefit any subject with an inherently high brightness range – and in addition low contrast can itself produce an effective pleasing quality. An exception to this is when it is raining, especially in urban areas where the normally flat grey gradations of roads and concrete are transformed into bright and sparkling tones by the reflections on the wet surfaces – street lighting at dusk or at night can produce images of very high contrast.

One of the ways in which weather conditions can be made to contribute pictorially is by creating a mood. The atmosphere created by fog or mist, for example, is almost totally visual, and the photographer does not have to resort to any special techniques in order to create it. The same is also true of rain and snow, and even a very grey day can add atmosphere to a scene – a picture of an industrial setting, for instance, would look more evocative under a dull grey sky than if it was photographed on a bright sunny day.

Some people may be deterred from going out on a wet day to take pictures by the fear of damage to their equipment, but providing elementary precautions are taken no harm is likely to occur – as long as the camera is dried with a soft cloth immediately after use, a hairdryer can be used on returning home to ensure that no drops of water are left in inaccessible places. You should, however, take great pains to protect your camera from salt water or sea spray because these have a very harmful corrosive effect if allowed to remain for any length of time. It is a very simple matter to make a cover for your camera from a plastic bag, with a hole cut into it for the lens to protrude. If the cover is made to fit quite loosely the controls will be manoeuvrable from outside the bag.

Low contrast subjects require quite critical exposure assessment, especially with colour materials, as the absence of dense shadows or bright highlights tends to produce an image which is very responsive to exposure variations. A slight amount of over-exposure will produce very pale high-key images, whereas a small degree of under-exposure will create a much more sombre picture with grey, murky tones. Where possible it is wise to bracket the shot by making additional exposures half a stop either side of the calculated setting.

Snow frequently releases uninhibited jollity, providing an observant photographer with unusual opportunities (left). The white background emphasizes the shapes and juxtaposition of these figures; snow and mist are ideal backgrounds for subjects with bold shapes.

A sudden downpour in Louisville, Kentucky, caught these school-girls unprepared (below left) but they, like the photographer, found something enjoyable in the experience. Raindrops – and snowflakes – show up best against dark backgrounds.

After months of winter, there is little pleasure in wet snow, particularly for an old lady who has to do her shopping (below). This snow scene has caught the discomfort of cold and snow, and the two people scurrying in the background reinforce the woman's plight.

Special lighting problems outdoors

In this photograph of a mountaineer (above) the spray of ice, strongly back lit by the sun, created a striking image that sufficiently detracts from the blue cast given by the combination of high-altitude ultra-violet light, and the lighting of the ice from the brilliant blue sky.

SOME SITUATIONS PRESENT a particular problem because of the unusual lighting conditions. One that is commonly encountered when shooting pictures on a beach, in snow or at high altitudes is the effect of varying amounts of ultra-violet light.

The visible spectrum is only a portion of the waves of radiation reaching the earth. Red represents the longest visible wavelength and violet the shortest, but beyond violet is ultra-violet which, although invisible to the human eye, will be recorded on film and will have the effect of creating a blue cast on colour photographic materials.

It is possible to mount a special colourless glass filter in front of the camera lens that will not affect exposures or the colour quality of an image except by reducing the blue cast that would otherwise result. Many photographers prefer to leave a UV filter or a 'skylight' filter permanently in position since they do protect the lens and have no adverse effects even when not required.

However, it is unwise to use more filters than necessary since this practice may adversely affect the performance of the lens. When other filters are being used it is preferable to remove the ultra-violet filter if it is not needed. Another factor which compounds the problem when ultra-violet light is present is the reflection of large areas of blue sky into open shadow areas. This quite frequently happens in snow scenes, for instance, in which case a filter with a stronger effect than the UV, such as a Wratten 81A (a pale straw colour) can be used to greater advantage.

Another method of improving the image quality in conditions where there is a considerable amount of light being reflected and scattered is by using a polarizing filter. Much of the light which is reflected from surfaces such as water, sky, snow, sand, glass and even foliage has its vibrations altered (polarized), and a polarizing filter rotated to the optimum angle will intercept some of these reflected waves, so eliminating glare. The polarizing filter is a neutral grey in colour and although it requires an exposure increase of 1 or 2 stops it will not affect the colours of a subject other than by removing glare, most noticeably from the sky, and so increasing their strength and 'depth'.

One situation which often results in disappointing pictures is a sunset. The area of sky which creates the most dramatic effect of a sunset also happens to be the light source, and because you are shooting towards it you are in effect using back lighting for the foreground.

An exposure which records adequate detail in your subject will result in the sunset itself being considerably over-exposed, and this will produce pale, weak tones with greatly reduced colour saturation of the sky. It is often more effective simply to treat your subject as a silhouette, making no attempt to try and obtain detail but simply to ensure that the position and outline of your subject creates an effective image in juxtaposition with the sunset.

An alternative method is to use a portable flashgun to illuminate the foreground subject independently, enabling the background exposure to be calculated for the most dramatic effect. Graduated filters can be used effectively with sunset scenes when the foreground subject is confined to the lower half of the image. The filter can be adjusted so that it darkens the sky at the top half of the frame but leaves the exposure of the lower half of the image unaffected. A neutral graduated filter can be used to increase the density of the sunset, or a tinted version, such as a brown or a pink, can add a more dramatic effect to the colour of the sky.

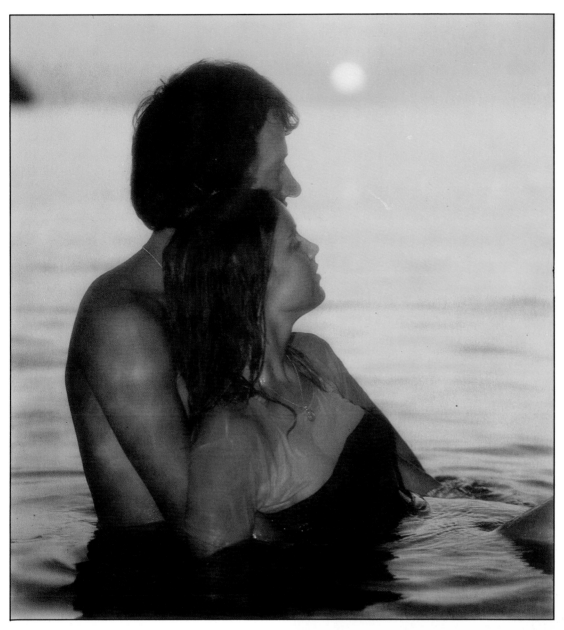

While an ultra-violet filter will reduce the blue cast frequently caused by sunlight and clear blue skies, some scenes, such as this snow scene (above) may call for a stronger, slightly yellow filter. A blue cast would have spoiled the bright sunny atmosphere.

Exposing to reveal even the small amount of detail shown in the foreground figures (left) would have resulted in a pale, washed out sunset. Instead a reflector has been used to add fill-in light of the same colour, so avoiding a pure silhouette.

Although a polarizing filter will reduce haze, a bluish 'aerial perspective' is created even on the clearest day by ultra-violet light (below left). This can be removed by using an ultra-violet filter, but this correction is not always wanted.

In some photographs of sunsets, silhouettes can be a vital part of the composition, as in this picture of a Mali fisherman (below). The fast shutter speed required for this photograph made it impossible to record foreground details.

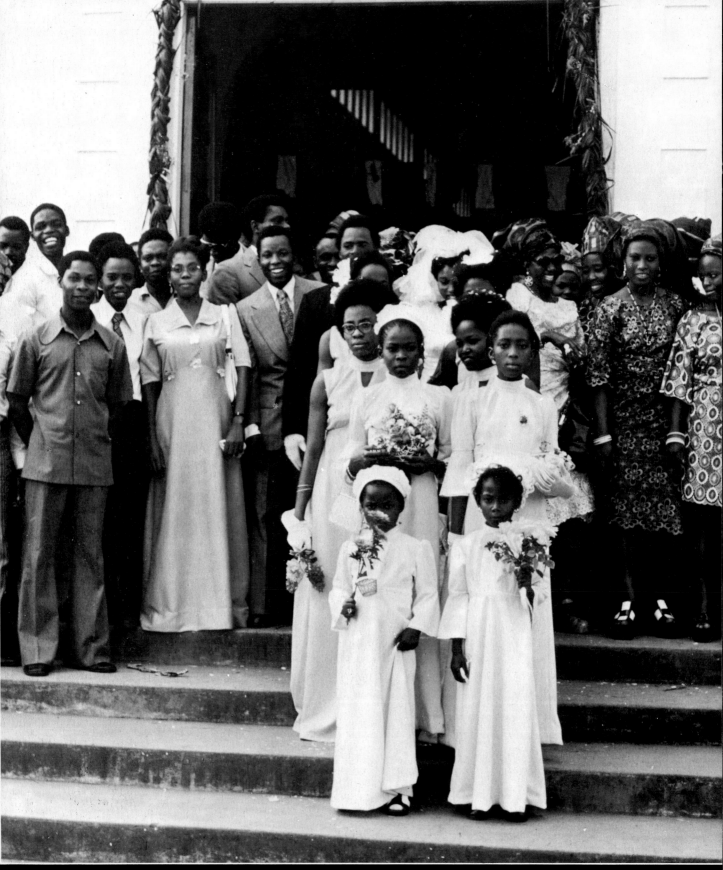

PHOTOGRAPHING GROUPS

FOR MOST PEOPLE, the opportunities and challenges of photographing groups of people, or couples and children, are likely to involve their families and friends, and 'family photography' occupies most of an amateur's time behind the lens. There can be very few families in our society that do not own at least one camera and the ability to make a permanent record of the growth of a family and the events and occasions that would otherwise only be memories are what prompt most people to buy a camera in the first place.

Many professional photographers first developed a taste for the pleasure of photography simply by having a go with the family camera, and it is a pity that there should be a division between those who treat the subject seriously and produce good photographs, and those who only take snaps of the family – especially as the effort involved in making a visually pleasing record is little greater than that which produces disappointing and boring results.

Even if you have no wish to be a 'serious photographer', the mere fact that you consider it important enough to own a camera means that it is worthwhile being able to take pictures you can look back on with pleasure, and not only for the memories they evoke.

In some ways the simplicity of the modern camera has not only made it easier to produce a good technical result, but it has also made it easy to take pictures without thinking about the visual quality. Many inexperienced photographers blame their disappointing results on the fact that they own modest equipment, but even the most humble and inexpensive camera of today is far more advanced than the instruments with which many of the great early photographs were produced. It is important to remember that good pictures are taken by photographers and not by cameras – a simple camera used by someone who is observant and careful will always produce a better photograph than a Hasselblad or a Nikon in the hands of a snapshooter.

Benin wedding, Nigeria,
from a colour transparency by
Dennis Moore.

Weddings

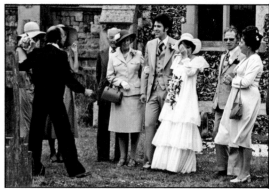

IT WOULD BE MOST UNUSUAL **if an amateur photographer was not approached once or twice by friends or family with a request to photograph a wedding. The first time can be rather a daunting prospect, even if the people involved are well-known to you, but the secret of shooting a wedding in a relaxed way is to plan it carefully and work to a system.**

The first step is to ask your prospective clients exactly what they would like and what they definitely do not want. They may, for example, want you to shoot pictures at the bride's home before she leaves for the church, and they may also want you to take pictures in the church as they walk up the aisle. Perhaps there will be a group of friends or family from far away who are rarely together, and of whom they would like a record. Next you should plan a schedule, noting the times at which people are expected to arrive at the church, when the ceremony starts and finishes, what time the cars will leave for the reception, etc.

It is also wise to visit each of the locations at which you intend to shoot pictures. Look out for suitable backgrounds and check if there are likely to be any special lighting problems. You should also obtain in advance any necessary permission

to take pictures in the church, vestry or registry office. It is also advisable to work out in advance approximately how many exposures will be needed at each stage, so that you can arrange to reload during a lull in the proceedings.

It is worth remembering that both before and after the occasion you are likely to be considered a fairly important part of the arrangements, but on the wedding day itself you are more likely to be thought of as rather a nuisance who holds up the proceedings and interrupts events – so it is vital that you carry out your activities with the minimum of fuss and delay.

Pictures taken before the ceremony can usually be made in a fairly relaxed way providing that you arrive in good time and have already planned exactly what you want to shoot. It is after the ceremony, when the main groups of people are usually taken, that the pressure becomes greater. You will already have established the best place to take these photographs, and after the bridal couple have emerged from the church and received their congratulations you should whisk them off on their own to your location and take the 'bride and bridegroom' pictures quietly – hopefully away from onlookers. After this you should enlist the

Many of the photographs that will be enjoyed most will be the 'unofficial, unposed' pictures, such as the three above. Even if you are the official photographer for the wedding, you should keep an eye open for informal scenes like these.

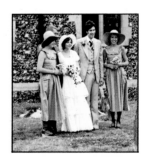

A photograph of the bride and groom and attendants is always essential (above). Because many prints will be needed, it will usually be best to use colour negative film.

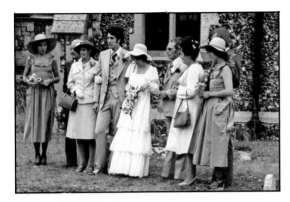

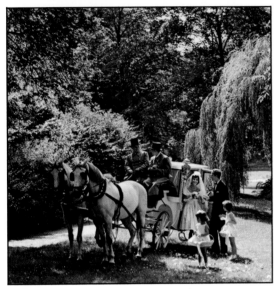

The best wedding album will contain a mixture of formal posed pictures and informal ones that cover the whole occasion, such as the photographs on this page. The most important people on the day, the bride and groom, seldom see (or remember) a great deal of their own wedding, and rely on photographs to show and recall the whole occasion.

A certain number of posed pictures are expected at a wedding, and the most common are (above, from top) the bride, bride and groom, bride and groom with attendants, bride and groom with parents, bride and groom cutting the cake, and, if possible, all the principal people together.

help of the best man or one of the ushers to bring in the other people who will be photographed in the traditional groups.

It is much easier to quietly build up the group from the smallest unit to the largest than simply to allow everyone to congregate, and then be faced with the problem of sorting them out (and do not forget to allow time for special requests). If you are going to shoot pictures of the bride and groom leaving in their car for the reception, it is a good idea to let this happen naturally while shooting pictures, as often spontaneous shots like this are better, but as a safeguard you could stop them before they leave and do a more posed picture. While family and friends will probably love the more casual shots, the bride and groom will often prefer to see themselves more composed.

If the organization and formality of conventional wedding photographs seem too daunting, it is far better to persuade the couple to employ a professional wedding photographer to shoot the more formal pictures and to allow you to concentrate on producing a set of more spontaneous and informal shots. Often these have a greater appeal – and there is rarely time for one photographer to take both types of picture.

Formal groups

Formality takes various guises, and this photograph (above) uses lighting techniques, expressions and composition that suit the image of a young, aggressive and ambitious pop group. In almost every photograph of a group there is bound to be some sort of hierarchy to be referred to, but the leader may not always be the physically most dominant person in the group. If this is the case, it is up to the photographer to arrange the group and to choose his viewpoint and lighting so that there is no ambivalence in the final image.
Pentax 6 × 7 with 55mm lens; f16 with studio flash; Ilford FP4.

A straight line of people is seldom attractive except in some very formal and traditional situations, such as for a football team photograph. Julia Margaret Cameron, in her picture 'Rosebud Garden of Girls' (above right) has used a curving composition in which all the people are on the same plane, but are posed at different heights.

THE MAIN PURPOSE of a group photograph in most cases is to provide a record of all the people present to mark some special occasion, and simultaneously to provide a momento for each of them. It follows that the prime requirement of a formal group picture is to show each individual's face as clearly as possible; because of this, the way that the photograph is arranged and lit is vital to how successful it will be.

A small formal group of people – at a wedding, for example – can be organized simply by arranging them in a line, shoulder to shoulder. But this can be done only when there are not more than about eight people involved, otherwise the proportions of the image will become excessively long and narrow. Even for six or seven people, it will help if the line curves slightly so that those at the ends are a little in front of the people who are in the centre of the group.

When more than eight are present it is necessary to find some way of making second or third lines in front of and behind the principal row. With something like a team photograph this is usually accomplished by having a row of people kneeling or squatting in front.

Obviously this is impossible when people are more formally dressed, in which case extra rows must either be seated in front, or raised up behind the standing line. Sometimes you can achieve enough separation between the relative heights of the rows simply by positioning the taller people at the back and staggering the rows so that those behind are seen between the heads of the front row for greater clarity. On some occasions it is possible to make use of a natural slope in the

ground; rows of steps can often be found, and, depending on the background, could do perfectly. Try to avoid placing the back row on a shaky bench – it is bound to affect someone's expression.

The problem of ensuring that each person in the group is not only looking towards the camera but also has a suitable expression can be achieved only by a positive and rather extrovert attitude on the part of the photographer. Particularly with a large group of people, it is necessary to get everyone's complete attention – very much a 'watch the birdie' situation since it needs the attention of only one of the subjects to wander for the picture to be spoilt. Some photographers tell jokes, others simply shout; whatever method you employ it is vital that you establish your presence in no uncertain way.

It is a positive advantage to have your camera mounted on a firm tripod for this type of work – and have it set up before you start to arrange the group. Not only is it vital for the image to be critically sharp in a group photograph, and for any possibility of camera shake to be avoided, but you will find it far easier to establish rapport with the group if you do not constantly have to peer through the viewfinder. Once the camera is positioned and focused you can communicate directly with the people you are photographing.

Lighting is an important factor because the crucial part of the image, the people's faces, occupies only a small area of the picture and yet the faces must be carefully lit. A soft light which creates the minimum of shadow is the most effective in normal circumstances. Lighting that creates strong, well defined shadows, as on a bright sunny day, is best avoided. The ideal

lighting conditions for group pictures are those that are found on a cloudy or hazy day when the sun is partly obscured.

If you are faced with shooting on a sunny day, with a bright blue sky and no prospect of a convenient cloud, it is usually possible to find an area of open shade, such as the shadow of a building or large tree. If even this is not possible it is worth considering shooting the picture into the light, so that the people are in fact creating their own shade – but be careful that the sunlight does not strike the camera lens, and be sure to allow for the extra exposure that is required when you are shooting into the sun.

In more informally posed group photographs, such as this family gathering (above), the photographer need not concentrate so much on getting undivided attention, but he may have to take a number of exposures quite rapidly to be sure that in at least one everybody looks reasonably presentable.

The traditional formal family portrait, such as this one of Tzar Nicholas II of Russia and his family (left), has a timeless quality that makes its composition no less suitable for many modern families.

173

Family occasions

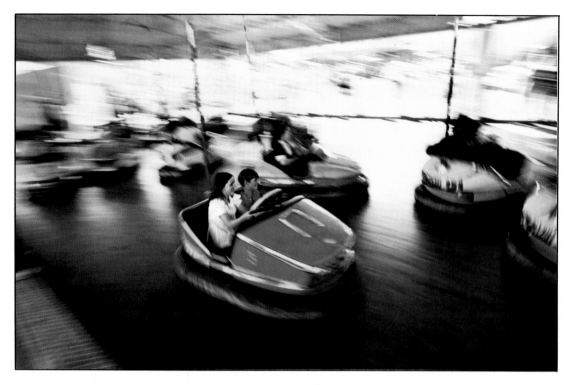

A chronicle of memorable events for the family album is more likely to call for a quick eye for a picture than for careful expertise and detailed posing instructions. The skills you gain through practice will help you to spot those occasions. Some scenes, such as this one in an amusement park (left) will be best captured with a wide-angle lens, and familiarity with the characteristics of different pieces of equipment will enable you to see and take better pictures.

ONE OF THE WELCOME BENEFITS **of being a photographer, whether professionally or as a hobby, is that it gives you the opportunity to make a record of the events and occasions in the life of your family, with the result of not only evoking pleasant and nostalgic memories for you in years to come, but also of providing a unique gift for future generations. It is really worth making every effort to produce at least one or two attractive pictures of every important occasion.**

It has been said that photographers never actually see things happening, only the image reflected in their viewfinders. But if this is true it is more than compensated for by the fact that they are able to produce a lasting visual record, and not just acquire a transient memory. Although the most important element of these pictures will be the subject itself, and the purpose at the time of making the exposure is not to produce a great masterpiece, the pleasure of looking at the picture in the future will undoubtedly be enhanced if it is also a good photograph.

The sort of occasions that become milestones during a lifetime are so varied that it is not possible to formulate any particular method of recording them. One week it may be a children's party with a dozen excited seven year olds crowding round the birthday cake and the following week it may be your grandparents' golden wedding anniversary or the school sports day.

It may well be that the complete family album will call on every photographic technique and skill you ever learned to do it full justice, convey-

ing everything from formal portraits to action pictures. While it may be out of place to turn such events into photographic sessions it would at the same time be a great pity not to use your abilities to create the most evocative pictures you can – if the birthday party would look even more festive when shot with a star filter, why not use one?

Many occasions can severely test your skills and your quick responses. The last thing you want is to spoil the atmosphere by issuing instructions, and very often the best shots will not be of the whole gathering, but segments of it – two people sharing a joke or watching someone else, a child suddenly overcome by tiredness or too much excitement. So, depending on the size of the room, something like a 70–150 mm zoom lens might give you an ideal range of opportunities, in addition to a slightly wider than normal lens for capturing the general scene.

Constant bursts of flash can be very distracting, so try to give some thought to lighting and film choice before the time. A moderately wide-angle lens, 35 mm or even 24 mm, will have the advantage of giving a good depth of field even with a wide aperture, allowing you to include almost everyone in some shots at least.

It is never possible to know what particular aspects of an occasion will be the most treasured in the future, or even which people you would most like, one day, to have a photograph of – but you can be certain that photographs that manage to capture the atmosphere of a special day, or record a loved one's spontaneous, typical expressions will be among those that you value most.

The atmosphere of most special occasions is likely to be best caught in unposed photographs (right and below right). These may call for the use of flash lighting (the bounce and fill-in capability of modern small units is particularly beneficial) and for long-focus or zoom lenses (a 70–150mm zoom will cover most needs).

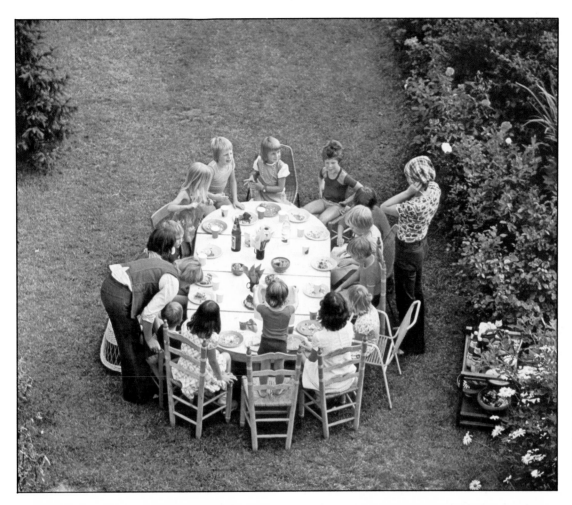

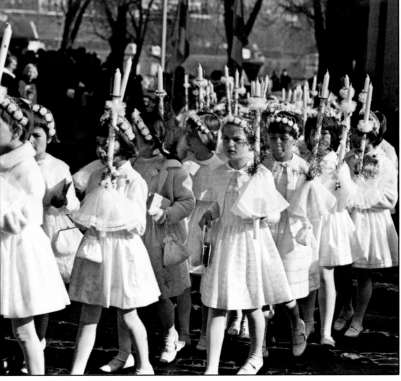

An unusual viewpoint, such as for this children's party (left), or patiently waiting for the right moment rather than taking a traditionally posed picture, such as in this Confirmation procession (below) can add an element to your album that lifts it out of the conventional 'snapshot' category.

Friends at work & leisure

A high viewpoint and a long lens were used to isolate the two bowlers from their background (above). The slow pace of games such as bowls, and the concentration of the players on their activity, give a photographer many opportunities for pleasant, informal pictures.
Nikon F2 with 200mm lens; 1/250 at f8; Kodak Tri-X.

ONE WAY OF ADDING **another dimension to the photographs you take of friends and acquaintances is to use their place of work or their hobbies as a theme and as a setting for your subject. One problem which even experienced photographers sometimes encounter is the sudden inability to find or think of a suitable subject, and quite often people you know can provide a solution.**

You may for instance have a friend who works in a printing shop or a computer centre, and in these situations, among the tools of his trade and surrounded by colleagues and workmates, the familiar identity of someone you know well can take on a completely new aspect, providing you with both a new subject and a new approach.

Of course it is vital that you seek the permission of the management, and ensure that your activities do not disrupt the routine of the office or workshop. It may be necessary for you to shoot your pictures during the lunch break or after hours, but few employers will object outright if approached in the right way. They may even be interested in the results for their own use, for promotional purposes perhaps, or as an item in a staff newpaper – indeed many photographic careers have started in just such a modest way.

One consequence of this approach is that it can open the doors, quite literally, to new ways of producing pictures. You may, for example, have a friend who is involved in some form of industry and through him you may be able to develop a completely different style of photography, with the dramatic lighting and strong compositions that often typify the industrial environment. Or you may know someone who is employed in a craft industry where you can shoot pictures of people working with their hands and with natural materials – a potter's, perhaps or a silversmith's.

An interesting way of approaching this type of subject is to produce a series of pictures which tell a story – how a product is made, or how tools and equipment are used. Working to a theme in this way can help you to achieve a variety and a pace in your picture taking, and will also provide more of a technical challenge. Another method which can be used to photograph a friend, preferably one who has a more mobile occupation, is to take a series of pictures throughout a working day – a day in the life of a farmer, for example, could produce some exciting and atmospheric pictures. Since few people work entirely on their own, be sure to include colleagues in many of the pictures – work is often the social pivot of our lives.

In addition to the business occupations of your friends it can also be rewarding to photograph their leisure interests. You may perhaps know someone who is interested in sailing or fishing, and apart from producing pictures which are satisfying in their own right, this can be a useful way of finding a market for photographs. A photographer who is interested in selling his work to book or magazine publishers may well find this a good way of getting started, for there is a constant demand for good pictures that illustrate aspects of popular leisure activities, and there is a wide range of specialist books and magazines on most of these subjects.

A photographer who is interested in sport photography could find it rewarding to become involved in a local sports club through the activities of friends and acquaintances. The opportunities afforded by the less formal arrangements at amateur events can easily produce more exciting and unusual pictures than may be possible at large national meetings, where photographers are limited to shooting from more distant and confined viewpoints. At a local level a very wide variety of sports and pastimes can be photographed. Equestrian events, acquatic sports, football, athletics, tennis, indoor sports, etc, are going on all the time, and not only will your friends welcome your interest in their activities, but local papers as well as magazines with wider circulations rely heavily on amateur and part-time photographers for illustrations.

Quite apart from the more interesting settings that people at work or at leisure can provide, these situations are also likely to produce pictures which have a more spontaneous, less static quality. People who are engrossed in what they are doing invariably make more interesting and varied subjects than they do when the camera and the photographer are the only distractions.

Familiar surroundings, such as their workplace, are ideal for photographing friends, since they are likely to be relaxed and less conscious of the camera – as happened with the two women in a factory (far left).

Although taken at the end of his shift in a small coal mine in Wales, this picture strongly conveys the miner's working conditions (left). In many cases it is not possible to photograph friends actually at work, but off-duty moments can have just as much interest.
Nikon F2 with 24mm lens; 1/250 at f5.6; Kodak Tri-X.

A good sense of composition and an eye for a picture (right) have made an interesting, pleasing image out of what could easily have been an ordinary holiday snapshot.

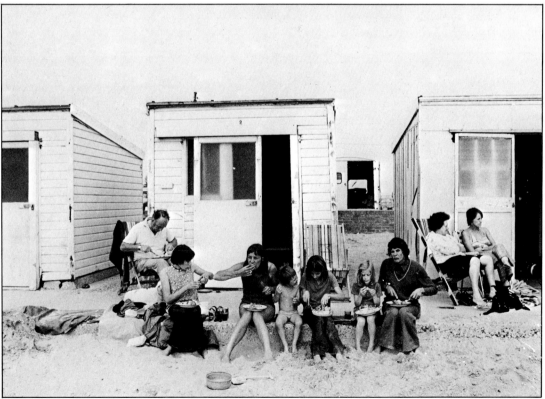

Holidays

The photographs on these two pages show a range of pictures that would make an attractive spread in an album. A shooting script, or simply a prepared list, will ensure that you cover a variety of subjects which will bring back memories, and that you do not forget the less obvious subjects – such as your favourite waiter at a beach-front restaurant (right, top). Different moods should be covered by your photographs, from those tranquil moments (right) to the essence of carefree days at the sea (below right).

THE ANNUAL FAMILY HOLIDAY is one occasion when even the least enthusiastic photographer is prompted to create a lasting record. Yet everyone must have suffered one of those tedious occasions when they have had to wade through boring and repetitive pictures that are often of little interest even to the people in them let alone anyone else.

All too often the photographic record of a holiday falls far short of capturing and preserving some of the family's most happy memories. One reason for this is simply that not enough effort is put into planning and shooting the pictures. No one wants to make a chore out of any aspect of a holiday, but good pictures require only a little more effort to take than bad ones, and they are much more satisfying to look at afterwards.

A very good way of approaching holiday photography is to prepare a shooting script either before you leave or as soon as you arrive. Make a list of the subjects you would like to record – a good shot of your hotel, for instance, a view from the balcony, a sunset perhaps, some attractive portraits of the children as soon as they are suntanned. It is also pleasant to have pictures of some of the local people you befriend, perhaps the waiter at your regular beach bar, or the instructor that takes your children water-skiing. These can really be enjoyable to look at again back home, and it is usually appreciated if you make a note of your friends' addresses and send them a few prints when they are made.

As with film shooting script it is essential that you have a variety of shots, not only from the point of view of content but also for lighting, time of day, and whether static or action. You should ensure that you have a good mixture of close-up, mid-distance and panoramic shots; an unbroken series of mid-distance shots, for example, can easily become monotonous when seen in sequence

regardless of subject matter; try to vary the time of day in which you do your photography.

Although a few carefully posed and arranged pictures can be attractive, many holiday photographs are spoiled because the photographer arranges every shot to the point where he interrupts every activity in order to take a picture. This destroys all feelings of spontaneity, and people look self-conscious and awkward.

Sometimes people will automatically stop what they are doing and begin to pose when a camera is produced, as if they were conforming to some special routine for holiday photographs. If this happens, it is best to humour them – take a picture and then wait until everyone returns to their activities and forgets about the camera before you start shooting again.

Posed photographs are often the least successful, but by deciding to capture the informal fun of a holiday, rather than attempting a composition that uses the best photographic techniques, you can get a happy picture that recalls the people you met, in the right atmosphere (below).

Your holiday portfolio should include a general scene, such as a photograph of your hotel or your favourite beach (right). The pictures on these pages are well within the scope of an inexpensive camera, and photography can often be more enjoyable if you do not have to worry about expensive equipment. If you are planning more serious photography as well, however, a 35mm SLR with one or two lenses is likely to be your first choice. A 35mm wide-angle lens and a 70-200mm zoom lens could cover most needs, if you want to keep the number of accessories to a minimum, while a small flash unit would extend your choice of subjects to many night activities.

Holiday photography calls for spontaneity rather than careful posing and composition. Although this close-up (above) shows little of the boy's face, it is full of holiday atmosphere. Children in particular are likely to resent being asked to disrupt their holiday for posing sessions.

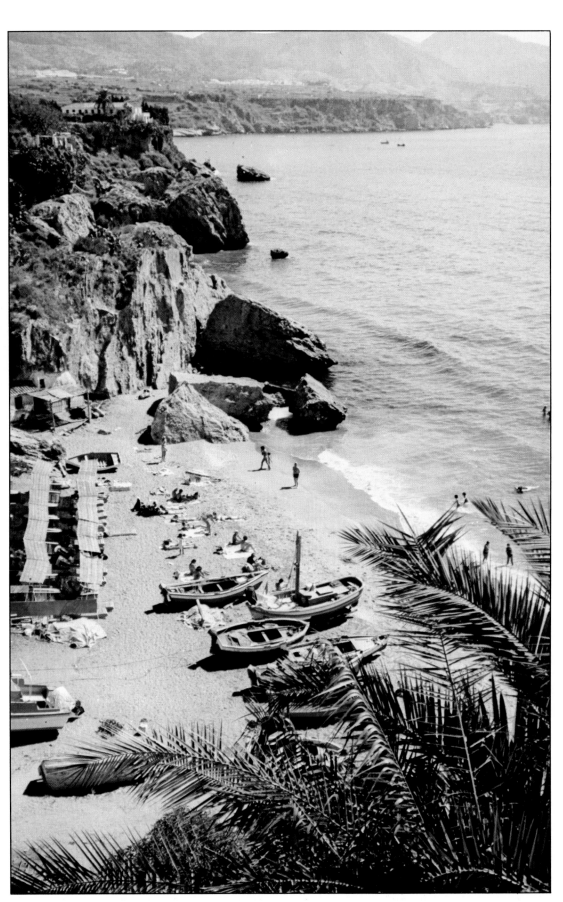

Couples

A PHOTOGRAPHER is often asked to photograph two people together, and it is a situation that can require a quite special approach. In most cases it is important not only to produce a good likeness of each of the two people, but also to suggest the relationship between them – and simultaneously to compose the picture in a way that produces a pleasing and balanced arrangement.

This can be considerably more difficult than taking a single portrait or even photographing a group, as the way in which you arrange the subjects will often be affected by the relationship you wish to imply – and two people can present more of a problem in terms of composition than will one person.

With a fairly close head-shot of a couple shoulders can be a particular hazard, as they make it difficult to position the models' heads close enough to each other without the picture looking rather strained and posed; besides, two heads side by side are normally best avoided altogether as this pose tends to produce a rather flat and uninteresting composition. In most cases it is preferable to offset the two heads, so that one is slightly above the other and they form a diagonal line rather than a horizontal. This can be achieved by positioning one of the models slightly behind and a little higher than the other so that the mouth of one is at least above the other's eyeline.

It is also important to ensure that the two faces are on a similar plane of focus, as with a close-up picture the depth of field will become quite restricted. For this reason it is safer to use the smallest practical aperture, and to allow for the fact that the depth of field extends rather farther behind the point of focus than it does in front.

It should not be assumed that side by side heads or heads directly above each other must always be avoided, as they can be effective provided that some other element of composition, such as a hand or even special lighting, is used to prevent the image appearing too static. This type of arrangement is probably the most suitable where the relationship between the two models is rather formal, but where a more intimate situation is being photographed – such as a mother and child, or a bride and groom – it becomes possible to position them much more closely so that they are in contact with each other. A bride, for example, could be placed so that she leans back against the shoulder or chest of her partner, and with a very tightly framed shot their faces can be positioned in contact with each other. Apart from making a more dramatic composition this will also help to create a warmer and more intimate mood. In this type of picture it is also possible to make more use of hands and arms, which can be an effective means of creating a more interesting arrangement.

The angle of the heads towards the camera is

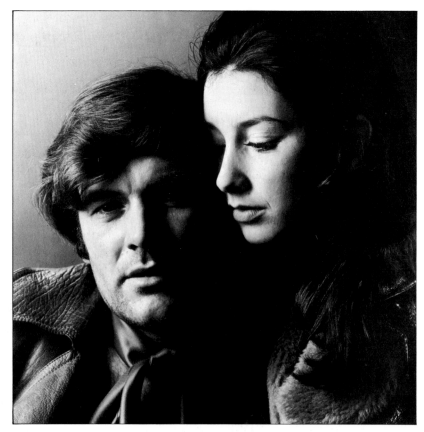

also an important consideration. Both faces full on to the camera can tend to create a rather bland and static arrangement and, as with a single protrait, three-quarter profiles usually make a more interesting composition as well as often being more flattering. The way the faces are angled will also affect the relationship of the subjects. It is possible to make one of the people more dominant, for instance, by having him pose full face, looking towards the camera, while the other person turns his or her face and eyes directly towards the 'dominant' subject. This arrangement is often used in bride and groom pictures, and also with mother and child portraits, where the purpose is to focus the viewer's attention more strongly on one particular face.

With three-quarter and full-length portraits of couples it is possible to obtain more control over the composition by using their body positions to create a balanced arrangement. The most commonly used, effective method with indoor portraits is to have one of the models seated and the other either standing or sitting slightly above, on the arm of a chair for example, or alternatively sitting or kneeling at a lower level, either on the floor or on a small stool. Outdoors it is usually quite easy to find a way of achieving a similar effect by using a low wall or park bench, or even arranging your models on the ground so that one is slightly higher than the other.

A conventional approach to a double portrait (above), has one head slightly above the other and one face directly towards the camera. The full face and direct expression of the man makes him more dominant than the girl who is looking down and away – another conventional element in many photographs of couples.
Pentax 6 × 7 with 150mm lens; f11 with studio flash; Ilford FP4.

The risk of an over-symmetrical composition, with two heads virtually on the same level, has been avoided in this picture (right) by the additional interest that the low viewpoint gives, and the corresponding attention focused on the legs.

The close relationship of Jane Birkin and Serge Gainsbourg is emphasized in this picture (above) by bodily contact, which in other circumstances can be a problem with tightly composed photographs of couples. The informality of the photograph nevertheless follows the conventions of one head above the other, and the man directly facing the camera.

Babies & young children

ONE OF THE MOST DIFFICULT aspects of photographing adults and older children is that of capturing a natural response and overcoming the inhibitions produced by a camera. With young children, however, it can be much easier to take really natural and spontaneous pictures provided you approach them in the right way. They invariably have a very brief interest in such things as cameras and photographers, and as long as you have the patience to allow them to overcome their initial preoccupation with your movements they will quickly forget your presence and again become engrossed in their own activities and games.

Posed pictures of young children are seldom pleasing and at best only provide a record of their appearance at a particular age. If you want to take pictures of children under more controlled conditions like a studio it is far better to find some way of confining and occupying their interest, such as by giving them a toy or a book, rather than simply sitting them down and trying to get them to look at the camera.

Taking good, lively pictures of children requires quick reactions on the part of the photographer, and a sure and instinctive knowledge of his equipment and lighting conditions.

The less involvement that is needed for exposure and focusing, the more time there is to concentrate on the response of the young subject. A hand held camera – even in the studio – is a virtual necessity, as is a fast shutter speed to eliminate the effect of subject movement, so it is usually an advantage to use a fairly fast film.

In outdoor situations like playing in the garden, it is best to use a lens with a fairly long focal length, such as 105mm or 135mm with a 35mm camera. This enables you to work at a more convenient distance from your subject and at the same time helps to keep the background well out of focus, giving good separation from your subject. A zoom lens can often be used to good advantage as it enables you to keep control over the size of the image and adjust the composition without having to follow the child around too closely.

When you are taking pictures of children who are playing and moving around a great deal the lighting can present a problem. Bright sunlight can easily create shadows deep enough to hide small faces and cause distracting and fussy details in the background. Once again, a bright cloudy day generally gives the best light for this type of picture. The soft, even light, without heavy shadows, makes it easier to change camera angles without having to consider the effect of the lighting. On a sunny day it can be better to shoot against the light and gain a softer effect on the faces while also getting greater separation from background details. Remember however to use a

It is far easier to take photographs of children who are busily engaged than it is to take posed portraits. If they are concentrating on something else, and have become used to your presence, you will be able to take close-up shots even if you do not have a medium long-focus lens.

Children and pets (right) often make excellent subjects, as this picture shows. Not only can they match each other for charm and innocence, but an animal invariably evokes a photogenic response from the child, and attracts attention away from the camera.

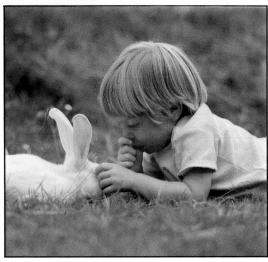

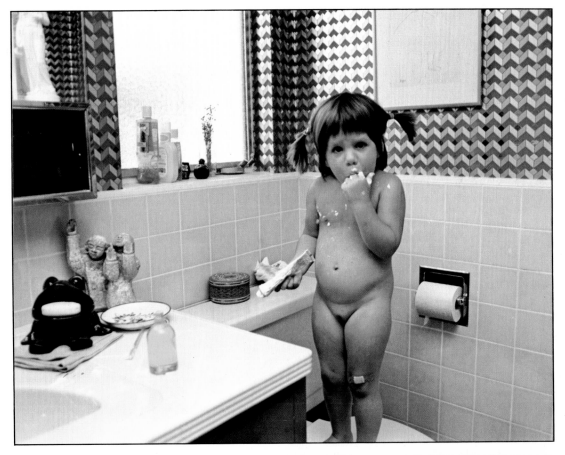

Daily activities, especially ones that are enjoyed by the child, such as bath time (left), can provide a photographer with pleasing or amusing pictures. Flash, used repeatedly, is quite likely to upset the child, even if you restrict it to bounced flash, but the warm colour bias of tungsten light on daylight film is seldom a disturbing element in photographs of children.

lens hood to shield the lens from direct sunlight, and also to compensate for the exposure reading. Shooting with the sun behind the subject usually requires about two stops more exposure than indicated to ensure adequate detail and tonal gradation in the shadowed face.

Photographing babies is in some ways simpler than taking pictures of children, mainly because they are less mobile and it is easier to set up a camera without it creating an inhibiting influence. With a very small baby the most effective way of producing an interesting picture is by capturing a lively expression or gesture. As a baby is much more likely to respond to its mother, it is best to enlist her help in persuading the baby to look in the direction you want, and she will also know what objects or sounds will provoke the most interesting reactions. Pictures taken indoors are best lit with either window light or flash (preferably bounced flash) – the bright glare and heat produced by photofloods would be uncomfortable and distracting for a very young baby.

With an older baby it is possible to find more lively situations to photograph such as bathtime and feeding time, not to mention the momentous first steps. Essentials are always to frame the image quite closely, keep the background simple and uncluttered – and be ready to capture attractive, spontaneous expressions.

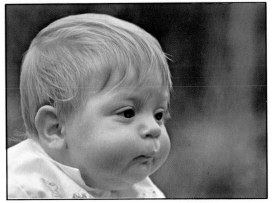

A long-focus lens of about 135mm focal length is invaluable when photographing young children (left), and with a parent to attract interest and elicit various responses, a wide variety of pictures can be taken in a short time. Soft, indirect lighting will give the best results with children, and will need little re-arrangement or re-adjustment when the subjects are constantly moving.

Formal occasions, such as a Christening (left) can call for patience and assistance. Since very young babies are relatively immobile, and spend most of their time asleep, they often are easier subjects to photograph than young children.

183

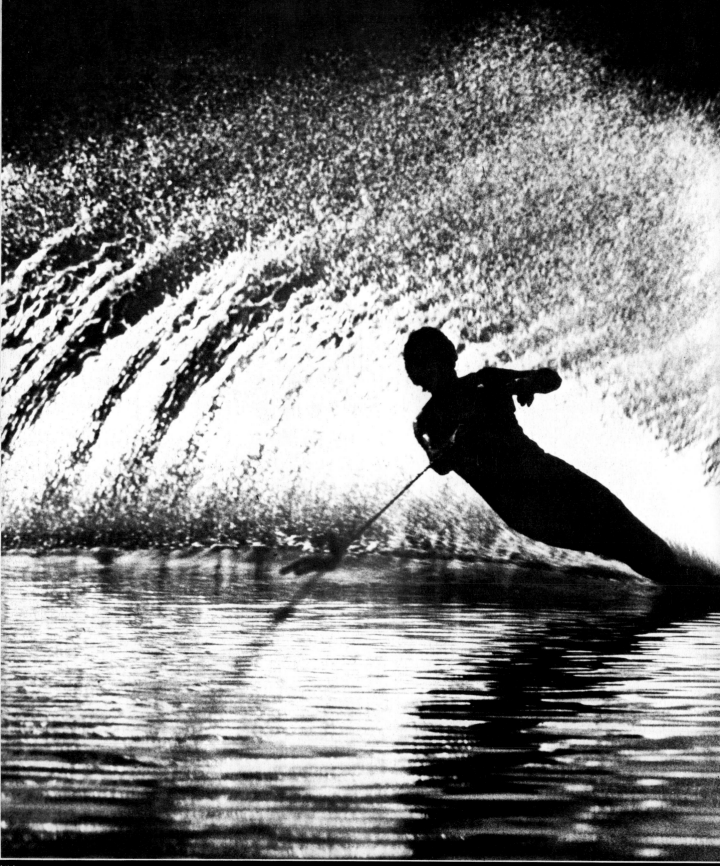

SPORT & ACTION PHOTOGRAPHY

ONE OF THE REASONS why sport dominates our leisure and our entertainment is because it is not only exciting to take part in but also exciting to watch. In addition to the thrill of competition, it is visually stimulating – the shapes that are formed by the human body when running or striking a ball, for instance, are often more graceful and beautiful that at any other time, and the challenges and opportunities that these actions offer a photographer are limitless.

The appeal is all the greater because these qualities are so transient, and one of the most exciting features of photography, the ability to reach out and capture a brief and dramatic moment, is fully realized in this particular field of photography.

Although it will obviously add to the pleasure to have an interest in, or a knowledge of a particular sport, lack of this should not deter a photographer who simply wants to take exciting pictures. In fact photographing action subjects is a good way of developing a keen eye for a dramatic moment and for improving picture-taking techniques.

Although the photographer who is specifically interested in sport subjects will want to acquire special equipment, such as long lenses and motor drives, conventional equipment will still enable the less specialized photographer to take good pictures – though perhaps with rather more restrictions on such things as choice of viewpoint.

It is also worth remembering that the possibilities of capturing exciting and even dramatic moments still exist at more modest events, such as a school sports day. The athletes you photograph need not be household names, and the lack of formality at such occasions will enable the more modestly equipped photographer to get much closer to the most interesting action.

'Night Skier' by Tony Boxall

Capturing movement

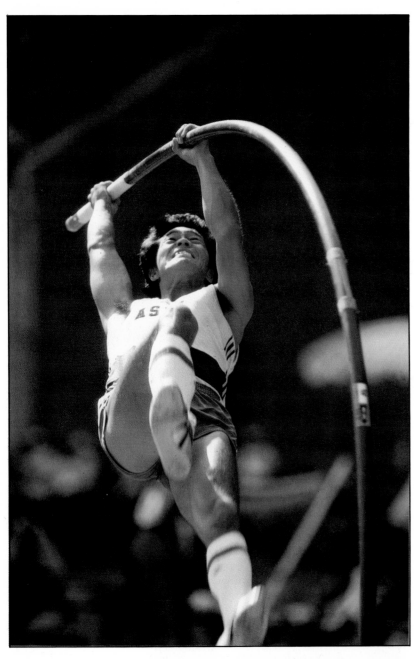

ONE OF THE UNIQUE aspects of the photographic process is its ability to record an image in a fraction of a second, and to do so in a way that reproduces the finest detail and the subtlest tones. This has made it possible for us to see things that were not visible to the naked eye, particularly with regard to subjects that are moving quite quickly.

It is now commonplace to see a frozen moment of action in which the tension and stress on the face of a sportsman are clearly recorded at the instant he makes his greatest effort. Although motion picture techniques provide us with a spectator's view of an event in the comfort of our homes, it is often the great still picture that more effectively captures the true drama of action and movement. It is purely the extremely brief exposure time which makes this possible, combined also with the photographer's judgement of the right moment to make the exposure.

The speed and direction of a particular movement will determine the shutter speed that will be required to record a sharp image. A sprinter, for example, moving directly across the field of view needs a much shorter exposure time than, say, a long distance runner or a sprinter running towards the camera. It is very difficult to give precise indications as to what shutter speed is required to freeze someone moving at a given speed, but if the intention is to record the sharpest possible image then it is obviously preferable to use the shortest exposure that the lighting conditions will allow.

Most 35mm cameras with a focal plane shutter are capable of exposures of 1/1000 sec (some of the more expensive instruments have a 1/2000 sec setting) and at these speeds most normal human movements will be completely arrested. Unfortunately, however, circumstances often do not allow such short exposures. Low light levels, the use of slower films and the smaller maximum apertures of long-focus lenses all contribute to the frequent need to use fairly slow shutter speeds with fast moving subjects.

In these cases it becomes necessary for the photographer to use his judgement in order to make the best use of the facilities he has available. Very often a little movement at the extremities of the subject is acceptable – the feet or a runner, for instance, or the end of a golf club or tennis racquet. The most important detail in many pictures is the face or head of the performer, and fortunately this is often the slowest-moving part of the body. Even when the subject is moving quickly the head and torso can still be recorded sharply with a fairly slow shutter speed, provided the camera is moved smoothly in a panning motion to keep pace with the figure.

Another important factor which enables a photographer to fully exploit the stopping ability

A pole vaulter in the middle of his jump is moving much faster than when he is just about to go over the bar, and a faster shutter speed will be necessary to record a sharp image.

The fastest shutter speed (1/1000 sec on most cameras) is often essential to capture a clear sports photograph. In some sports, such as skiing (right), even this speed may be insufficient so a viewpoint should be chosen where the competitor is coming towards the camera, rather than travelling across the frame.

of his camera is recognition of the peak of the action. In most athletic movements there is a point at which the figure moves most slowly, and fortunately this is frequently the very moment when the performer reaches the climax of his effort, providing the most dramatic illustrative possibilities as well as the most convenient time to expose. The moment at which a pole vaulter reaches the highest point, and begins to turn his body for the descent, he is almost stationary; and often the follow-through of a tennis stroke or a golf swing has all the drama and tension of the effort still apparent in the sportsman's face and body, and these can be very significant moments to make your exposures.

Probably the biggest asset a sport photographer can have is the ability to anticipate such moments accurately – they last for only the briefest possible time, and a split-second later it would be an anti-climax, with all the drama and tension gone. It is no coincidence that many of the great sport photographers are either practising or ex-sportsmen themselves, or else are dedicated enthusiasts who live and breathe the events they are photographing. It is only if you can put yourself into the situation of the person you are photographing, and can become aware of his pace and timing, that you can begin consistently to anticipate this peak moment of action.

In this photograph of a surfer (above) a fast shutter speed and very accurate focusing have been used to form a beautiful and exciting image. A panned shot that emphasized the surfer's speed would have lost most of the glassy effect of the wave.

The only way to take photographs like this one of a motor cyclist (left) is to have a dummy run and to pre-focus the camera at a certain point. For the actual shot, wait until the competitor comes into focus, then trigger the shutter.

Using a motor drive

AMONG THE MANY accessories that have become part of the photographer's equipment in recent years, the motor drive is one that has particularly useful applications for the sport photographer. Although by no means new it is the popularity of the SLR system camera which has caused it to become much more widely used today.

There are various types available over a range of prices, but all the modern ones use electrically driven motors that are run from small batteries, the unit simply fitting to the base of the camera body. Not all cameras can be fitted with motor drive, however, and if you are choosing a camera with the hope of adding one in the future, you should make sure of this point.

The most basic and inexpensive form is the motor wind, a small, lightweight unit which simply provides the facility of automatically advancing the film after each exposure – in addition, motor wind units usually permit continuous firing at the rate of one to two frames per second by holding the release button down. They cost only a fraction of the more elaborate motor drives, but can be very useful for the sports photographer.

A great deal of the effort in shooting a moving subject goes into framing and focusing the image, and the process of winding on manually can be quite disruptive; having the film advanced automatically, ready for the next frame, not only means that you are ready to make another exposure sooner, but also that you need give less attention to manipulating the film advance lever.

The next progression is to the medium-range motor drives which, in addition to automatically advancing the film, also give a continuous firing facility of four, five or six frames per second (but usually without intermediate settings). Being able to select the number of frames per second generally means using a more expensive, somewhat heavier machine. While it is possible to use any shutter speed with the basic autowind facility, the continuous firing mode normally restricts shutter speeds to a minimum of 1/125 or 1/250 sec, depending on the make of motor and the

The greater availability of motor drive attachments of varying degrees of sophistication is a benefit of the electronic age. Illustrated below (clockwise from top left) are: a motor driven Nikon F2 fitted with a magazine back allowing sequences of up to 750 frames without interruption, shutter speeds up to 1/2000, and a firing speed of 3.7 frames/second; a motor driven Nikon fitted with a receiver that can be activated by the transmitter over a distance of up to 200ft (60m); an inexpensive Chinon motor wind with a firing speed of about 2 frames/second; the Nikon F2H which uses a fixed mirror, partly silver-coated, to enable firing speeds of up to 9.5 frames/second to be used.

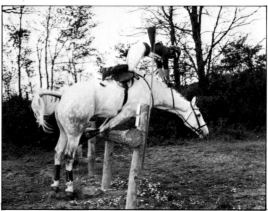

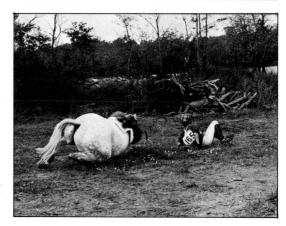

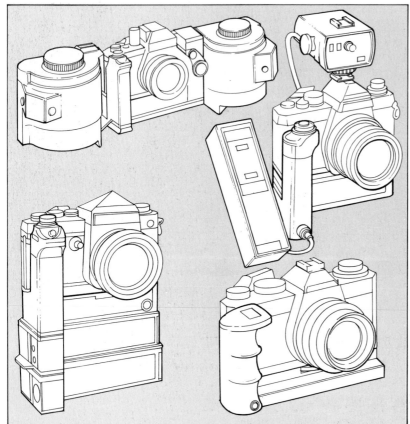

frame frequency used. This is because there is a limit to the speed at which the mirror can be returned to position after firing, and this also depends on the duration of exposure.

Most motor drives have a limit of about five frames a second, partly because of the mirror problem, but one system that offers a higher rate of firing is produced by Nikon, where a model with a fixed semi-silvered mirror enables a firing rate of about ten frames per second. It requires a very large battery pack to power the motor, however, and is consequently quite heavy and bulky.

The main advantage of a continuous firing facility is that it provides a sequence of pictures of a movement (it is also essential for pictures taken

These six pictures (below left, from a sequence of seven pictures) show the sort of action that can be captured so well by a motor drive – not only because of the speed of shooting the frames, but because the photographer's attention is not distracted by having to wind on the film. Nikon F2; 1/500 at f5.6; controlled firing on continuous mode; Kodak Tri-X.

by remote control). It is also useful as insurance, in so far as it enables several frames to be exposed of a subject in the space of a second, with the chance that one of them will be taken at a vital moment. However, it is still only a chance, and a photographer who uses a motor drive for this reason is really delegating the responsibility of making what could be a crucial decision to a piece of machinery. And even at five frames per second there is no guarantee that a precise moment will be captured (most of the second is taken up by film transport) – in fact a photographer who is able to anticipate accurately is more likely to be able to expose with certainty at a particular instant than if the motor drive does it for him, though of course he will get only one frame.

One problem that the use of a motor drive creates is the rate at which film is used – at four or five frames per second it takes less than ten seconds to run a standard cassette of film through the camera. A photographer who contemplates extensive use of such equipment, with long shooting sequences, should consider using a bulk film back which can be fitted to many of the SLR system cameras. These generally enable enough film to be loaded to give up to 250 exposures. It should also be remembered that the frame speed specified for a particular unit is dependent on fresh batteries, and the rate will slow down noticeably as they become exhausted.

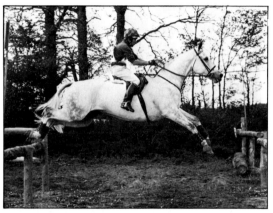

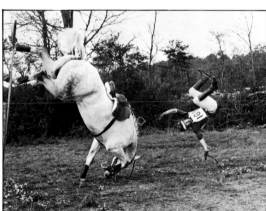

Total reliance on motor drive is no guarantee that you will always catch the best moments in sport (below), even at 9 frames/second. Many habitual users of motor drive prefer to trigger their shots individually (but very rapidly) rather than shoot long continuous sequences.

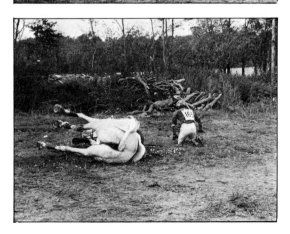

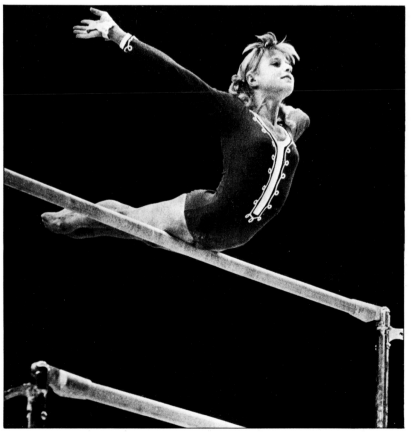

Conveying movement through blur

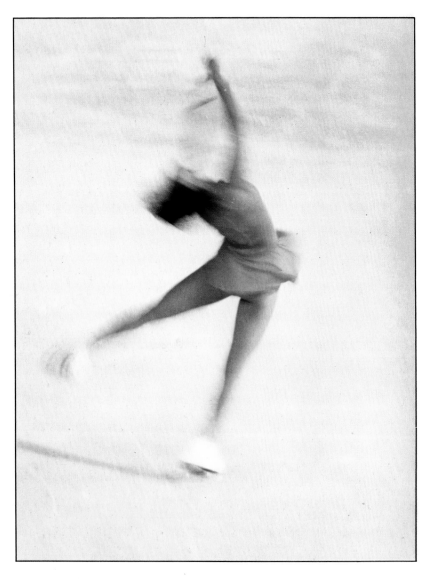

A plain background, such as the surface of an ice-rink (above), is seldom able to give a convincing blur. The suggestion of movement is best achieved by a considerable degree of blur on the subject, as in this impression of a skater. When low light levels prevent a photographer capturing movement clearly without using flash, it is often better to use a slow shutter speed to create this effect motion.

THE EFFECT OF PHOTOGRAPHY on a moving subject can be quite varied, and the technique that a photographer uses should depend on the image he is trying to create. A picture taken with a very fast shutter speed that records the finest detail may be needed to demonstrate a particular sportman's action, or even to determine the outcome of a close race, but there are many occasions when this is not the most effective means of approach.

In order to create or accentuate the impression of speed and movement of a particular subject it is often preferable to allow a degree of subject or camera movement to occur, and a picture that contains areas of blur through movement often produces an image that has a much more dramatic and visual interpretation of movement than when the subject is frozen in total sharpness. The blur that results when the shutter speed is not quite fast enough to stop the movements of the limbs' extremities in a picture of a running man, for instance, may create a stronger impression of speed than if a faster shutter speed had been used.

It is impossible to accurately predict the effect of slower speeds, as often different parts of the body are moving at different speeds and in different directions, and one of the most informative exercises you can carry out is to take a subject which is moving at a fairly constant speed across the cameras view (perhaps an obliging friend will run for you) and make a series of exposures at varying shutter speeds from 1/15–1/500 sec, and then study the results. This may not enable you to know precisely the effect that you would get with any other subject in the future, but it will clearly demonstrate the relationship between the different shutter speeds and their relative effect on the amount of blur.

The effect of a slightly blurred subject is much stronger when the camera is static and only the subject is moving, and it will produce an image where the background is sharply recorded, without the impression of movement.

In many instances the effect of blur can be more fully exploited when the camera is moved or 'panned' in pace with the subject. This technique involves 'picking up' the moving figure in the viewfinder well before it reaches the point at which you intend to make the exposure, then moving the camera smoothly in the same direction and at the same speed as the figure, following the action until the chosen spot is reached and then releasing the shutter in one continuous action. If this is all carried out smoothly it is possible to use a very slow shutter speed even with a quickly moving figure and still retain a sharp image of the subject – but with the background blurred into an indistinguishable pattern.

Panning can be an extremely powerful method of creating a feeling of movement in a picture. To be fully effective the subject ideally needs to be travelling across the camera's field of view, and it is also important for the subject to be in contrast with the background, either in terms of colour or tonally. Best of all, the background should consist of bold tonal or colour contrasts so that the lighter tones or highlights create blurred streaks against the darker tones – spectators at a sports meeting frequently create an ideal background.

It is also possible to create a near abstract image through panning, especially where parts of the subject are moving in different directions, as with the arms and legs of someone running. With the use of a very slow shutter speed the limbs will record as broad streaks of colour or tone emphasizing their movement in addition to the blurred background. In most cases the effect is enhanced by having at least part of the image sharply recorded, such as the head and torso, but often even a very small area such as the face will be enough to achieve this.

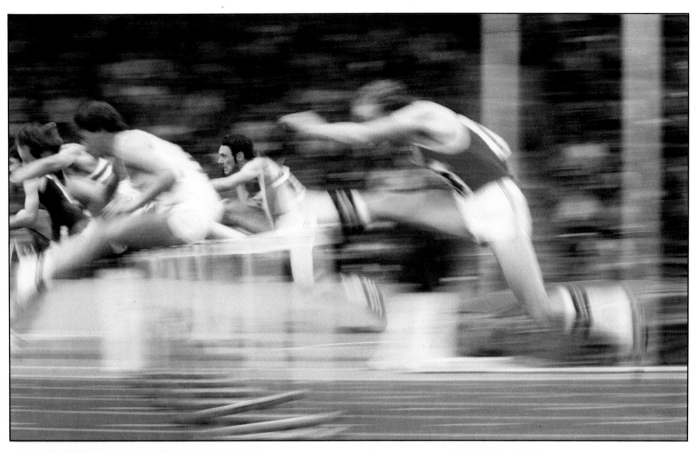

This picture of hurdlers by Tony Duffy (above) is a superb example of a sport photographer's ability to combine a number of elements in one picture. The blurred background creates an impression of speed, the different degrees of blur on the competitors accentuate the thrill of the race, and one clearly recorded face illustrates the tension and effort of competition.

Complex movements, such as those of a gymnast (far left) or of swimmers diving forwards and downwards (left) can result in impressionistic pictures that convey more atmosphere than perfectly sharp photographs.

In these two pictures (left) the photographers have conveyed movement by accurate panning, capturing the central figures with very sharp focusing but blurring everything else to convey the feeling of speed and the direction of movement.

Telephoto techniques

LONG-FOCUS AND TELEPHOTO lenses have many useful applications in photography, and sport photography is an area in which at least one long-focus lens is considered vital equipment.

The standard 45 mm to 55 mm lenses fitted to 35 mm cameras give an angle of view between 40° and 50°, whereas a lens of 200 mm fitted to the same camera would give a field of view of only $12\frac{1}{2}°$ – but the subject would appear about four times larger. To a photographer who is unable to approach his subject closely, this magnification of the subject is an invaluable aid, and in many aspects of sport and action photography a lens of even greater focal length is required to produce a large enough image. In a sport like cricket, for example, where the most important action takes place at a considerable distance from the closest possible camera position, it would be virtually impossible to take photographs without the help of a lens with a very long focal length.

A telephoto lens is strictly a long-focus lens that has an additional set of elements which makes it physically shorter, and correspondingly less cumbersome, than a true long-focus lens. A mirror (catadioptric) lens is designed so that a combination of optically curved mirrors and lenses effectively 'fold' the light path into three by reflecting it back and forth; this enables a lens of very long focal length to be made quite compact and much lighter than a conventional lens of similar focal length. One problem with the mirror lens is that it has a fixed aperture, so the exposure has to be regulated by the shutter speed alone.

As well as magnifying the image, a long lens also has the advantage that its relatively shallow depth of field enables the photographer to separate his subject from the often fussy and intrusive backgrounds that characterize sports arenas. At the same time, however, such lenses need to be focused very accurately – and this can be difficult because the maximum apertures of most long lenses are smaller than those of standard lenses, and the image is correspondingly less bright on the viewing screen.

Camera shake is also a particular hazard with long lenses because any movement or vibration is also magnified, and, in addition, their extra length and weight make them much more difficult to hold steady. With very long lenses, shutter speeds of as little as 1/250 sec or 1/500 sec will not always guarantee freedom from this problem if the camera is hand held, and it is far preferable to mount the camera on a firm tripod wherever possible. Where this is not possible or convenient some form of camera support is vital when working with slower shutter speeds – rifle butt supports are sometimes used, and if nothing else is available a worthwhile advantage can be gained by simply propping the lens against some natural

support such as the back of a chair, or a fence pole or a crowd barrier.

Focusing a long lens accurately cannot be done as easily and as quickly as with a standard lens. For moving subjects such as those at track sports it is usually best to pre-focus on a particular point and wait until the subject reaches it before making the exposure, rather than attempting to follow the movement and alter the focus at the moment when you want to take the shot.

With subjects that move in a fairly unpredictable way, such as football players, a zoom lens can be a useful asset since it enables the focal length to be varied simply by turning a ring or sliding a collar. The image size of someone running towards the camera, for instance, can be controlled without having to change the camera position or the lens – and of course a zoom lens is a good compromise for a photographer who wants to buy only one long lens and is uncertain of the best focal length to choose.

The light weight of the telephoto gives many advantages in sport photography, being more versatile for hand held shots, for panning and for switching quickly from one scene to another. But any long-focus lens will greatly extend a photographer's range. Not only can you switch from an exciting finish to a close-up of a javelin thrower across the arena, but you can create dramatic images through the foreshortening effects of long-focus lenses. A bunched group of runners, a rugby line-out, the bustle at a motor racing pit area, can all be given a compact, action-filled atmosphere using a long-focus lens.

The shallow depth of field of a long lens has allowed the photographer to isolate the subject (above) from the confusing foreground of players, and from the crowd in the background, recording the goalmīnder's apprehension in sharp detail.

Certain moments during a sports event (above right) enable the careful focusing that is so important with telephoto lenses. The close cropping in the framing of this shot, and the shallow depth of field, has emphasized the combined power of the pack.

A zoom-lens can be ideal in sport photography as it allows you to follow the action (far right) and to alter the focal length and the framing. Only still photography can capture this degree of clarity and closeness of a single moment in an event.

Modern technology has brought a variety of lenses within the price range of many keen photographers. Illustrated here are (from left to right): 300mm long-focus lens; 100–500mm zoom lens; 80–210mm zoom lens; 300mm telephoto lens; 500mm long-focus lens; and two mirror lenses, 500mm and 800mm.

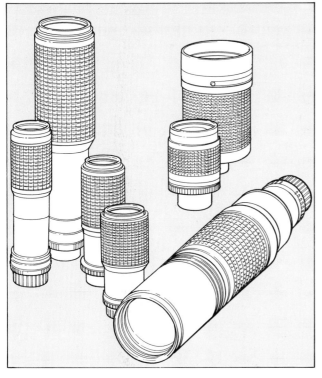

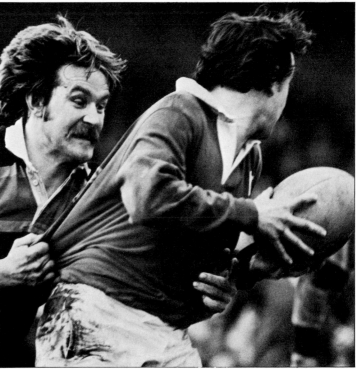

Choosing a viewpoint

THE SUCCESS OF A GOOD SPORT or action picture is mostly dependent on capturing a dramatic or significant moment in a particular event, and this is often a result of the choice of a good viewpoint. Obviously this choice will sometimes by restricted by the nature of the sport, and unless you have been afforded special facilities you will be limited to the more obvious positions within the spectators' enclosures – but with a little planning it is still possible to ensure that you have the best chances of success.

There are three main consequences to bear in mind. The most important is to be within the range, at least using your longest lens, of a point where you can be reasonably sure of some action – near the goal at a football match, or near the hurdles of a steeplechase. It is also essential to consider the position of the lighting and the nature of the background.

For the most dramatic results it is best to shoot from a position that allows the subject to stand out quite clearly from an uncluttered background. This can be aided by a long lens and a wide aperture where the resulting shallow depth of field will throw background details well out of focus, but often a high viewpoint provides a plain tone by allowing the ground surface – a tennis court for example – to become the background. Alternatively a low camera position can enable you to use the sky as an unobtrusive area behind the subject.

There are many sports where you can have a far better opportunity to approach your subject more closely, and where there is greater freedom to use more unusual and interesting viewpoints. This is particularly true of the smaller local events, when the restrictions are likely to be far less than for the major national events. From a photographic point of view it is better to take pictures that have a strong visual impact than it is to take rather uninteresting pictures of more famous sports personalities.

As well as being on the lookout for dramatic action, you should also try to find viewpoints that enable you to capture less obvious but equally telling moments – the tension in a sprinter's face just before the start of a race, for example, or that anxious moment after a golf swing when the ball is watched to see how well it is flying. These are the sort of instances that have given rise to some great pictures, and quite often pictures taken behind the scenes, or before and after an event, can have as much dramatic appeal as the more public and visible happenings.

Lighting can also add a great deal of drama to action pictures, and your choice of viewpoint should take this into account. Shooting into the sun can often produce pictures with powerful impact. If you shoot from a low viewpoint, and

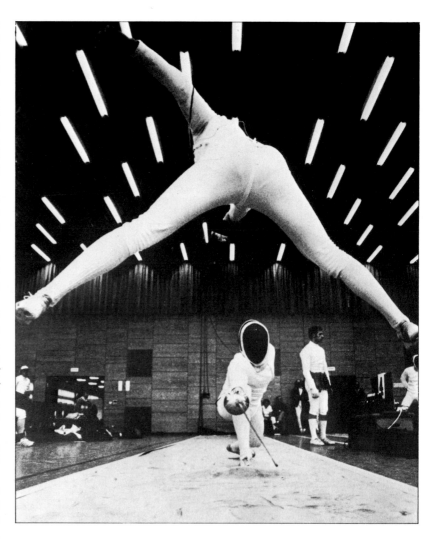

your subject is shown against the sky and the light source, you can achieve an interesting silhouette by reducing the exposure. This can be very effective with a subject or an action that creates an interesting or dramatic outline, such as a high jumper, a skier or a pole vaulter. Some very dramatic pictures like this have been taken by positioning a camera with a wide-angle lens and a motor drive on the ground very close to the action, and exposing by remote control. It is vital, of course, to obtain permission for this technique, and to ensure that the camera is placed so that it does not distract or cause danger to a performer.

It is always worthwhile considering any really unusual viewpoints that can be exploited by various techniques, as the results are invariably exciting; quite often a little imagination in this direction can produce an entirely new approach to the photography of a particular sport.

Experimentation can often be more easily done at practice sessions, and most sportsmen, amateur and professional alike, are enthusiastic enough to be willing to co-operate in producing some dramatic pictures if approached in the right way.

'Fencing Eagle' (above) by Dieter Baumann, was Germany's 1977 sports photo of the year. By shooting from behind one of the competitors, and from a very low viewpoint, the photographer was able to capture a moment when the foreground figure made a dramatic frame for the second fencer.

Shooting from outside the tennis court (right) has added an interesting pictorial quality to what was a passive, unexciting moment in the game – photography need not stop when the game stops. Nikon F2 with 200mm lens; 1/250 at f8; Kodak Tri-X.

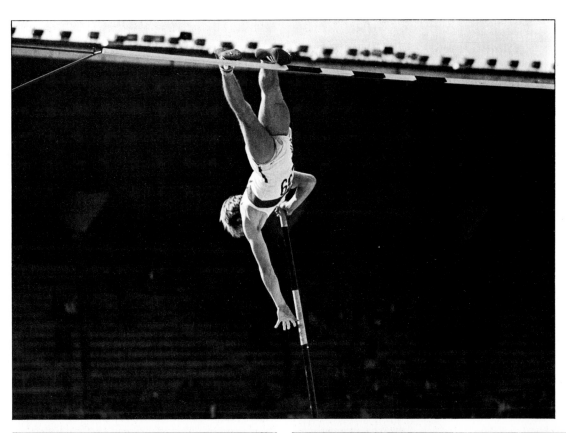

This viewpoint (left) not only gives an unusual view of a tense moment, but adds to the composition by setting the back lit figure against the dark tone of the stadium stands.

As much drama and interest can be found before and after an event as during the action itself (below). Some sports, such as cross country running, gives the photographer many opportunities to look for unusual viewpoints.

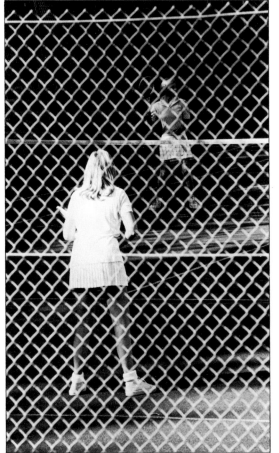

Adventure sports

Caving offers many opportunities for dramatic photographs (above) – but many problems too, for conditions are probably worse than in any other adventure sport. A camera is likely to be bashed against rocks, covered in water, and be a hindrance in narrow tunnels. A small camera with a powerful built-in flash, and housed in a tough waterproof case, is essential and the photographer will have to be adept at taking long exposures without the benefit of a tripod.

IN NORMAL SPORT and action photography the photographer is very much an onlooker. He has far less control over, and involvement with, his subject than in many other aspects of the art – portraiture, for example – but there is one notable exception and that is the photography of the more dangerous and hazardous pastimes, where the photographer either takes part himself, or is at least exposed to the same risks as the participants. In mountaineering, for instance, it is vital that the photographer is an experienced climber first and a photographer second, since lack of experience or care could easily result in risk to his companions as well as himself.

One of the main problems in this type of photography is the care of equipment, as the conditions under which pictures are taken are such that you could find yourself in the right situation for a picture, but without a camera in a fit state to be used. Apart from the physical hazards of the camera being knocked or dropped, the main problem is exposure to the elements, and any extreme variation in atmospheric conditions is a potential risk to the performance of the equipment.

There are a number of cameras that are specifically built to withstand humidity, rain and even sea water – the Nikonos, for example, can even be used under water up to about 150ft (46m) deep. These cameras, however, are limited in the variety of lenses that can be used, and most photographers will want the facilities of the normal camera systems. Carrying a camera safely can be made much easier and more certain by the use of a harness that, unlike a normal strap, allows the camera to be held firmly to the body when not in use and prevents it from swinging – ideal for climbing, for example. There are also cases that are made to protect a camera from impact damage, and at least two are available that provide a buoyancy aid that will support the camera afloat if it is dropped into water.

Many photographers who do this type of work develop their own system of carrying and protecting their cameras to suit their own particular sport and method of working, and often their clothing is designed to hold lenses and accessories.

Temperature is another condition that can present a problem for both the mechanical and electrical components in cameras. Batteries, for example, become less efficient when subjected to sub-zero temperatures, and very high temperatures can cause serious deterioration of film stock. High humidity is also a potential danger to camera mechanisms. Most manufacturers will give details of the precautions that are necessary to avoid malfunctions due to these problems, and if you are contemplating photography in any unfamiliar and extreme conditions it is vital to check the potential hazards in advance.

In some sports it is not possible to have both hands free to operate the camera and it is common practice, in activities like sky diving for instance, to mount the camera on a helmet and to make the exposures by the means of a motor drive and a long bulb or electric shutter release. Focusing is of course not possible in these circumstances, so the lens has to be pre-set to the estimated distance, the photographer manoeuvring himself bodily to bring the subject within range. A small aperture and a fairly wide-angle lens are used whenever possible to give the greatest depth of field, and viewing is usually managed by a simple frame or optical finder fixed onto the helmet and coming down over the eye.

An extension of this remote technique is used to mount cameras in all sorts of dramatic positions, such as on the front of a bobsleigh, for example, or on the end of a hang glider spar. A motor drive is of course essential, and the camera can be fired either by a long release or even by remote control using a radio beam from several hundred yards away. This has given rise to some very dramatic pictures, but it is hard to know to whom the pictures should be credited, since in these cases even the exposure has to be left to the decision of an automatic camera.

Photographs taken while mountaineering or hang gliding need not be exciting to be successful, for these sports also give the photographer a chance to use unusual viewpoints and shoot unfamiliar scenes – like this striking rock formation in Patagonia (right). For such pictures, however, the photographer needs time and steadiness for composition and accurate focusing.

The photographer who can look out for pictures while keeping his footing on a rock face is likely to be well-rewarded (above). A wide-angle lens is better able to capture a scene if it has to be photographed in a hurry.

A variety of waterproof cameras are available (above) which have the additional advantage of being able to withstand rough treatment. Even if you do not take pictures under water, these cameras are ideal for keeping out rain, snow and dust.

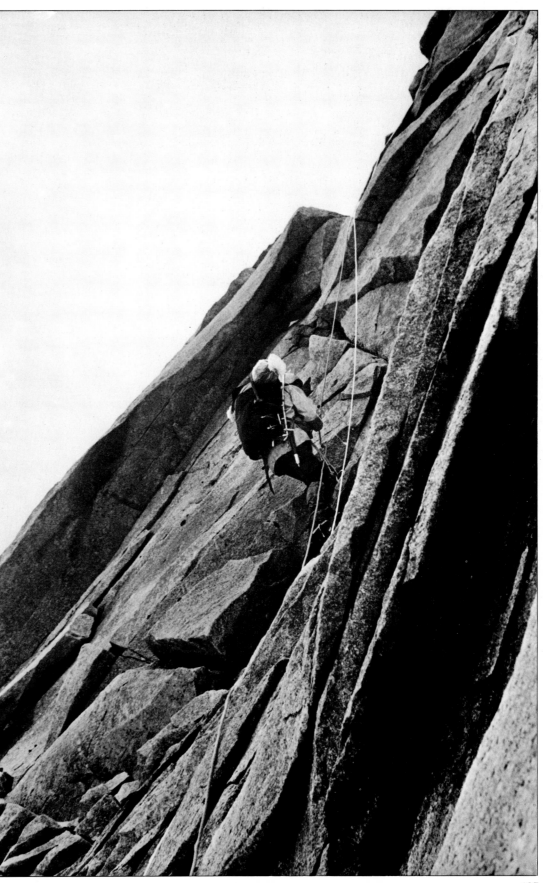

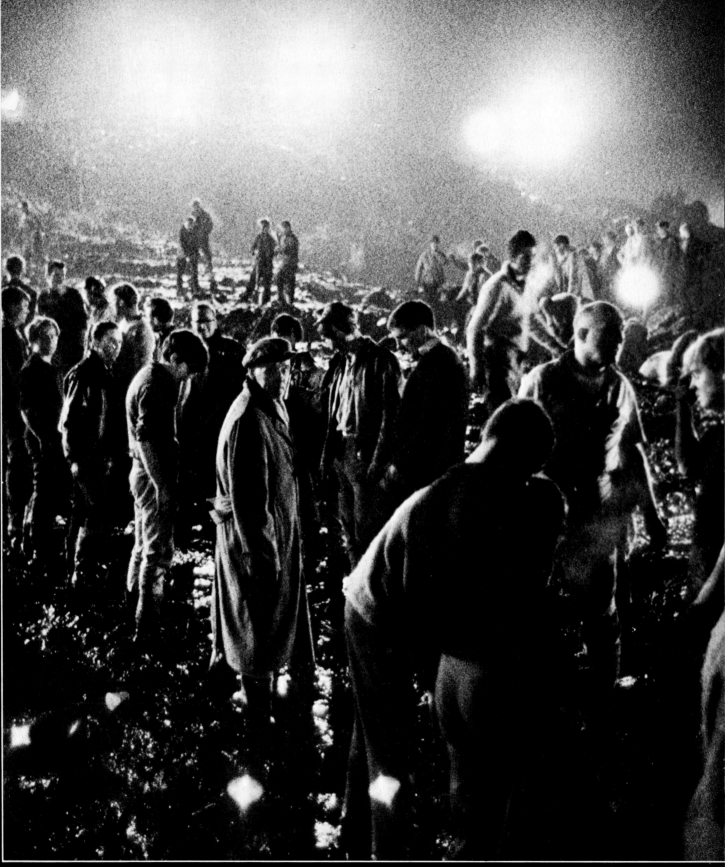

NEWS PHOTOGRAPHY

IF THE MOST SIGNIFICANT development in our society in the nineteenth century was the Industrial Revolution, then it could be argued that historians will see the media revolution as one of the dominant influences of the twentieth century. More people know more about the world they live in than they have before, and this is largely due to the camera.

Although history has been diligently recorded by generations of dedicated and brilliant writers, no amount of descriptive text (or objective, interpreted paintings) can capture the immediateness and reality that a camera can record and preserve. Frequently words that were vivid in their time make an account seem blurred and unreal to present generations because the style of expression and the meaning of the words has changed – but a

photograph is something that increases its value in terms of credibility and impact. Imagine what it would be like to see pictures taken during the Battle of Waterloo!

In addition a photograph is the only truly universal language, and its message can be seen and understood by people of every race.

Helmut Gernsheim, the American writer, wrote 'Photography is the only "language" understood in all parts of the world, and bridging all nations and cultures, it links the family of man. Independent of political influence – where people are free – it reflects truthfully life and events, allows us to share in the hopes and despair of others, and illuminates political and social conditions. We become the eye-witnesses of the humanity and inhumanity of mankind.'

Night scene after the mine dump disaster at Aberfan, Wales, photographed by Ian Berry.

Moments in history

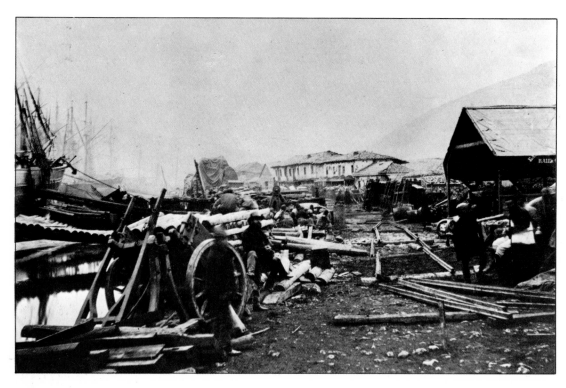

The shambles and desolation of war are poignantly portrayed in this Crimean War photograph (left). In the early days of photography, technical limitations made it extremely difficult to take photographs during moments of action – even in this scene, most figures are partly blurred.

The technical qualities that are normally associated with good photographs can become unimportant when tension and drama dominate the picture – as in this photograph (right) of British troops in the Battle of the Somme during the First World War.

SINCE THE INVENTION of photography the visual recording of history has increased in importance to the point where no newspaper or magazine would consider covering an important story without the use of photography. In-depth stories and features use photographs even if they are not specially taken, and most publications consider that pictures and words are equally important.

The newspaper or magazine photographer differs from his colleagues in other fields in that his work must tell a story in its own right while simultaneously contributing to the written story. For this reason there needs to be a close relationship between the writer and the photographer on an assignment, and the photographer must not only be able to see a good picture but also to recognize one that is relevant.

There also needs to be an element of ruthlessness in a news photographer. Much of the work he has to do involves being present during moments of tragedy, disaster and personal grief, and it requires a very special attitude simply to think in terms of composition and exposure at these times – there must be many occasions when a photographer is confronted with the choice of taking pictures or helping someone in need. Rightly or wrongly, the successful photographer, while hoping to do both, is likely to take a picture first. It also requires the technical ability to be able to operate a camera well in conditions where the basic act of survival would be task enough for most people, and complete familiarity with his equipment is vital for a news photographer.

In some situations it is enough simply to get an image, and many famous pictures of dramatic events have been very poor pictures in the technical sense. In the past there often has existed a notion that, compared to other fields of photography, newspaper work required somewhat less in the way of technical expertise. But nothing could be further from the truth. The demands of a modern newspaper or magazine can require the highest possible abilities on the part of its photographic staff – quite apart from the fact that good black and white reproduction in newsprint calls for the original image to be of exceptional quality.

The conditions under which such pictures have to be taken, and the variety of subjects that a news photographer is called upon to handle, require complete mastery of the whole photographic process. The use of colour is also now widespread in the news media, and the average newsman must be able to tackle subjects as wide ranging as a black and white glamour session to colour shots of a coal mine disaster, at a moment's notice.

In many cases the moment at which the exposure is made is only one in a long process of getting the picture. The business of actually making it possible to be at the right place at the right time and in the right position is the major part of a newsman's work – plus, of course, getting the film back to the picture desk. Most news photographers therefore have to be seasoned and resourceful travellers who are able to find their way around strange and unfamiliar countries and can charm or con their way both into and out of every conceivable situation.

The light and mood of this picture (right, middle) underline the feeling of calm before the storm during the US Marine assault at Inchon, in the Korean War.

The camera's ability to capture spontaneity is evident in this picture (right, bottom) when President Truman's unexpected election caught newspaper headline writers unprepared – an ideal example of the moment making the picture.

No matter how much evidence of destruction there is, it is the reaction of people and the display of their emotions (far right) that drives home the true horror of war, as in this photograph taken during the London Blitz in the Second World War.

The camera as witness

ALONGSIDE THE DAY TO DAY reporting of events, tragic and trivial, that is the main preoccupation of the press, there is also the coverage of the more momentous and far-reaching occasions which affect our lives – war and famine, riots and demonstrations, and so on. The camera has enabled us all to be witnesses to these events, and many of the photographers who have taken it upon themselves to record these happenings have, rightfully, become almost legendary.

The camera has the strange ability to create a barrier between the photographer and what is happening around him, and although he is exposed to the same dangers as the people he is photographing in a sense he is slightly removed from the reality of the situation. The act of taking a photograph is essentially one of non-involvement, and yet the result can often appear to be more real than the event photographed, just as there is some quality given by the way a still photograph is composed and isolated from time that often makes it more memorable than the real subject.

There was probably more live coverage on film and television of the Vietnam war than any other event in history, and yet most people remember a single strong photograph – such as the screaming child running from the scorch of Napalm – far more powerfully and lastingly than any of the motion pictures. This gives such pictures, and the photographers who take them, a daunting responsibility. Such a powerful means of communication can just as easily be used to mislead as it can to inform, and it would be a very strange person indeed who could remain totally unbiased.

The non-involved observation of this type of picture almost becomes a standard by which it is judged, and although a certain amount of poetic licence is accepted in other aspects of the medium (in terms of slight adjustments to a situation in order to improve the composition or the lighting) here its value both as information and as a photograph is dependent on complete integrity.

There is a very famous picture by Robert Capa of a Spanish Republican soldier photographed at the moment of death as a bullet struck him; it is a picture that has become important both as a fine photograph and as a piece of reportage. A little while ago, however, it was suggested that the scene might have been set up, and that the soldier was simply performing. Although the image had not physically changed it would be impossible, if one believed such a suggestion, to see the picture in exactly the same way. If it was not genuine then it could not be a great photograph.

Even when a photographer has been truthful, and his pictures are an honest and unbiased record of an event, it is still possible for them to be used in a way that misleads or calculatingly distorts the truth. A part of the image can be cropped off, or the context in which it was taken can be changed by the wording of a caption.

Although the camera plays a vital role in the way we are informed and influenced by events in distant places, it does have its dangers. Apart from misuse there is also a tendency for excessive exposure to reduce the impact of such pictures. While this is almost certainly true in terms of quantity, it is unlikely that the truly great individual pictures will ever cease to have an emotive effect, and in the end it may well prove to have been the skill and sensitivity of the photographer that prevents us from being unmoved and from growing indifferent to tragic events.

A newspaper's picture editor is always on the look out for a different angle on an event that is being covered by all the other papers. A picture that is as full of human interest and emotion as this one (above), taken during a city festival, says far more than any conventional crowd scene could.

Although many of the most famous news pictures are of tragedy and violence, human achievements can be just as moving – particularly when they encompass courage and supreme effort as in this picture (right) of 1908 marathon runner Dorando staggering across the finishing line. We now take it for granted that everything important or interesting that we cannot witness ourselves, we will see in photographs.

The still camera's ability to witness and record a split second of history is dramatically illustrated in this photograph of the stabbing of a Japanese politician. A news photographer can never forget that his job, in situations like these, is to take photographs, and hope that in the end his pictures do more good than would his immediate personal involvement.

The worst side of human nature frequently has the biggest pictorial coverage – such as these photographs taken in Paris during the 1972 student riots (left) and during a political demonstration (above). A great deal of the public's views of such events is based on the way the photographer takes his pictures. In these two instances, the photographers were among the rebelling factions; in one we tend to feel sympathy with them as they are confronted by massed ranks of riot police, but in the other we recoil from the unleashing of violence.

Photographing personalities

THE PHOTOGRAPHY OF FAMOUS **people is a large and important part of a magazine and newspaper photographer's work and basically can be divided into two types – pictures that are taken with the co-operation of the personality and those that are produced by persistence and subterfuge.**

The photography of some people, such as royalty and politicians, tends to fall into both categories, since although they are usually quite willing and co-operative towards the press and will make allowances during events and occasions for special photo-calls, there is also great enthusiasm on the part of photographers to capture or even engineer candid, embarrassing or unscheduled moments. This type of work tends to be very competitive, and when a public appearance is made by, say, a member of the Royal Family, most of the national publications will send their own photographers – who can often be as much of a problem to each other as any of the difficulties created by the personalities or by poor lighting.

Many newspapers have photographers who virtually specialize in this type of 'candid' photography because it requires a great deal more than the ability to take good pictures. A degree of detective work is often needed to discover the movements of a particular personality so that the photographer can be in the right place at the right time. This may mean cultivating the friendship of various employees or hotel staff, and frequently it also requires a considerable amount of patience – perhaps waiting into the early hours of the morning, for someone to leave a dinner or a party.

The potential prey is usually just as experienced at avoiding such confrontations as the photographers are at contriving them, and this can lead to quite violent and unpleasant incidents when excessive persistence has been employed. Some of the photographers who work for certain European

A long-focus lens is an essential piece of equipment for the photographer of personalities, and the compactness and lighter weight of telephoto and mirror lenses is welcome in the hours of waiting and the crowded jostling that is part of the job. It is also essential to know where your subject is going to be, and to be well-enough organized (and suitably dressed) to be on the right place at the right time – to obtain an informal picture of Queen Elizabeth enjoying a day at the races, for instance (below).

The problems of being a photographer of personalities are well-illustrated in this picture (right) of newsmen struggling to get a passable shot of Elizabeth Taylor at the height of her popularity.

People in entertainment, such as Jane Birkin and Juliette Greco (far right, top), are natural subjects for the camera; but there is a great difference between photographing them at public events and invading their privacy.

Photographs of familiar faces need to be unusual to gain interest (right), but only successful photographers, like David Hurn, will get the opportunity to take such a pleasant picture of Jane Fonda and Roger Vadim.

Even royalty may suffer indignities (far right), but an alert photographer benefited from the sudden gust of wind that dislodged the Queen's hat. This picture was one of a colour sequence taken with motor drive.

picture agencies and magazines have acquired a considerable degree of notoriety through their methods – the Italian paparazzi are an especially persistent group whose name is now almost representative of a photographic style.

The way in which the more co-operative pictures are taken can vary considerably. At a photo-call a large number of photographers from different papers will be present, with only a short time and limited conditions in which pictures can be taken. At the other extreme there may be an in-depth feature or interview of a personality, involving a single photographer spending several days with the subject. Frequently a photographer and a journalist will work together so that the photographer is able to take some quite informal and spontaneous pictures while the journalist is conducting the interview.

The way in which a photographer is able to work is often largely determined by the attitude of his subject. Sometimes he may be told 'Right, you've got three minutes' while on other occasions the personality may be prepared to spend several hours with the photographer and make suggestions for particular shots. Consequently this type of photography requires someone who can work in a very flexible way and not be rattled by pressure or by being treated inconsiderately. He must also be able to get along well with people at all levels, have considerable tact when necessary, and yet be relaxed and not easily dominated. There is a story that a now very well known photographer was sent, in his early days, to North Africa to photograph an extremely famous Allied general who immediately told him that unless he had his hair cut he would nõt be allowed to take any pictures. The then-unknown photographer said 'Well, if that's how you feel, goodbye.' The general changed his mind, and the photographer got his pictures.

Luck inevitably plays a part in good photographs of famous people, for individual posed sessions are reserved for only a few professionals. This photograph of Winston Churchill, Britain's wartime leader (below), would have been a lot less effective had the photographer chosen to take it a moment earlier, before the hand was raised in the famous victory sign – and the composition would have been spoilt a moment later when the central figure would have been in front of a confusing background.

Photojournalism & the picture story

MOST PHOTOGRAPHS are intended to be viewed as a single entity, each one representing a specific idea or describing a particular situation, and much of the skill of a newspaper photographer lies in being able to combine various elements into one strong image. It is this type of picture that is most widely used in newspapers, but magazines frequently use pictures in a rather different way, frequently referred to as photojournalism.

The picture story or photo-essay is a series of photographs that are intended to be seen in a particular sequence and that combine to create a narrative. The way in which these pictures are taken requires a different approach on the part of the photographer since it is the way that the pictures work together, and the sequence in which they are seen, that becomes more important than the purely visual impact of a single image. The photographer must have a far more journalistic attitude to his subject and must be able to recognize the most significant aspects of a situation in terms of the story itself before he can begin to consider it in visual terms.

A picture story can be a simple series of pictures showing, for instance, how a product is made, and the complete sequence of events may last no more than an hour or so. On the other hand it could be a much more complex story that requires photographing a whole group of people involved in a

wide variety of activities over a period of weeks or even months. But in either case the aim remains the same, which is to take pictures in such a way that each successive image unfolds a little more of the story, enabling the viewer to follow the progress of events with the help of the pictures alone – the captions will simply add more information, as opposed to actually telling the story.

Both the preparation for the story and the degree of involvement needs to be much greater for a photographer embarking on this type of assignment than for the normal coverage of an event. It is vital for the photographer to be fully briefed on the subject in order to understand and recognize the significance of what he is photo-

graphing. Many photographers who have excelled at this type of photography have been very committed people, and the often powerful pictures that they have produced have resulted as much from their involvement and concern as from any photographic skill. W Eugene and Aileen Smith, for example, lived for a long period in the Japanese fishing village of Minamata in order to record and expose the horrific effects of pollution on the community, and as a result suffered considerable personal hardship and harassment. The pictures they produced (five of which are reproduced on these pages) contain some very powerful single images, in addition to forming part of an eloquent and moving story.

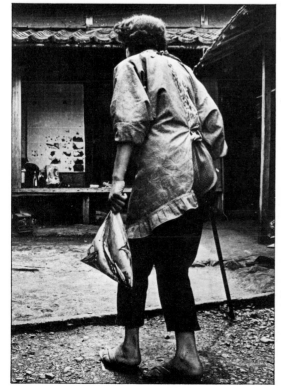

The photographs on these two pages are some of those taken by W. Eugene Smith to show the effects of mercury poisoning from industrial pollution on the Minamata village community.

207

Photojournalism & the picture story

IT IS NO COINCIDENCE that many outstanding single photographs have been produced from a series taken as a picture story. The photography of people, in particular, tends to produce lasting and compelling images as a consequence of the greater degree of involvement with the subject that inevitably results from such an assignment. It is possible, for example, to produce a moving and dramatic landscape picture from a quite transient experience – but it is far less likely to be as meaningful to the general viewer as when a number of people are involved.

Quite apart from aiming to suit the requirements of books and magazines, photographers usually tend to be more interested in producing images that are self-contained and need no story line or sequence to justify them, and there is much to commend this way of working, especially for the photographer who has a feeling for the documentary aspects of photography. The discipline that is required to think a subject through in terms of a narrative will help a photographer to see past the purely superficial aspects of his subject and, in addition, the need to produce a good picture from the less obviously photogenic situations that are needed for the story will help to develop a good visual sense and effective techniques.

You do not have to be a photojournalist to benefit from this approach to your photography,

The English Seaside Pier
The photographs on these two pages were selected from a series taken over a period of time to show how these unique relics of the Victorian era still have much to offer in the way of entertainment and leisure.

Many of the piers that were built in the 19th Century have been lost through storms and erosion, and the cost of repairing those at present under threat becomes increasingly prohibitive.

Only one new pier has been built since World War II, and that is the precast concrete structure at Deal (on the right of the bottom picture) - not a very attractive pier but nevertheless one with much to offer those who like to fish, stroll about or simply sit in the sunshine.

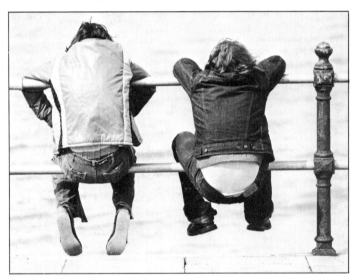

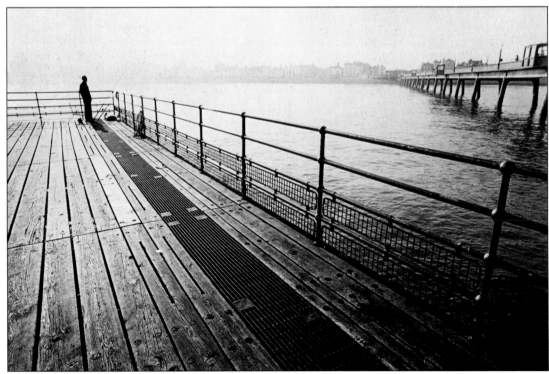

for there are many other aspects of the medium in which a series of pictures can be used more notably than the more blinkered approach that is encouraged by the search for a single strong image. Photographing a holiday or a wedding, for instance, can be tackled very effectively in a picture story way. The need to think the project through before you start will ensure that you have a complete and varied account of an event, rather than a number of repetitive or seemingly un-related single pictures.

Another way that such an approach can help a photographer is in providing a theme or a motive for shooting pictures. Most photographers, no matter how enthusiastic or experienced, some-times go through the equivalent of writer's block where they simply do not seem able to 'see' pictures, and suffer a very real lack of inspiration. In these situations it can be a help to set yourself a project that you can get involved in; doing so will often stimulate you to see pictures worth taking.

The subject you choose can be quite arbitrary – it does not necessarily have to be something in which you have a particularly compelling interest. In her book *On Photography* Susan Sontag quotes the photographer George Tice as saying 'As I progressed further with my project, it became obvious that it was really unimportant where I chose to photograph. The particular place simply provided an excuse to produce work.'

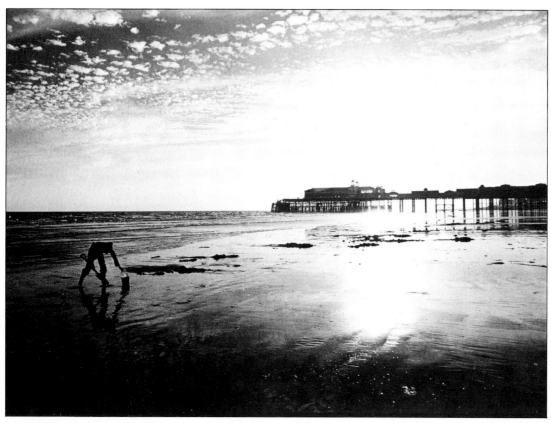

In contrast to the pier at Deal, the elegant structure at Hastings (left), designed by Eugenius Birch, is a delight of intricate and decorative ironwork.

A pier affords the nearest experience to being at sea without leaving terra firma, and many people spend a day or an afternoon on the pier for that reason.

A theme such as this can provide a photographer with a continuous purpose for shooting pictures. Above all it is one that he can leave for months or even years, and return to again and again as opportunity permits.

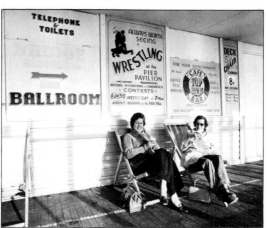

The travelling photographer

When you are going away from home for a period of time intending to take pictures you need to give some thought to the planning and organization of the trip, particularly if you are travelling abroad. It is always a good idea to write a detailed check list of absolutely everything you think you may need.

Obviously the basic camera outfit is the most important item. This will depend to some extent on the type of pictures you intend to take, but the 35 mm SLR system makes it possible to be prepared for most contingencies without being excessively weighed down with equipment.

If, for example, you are going abroad for a couple of weeks to take some general travel pictures (which could encompass everything from close-up portraits to general landscapes) then you would ideally need to take at least one wide-angle lens and one of medium to long focal length in addition to the standard lens. In fact a great deal can be accomplished with just three lenses – a 24mm or 28mm ·wide angle, a reasonably wide aperture standard lens for difficult lighting situations, and a 105mm or 135mm lens for portraits and more distant viewpoints. A 70–210mm zoom is a very useful lens to have on such a trip, and at a pinch it could replace both the standard and long-focus lenses.

The most widely used range of lenses for a 35mm camera are between 20mm and 200mm. Focal lengths shorter than 20mm are really useful only for extreme effects or for confined interiors, and

lenses longer than a 200mm are principally needed for subjects like sport photography.

It is very important that you do not allow yourself to be tempted into taking a new piece of equipment that you have not thoroughly tested, as this can easily lead to disappointment and to spoiled, irreplaceable pictures. A lightweight but rigid tripod is also a very useful accessory, and it is a good idea to buy one that fits into your suitcase to save you being unduly cluttered on the journey, particularly if you are travelling by air.

A selection of filters should always be included. The most useful are red or orange for more dramatic effects in black and white pictures, a slightly warm-tinted filter, such as a Wratten 81A, for overcoming blue casts on overcast days or open shade using colour film, UV and polarizing filters for difficult lighting situations, and possibly a graduated filter for toning down sky areas. The integrated filter systems (such as Cokin) are ideal for travelling as they can be used to fit different sized lens mounts and are light and virtually unbreakable.

A small portable flash-gun is also useful to have along. It will take up little extra space and could often provide that extra bit of light in poor conditions that makes a picture possible.

A plentiful supply of spare batteries is essential, particularly with automatic cameras, as some of these will not function at all if the batteries lose their power.

It is also advisable to pack a separate exposure

The choice of an equipment bag is very much dependent on individual preference and on the conditions it is going to be used in. A soft bag (below left) is less conspicious and less inconvenient in crowds. A hard bag (below centre) protects equipment better and could be used as the main equipment 'store' on location. A fitted hard case offers maximum protection from shock, dust and moisture, and many of them can be stood on or sat on quite safely. A sturdy but light tripod is essential on most trips and can be strapped to the outside of the equipment bag.

meter even if your camera has an integrated meter. Apart from the possibility of the camera meter breaking down it is also comforting to occasionally check them against each other to ensure that they give constant readings. It is a good idea to make frequent checks when the camera is unloaded to ensure that the shutter is functioning correctly and that the automatic iris mechanism is working properly.

A soft cloth to dry the camera if it gets wet can be tucked into the case, and a packet of lens cleaning tissues is always useful.

It is wise to make sure that you have enough film for the trip and that you will not have to fall back on local supplies – these may be badly stored or short-dated, and of unpredictable colour quality. It is vital to keep your own film out of the heat while travelling, as even a short spell of exposure to bad storage conditions can have an adverse affect. If you are buying film especially for a trip it is well worthwhile to ensure that it is all from the same batch, and to test a roll before you leave. It is not unknown for a rogue batch of film to be circulated and this risk can easily be avoided. Pack something light-tight into which you can immediately put exposed films and take a marking pen to identify individual rolls.

The carrying case is something that can make a great difference to the comfort of working. It is a good idea to have one which is not too ostentatious for strolling around, but at the same time it should give a reasonable degree of protection when you travel. Many photographers who travel a lot use a feeder case, which is simply a solid compartment case large enough to hold all the equipment securely, and also carry a small lightweight bag into which individual items can be transferred for short periods. The small case can be used to carry film on the journey out.

If you are flying, NEVER pack your film in the suitcase that goes into the baggage hold – it may well be X-rayed, which can completely ruin both exposed and unexposed film.

Most countries restrict the amount of film and equipment that can be taken in by tourists, and this could easily be less than you need for some serious photography on a two week trip. It is possible to obtain a Carnet (from the Trade or Customs department in your country) which is a document that contains full details of everything you are taking abroad. This enables the Customs authorities of the country you are visiting to make sure that you do not sell anything during your visit – your equipment must be checked against the Carnet by a Customs official as you enter and leave the country you are visiting.

An alternative to the Carnet, and one that is usually acceptable to most Customs departments, is simply to prepare a thoroughly detailed typed list, in duplicate, of all the items. It is important, however, that you draw attention to your cameras when you are asked if you have anything to declare, as many countries impose heavy spot-fines if you are in breach of their regulations.

Many manufacturers cater for the travelling photographer, and dust-proof film cassette holders, worn on a belt like a bandolier (below left), could be handy on location. Most photographers take advantage of the profusion of filters now available, and a pouch with individual pockets makes storage and protection much easier (bottom left). A photographer who does a lot of telephoto work would do well to consider the size and weight advantages of using a mirror lens (below, seen next to a conventional lens of equivalent focal length).

Presentation and storage

MOST PHOTOGRAPHERS **put a great deal of thought and effort into taking pictures, but much of this will be wasted if consideration is not also given to presenting and storing them. The best photograph in the world will still benefit from being presented well – and may be permanently harmed by bad storage.**

Colour and black and white prints can be displayed in a number of ways. An album is a simple and relatively inexpensive method, and provides a convenient way of showing (and keeping) a number of prints in a predetermined sequence. Smaller prints, such as enprints, can be made to look very effective even in a modest album if they are laid out in a pleasing way on the page.

A photographic album of about 10 × 12 in (250 × 300 mm) will enable three or four enprints to be mounted on a single page. The cheapest type of album has plain card leaves onto which the prints can be mounted by adhesive on the back of the prints, or by the use of a small self-adhesive triangles that hold down the corners of the print –

this method has the advantage that the prints can easily be removed or changed round.

The same flexibility is offered by albums which have thin acetate overlays. The prints are simply positioned on the page and the acetate is then laid gently on top and pressed down, holding the pictures in place – this has the additional advantage of protecting the prints.

Whichever method is used, the ultimate success of the presentation will depend on the way the prints are laid out, and it is best to position them loosely in various positions to judge the best effect. They may be arranged in chronological order to tell a story, or placed together to create the best visual effect. Larger prints are best displayed individually on each page.

Albums are available in various sizes from 8 × 10 in (200 × 250 mm) to 16 × 20 in (410 × 510 mm) with acetate sleeves fitted into a fixed or loose-leaf ring binder. The prints can be mounted on this card and slipped into the transparent sleeves, back-to-back. It is important to use a mounting adhesive that is

Good presentation always enhances a picture. Illustrated here (right, clockwise from left) are: two albums for displaying prints, either using corner tabs or placing the prints beneath acetate sheets; a light box for viewing and sorting a number of prints at once – ideal for preparing a slide presentation or for viewing slides in a transparent wallet; a small portable light box that looks like an executive briefcase; and card mounts for transparencies, which are available in a large variety of shapes and sizes.

recommended for photographic use because the chemicals in some adhesives can react with prints and cause staining. The best method is dry mounting, which involves sandwiching a thin layer of special tissue between the print and the mount, and subjecting it to heat and pressure. The tissue melts and forms a bond, leaving the print very smooth and flat.

Sometimes it is preferable not to be restricted by an album, and to have the prints individually mounted and carried loose in a case. This can be done in a similar way to the dry mounting method described, but using a rather heavier and more rigid mounting board. An alternative method is to use lamination. The print can be mounted first on a thin card, as before, but this is not essential, and a number of service houses and art suppliers offer a service whereby the photograph (or any fairly thin printed matter) is encased in a thin plastic sandwich. The result is a very light but quite rigid print that is almost completely protected against creasing and surface damage.

Colour transparency presentation poses more of a problem. The most effective method, of course, is by projection, and the effort involved in preparing a carefully conceived programme of slides, with background music and the use of techniques such as dissolves, can be well rewarded. But there are many occasions when this method of presentation is not possible and something more simple and convenient is needed. It is possible to buy thick, black card mounts, about 11×14 in (280×355 mm), with a number of apertures of standard film formats cut into it – the transparencies can be mounted in the apertures by adhesive tape around the edges, and the whole sheet slipped into an acetate pocket that is clear on one side and frosted on the other. This enables the complete display of transparencies to be held up against a convenient light, such as a window, and evenly illuminated. Transparencies can also be mounted singly in smaller mounts, and this is a good way of presenting and protecting slides when submitting them for publication or for competition.

Transparencies are enjoyed most when they are projected. Some projectors use drum or carousel magazines (left top) and these can be bought separately with transparent dust covers for slide storage or for preparing a large number of slides for projection. A more expensive unit with two projection lenses (middle) allows either a more rapid change of picture or a dissolve-over effect. Storage cabinets holding a number of straight slide magazines or cassettes are available for projectors using this system.

213

Presentation and storage

IF YOU HAVE PICTURES **you are particularly proud of it is pleasant to be able to have them permanently displayed in your home, and there are a number of ways that this can be done quite simply and inexpensively. It is important to remember, however, that colour prints in particular are liable to fade, and it is best not to display them in a position that is exposed to direct sunlight or even to very bright daylight. It is possible to buy an aerosol spray from photographic suppliers that can be used to coat the surface of the print to afford some protection from ultra-violent light, the main cause of the dyes breaking down.**

If you are having prints made with the intention of putting them on permanent display, it is worth the extra expense of using the Cibachrome process, as this is particularly resistant to fading.

The simplest method of preparing prints for wall-mounting, and one that is quite effective, is to use self-adhesive illustration boards. These can be up to $\frac{1}{2}$ in (12mm) thick and have a protective film over the adhesive surface. The film is peeled back, the print is smoothed down onto the adhesive surface, and the board trimmed flush with the print using a thin, sharp blade. The edges can either be left white or painted matt black, and the board is so light that it can be mounted on a wall with adhesive tabs, or with double-sided tape. These mounts can also be bought in standard sizes with the edges already finished, and then you just have to trim your print to size.

Another inexpensive but very effective way of displaying a print is to mount it on a thickish card, and then sandwich it between a sheet of picture glass and a piece of hardboard or masonite of the same size. The combination is then held together by small metal clips that grip the edges of the sandwich at each corner or along the side. The presentation can be made to look even more effective if the photograph is given a cut-out overlay, known as a mat. This is a thickish card of the same size as the glass with an aperture cut into the centre, slightly smaller than the print, which is positioned behind it – the appearance is best when the aperture is cut with a bevelled edge.

In addition there are a wide selection of do-it-yourself framing kits. Many of these are of the slim metallic type which often looks best with photographic prints, and they also have the advantage of being easily dismantable, so it is possible to change your display.

Storage

One of the best ways to store colour transparencies is in the soft plastic wallets that hold a number of card-mounted slides in small pockets. These usually have a frosted back which makes it easy to view all the slides without a lightbox, and up to twenty 35mm transparencies can be held in one wallet (with a correspondingly smaller number of larger format pictures). These wallets are normally A4 or 8 × 10 in (200 × 250 mm) (for twenty 35mm transparencies) and can either be stored in a filing cabinet with suspension bars or clipped into a ring binder. The big advantage is that as well as offering an efficient and compact method of storage they also enable a large number of transparencies to be seen at a glance, and make it fairly simple to plan an indexing system.

Those who are more concerned with projecting their slides can store them individually in slide boxes, transferring them to the special tray for projection. Whatever system is used it is important that the transparencies are kept in a cool dry place and away from the light, as the dyes used in colour transparencies are as vulnerable to fading as those in colour prints.

Black and white negatives can be kept in thin plastic sleeves that hold a complete roll of film when it is cut into strips of the right length. It is possible to buy clear sleeves of this type, which enables contact prints to be made without removing the negatives from their protective cover. It is a good idea to store the negatives together with their corresponding contact sheets in an album or a cabinet, as this makes it very easy, and quick, to locate and identify individual pictures.

Prints displayed behind glass look especially attractive, and the methods illustrated below require no glueing. The mats or masks placed over the prints can be bought ready cut or made quite easily, and various colours can be chosen. Non-reflective glass is widely obtainable and will give an even better appearance.

Moisture and dust rapidly spoil negatives and slides, so storage systems should guard against this. Single strip negative sleeves can be marked and kept in metal drawers, or they can be bought in sheet form and kept in a ring binder. Although the negatives are easily visible in the transparent sleeves, an index will make it a lot easier to locate the ones you want. Mark envelopes with a felt tip pen to avoid damage to the negatives.

Slides are particularly susceptible to moisture, and should be kept in a dry place where air can circulate. Viewpacks, or transparent wallets, can be bought in a variety of sizes, and can either be kept in ring binders or suspended in a metal filing cabinet. If you do a lot of projection, it will be worthwhile remounting cardboard mounted slides in stiffer plastic mounts. Diagonal lines drawn across the top of slides will ensure that they are kept in sequence in the slide boxes.

Selling your work

THERE ARE TWO BASIC METHODS of earning money by taking photographs. One is to persuade someone to pay you to take them, and the other is to find someone to buy pictures that you have already taken. The method you choose would depend partly on the type of picture you like to take and partly on your commitment in money and time.

In order to obtain commissions for which you can charge a fee it is first necessary to accumulate a portfolio of work to show prospective clients. If, for example, you are interested in taking portraits either as a part time occupation or simply to help finance your hobby, then you should collect together the very best pictures you have made of friends and family, and make really good quality prints of a suitable presentation size. They should be carefully mounted and finished, and displayed in a portfolio case or an album – the type with acetate sleeves are particularly useful for photographs as they offer some protection for the prints.

You should make the most of any particular abilities you have, such as a good rapport with children. It is unwise to encourage commissions involving a type of work you feel less confident about or simply do not enjoy very much. If, for example, you have limited studio facilities but enjoy working with natural light, then it would be best to promote the informal type of portrait taken in peoples' own homes as your speciality.

It is also vital to base your fees on a realistic costing. Make sure you know exactly how much it costs you to do a session – the cost of film and processing, making contact prints or proofs, and the cost of producing the finished enlargements together with mounts or folders. You should make a proper allowance for waste, for postage when you use a colour laboratory, and even the cost of travel should be recorded and incorporated.

If you intend to do a substantial amount of work for which you recieve payment it is vital to keep proper records both of fees received and expenses incurred. You will be liable for additional income tax, but you will be allowed to deduct the costs incurred in doing the work provided you can furnish evidence of them.

Another possibility is to find a market for pictures that you have already taken. This means that you can shoot precisely when you want to, and you will also have a greater choice over your subject matter. There is a very large market for 'stock' photographs of a wide variety of subjects, from nude and glamour pictures to travel and sport photographs; many publishers of books and magazines use a large proportion of their pictures from existing sources.

There are two methods of selling pictures in this way. You can approach publishers directly or you can submit your pictures to a photographic agency, which will sell the pictures on your behalf. This means that they will have to keep the pictures they select and they charge a fee for their service, usually in the order of 50 per cent of the reproduction fee paid by the publication. The agency will be responsible for collecting the fee and will then pass on your share. This may seem like a high proportion to charge but in fact the cost and time involved in submitting pictures to prospective clients is considerable. But they are also in a position to be much more aware of potential markets, and most of the larger picture agencies operate on an international basis, so the 50 per cent you receive may be considerably more than you could earn selling your pictures yourself.

Selling direct can be an advantage if you are able to fulfil a specialized need with a relatively small number of publications with which you are able to establish yourself as a regular contributor. This involves studying their requirements carefully, and submitting only pictures of the type and format that they frequently use. If you intended to submit pictures for possible use on the cover of a magazine, for instance, you should look at the covers they have produced over the last few months to establish the type of picture they use. A 'girlie' magazine for example may use a bikini clad model on the cover but never a nude, and you should also see whether they prefer an upright picture which fills the page, but has a plain area at the top for the title, or whether their style suits a square format picture with a panel title.

It is vital that your work is presented and packed well, with your name, address and telephone number clearly marked on each individual picture submitted. Colour transparencies should never be mounted in glass, and return packaging and postage should be included, particularly with unsolicited work.

If you intend submitting your pictures for consideration by an agency it is best to write first, asking them what their requirements are and including a small cross-section of your work so that they can judge the style and quality of your photographs. You should always make sure that each of your pictures is accurately captioned, identifying when and where it was taken and, if necessary, describing what is happening in the picture. It is also essential to obtain signed model release forms from any people who feature prominently in the pictures you submit.

Optimism is something you can never have too much of when you try to sell your work – photography is a very competative business, and you should not be too discouraged when pictures are returned unused and unwanted. You can lessen the chances of this happening considerably by making sure you present your work cleanly, and by being sure you never send it to sources that are unlikely to want it – after all, one of the first and best rules of selling is 'know your market'.

*Street photographer in
Iráklion, Crete, by
A. Zeimbekis.*

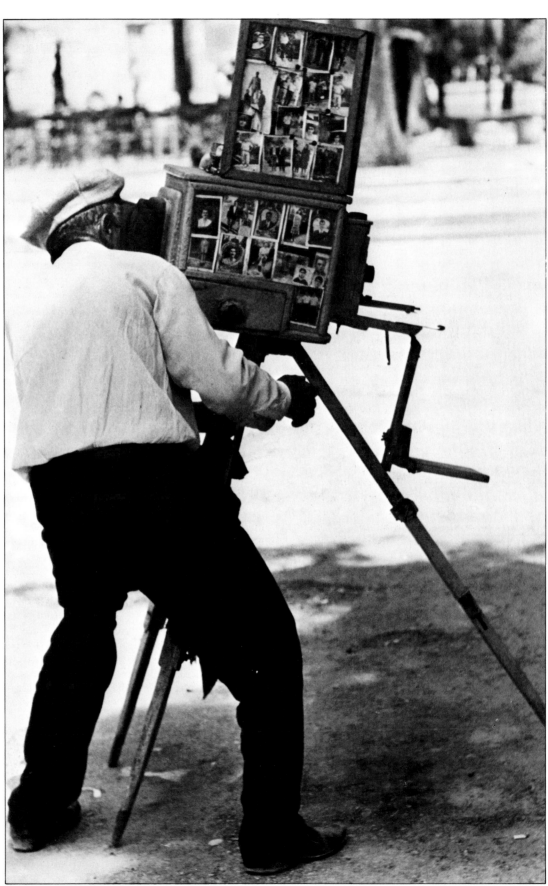

Angle of view The widest angle at which light rays are accepted by a lens for a usable image on the film.

Aperture The hole in the lens through which the image-forming light passes, adjusted by an iris diaphram in marked steps called *f*-stops.

ASA See ISO

Auto-winder A battery driven motor attachment that automatically winds on the film in the camera after each exposure – a simplified motor drive.

Available light photography Taking photographs, usually in poor daylight conditions, without supplementary lighting such as flash.

Back lighting Natural or artificial lighting that either points towards the camera or lights the background, creating lighting effects that do not affect the front of the subject.

Back projection Projecting a slide on to the back of a translucent screen to form a background setting.

Barn doors Hinged flaps on studio lights which control the direction and width of the light beam.

Boom Long counter-balanced arm on a stand to which a lamp can be attached for overhead lighting.

Bounce Lighting term, usually applied to flash lighting, in which an indirect light is achieved by reflecting the light off the ceiling or a wall.

Bracketing Taking a series of pictures of the subject at the estimated exposure and at greater and smaller exposures.

Brightness range The range of luminance between the brightest and darkest areas of an image. A wide range is referred to as contrasty, a low range as flat.

Cast The overall bias in a colour photograph towards one colour, frequently caused by lighting conditions, and generally not apparent when viewing the scene.

Catch lights Small points of reflected light in the eyes of a portrait subject.

Colour conversion (CC) filters Filters used on the lens to adjust the colour temperature of a colour film to the light source being used – eg to allow daylight film to be used with artificial light.

Colour filters Filters that absorb light of the complementary colour.

Colour sensitivity The relative response of film to different colours of the spectrum.

Colour temperature A scale used for expressing the colour quality of a light source in degrees Kelvin (K).

Complementary colours Two colours that together produce white light. Complementary colours of the three primary colours (red, green and blue) are cyan, magenta and yellow.

Composites Models' publicity cards showing them in various poses and giving their measurements, agency name and address, etc.

Contrast The subjective judgement of the brightness range of an image or a scene.

Contrast filters Tinted filters fitted to the lens and used with black and white film to exaggerate the difference in tones that would otherwise appear similar on the print – eg red contrast filter causes a blue sky to come out almost black.

Correction filters Filters attached to the lens when using black and white film to modify the tonal rendering of colours – eg a yellow filter to give a more pronounced difference between clouds and a bright blue sky.

Definition Term used for judgement of the clarity of a photograph, and referring to sharpness, graininess, contrast and tone.

Depth of field The distance covered by acceptable sharpness of an image, extending in front of and behind the point of focus – it extends further behind than in front.

Diffusion Scattering of light, either by a translucent screen in front of the light source or by a diffusion filter on the camera lens, to soften the light or the rendering of the image.

Double exposure Strictly the exposing of two images on one film frame, now practically impossible to achieve, even deliberately, on most cameras because of safety devices. Also refers to printing two images on one sheet, though this is essentially photomontage.

Dry mounting Bonding a print to a card mount by heating a layer of shellac tissue between the print and the card.

Electronic flash An instantaneous bright light source produced when a high voltage electric current is discharged across two electrodes inside a gas-filled tube. The current is stored in a capacitor, and is produced by dry-cell batteries, rechargeable cells or mains power.

Exposure The amount of light that reaches the film to form the image, controlled by the size of the aperture and length of time it is open (*f* stop and shutter speed).

Fill-in light Light additional to the main light source and provided by smaller lights or reflectors, directed into the shadow areas to reduce contrast.

Film speed Measure of a film's sensitivity to light, previously recorded in ASA or DIN scales, now increasingly in ISO.

Filter factor The factor by which exposure must be increased to compensate for the light absorbed by the filter.

Fish-eye lens Lens with extremely wide angle of coverage – possibly greater than 180° – and not corrected for barrel distortion, so straight lines are curved away from the centre.

Flare Light in a lens, caused by reflections or unshielded bright light, which degrades the image.

Flash See electronic flash. Flash can also be provided by disposable flash bulbs, flash-cubes or *Flipflash*, in which a zirconium wire in oxygen ignites with a bright flash.

Flash synchronization Method of ensuring that the shutter is open when the flash is at its brightest. Cameras usually have X and M settings, for electronic flash and flash bulbs respectively.

Focal length The distance between the optical centre of a lens focused at infinity and the film plane – the longer the focal length, the more the image is enlarged.

Format Size and shape of the picture formed on the film.

Front projection A method of projecting, from in front, a slide on to a screen to form a pictorial or abstract background for a composition. The image is only formed on the special screen, allowing a person, lit separately, to pose in front of it.

Gradation The tonal range in a black and white image, from white through grey to black. Hard gradation has few tonal steps, giving a contrasty image, while soft gradation has many tonal steps.

Graininess The rough or granular appearance of an image caused by the clumping together of silver halide crystals, resulting from the use of fast film, over-exposure or long development.

Head sheets Posters or booklets issued by model agencies bearing photographs of the faces of all their models, together with their essential measurements.

High key Photography that has mostly brighter tones, usually conveying lightness or delicacy.

Highlights Brightest areas of a print or a transparency, therefore the darkest areas on a negative.

Hot shoe Metal slot, usually on the top of a camera, for holding a flashgun and providing cordless flash synchronization.

Incident light reading Method of taking a reading of light falling on a subject rather than reflected from it.

Index cards Small reference cards used by photographers and model agencies (then usually called composites) for publicity purposes, bearing photographs and copy.

Infra-red film Film that records the infra-red wavelengths, which are beyond the red end of the visible light spectrum, and therefore permitting photography in the dark when an infra-red light is used. With black and white film, green foliage appears white and there is considerable penetration of haze when an infra-red filter is used.

Inverse square law Illumination on a surface is inversely proportioned to the square or its distance from the light source – eg double the distance and the light is reduced to one quarter.

ISO Letters replacing ASA and DIN as the measurement of film speed – the higher the ISO number, more sensitive to light is the film.

Joule Unit of measurement, equivalent to one watt-second, describing the output of electronic flash, and used to compare the power of flash systems.

Kelvin (K) Unit of measurement for colour temperature – eg a colour daylight film may be balanced for 5400°K.

Lith film Extremely high contrast black and white film that requires special processing in lith developer.

Long-focus lens Lens with a focal length considerably longer than the diagonal of the film format used. See also mirror and telephoto lenses.

Low key Photograph consisting of predominantly dark tones.

Maximum aperture the largest f-number (aperture opening) on a lens. Fast lenses have maximum apertures wider than $f2$.

Mirror lens Lens with a long focal length that uses mirrors instead of some of the transparent lenses, resulting in a very short, lightweight unit even for focal lengths of over 500mm. They have no aperture adjustment.

Motor drive Battery powered attachment that automatically winds on film and is capable of automatic shutter release for a sequence of shots at a rate of 4–10 frames per second.

Optical axis Imaginary line through the centre of the lens system to the middle of the image area.

Open flash Firing of flash when the shutter is held open – eg at night when there is practically no ambient light.

Over-exposure Consequence of too much light falling on the film, causing density on negatives and thinness on transparencies, reducing contrast.

Panning Technique of following a subject moving across the field of view by swinging the camera; in the photograph the subject will appear clear against a blurred background.

Parallax error Difference between the image seen in the viewfinder and that recorded on the film; avoided in SLR cameras.

Polarized light Light rays that are restricted to vibrate only in one plane by being reflected from a surface.

Polarizing filter Filter that cuts out polarized light, eliminating reflections off water, etc. On colour film it also darkens blue sky without altering other colours.

Rangefinder camera Camera that is focused by aligning two images of the same part of the subject.

Reciprocity law If the product of exposure (aperture × time) is constant, the exposure effect will by the same – eg $f11$ at 1/25 sec produces the same effect as $f5.6$ at 1/100 sec.

Red eye Caused by flash source being too close to the optical axis, when the red layer beneath the retina reflects light into the camera lens, giving the subject red pupils in a colour photograph.

Reflector Any surface that directs and concentrates light, from the bright, curved metal bowls around studio lights and flash lights to a plain piece of cardboard used to fill-in outdoor shadows.

Reflex camera Camera with a focusing and viewing system that reflects the image via a mirror on to a viewing screen.

Ring flash Electronic flash in the form of a tube around the camera lens, specifically used for close-up, shadowless lighting, but often used in fashion photography because of the attractive outline it produces.

Single-lens reflex (SLR) Camera that uses one lens for both viewing and recording the image on the film, a hinged mirror between the lens and the film directing the light to the viewing screen and lifting when the shutter is released to allow light to pass to the film.

Skylight filter Pale pink filter that reduces the blue colour cast encountered in certain daylight conditions.

Slave unit Relay mechanism that fires flash sources simultaneously.

Snoot Cone shaped shield fitted to a light to direct the light on to a small area.

Soft focus Reduction of definition of a lens, by a filter or a piece of muslin or gauze, to give a soft, romantic appearance to a photograph.

Spectrum Bands of visible light produced when white light passes through a prism.

Spotlight Artificial light source that has a focusing mechanism to concentrate the light to a specific width.
Standard lens Camera lens with a focal length approximately equal to the diagonal of the film format used, and giving an angle of view similar to the human eye.
Stop Alternative name for aperture. Stopping down reduces the aperture.
Strobe light Another name for electronic flash. Stroboscopic light, however, is produced by a special lamp flashing at a chosen frequency.

Telephoto lens Lens with a longer than standard focal length, but with an optical construction that gives it a much shorter physical length than a conventional long-focus lens of similar focal length.
TTL metering Abbreviation for 'through the lens' metering, common on SLR cameras, in which the camera's exposure meter takes its reading from the light that passes through the lens, thus accounting for absorption by the optical elements.
Tungsten light The basic artificial light source in photography and in the home, produced by passing electricity through a tungsten filament in a glass bulb. A tungsten halogen lamp contains halogen traces to reduce gradual discoloration of the light with age.
Twin-lens reflex (TLR) Camera with a viewing lens mounted immediately above the image lens.

Ultra-violet light Invisible light beyond the blue end of the spectrum, causing a blue cast in colour film which can be reduced by a filter (used at high altitudes, for instance) and requiring no exposure adjustment.

Under-exposure Consequences of insufficient light falling on the film to make a clear image, and causing prints to be too dark, though slight under-exposure on colour film can increase the colour saturation.

View camera Large format camera using plate or sheet film.
Viewfinder System for viewing and (frequently) focusing the subject in the camera.
Viewpoint Position of the camera in relation to the subject.

Wide-angle lens Lens with a wider field of view and a shorter focal length than a standard lens.

Zoom lens Lens of continuously variable focal length that does not require simulataneous readjustment of focus or aperture.

BIBLIOGRAPHY

One of the most enjoyable and effective ways of learning to take better photographs is to study the work of as many successful photographers as possible. This is not to say that you should always consciously try to copy them (though it can be an interesting and useful exercise to try to do so); the greatest benefit comes from inspiration and from the appreciation of new approaches that really good photographs can convey.

The keen photographer is fortunate in this respect, for numerous superb photographic collections are available, ranging from the very expensive to bargain prices. Any list of well-liked books is necessarily subjective, but the titles below have given the author and the editor of this book particular enjoyment. If you gradually build up a library of your own and study the pictures to try to analyze how (and why) they were taken, you will not only enjoy the photographs all the more, but also find your own photography improving.

The Americans, *Robert Frank.* Aperture.
Avedon Photographs 1947–1977, *Richard Avedon.* Thames & Hudson; Farrar, Straus & Giroux.
Henri Cartier-Bresson: Photographer. Thames & Hudson; Little, Brown.
Compassionate Photographer, *Larry Burrows.* Time-Life.
Concerned Photographer. *Capa & Cornell.* Grossman.

Cowboy Kate, *Sam Haskins.* Bodley Head; Crown.
East 100th Street, *Bruce Davidson.* Harvard University Press.
Five Girls, *Sam Haskins.* Bodley Head; Crown.
Robert Frank. Gordon Fraser; Aperture.
Good-Bye Baby & Amen, *David Bailey & Peter Evans.* Collins; Coward McCann.
The Great British, *Arnold Newman.* Weidenfeld & Nicolson.
The Great Photographers. Time-Life.
Great Photographic Essays From Life. Life Books; New York Graphic Society.
Interior America, *Chauncey Hare.* Aperture.
The Last of the Nuba, *Leni Riefenstahl.* Collins; Harper & Row.
The Life Library of Photography. Time-Life.
Masterpieces of Erotic Photography. Arrow; Talisman.
Moments Preserved, *Irving Penn.* Simon & Schuster.
Personal View, *Snowdon.* Weidenfeld & Nicolson.
Photojournalism: The Woman's Perspective. *Mary Ellen Mark & Annie Leibovitz.* Thames & Hudson; Alskog.

Pictures on a Page, *Harold Evans.* Heinemann; Holt, Rinehart & Winston.
Private Collection, *David Hamilton.* Morrow.
The Secret Paris of the 30s, *Brassai.* Thames & Hudson; Pantheon.
The Shadow of Light, *Bill Brandt.* Gordon Fraser; Da Capo Press.
Sisters Under the Skin, *Norman Parkinson.* Quartet; St Martin's Press.
Sleepless Nights, *Helmut Newton.* Quartet; Congreve.
Edward Steichen. Gordon Fraser; Aperture.
A Victorian Album: J. M. Cameron and her Circle. Secker & Warburg; Da Capo Press.
Victorian Photographs of Famous Men & Fair Women, *Julia Margaret Cameron.* Hogarth Press; Godine.
Vogue Book of Fashion Photography, *Text by Polly Devlin.* Thames & Hudson; Simon & Schuster.
Women on Women: Twelve Photographic Portfolios. Aurum Press.
The World of Cartier-Bresson, *Henri Cartier-Bresson.* Gordon Fraser; Viking.

ACKNOWLEDGEMENTS
This book has been illustrated mainly by Michael Busselle's own photographs, but to show the scope of the subject pictures taken by many other photographers have been used, as indicated below.

6 Max Oettli/*EPL*
8/9 Charles Van Schaick/*The State Historical Society of Wisconsin*
12 Henri Cartier-Bresson/*Magnum*
23 (top left) Michael Sharman/*EPL* (bottom left) Chris Kapolka/*EPL*
36 Sarah Errington/*Alan Hutchison Library*
37 (top) F Jackson/*Robert Harding Associates*
37 (bottom left) John Hemming, (bottom right) Robin Hanbury-Tenison/*Robert Harding Associates*
48/9 Cecil Beaton/*courtesy of Sotheby's Belgravia*
53 (top right) Kevin MacDonnell
58 Bill Large/*picture of Woburn Studios courtesy of LAPtech Studio Workshop*
62/3 E O Hoppé/*National Portrait Gallery (private collection)*
64 (top) Rolf Winquist/*Camera Press*
66 Kevin MacDonnell

68 (top left) *courtesy of Scissors Hairdressers*
70 (top left) Richard & Sally Greenhill, (top right) Paul Tanqueray
71 (left) Rolf Winquist/*Camera Press*, (right) J M Cameron/*National Portrait Gallery*
72 (left) E O Hoppé/*The Mansell Collection*
73 (left) Karsh of Ottawa/*Camera Press*, (right) Bill Potter/*Camera Press*
74 Cecil Beaton/*courtesy of Sotheby's Belgravia*
75 (top) Kevin MacDonnell, (bottom left) *courtesy of Scissors Hairdressers*, (bottom right) J M Cameron/*National Portrait Gallery*
76 Brian Aris/*Camera Press*
77 (top) Michael Sharman/*EPL*, (middle left) Rolf Winquist/*Camera Press*, (bottom left) Herman Leonard/*Camera Press*
78 Richard & Sally Greenhill
79 (top) David Steen/*Camera Press*, (bottom right) Cecil Beaton/*courtesy of Sotheby's Belgravia*
80 (left) Michael Sharman/*EPL*
81 Karsh of Ottawa/*Camera Press*
83 (right) Rolf Winquist/*Camera Press*, (top left) Michael Busselle/*courtesy of*

Octopus Books Limited
84 Richard & Sally Greenhill
85 (top left) Pellegrini/*Camera Press*, (top right) Nicholas Sapieha/*John Topham Picture Library*, (bottom) Michael Busselle/*courtesy of Octopus Books Limited*
88 (left) David Hurn/*Magnum*, (right) Michael Busselle/*courtesy of Octopus Books Limited*
89 (left) Brian Aris/*Camera Press*, (right) Richard & Sally Greenhill
91 (top left) Michael Sharman/*EPL*
93 (top) Michael Sharman/*EPL*
94 (top) Cecil Beaton/*courtesy of Sotheby's Belgravia*, (bottom) Martine Franck/*John Hillelson Agency*
95 Cecil Beaton/*courtesy of Sotheby's Belgravia*
96 (left) David Hurn/*Magnum*
97 David Hurn/*Magnum*
98 C Harvey/*Tony Stone Associates Colour Library*
99 (top left, 2) *courtesy of Hoya Corporation* (middle right) J Cowan/*Tony Stone Associates Colour Library*
102 (top) Mike Prior/*David Redfern*, (middle) Ray Palmer/*EPL*, (bottom) Anwar Hussein
103 (top left) John Starr/*All-Sport*

Photographic, (top right) Anwar Hussein, (bottom) *Fox Photos*
104/5 James Wedge/*courtesy of Tavistock and J Osawa & Co (UK) Ltd*
106 (top) Suomen Kuvapalvelu OY/*Camera Press*, (bottom, 3) *Camera Press*
107 Stuart McLeod/*Camera Press, courtesy of NOW! magazine*
112 (top) Michael Sharman/*EPL*, (bottom) Jozef Vissel/*Barnaby's Picture Library*
113 (right) *Fox Photos*, (left) Michael Busselle/*courtesy of Octopus Books Limited*
114 (bottom) Michael Sharman/*EPL*
115 (top right) Michael Sharman/*EPL*
116 Anthony Van Grieken/*courtesy of Mode Avantgarde and Petal Model Agency*
117 (bottom) *courtesy of Select Model Agency*
118 (left) Andreas Heumann/*courtesy of Kodak Limited*
119 (left) *The Photographers' Library*
123 (left) Andreas Heumann/*courtesy of Kodak Limited*
124 Kevin MacDonnell
125 (top) *Fox Photos*, (bottom left) Ian Murphy/*Tony Stone Associates Colour Library*, (bottom right) George Pollock/*Barnaby's Picture Library*
126 (top left) Sam Sawdon
127 (top right and bottom left) A Powell/*Tony Stone Associates Colour Library*, (bottom right) Jerome Yeats/*EPL*
128 Tony Sleep
129 (top) Jozef Vissel/*Barnaby's Picture Library*, (bottom) Tony Duffy/*Tony Stone Associates Colour Library*
131 (bottom right) John Starr/*All-Sport Photographic*, (bottom left) Michael Busselle/*courtesy of Octopus Books Limited*
132/3 Bob Carlos Clarke/*EPL*
134 (top) B Bernard/*ZEFA Picture Library*, (bottom) G Newman/*Camera Press*
135 (top) Blume Photo/*ZEFA Picture Library*, (bottom left) Michael Boys/*Susan Griggs Agency*, (bottom right) John Garrett/*Camera Press*
136 Caroline Arber/*Camera Press*
137 (top) Bob Carlos Clarke/*EPL*, (bottom left) Michael Sharman/*EPL*, (bottom middle) Brian Aris/*Camera Press*, (bottom right) John Dean/*Camera Press*
139 (left) Klaus Benser/*ZEFA Picture Library*, (right) Michael Boys/*Susan Griggs Agency*
140 Bob Carlos Clarke/*EPL*
141 (left) David Hamilton, M Magazine/*Camera Press*, (right) Emil Perauer/*Camera Press*, (bottom) Karin

Szekessy/*Camera Press*
143 (top) Blume Photo/*ZEFA Picture Library*, (bottom right) Chris Kapolka/*EPL*
144 Bill Brandt
145 (middle left) Francis Giacobetti/*Camera Press*, (middle left) Bob Carlos Clarke/*EPL*, (bottom) Peter Basch/*Camera Press*
147 (left) John Robertson/*EPL*, (right) Bob Carlos Clarke/*EPL*
148 (bottom) Brian Aris/*Camera Press*
150 (top) Michael Boys/*Susan Griggs Agency*, (bottom) Bob Carlos Clarke/*EPL*
151 (left) Caroline Arber/*Camera Press*,(right) Bob Carlos Clarke/*EPL*
155 (bottom) Julian Calder/*Susan Griggs Agency*
156 Mark Edwards
157 (top right) George Whitier/*Camera Press*
159 (left) Tony Boxall/*EPL*
161 (left) Michael Sharman/*EPL*, (right) Rolf Winquist/*Camera Press*
162 Michael Boys/*Susan Griggs Agency*
164 Henri Cartier-Bresson/*Magnum*
165 (top) Richard & Sally Greenhill, (bottom left) Bill Strode/*Camera Press*, (bottom right) Robert Blomfield/*Camera Press*
166 *All-Sport Photographic Ltd*
167 (top left) B Julian/*ZEFA Picture Library*, (bottom right) Foto Leidmann/*ZEFA Picture Library*
168/9 Dennis Moore/*EPL*
170 (top left) F Walther/*ZEFA Picture Library*, (top right) Christopher Templeton/*EPL*, (middle and bottom) Peter Evans/*EPL*
171 (top left) Peter Evans/*EPL*, (top right) Michael Sharman/*EPL*, (middle left) A Schnell-Dürrast/*ZEFA Picture Library*, (middle right) Jack Novak/*EPL*
172 (right) J M Cameron/*National Portrait Gallery*
173 (top) Richard & Sally Greenhill, (bottom) *Popperfoto*
174 J Chard/*Tony Stone Associates Colour Library*
175 (top) *ZEFA Picture Library*, (middle left) G Smith/*Tony Stone Associates Colour Library*, (bottom left) Idem Manfr./*ZEFA Picture Library*, (bottom right) Manfred Becker/*ZEFA Picture Library*
177 (top left) David Hurn/*Magnum*, (bottom) Richard & Sally Greenhill
181 (left) Giancarlo Botti/*Camera Press*, (right) *EPL*
182 (top) Adam Woolfitt/*Susan Griggs Agency*
183 (top) Richard & Sally Greenhill, (bottom) G Rettinghaus/*ZEFA Picture Library*

184/5 Tony Boxall/*EPL*
186 (top and bottom) Tony Duffy/*All-Sport Photographic*,
187 (top) Tony Duffy/*All-Sport Photographic*, (bottom) Don Morley/*All-Sport Photographic*
188/9 (motor drive sequence) Geoff Giles/*Marston Photo-graphics*
189 (right) Albrecht Gaebele
190 Tony Duffy/*Tony Stone Associates Colour Library*
191 (all except bottom left) Tony Duffy/*All-Sport Photographic*, (bottom left) Don Morley/*All-Sport Photographic*
192 Sven Simon/*Camera Press*
193 (top) Graham, OBS/*Camera Press*, (bottom) Neil Libbert/*Camera Press*
194 Dieter Baumann/*Foto Inter-Nations & Camera Press*
195 (top) Fionnbar Callanan/*Camera Press*, (bottom right) Tony Boxall/*EPL*
196 John Wright/*Camera Press*
197 (left) Gary Steer/*Camera Press*, (right) Ian Clough/*Camera Press*
198/9 Ian Berry/*Magnum*
200 Fenton Photos/*The Mansell Collection*
201 (top, bottom and right) *Popperfoto*, (middle) Bert Hardy/*BBC Hulton Picture Library*
202 (left) Jerome Yeats/*EPL*, (bottom) *Popperfoto*
203 (top) *Popperfoto*, (bottom and right) *Rex Features*
204 (left) Reg Davis/*Camera Press*, (top middle) John Bulmer/*Camera Press*, (top right) Team International/*Camera Press*, (bottom left) David Hurn/*Magnum*, (bottom right) Anwar Hussein
205 *Popperfoto*
206/7 W Eugene Smith/*Magnum*
208 Michael Busselle/*courtesy of Octopus Books Limited*
217 A Zeimbekis/*Barnaby's Picture Library*

Drawings by Chris Forsey.